FOREWORD

THE FIRST ART OBJECT Avery Brundage ever bought was Japanese. It was 1927, and the work that caught his eye was a netsuke, a toggle formerly used in Japan to secure a portable case to one's belt. Much collected by foreigners as well as Japanese, netsuke continued as a Brundage favorite until he had acquired one of this country's largest and most important collections. He broadened his interests along the way to founding this museum, and eventually, his collections included outstanding screens, hanging scrolls, ceramics, and sculpture. Japanese art came to be second in size only to Chinese among his collections.

It was, however, not only a beginning in collecting that forever assures the name Brundage an important place in Japan's history. As chairman of the International Olympic Committee, he took the games to that country in 1964, marking Japan's full reemergence into the international community after the disasters of war.

In this same year, the tragedy of the Santa Barbara fire, and the resulting loss of their home with numerous works of Japanese and Korean art, prompted Mr. and Mrs. Brundage to renew their collecting efforts with increased vigor; indeed, some of the finest objects in these collections were then acquired.

This museum benefits greatly from the era of Brundage's collecting. I do not think it possible for anyone now to acquire in quality and comprehensive quantity as the Brundages did; costs, competition, and the restrictions now often placed on the movement of art for acquisition across many borders, as well as the admirable and increasingly national development of museums—especially in Japan—mitigate against the emergence of another such collector.

Since the founding of the Asian Art Museum, Yoshiko Kakudo has served as curator of Japanese art, and the museum owes her a great debt of gratitude for her distinguished service. I would be remiss were I not to include in thanks the good work of Richard Mellott, curator of education and an expert in early Japanese ceramics. He has contributed in important ways to the work of the department and to this handbook.

The Asian Art Museum gratefully acknowledges the substantial contribution made by René-Yvon Lefèbvre d'Argencé, director emeritus, in the acquisition of, research on, and interpretation of the arts of Japan in the Avery Brundage Collection from 1963 to 1985. I also thank our Commissioners, Hatsuro Aizawa and Roger Fleischmann, for their help in the development of this project. Osamu Yamada of the Bank of California, too, has been a good friend to the department of Japanese art and provided valuable assistance to us in the publication of the handbook. Finally, I want to thank the Metropolitan Center for Far Eastern Studies for their generous financial support of this project.

Rand Castile
Director
Asian Art Museum

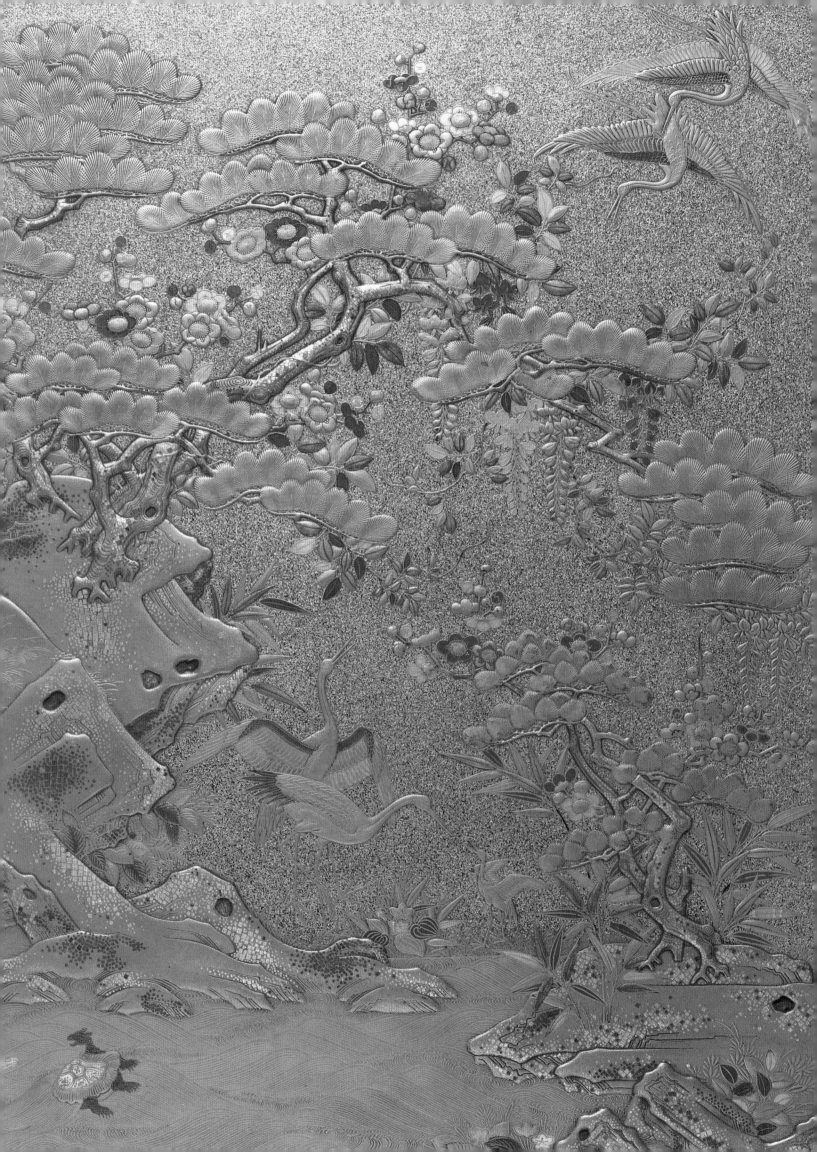

PROLOGUE

THE ACCOMPLISHMENTS of human energy — individual or collective, creative or destructive — can sometimes be remarkable. The assemblage of objects in this book, ranging from simple, anonymous works by artisans whose names and intentions can never be known, to highly sophisticated, well-documented, and collaborative works by artists and poets, forms a kind of testament: men and women seem over time to be guided by a faith and the historical evidence that creative energy is a bit stronger and probably more prevailing than destructive energy — a faith being tested at this time, February 1991.

The preparation of this book has been a long and thoughtful, sometimes lonely, but often exhilarating experience, a kind of awakening. The energies and talents of many have contributed to its completion, which happily coincides with the twenty-fifth anniversary of the Asian Art Museum of San Francisco.

Only a few of the artists represented in this book were blessed with fortune and recognition during their lifetimes. Many made a living in the trades in which they had simply grown up, rather than by their artistic pursuits or talents. Others seemed to follow passionately a creative instinct and energy, one of the strongest of human motivations.

The products of such instincts and energies — from the time an unknown potter pressed a cord pattern in the wet clay surface of a Jōmon pot to the days when the versatile Rosanjin painted his tiny, exquisite sake cup — delighted those who came in touch with them. Some of the objects depicted here were worshiped in temples; others graced great castles and humble tea houses, or were put to practical use by simple people. Now we call them works of art. The elegance and strength which endow every piece that has survived is the result of the loving care invested in them by their makers. Yet their origins, and even their makers' intentions, while interesting, are perhaps not as important as our perceptions of these works of art today. We should consider that they preserve not only their own history and evidence of the talents and skills of those who made them, but also their makers' faith, passion, and conviction in the focus of their creative energies.

In assembling this volume, and in the effort of assimilating what these artists have made, we have gained an ever-growing respect for those who are able to fashion those simple things in our lives — colors, forms, sounds, words — in ways that, by knowing them, others' lives may be changed, be it ever so slightly.

Yoshiko Kakudo
Curator of Japanese Art

FROM PRIVATE COLLECTOR

TO PUBLIC DONOR

Avery Brundage and Japanese Art

AVERY BRUNDAGE is often recognized as the most successful modern collector of Asian art. With a gargantuan appetite for acquiring objects, it's ironic that his first acquisition, at age forty, in 1927, was a nibble of a netsuke, a miniature toggle sculpture used as an *inrō* counterweight. Twenty-five years later, interviewed by a *Chicago Tribune* writer, Brundage regretfully admitted that he could no longer recall which netsuke was the first because he was forever culling and turning over his collection. "Pure aesthetics," he said, was the primary criterion for assembling his collection.[1] He revealed the reason for his attraction to netsuke in a speech in Tokyo during the 1964 Olympics, addressing diplomats, Olympic officials, competing athletes, and sportsmen. At this time he had four thousand netsuke in his collection and claimed all of them were ancient; he held a couple aloft as he spoke:

> Originally, these netsuke were carved with loving care for strictly personal use. The carver conceived the design and built something of himself into the object. It may have taken him six months, but it bore the stamp of his own personality. He was an amateur carver. Later . . . there arose a class of professional carvers. . . .Their work was perhaps more polished and displayed a superior technical skill. But it was ordinarily cold, stiff, and without imagination. Missing was the love and devotion of the amateur carver, which causes these older netsuke to be esteemed more highly by the collector than the commercial product carved for money.[2]

The athletes in his audience, imbued with Olympic principles, and the Japanese, appreciating the cultural analogy of amateur excellence, gave Brundage a standing ovation for this parable confirming that success in any field arises from the amateur's devotion and search for perfection.

Brundage's education had fostered his passion for the arts and for excellence. A scholarship student (class of 1909) at the University of Illinois, he majored in engineering but took courses in literature, aesthetics, Asian philosophies, and ancient civilizations. As a boy and a young man, Brundage had also excelled as a versatile athlete. He was discus champion of the Big Ten midwestern universities in 1908 and represented the United States in the Stockholm Olympics of 1912, placing fifth in the pentathalon events. A staunch advocate of the universal man in art as well as sports, Brundage had championed as chief spokesman the reactivation of the Cultural Olympics in Rome in 1960: "In pursuit of our objective of the development of the complete man, perhaps we do not sufficiently stress the Fine Art section of the Olympic program. I am sure that, in Tokyo, the Japanese with their sensitive love of beauty will give attention to this section of the program. Even so, more must be done."[3] Brundage enthusiastically participated in the 1964 Cultural Olympics, loaning several of his best objects to the Tokyo National Museum's exhibition of world art.

A millionaire by 1927, Avery Brundage barely survived the Depression of the 1930s; he credited his success to self-reliance and character building based on the Olympic sports discipline that guided him. I once asked him how he managed to acquire art objects during those lean years. Matter-of-factly he explained that he had been forced to foreclose on the assets of developers who failed to meet their contractual obligations to his construction company. He thus came to own outright many posh apartment buildings his company had built on Chicago's North Shore; he used income from them to remain afloat.

During the 1930s Brundage's collecting was confined to Japanese prints, netsuke, and sword-guard

paraphernalia, interests spurred by his familiarity with the well-known collections in the Art Institute of Chicago. Like all dedicated art collectors, he was part of a wide network of interdependent dealers, art auctioneers, agents, museum curators, and collectors, all devoted to finding, identifying, appreciating, evaluating, and acquiring the finest quality objects.

Sometime during the 1930s Brundage adopted a rating system for evaluating objects; his first use of it is found in his archives among papers dated 1939.[4] He used the categories Tops, Excellent, Good, and Discard, evaluating objects first in terms of pure aesthetics, then considering historical importance, form and decoration, physical condition, and price. According to former Asian Art Museum Director René-Yvon Lefèbvre d'Argencé, "Brundage's vision was global, his knowledge encyclopedic and his taste eclectic. The only two criteria he respected consistently were those of quality and diversity."[5]

In 1937 Brundage became the American representative to the International Olympic Committee, advancing by appointment to the executive board that same year. This later allowed him to travel constantly, mixing sports and art acquisition. The twelfth Olympiad had been awarded to Japan, the 1940 games to be held in Tokyo and Sapporo. But on July 16, 1938, reflecting the concerns of Japan's military government with geopolitical matters, the Japanese Olympic Committee requested a release from their commitment to the games. This was a perplexing time for Brundage. Allen Guttmann, in *The Games Must Go On*, relates that in February 1938 A. C. Gilbert (a fellow 1908 Olympian and member of the American Olympic Committee) wrote to Brundage urging the IOC to postpone the games because of Japan's invasion of Manchuria and China. Brundage disagreed but acknowledged, "It is difficult indeed to keep the public clear on the point that politics have no part in the Olympic movement."[6]

Brundage and his wife, Elizabeth, then undertook, in April 1939, a Far East odyssey that ended at the Imperial Hotel in Tokyo in a last-ditch attempt to keep the 1940 Olympics in Japan. In addition to conducting sensitive meetings concerning the games, he visited dealers and bought on the spot, a practice unusual for a man invariably methodical and patient in making decisions to purchase.

Brundage spent $722.60 on his Tokyo acquisitions, which included a pair of bird and flower screens, two Kano-school hanging scrolls, a flower basket signed *Keison*, seven prints of sporting subjects, a samurai helmet, a red lacquer *inrō*, and a carved-wood ox netsuke. Among the lists are reminders to himself to

"think about the small screen with figures at $180 and the bird and flower screen at $200."

After Tokyo, Brundage and his wife proceeded to Nikko, Miyanoshita, Kyoto, and Beppu, where he purchased "12 Satsuma porcelains by Meizan, two boxes of cloisonné, 1 box of silks from Nomura, 1 old Imari water bottle, an *oizushi* (portable cabinet for monks), an ivory ox netsuke, a lacquer fox netsuke, 1 pair of wooden temple dogs, a bronze figure of the god of wisdom, a gong stand, more Satsuma ware, unsigned, an 'old' ivory netsuke, and several bronze bowls and vases."

Avery Brundage judged the September 1939 outbreak of World War II as the "suicide of cultures."[7] He publicly chose to repudiate, and later ignore, the war, saying he had "so many dear friends on both sides that this wholly unnecessary war" saddened him. He became a highly vocal antiwar pacifist and staunch antagonist of Roosevelt's war efforts. Politically, he was essentially a midwestern isolationist with a naive, consuming vision that somehow the 1940 Olympic Games could be saved; he was probably most upset by the Japanese cancellation of them. His fascination with Japanese art and its humanistic values as well as his zealous support of Japan's launch of the Olympic movement in the Far East blinded him to the country's military aggressiveness. While publicly maintaining a pro-Japanese stance (until the attack on Pearl Harbor), his enthusiasm for Japanese art suddenly waned. For the next few years he turned his avid attention to Chinese art. The Brundages' interest in it had been fostered in 1935 by the first comprehensive exhibition of Chinese art in the Western world, at the Burlington House in London, where they spent three long, intense days.

During 1940–41, Brundage started his search for Chinese bronzes and sculptures by approaching the Yamanaka Gallery branches in Chicago and New York, having made his initial contact with the parent gallery in Kyoto in 1939. Hisazō Nagatani, the Chicago manager, became a close friend, serving Brundage until his death. The New York manager, Shinzo Shirae, also became a close friend as well as Brundage's most trusted informant about objects available in New York galleries and auction houses. He evaluated them for Brundage, negotiating and bidding on his behalf. During the 1940s and 1950s Shirae was responsible for ferreting out and alerting Brundage to opportunities to purchase the finest available Chinese bronzes and the best Japanese prints on the market.[8]

From 1935 to 1950, Shirae represented Yamanaka and Company in New York. In 1942 the Chicago and New York branches were taken over by the federal government's Alien Properties Custodianship, and in 1944

the Yamanaka holdings were liquidated by auction. Shirae and Brundage remained close friends and associates during this difficult period. Shirae offered to represent Brundage's interests at the auction, and the collector acquiesced enthusiastically, giving Shirae little guidance; his purchase invoices make a stack 1½ inches thick, but fewer than 10 percent of the objects were Japanese. In August 1944 in New York, Shirae introduced Brundage to the famous international dealers in Chinese art, C. T. Loo, C. F. Yao, and J. T. Tai. The appreciative Brundage, his interest in Japanese art reemerging, asked Shirae to inform him promptly of any "top quality netsuke, *inrō*, *tsuba*, Japanese lacquers." By 1946 Brundage had to tell the all-too-successful Shirae, "I have so many prints, netsuke and *tsuba*, that I will have to return some of them to dealers as they're duplicates. . . . I do not have a catalog, so will probably have to refrain [from buying more] until I have time to compile one."

As his interest in collecting Japanese art reawakened in the 1950s, Brundage continued to trust and depend on Shirae. On January 28, 1950, a young, recently demobilized soldier living in Tokyo, Harry G. Packard, showed up "with a few very good pieces" in Chicago at the Brundages' La Salle Hotel and claimed to know Shirae. Brundage lost no time in inquiring of Packard's *bona fides*. Shirae responded on February 5, "I think I met him only once or twice at the Yamanaka shop many years ago. I don't know, however, anything about him. What kind of articles did he bring from Japan? I heard that the prices of antiques in Japan are much higher than here." Packard willingly shared his knowledge with Brundage, assembling for him a three-ring notebook with the names of all the respected dealers in Japan, the dates of the important periods of Japanese art history, and the various schools of painting. A mutual respect grew between the two as Brundage pondered the idiosyncrasies of dealing with the Japanese and the primary question of who in fact were the best dealers. Brundage kept the notebook all his life, and the dog-eared condition of the pages indicates he consulted it often.[9]

In October 1950 Junkichi Mayuyama, the Tokyo-based dealer, first visited Brundage in Chicago with art dealer Howard Hollis. Writing to Shirae, Brundage noted: "I am impressed with Mayuyama's knowledge of Oriental art, particularly Chinese ceramics. . . . J. M. has some interesting news of Japanese discoveries and research during the war years. What do you know about him?"

Even though Brundage had made several important contacts with knowledgeable and respected dealers

of Japanese art, only in the mid-1950s was he ready to think about a trip to Japan and a commitment to acquire Japanese art with the same intensity as he collected in other areas. He had been offered a screen by the famous painter Sesshū and immediately sent a photo of it to Shirae. Disclaiming expertise, Shirae referred him, in a note of December 27, 1954, to Yukio Yashiro, a bilingual, Western-educated art historian who was later exceptionally helpful to Brundage in his Japanese art collecting. Shirae also encouragingly noted: "I have heard some time ago that the prices of Sesshū paintings are low in Japan these days. . . . I think it is wise to buy Japanese paintings and potteries in Japan. You will have a better selection and safer. . . . Prices of prints are higher than U.S., moreover there are very few prints to be found at any prices."

Brundage stopped in Japan in May 1955 after an Australian trip on IOC business. In Tokyo he dealt directly with Mayuyama, but with the other dealers, he asked for the assistance of Kyoto's Toyokichi Shimozuma, then associated with Yamanaka Gallery, who later founded his own company, Kyo Trading Company. Shimozuma became indispensable to Brundage. The American collector was accustomed to doing business in particular ways, which the Japanese found unorthodox. Brundage wanted long periods to consider objects, the privilege of returning items for credit, and payment over time. He expected the standard hefty reduction of base price he received from his European and American dealers. He wanted to "bank" sums of money above purchase price with the Japanese dealers, in exchange for first refusal on exceptional items. Later, in 1960, he wanted discounts on objects specifically destined for the Asian Art Museum. But he recognized that he did not have the status in Japan he enjoyed with his Western dealers, despite his reputation as a "big, steady, reliable" collector.

Shimozuma agreed to serve as Brundage's coordinating agent, working on commission, handling nearly all of Brundage's purchases in Japan. He was indispensably adept at conducting business "the Japanese way." He made sure that Brundage actually met Yukio Yashiro, who was a member of Japan's National Treasures Committee. (This body, established shortly after World War II to identify and register art objects important to the Japanese cultural heritage, figured often in Brundage's subsequent collecting.) He also met Sueji Umehara, professor of archaeology at Kyoto University, and Bunsaku Kurata, curator of Nara National Museum and a specialist in Japanese sculpture. In addition, Shimozuma was fairly fluent in English; he knew how to process trade and customs forms and how to obtain

clearance for objects of Chinese or Korean origin that had been embargoed under the Trading with the Enemy Act of 1950.

Since Brundage had met Mayuyama five years earlier in Chicago, he relied on him to make his own shipments without going through Shimozuma. The May 1955 purchases he entrusted to Mayuyama included a *haniwa* horse (B60 S203), a *haniwa* warrior (no. 11), a Fujiwara period Buddhist sutra scroll (no. 40), nine prints, and twenty-two items of Chinese and Korean origin. Two hanging scrolls, one of Buddhist figures, the other attributed to Sōtatsu, were later returned.

But even Mayuyama experienced difficulty in expediting international transactions. The shipment was held up in San Francisco customs for over a year on import document technicalities. Despite persistent prodding from Brundage, Mayuyama was unable to obtain the required clearance. With resignation and profuse, deeply ritualistic apologies, he explained, "We . . . made up a list of only those [antiquities] that can be easily imported . . . without any troubles."

Brundage, undeterred, was determined to obtain the entire shipment. He had Shimozuma consult with the U.S. consul in Japan, whom Shimozuma apparently knew and who immediately had the shipment cleared, writing, "inasmuch as Japan had been at war with China for 10 years, and after the war, occupied by the U.S. Army for almost 10 years, there was no trade whatsoever with Communist countries, therefore the objects of Chinese origin in Japan had obviously been in Japan for at least 15 or 20 years."

All subsequent shipments from Japanese dealers were coordinated through Shimozuma, who negotiated the purchase of objects Brundage had seen and decided on at various Tokyo, Kyoto, and Nara dealers. But the cost of acquisition in Japan continued to irk the collector, who considered the prices too high, far different from what he had been led to believe. He felt that perhaps they were being elevated simply because he was the buyer, saying bluntly, "This is highway robbery by a bunch of bandits." Thereafter in correspondence, Shimozuma, an accomplished diplomat, referred to the Japanese dealers as "bandits" and to himself as the "chief bandit," saying, "It cannot be denied that the prices are very high in Japan and we want the prices be brought down to the proper level."

During the 1955 trip, Brundage shared with Shimozuma his dream of plans for a museum for Asian art, preferably on the West Coast, telling him that he had offered his collection in 1953 to the University of California at Berkeley, at Los Angeles, and Stanford University as well. Because of building costs or an absence of broad-based support for Asian art, none was able to accept it. He then entered negotiations with city officials in San Francisco.

By the mid-1950s, Brundage's collection had grown far beyond a personal enthusiasm to be savored in residential rooms. It consumed several large storage rooms in his Chicago hotel and was displayed in his office, his North Shore apartment, and the Brundages' Santa Barbara home. Some of the larger items were still being stored in dealers' warehouses. Interested only in sharing his collection to educate and enrich the world community, Brundage was obviously inspired by his Olympic ideals; he realized that international understanding and respect for the fine arts could develop international amity, just as he envisioned the Olympic movement had done. He often said, "There's nothing to be personally gained by Avery Brundage in this project," disclaiming material advantage or renown.

With a museum repository in mind, Brundage, urged by Shimozuma, insisted on obtaining "nothing but the very best," although he still drove a hard bargain. Concerning a group of objects, Shimozuma pointed out to him on May 11, 1955:

> The screens, paintings and bronzes are registered items [forbidding their exportation from Japan]. . . . My personal opinion is that they are higher priced for the quality of the painting since they were selected out of many thousands of screens and paintings by the recognized authorities. . . . I have obtained a confidential assurance from some members of the board of the National Treasures Committee that they will be willing to do everything they can to release them. . . .This is quite a drastic change from their former attitude . . . brought about as the result of the arguments we have been carrying on against them for the last many years.

Shimozuma further advised Brundage about negotiating prices:

> He is one of those men whose asking price is based on the lowest price at which he would sell. . . . He would insist on a crazy price if we should give him any impression that we are particularly interested in any item from his collection. Therefore we have to pretend that we are not particularly interested, but we might consider buying provided he accept our offer naturally such negotiations would take more time consequently.

One can almost hear the battle-hardened Brundage's snort upon reading this instruction on how to do business the Japanese way.

Shimozuma ended this letter by commenting on their marathon trip to see Japanese dealers: "The pro-

gram during your stay in Japan was the most strenuous one that I have ever experienced, but I have enjoyed every bit of it." Brundage replied, "Since I live this way most of the time, I am more or less accustomed to it," probably referring to his habit of seldom sleeping for more than a couple of a hours a day.

Shimozuma worked strenuously to have the National Treasures Committee annul registration on paintings in which Brundage had expressed an interest. These efforts proved unsuccessful, and the Chicago collector was disappointed that he could not acquire a number of works by Shūbun, Noami, and Sansetsu.[10] In the end Brundage purchased more objects of Korean and Chinese art than he did Japanese. Still protesting prices and treatment, in a May 26, 1955, letter to Shimozuma he wrote, "On items which appeal specially to Japanese collectors the figures are five or ten times what the objects would bring in other countries. I feel that I paid too much for nearly everything I purchased, but anyway, I enjoyed my trip."

During those five days in May 1955, Brundage visited and revisited the dealers, keeping notes on over six hundred art objects he viewed.[11] He finally decided on buying only twenty-two of them, the most significant being a Fujiwara wood sculpture with lacquer and gilding of a seated Amida on a lotus pedestal, purchased from H. Hirota of Kochūkyo (no. 32). The archives indicate that Brundage continued to review his five days' worth of notes, dividing all the items into categories, then evaluating, reevaluating, and rearranging them by rank and importance. As was his long-standing custom, he listed everything, compiling forty-three legal-size sheets annotated elaborately on both sides. The dates he entered each time he reviewed his lists reveal that Brundage spent over two years considering the Japanese art he had encountered during the 1955 trip.

In May 1958 Brundage made his third trip to Japan, this time with the IOC for a general meeting to consider Tokyo as the site of the 1964 Olympic Games. On completing his Olympic business, Brundage, with Shimozuma, again visited dealers with whom he had spent time in 1955. For Brundage, 1958 was probably the most favorable time psychologically for collecting Japanese art. The world political situation had stabilized, the international market for Japanese art had reached an equilibrium, and the offer of his collection for a museum project in San Francisco, positively supported by city officials, was proceeding more or less smoothly.

But most important for Brundage, the scheduling of the Olympics for Tokyo and Sapporo had set to rights what he had long considered to be eighteen years of per-sonal slights, triggered by the Japanese reneging on the 1940 games. So euphoric was he that this whirlwind Japanese art-acquisition trip resulted in three astounding shipments totaling thirty-five crates, some containing many of the objects he had seen three years previously and had been evaluating ever since.

Brundage had requested that Shimozuma "get rock bottom prices and I'll give you a prompt decision." Evidently Shimozuma was successful; on June 9, 1958, he wrote to Brundage, "I have compiled the list of the objects you selected from the various bandits, including those items which you have more or less decided to add to your collection, and those reserved for future consideration." The definite list totaled $143,500 and the pending list $177,000, almost all of which were finally purchased.

Brundage acquired some of the most significant Japanese objects in his collection at this time, including the pair of six-panel sixteenth-century screens, *Landscape of the Four Seasons* by Shikibu Terutada (no. 53) from Mayuyama Ryūsendō, along with two Nabeshima, three Kakiemon, and two Kutani porcelains. From Kochūkyo came the Edo period screens *Inuoumono* (no. 59). From S. Yabumoto, Tokyo, came the pair of *kaerumata* of the wind and thunder gods (nos. 38–39), mentioned in Brundage's notes as being "from Nagoya Castle, Kyushu, where Hideyoshi stayed during Korean expedition." Also acquired there were two *ema*, or votive paintings, one of "Dog-foo" [*sic*] dated 1693 from Kōfukuji temple, Nara (B60 D74), and another by Toyonobu from the Chichibu shrine, painted in the *ukiyo-e* style and dated 1757 (B60 D7+). A pair of Edo period screens depicting the Gion festival (no. 60) were purchased; Brundage rated only these screens "T" (Tops). Other Yabumoto objects listed were a pair of screens attributed to Tosa Mitsunobu, *Herons and Willows* (B60 D62, B60 D63), a *Willow and Cherry Tree* screen attributed to Tohaku; a pair of screens attributed to Mitsunori, *Chrysanthemum, Autumn Grasses, and Birds*; and twelve paintings by Yamamoto Soken, subsequently restored to their original condition as a pair of six-panel screens (no. 63). He also purchased the "Portuguese screens" (no. 57), about which Yashiro wrote to Brundage, "These Portuguese screens are of the late Momoyama period and are as good as the Hirota screens, although ours under consideration are not registered [and] . . . are enthusiastically evaluated by Miss Shirahata." The certificate of authenticity signed by Y. Nakanishi of the Kyoto Antiques Association mentioned that the screens were previously owned by Shohei Kumita, Tokyo.

From the Yabumoto lists, Brundage pondered a standing wooden Amida Buddha (B60 S11+) of the Kamakura period ("feet have been badly repaired," he noted), and a collection of nine Nō robes of the Tokugawa era from the collection of Ikeda, provincial lord of Okayama. For some unstated reason, he decided against the latter while settling for the former, even though each had the same price, and the Nō robes had his higher rating. Later that year Brundage decided to purchase the large Negoro lacquer offering-stand that he had seen at Yabumoto.

From the dealer Setsu came sixteen items, some of which ultimately ended up with Nagatani. Of this assortment, consisting primarily of lacquer boxes and porcelains, Brundage was enthusiastic about only his bronze *egoro*, a Kamakura period incense burner for temple ceremonies, formerly in the Masuda collection.

Brundage purchased from Ogiwara a two-panel screen, *Deer*, by Watanabe Shikō, an Edo period pair of screens, *Pheasant and Pine Tree*, and the hanging scroll *Hawk on Oak* by Soga Nichokuan (no. 58). He also bought triptych hanging scrolls of Buddha, Monju, and Fugen attributed to Chōdensu (1350–1430).[12]

Brundage first saw a *sueki* jar with cups and animals on the shoulder at Mayuyama's gallery on May 24, 1958. The potent sculptural quality of this mortuary object immediately appealed to him, but the jar was registered with the National Treasures Committee and had a clear excavation date attached to it; the Committee was reluctant to consider annulling the registration. Later during that May 1958 trip, Brundage saw another, very similar *sueki* jar (no. 19) in K. Irie's shop in Nara. While Mayuyama was asking ¥1,000,000, Irie's price was a rock bottom ¥380,000. On July 30, 1958, Shimozuma wrote to Brundage explaining the intrigue behind his quick purchase of Irie's *sueki* vessel:

The owner told me that the bandit Mayuyama saw it and made many propositions to him to buy it right away, but since you have a reserve on it, Mayuyama asked the owner to give an option on it. I told the dealer you will be holding an empty bag if you count on Mayuyama making the sale to you, since I (Shimozuma) am the only one in a position to know something about whether he'll sell the piece to you or not, thus I bought the piece in Nara right away.

Brundage continued to search throughout Japan for Sesshū screens during that trip. He had previously traveled with Isshō Tanaka, of the Kyoto National Museum, to see a pair housed in the Tenjuan at Nanzenji temple, just down the street from Shimozuma's gallery. Tanaka wrote to Brundage about the rarity of Sesshū screens, suggesting that he start looking at the worth of

the followers of Sesshū, such as the painters of the Unkoku school. Brundage obviously took the advice, for at Yamanaka's gallery he purchased two sets of screens, one pair by Yushō Kaihoku of a landscape in sumi ink (B60 D50+, B60 D51+), and another pair by Unkoku Tōgan with figures in a landscape (no. 55). Later, in a letter to Shimozuma, Brundage commented, "As I remember it, we looked at three pairs of screens, the pair by Yusho, a pair I marked Unkoku and a third pair illustrating the *Tale of Genji*," requesting that Shimozuma get outside opinions on the last pair from the top experts in Japan. The screens were eventually examined by Umezu and Hirano of the Kyoto National Museum, who, according to Shimozuma, "are looked upon as the scholars who know about Japanese painting as good as any scholars in Japan, including Yashiro although they do not enjoy the fame of the latter or of Shimada." The joint opinion of Umezu and Hirano was translated by Shimozuma from Japanese:

The screens are not signed as customarily for the artists attached to the Imperial Household but judging from the technique of the painting, they can be attributed to Tosa Mitsuyoshi or an artist of Mitsuyoshi's time. Mitsuyoshi died in 1614 A.D. therefore the work might have been done around 1600 A.D. and certainly important enough to be classed as representative work of that time.

Shimozuma informed Brundage of Jirō Yamanaka's original price for these screens and, further, that he had negotiated a reduction. But Brundage recalled the asking price when he was in the gallery, producing the slip of paper with his notes written while there. After much negotiation and letter writing, the Genji screens (no. 64) were finally purchased for a difference of only a few hundred dollars between the base price and the final sales price. He acquired from Jirō Yamanaka twenty mirrors dating from the Fujiwara, Kamakura, Nambokuchō, and early Muromachi periods; this group comprises most of the Japanese bronze mirrors in the Brundage collection. Brundage also selected for potential purchase some *haniwa*, with the stern message: "It is important they be authentic. There are too many fakes on the market. I saw plenty while I was there. Please have each Haniwa passed by an expert before shipment." None of them passed muster.

While at Yamanaka, Brundage viewed and took copious notes on six sculptures, all of which he rated "E" (Excellent), and put a hold on them. He finally decided on a life-size standing wooden figure of Shō Kannon, Heian in date (no. 33). It took two years of negotiations, with the help of Yashiro, to get this sculpture deregistered; it was finally shipped to the Brundage

home in Santa Barbara, where it arrived regrettably with a broken arm and finger.

Brundage had been methodically assessing the availability of first-class specimens of Japanese sculpture since 1956. When 206 of his Chinese, Siamese, Khmer, Indian, and Middle Eastern sculptures were displayed for the first time in 1956 at the Santa Barbara Museum of Art, he lamented to Shimozuma that not a single Japanese example would have been worthy of inclusion. For the decade following the decision to purchase the Heian Kannon, Japanese sculpture was Brundage's priority; during this time, he acquired practically all his major and significant sculptures.

All of the 1958 Japanese purchases were shipped to La Piñeta, the palatial Brundage home on Ashley Road in Santa Barbara, where some of the art collection was housed in downstairs galleries looking out on a Japanese rock garden. Brundage was assisted at this time by Victor Merlo, who functioned as a registrar or collections manager, receiving and unpacking crates, properly storing objects, and registering each item in a basic catalogue format with a permanent identification number. Previously curator of classical art and antiquities at the Los Angeles County Museum of Art, upon leaving that institution Merlo became a dealer in Greek pottery. He also dealt in Japanese pottery; his immersion in the tea ceremony had led to his appreciation of Japanese ceramic wares. Merlo first met Brundage when he sold him three Greek vases in 1952; in 1953 Brundage purchased sixteen Japanese ceramics from him.

Although difficult to work with, Merlo was most helpful to Brundage in the 1950s, frequently urging him to upgrade his Japanese pottery. Before 1955 Brundage had purchased all his Japanese ceramics through various American dealers. He owned 189 pieces in February 1955, but by then he was becoming more perceptive and critical, noting in a letter to Merlo, "While in Seattle I saw some Japanese pottery that makes me want to discard practically all of our specimens."

In 1954 Merlo had moved to Santa Barbara from Glendale to formulate a registry of Brundage's collections. Unasked, he then prepared an ambitious museum program, trying to persuade Brundage that Santa Barbara was by far the most appropriate West Coast home for his collection. But Brundage kept to his museum plans in San Francisco, and in 1962, after Jan Fontein of the Rijksmuseum became a one-year consultant to the Brundage collection, Merlo and Brundage finally parted company.

Brundage, as he learned more about the aesthetics of Japanese ceramics, became decisively more unhappy

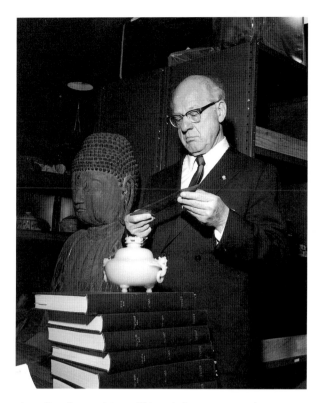

Avery Brundage studying a Chinese jade in storage at the Asian Art Museum.

with his Santa Barbara assemblage. When his other objects were being transferred to the museum in San Francisco in 1960, he decided to withhold the Japanese ceramics, as most were likely fated for discard. With the negotiations for the ongoing museum project, the pressing demands of the upcoming Tokyo Olympic Games, and the lack of a permanent curator in San Francisco, Brundage kept deferring their evaluation, culling, and transfer.

These objects were still on display in the downstairs galleries at La Piñeta in the autumn of 1964, when a savage canyon fire swept over the Santa Barbara hills, destroying everything in its path. La Piñeta burned to the ground.[13] After the cataclysm, a Japanese acquaintance wrote expressing regret that Brundage was not able to salvage anything from the ruins, attempting to console him, Japanese fashion, with an old adage: "The worst scare and calamities are Jishin (earthquake), Kaminari (thunder), Kaji (fire) and Oyaji (tyrannical father), so your fire is only the third worst calamity in the world." One may safely assume Brundage found this of dubious comfort.

From late 1958 onward, as the museum project came ever closer to realization, Brundage concentrated his attention on Japanese screens, paintings, ceramics, sculptures, and outstanding archaeological objects. Correspondence reveals complex negotiations, with Shimozuma, Brundage, and Mayuyama sometime-

partners in elaborate *pas de trois*, and Brundage intent on improving the quality of his Japanese holdings in the museum-bound collection.[14] Shimozuma "lost" a pair of Ōkyo screens (no. 72) to Mayuyama, from whom Brundage, still conscious of cost, then had to purchase them. This transaction was further complicated by the fact that Laurence Sickman, curator at the Nelson-Atkins Museum of Art, was in the wings, waiting for Brundage to act or pass, as Mayuyama, expressing his thanks for Brundage's great efforts to introduce Japanese arts to American museum audiences, explained his offer late in 1959:

> Now, please understand that I told Dr. Sickman the screens 3 million yen ($8,333) and that we like to say two and a half million yen ($6,944), just this one time if Brundage should take the screens. Please allow me to add that these screens have an excellent reputation in our country, and are going to be published in the future in *Kokka*, the most authentic and oldest art magazine in Japan.

Brundage made a partial payment for the screens in May 1960, later instructing that they be sent for his review to the museum in San Francisco, as he planned to be there for the eighth Olympic Winter Games. The balletic Shimozuma, negotiating with Mayuyama on the payment schedule for the balance, assured Brundage:

> All of the bandits are most anxious to have their money for those pieces they are holding, because the tight money policy of government is making it difficult for them to manipulate their financial position and I shall appreciate most deeply what you might be able to do. Job of bandit chief is not an easy job as it looks because he has to listen to their selfish arguments.

In the middle of 1960, Brundage submitted payments in full and appealed to Shimozuma for his advice and assistance:

> It is true that my Japanese things are not of as high standard as the Chinese section of my collection. Since the Museum project in SF has been approved, it will be most unfortunate if the Japanese is inferior to the Chinese section and I am sure that everyone concerned, and this includes the scholars and the people of Japan, will be very unhappy unless this is remedied.

Shimozuma, who shared Brundage's vision and passion for collecting Japanese art, responded earnestly:

> I am right now searching for important Japanese art and have been getting together some items which would be National Treasures if they happened to be brought to the attention of the National Treasures Committee, and

photos of them will be sent to Mr. Nagatani so he may discuss them with you.

From May 10 to June 12, 1960, 137 of Brundage's Asian art objects were displayed in a preview in San Francisco, so that the public could view and evaluate the collection before voting at the June primary election on a bond issue measure to fund the museum. In the foreword of the preview catalogue, which was illustrated with thirty-four superb examples of Japanese art, Laurence Sickman, then director of the Nelson-Atkins Museum of Art and Brundage's longtime friend, wrote, "There is good reason to believe that the objects of Asian art offered San Francisco by Avery Brundage comprise the last comprehensive collection in this field that can be assembled in our time." On June 7 the citizens of San Francisco overwhelmingly passed the bond measure, accepting the offer of Brundage's collection and agreeing to construct a building to house it and to support it in perpetuity.

Brundage sent copies of the small exhibition catalogue to all his dealer-acquaintances in Japan. A typical response was Hirota's; he wrote on August 10, 1960, "I am much pleased to find the Buddha sculpture of the Fujiwara period in this catalogue, the one I sold you." Professor Umehara then enthusiastically located several important archaeological specimens for Brundage, one of which Shimozuma specifically mentioned in an August 25 letter: "Dōtaku [no. 9] which Professor Umehara was kind enough to obtain for you has been shipped to you in care of the Museum. . . . I believe it is a very important piece and casting and patina are exceptionally good."

The early Japanese sculptures that Brundage subsequently purchased were notable for their rarity and the fact that he was still able to obtain them, even though some were of National Treasure quality. It is perhaps likely that by this time Japanese dealers as well as officials were ready to accept him not only as the quintessential American collector but also as a man whose altruism, given form and substance by the museum project, elevated his hard-headed negotiating attitude above commerce solely for personal gain.

San Francisco's enthusiastic response greatly stimulated Brundage. He wrote to Shimozuma, "I want a few large pieces of Japanese sculptures. A seated Buddha, 9' to 10' high, would make an attractive entrance feature. Will you please be good enough to look around and see what you can find of this nature?"

Shimozuma in early 1961 located a 5-foot high Fujiwara period seated Amida Buddha (B61 S23+) and sent Brundage a photograph of it. Brundage agreed that

Shimozuma should proceed to get it cleared, only to learn that the National Treasures Committee was getting "very fussy" about granting export permits. The Buddha, which Brundage uncharacteristically bought without first examining it, had once resided in a mountain temple outside Kyoto and was in fact unregistered; it therefore was cleared for export, not without reluctance, by the National Treasures Committee. Brundage saw it in San Francisco for the first time late in September 1961, and pronounced himself "quite happy with it, except for the price."

Later in 1961, Shimozuma found two 6-foot high wood Fujiwara period Niō guardian figures (B62 S23+, B62 S24+). He wrote Brundage on December 18:

> This last week, I returned Kyoto and went to Nara to see the pair of Nios for which you have photo, it was the real surprise to find that these Nios are truly fine sculptures of Fujiwara instead of Kamakura period, as such, they always have been attributed by the temple which owns them.

Shimozuma went on to explain that although most Niō are weathered by exposure, this pair remained in good condition, original except for the Genroku period replacement of hands and feet; he also planned to have a number of shrinkage cracks in the wood filled. Again with reluctance, the National Treasures Committee eventually cleared the Niō, since they were unregistered, and Brundage had them shipped directly to the museum in California, only to have another conflict arise: "The reaction of the museum people, however, has been mixed, as some seem to think they are a little coarse for use inside the museum. . . .The argument is still going on, but I will let you [Shimozuma] know as soon as a decision is reached." Brundage prevailed: "They are very impressive to me, despite the repairs and additions. I like their primary potency."[15]

After the Summer Olympic Games in Tokyo in 1964, Brundage, once again with Shimozuma, toured Japan to visit the dealers. Nagatani also accompanied them. Shimozuma took them to the Masuda family villa in Oiso, about a two-and-a-half hour drive outside Kyoto, to view a pair of Tempyō period dry lacquer figures (nos. 28–29). He also gave Brundage two old illustrations of the figures from an unidentified Japanese publication. In the fall Brundage wrote Shimozuma inquiring about these sculptures.

Shimozuma replied promptly and at length, explaining the figures' good condition, rarity, and favorable price compared with the cost of other, smaller dry lacquer figures. He maintained that the quality of the pair was worthy of National Treasure status (their dating was confirmed by a member of the committee), although these, too, were unregistered. He also encouraged Brundage to inquire of another museum concerning the price:

> I do not recall any dry lacquer figures of the importance of these figures in any American Museums not because they do not have any interest but they did not have any chance of acquiring, however I understand a dry lacquer figure . . . has been purchased by the XXX Museum paying $150,000 for just one figure and it would not be difficult for you to obtain true information from such Museum.

The ever-persuasive Shimozuma had once again influenced Brundage to pursue these rarities, for Brundage requested that he proceed with getting clearances for export. Shimozuma continued in a later letter, cautioning about the effect the collector's expression of interest might have on the transfer:

> Your seeing the statuettes has to be kept absolutely confidential from National Treasures Committee, scholars and bandits, until we are ready to make the formal applications for the permit to be sent to your museum, and any commotions might be raised by the rank and file will make it impossible for National Treasures Committee, to release even they might be most anxious to act in your favor.

In recognition for what Brundage was doing to promote the arts and culture of Japan, the committee willingly allowed the export of the figures; it probably helped that Brundage had just been decorated by Emperor Hirohito with the Order of the Rising Sun, the highest honor that could be given a foreigner, for his efforts as the Sports and Cultural Ambassador with the International Olympic Committee. The dry lacquer figures of Bonten and Taishakuten arrived in San Francisco in early 1966, in good time for the June opening of Brundage's collection.

The last year of acquisition before the museum opening was intense, since Brundage wanted the Japanese artworks to create as much of an impact as the Chinese objects. Assisted now by René-Yvon d'Argencé (later director of the museum) and researcher Yoshiko Kakudo (later curator of Japanese art), Brundage added, among hundreds of others, a single Yosa Buson screen (B60 D80+), a Kamakura Fugen Bosatsu hanging scroll (no. 41), a Kamakura fragment of the Jinnōji *Engi* hanging scroll (no. 49), a Momoyama squarish E-Shino dish (no. 93), a large Muromachi Shigaraki jar (no. 87), and an Old Kutani porcelain plate with the Three Friends theme (B66 P36). And on and on it continued, as he worked with dealers in Japan and the United States.

As Brundage was progressing from his position of private collector to major donor of a museum-quality collection, the American dealer Harry Nail sent him what amounts to an eloquent accolade:

> Some time ago I wrote to you expressing concern that your joy of collecting was being marred by this museum endeavor. You know full well that names come and go; approbations in the long run are tied into the object itself and do not depend on the name of its creator. Your collection was formed by your eyes and what the people are going to see for time immemorial are those things which your eyes selected. Anyone willing to spend the money can buy a great name painting and hang it in a museum. Only a few people [like yourself] can recognize beauty and great lasting art disassociated from dealer's talk and the build-up of the critics who make present day taste.

A few years later, I was walking with Avery Brundage around the museum concourse. By then, despite his outwardly robust condition, he had started to show the infirmities of age. Glaucoma blurred his sight; he had stubbed his toe and broken it but was determined to "not let the world see me limp when I open the next Games."[16] In obvious pain, he continued his stride, with me panting to keep up. We turned our attention from his injury to the more pleasant subject of art, and he remarked quite spontaneously, "My Japanese collection will never be complete." He was, I think, perhaps recognizing something about the nature of his collection that he may have at times avoided acknowledging when in full cry after the splendid works he loved so well: the collection was a growing, changing entity with a life now apart from his own, its "completeness" of an order transcending acquisition. I could only say, "Mr. B, you're an Olympic competitor . . . certainly you've enjoyed every moment of it . . . haven't you? Wasn't it all worth it?" Either he did not hear or did not want to respond, and silence prevailed as we continued circling the concourse. For the next few years, until his death on May 8, 1975, he made no further major purchases of Japanese art.

Clarence F. Shangraw
Chief Curator

NOTES

1. Avery Brundage personal archives. The identities of all those with whom Brundage dealt are contained in his personal art-collecting archives, now housed at the Asian Art Museum, San Francisco. All quotations not otherwise cited are from these archives.
2. Heinz Schobel and René-Yvon d'Argencé, *The Four Dimensions of Avery Brundage* (Leipzig: Editions Leipzig, 1968), pp. 33–34.
3. Ibid., p. 24.
4. The system may have been suggested by a fellow-collector with impeccable connoisseurship or a museum curator, perhaps Laurence Sickman of Kansas City, whose Asian art connoisseurship made a profound impression on Brundage.
5. *Gems of Chinese Art from the Asian Art Museum* (Hong Kong: Hong Kong Museum of Art, 1983), p. 6.
6. Allen Guttmann, *The Games Must Go On: Avery Brundage and the Olympic Movement* (New York: Columbia University Press, 1984), p. 89. Guttmann observes (p. 85): "Then, as now, the IOC considered war and peace pragmatically, as an organizational question." This work provides a fair and balanced assessment of Avery Brundage's outlooks and beliefs in areas where international politics, conditions, and tensions touched concerns of the IOC.
7. Ibid., pp. 85–87.
8. Brundage sold all these wood-block prints in the late 1950s, when he decided to enlarge his other Japanese holdings.
9. Harry G. C. Packard is an American who took up residence in Japan shortly after World War II. Although trained as an engineer, he became fascinated with Japanese art. He soon began to collect and sell important works of art to museums, dealers, and other collectors. Avery Brundage was one of the more important collectors who purchased many works of art from Mr. Packard.
10. Brundage and the ever-resourceful Shimozuma then attempted to develop a scheme involving Nagatani as a go-between, hoping the Japanese dealers would be willing to accept a very low "dealer's" price Nagatani would offer them. Nothing indicates it worked.
11. Brundage looked at the following roster of objects: 80 at Setsu, 33 at Hirano, 17 at Fujiwara, 23 at Ogiwara, 88 at Mayuyama, 42 at Hirota, 11 at Satomi, 79 at Nara's Tamabayashi, 16 at Watanabe, 62 at Shimozuma, 45 at Yokota, 71 at Tokyo's Yabumoto, 37 at Kyoto's Yamanaka, and 27 at Kawai.
12. Controversy over the Chōdensu triptych aroused Brundage's anger during a 1966 international symposium, when various experts prematurely assigned it to China and Korea. The question was finally settled by Wai-kam Ho in the exhibition catalogue *Chinese Art under the Mongols* (1968). He declared the paintings were done in Japan after Chinese models, essentially validating the dealer's opinion when Brundage bought them.
13. The burnt shards and fire-altered survivors of the Brundage Japanese ceramics were collected and are now stored in the museum's conservation-study collection. Although hundreds of examples of Chinese, Egyptian, Roman, Greek, Pre-Columbian, Italian, and Indian works of art were also lost, Brundage was most bereaved over the devastation of his Japanese sword and sword-guard collection, over five hundred items, which melted into amorphous charred shapes. After the fire he tried unsuccessfully to locate other sword-guard collections of quality to buy.
14. Between 1958 and 1963, Brundage was also relying heavily on the advice of the late Phil Stern, then curator of Japanese art at the Freer Gallery in Washington, D.C.
15. When displayed in the museum, these Niō attract the attention of hundreds of thousands of visitors, who become so responsive to their dynamism that they mimic the temple guardians' poses. They are the only examples of Fujiwara period Niō guardians in any American museum.
16. Personal conversation with Avery Brundage.

CHRONOLOGY

JŌMON PERIOD • ca. 12,000–250 B.C.

YAYOI PERIOD • ca. 250 B.C.–A.D. 250

KOFUN PERIOD • 250–552

ASUKA PERIOD • 552–645

NARA PERIOD • 645–794

HEIAN PERIOD • 794–1185
FUJIWARA 897–1185

KAMAKURA • 1185–1333
PERIOD

NAMBOKUCHŌ • 1333–1392
PERIOD

MUROMACHI • 1392–1573
PERIOD

MOMOYAMA • 1573–1615
PERIOD

EDO PERIOD • 1615–1868

MEIJI PERIOD • 1868–1912

TAISHŌ PERIOD • 1912–1926

SHŌWA PERIOD • 1926–1989

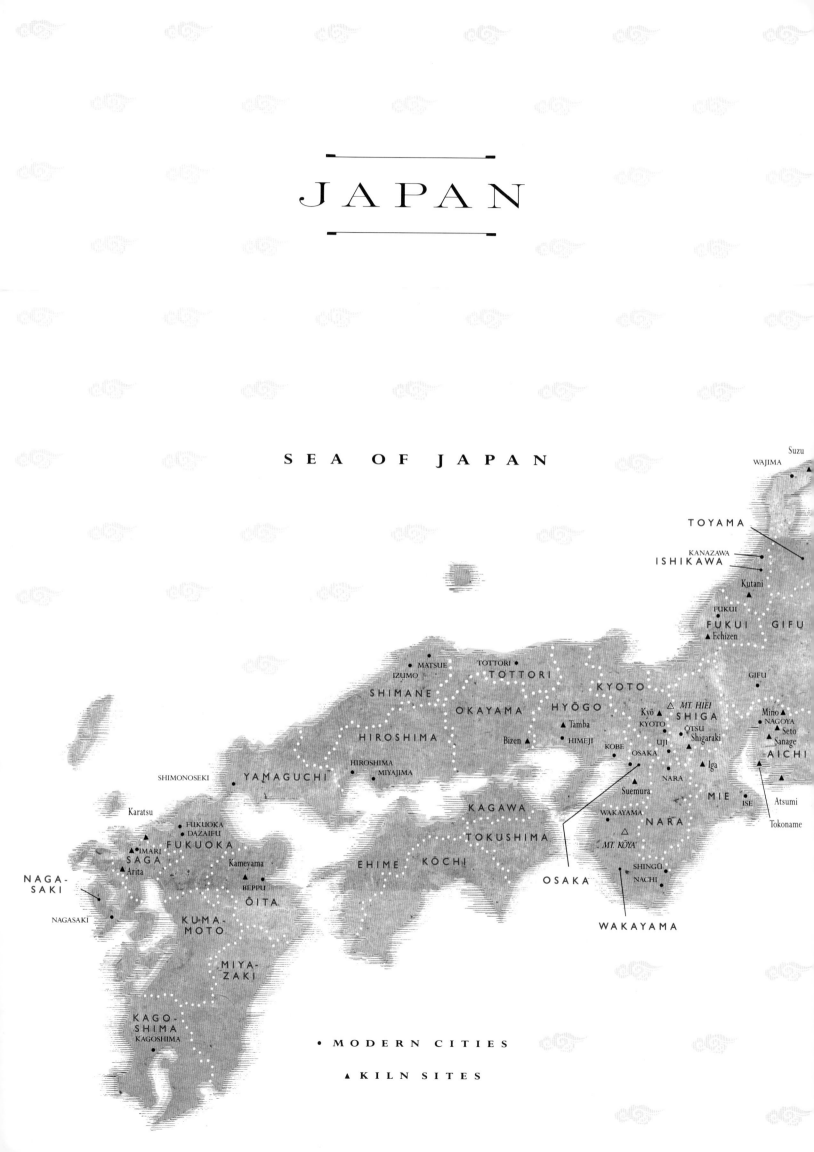

JAPAN

SEA OF JAPAN

Suzu
WAJIMA

TOYAMA

KANAZAWA
ISHIKAWA

Kutani ▲

FUKUI
FUKUI
▲ Echizen

GIFU

GIFU

MATSUE
IZUMO

TOTTORI
TOTTORI

KYŌTO

Mino •
SHIGA NAGOYA
△ MT. HIEI • Seto
Kyō ▲ ▲ Sanage
SHIMANE

OKAYAMA

HYŌGO

KYOTO
ŌTSU
Shigaraki

AICHI

▲ Tamba
Bizen ▲

HIMEJI

UJI

▲ Iga

MIE

Atsumi

HIROSHIMA

KOBE

NARA

ISE

HIROSHIMA
MIYAJIMA

OSAKA

Tokoname

SHIMONOSEKI

YAMAGUCHI

Suemura ▲

WAKAYAMA

NARA

Karatsu

KAGAWA

FUKUOKA
DAZAIFU
FUKUOKA

△ MT. KŌYA

SHINGŪ
NACHI

▲ IMARI
SAGA
Arita

Kameyama

TOKUSHIMA

OSAKA

EHIME KŌCHI

▲ BEPPU
ŌITA

WAKAYAMA

NAGA-
SAKI

NAGASAKI

KUMA-
MOTO

MIYA-
ZAKI

KAGO-
SHIMA
KAGOSHIMA

• MODERN CITIES

▲ KILN SITES

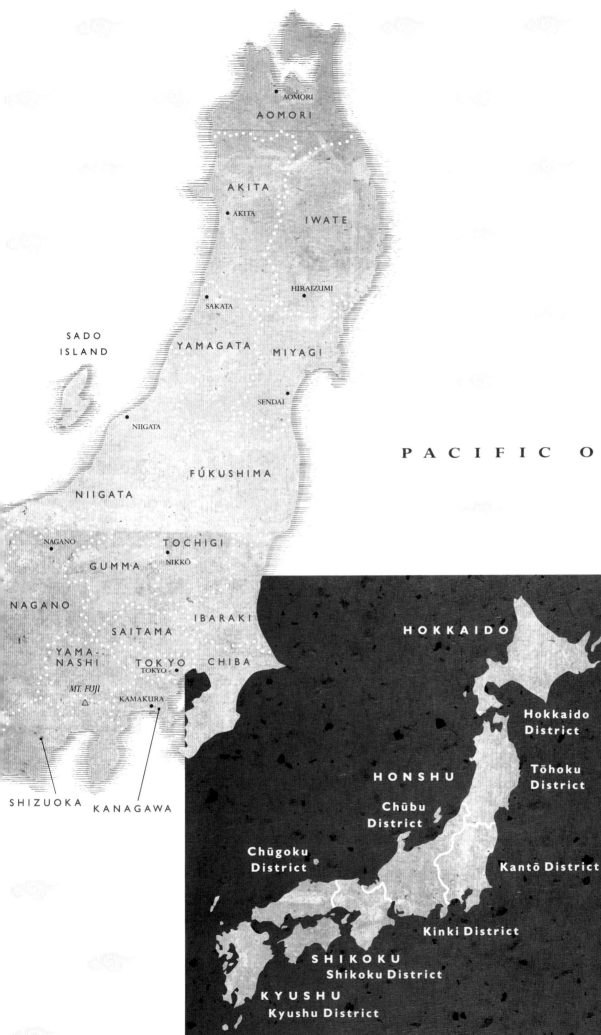

AOMORI

AOMORI

AKITA

AKITA

IWATE

HIRAIZUMI

SAKATA

SADO
ISLAND

YAMAGATA

MIYAGI

SENDAI

NIIGATA

PACIFIC OCEAN

FÚKUSHIMA

NIIGATA

NAGANO

TOCHIGI

GUMMA

NIKKŌ

NAGANO

IBARAKI

SAITAMA

YAMA-
NASHI

TOKYO

CHIBA

TOKYO

MT. FUJI
△

KAMAKURA

SHIZUOKA

KANAGAWA

HOKKAIDO

Hokkaido
District

HONSHU

Tōhoku
District

Chūbu
District

Chūgoku
District

Kantō District

Kinki District

SHIKOKU
Shikoku District

KYUSHU
Kyushu District

PREHISTORIC ART

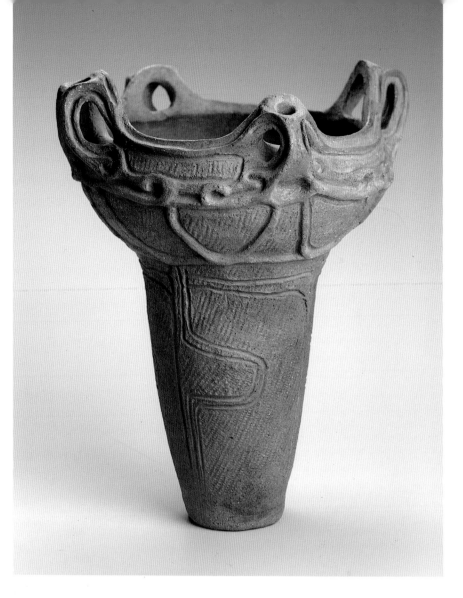

1

JAR

Earthenware, Kasori E type, Central Honshu; Jōmon period, 3rd stage,
3000–2000 B.C.; H. 45 cm (17³/₄ in.) W. 36.8 cm (14¹/₂ in.); B60 P932,
The Avery Brundage Collection

THE TERM *JŌMON* originally described the pattern on earthenware associated with the earliest ceramic culture in Japan. In describing these patterns, created by pressing a cord into a soft clay surface, the term *sakumon* was briefly used before *jōmon* became the accepted designation. It now refers not only to the pattern but also to all other earthenware from the same period, which spans several thousand years.

The earliest records of Jōmon ware date to the late eighteenth-century Edo period, when the literati connoisseur Sugae Masumi described different styles within the group in an account accompanied with good accurate illustrations. Although some connoisseurs of the late Edo appreciated the ware, scientific study of it did not start until Edward S. Morse, who came to Japan in 1877 to teach zoology, started investigating shell mounds in the Kantō (east central Honshu) area.

During the last one hundred or so years, about fifty different types of Jōmon ware, which is found as far north as Hokkaido and south to the Okinawa islands, have been identified. Often named for their sites, its types have been organized geographically as well as chronologically. The general development of Jōmon ware has been divided into five stages plus an additional incipient stage.

The third through fifth stages of Jōmon show the greatest variety and most elaborate stylistic developments. Jōmon wares are all coiled and hand-built and are decorated by various methods—applied clay bits and coils, pressed patterns created with rope, shell, and split-bamboo sticks, or simply by applied sculptural elements. Many of the middle stage examples have plastic ornaments that attain elaborate visual fantasies. Some pieces from the middle stage are called *kaen-doki*, flame-earthenware, because of the resemblance of their decoration to swirls of fire; they were fired in an open field

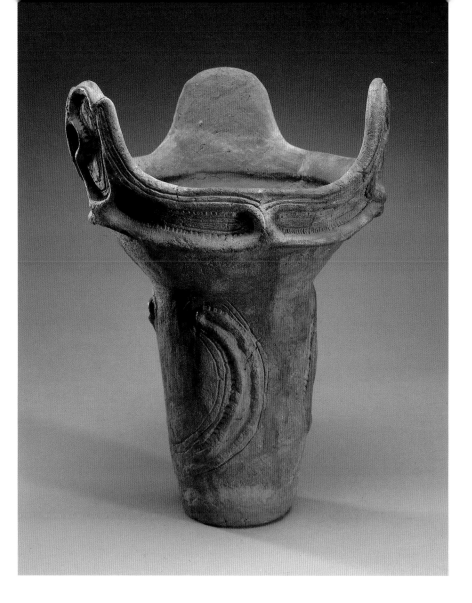

2

JAR

Earthenware, Atamadai type, Central Honshu; Jōmon period, 3rd stage,
3000–2000 B.C.; H. 42.5 cm (16³/₄ in.) W. 32 cm (12⁵/₈ in.); B62 P55,
The Avery Brundage Collection

beneath a pile of wood, not in a stationary kiln. Other examples show the use of lacquer as surface decoration.

The Jōmon period people had stone, wood, and bone tools of varying sophistication. They were hunters and gatherers with a food supply generally determined by their geographic locations; that is, they consumed more fish and seafood in the northeast, more nuts and seeds in the southwest. In daily life, within pit dwellings, Jōmon wares were used for storing, cooking, serving, and no doubt, for ceremonial occasions. Some were used as infant burial jars, others as adult ossuaries.

The Kasori E type of the middle stage has been widely excavated from sites all over central Honshu. This example (no. 1) is rather top-heavy with a sculptural, decorative, openwork mouth rim. The area below the rim is decorated with applied coils and pressed cord patterns, while the lower part is decorated with grooves

as well as *jōmon*. The clay has some mica and is generally coarse and reddish in color.

The other vessel (no. 2), from the same period, is of the Atamadai type and shows the same top-heavy proportions, but its decoration is bolder. The mouth rim has three peaks with coils and an incised design with strong fluid movements. The vessel body below the plain middle area is decorated with two asymmetrical coils and freely applied pressed-cord motifs.

Dating of the beginning of Jōmon is unsettled. It ranges from 3000 B.C., the date accepted by the early scholar Sugao Yamanouchi (1902–1970), to 10,000 B.C., which is based on a recent, more scientific dating method.[1]

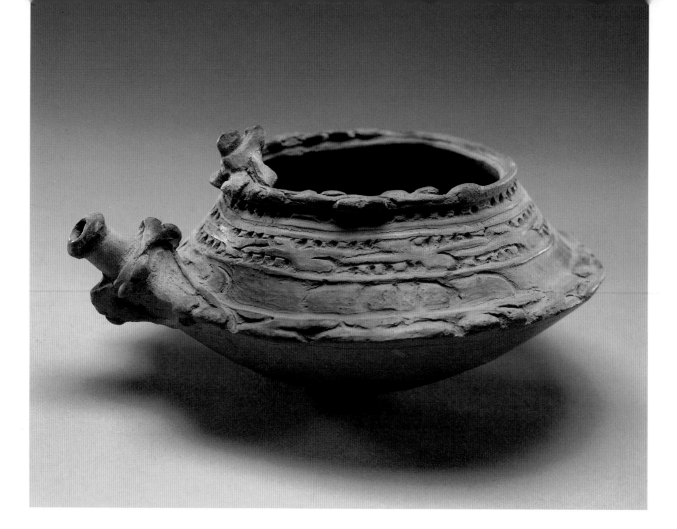

3
SPOUTED VESSEL

Earthenware, Ōbora B-C type; Jōmon period, 5th stage, 1000–300 B.C.; H. 10.2 cm
(4 in.) W. 21 cm (8¹/₄ in.); B67 P5, The Avery Brundage Collection

4
CENSER-SHAPED VESSEL

Earthenware, Ōbora B2 type; Jōmon period, 5th stage, 1000–300 B.C.; H. 10.3 cm
(4¹/₁₆ in.) W. 10.1 cm (4 in.); B67 P4, The Avery Brundage Collection

ONE OF THE MOST common decorations found in the latest stage of Jōmon ware is the *suri-keshi jōmon*, a smoothed, cord-pressed pattern. The clay, fine and dense in consistency, is much more amenable to this method. These two vessels are examples of the many new shapes that appeared while deep pots continued to be the bulk of production. The new shapes seem to indicate more sophisticated uses, which in turn suggest much more complex social structures.[1]

The spouted vessel in its upper half, from the widest ridge to the mouth rim, shows four decorative bands (no. 3). The decoration consists of series of incised dots and grooves that had been smoothed over. The ridge and the mouth rim have a slightly more plastic decoration. The incised dots here were obviously made by a stick-type instrument. Around the base of the spout are decorative plastic protrusions, their form repeated by the silhouette of a small humpbacked frog-

like creature squatting facing inward. Many small reptiles and mammals appear on late Jōmon ware and have been interpreted as watchful guardians, keeping the contents from possible contamination.[2] The round bottom is plain except for the area below the spout, which has an incised curvilinear decoration.

A few spouted vessels almost identical to this one have been mentioned in publications as being excavated from sites in both Iwate and Aomori prefectures and belong to the Ōbora B-C type.[3]

The Ōbora B2 censer (no. 4) shows many of the same characteristics as the spouted one. It is small and was made for a specific use, although the exact function of this particular shape is still unknown.[4] Again, decoration consists of the same basic method of incised and smoothed dots with small protrusions. The relative thinness of the ware also characterizes the latest group.

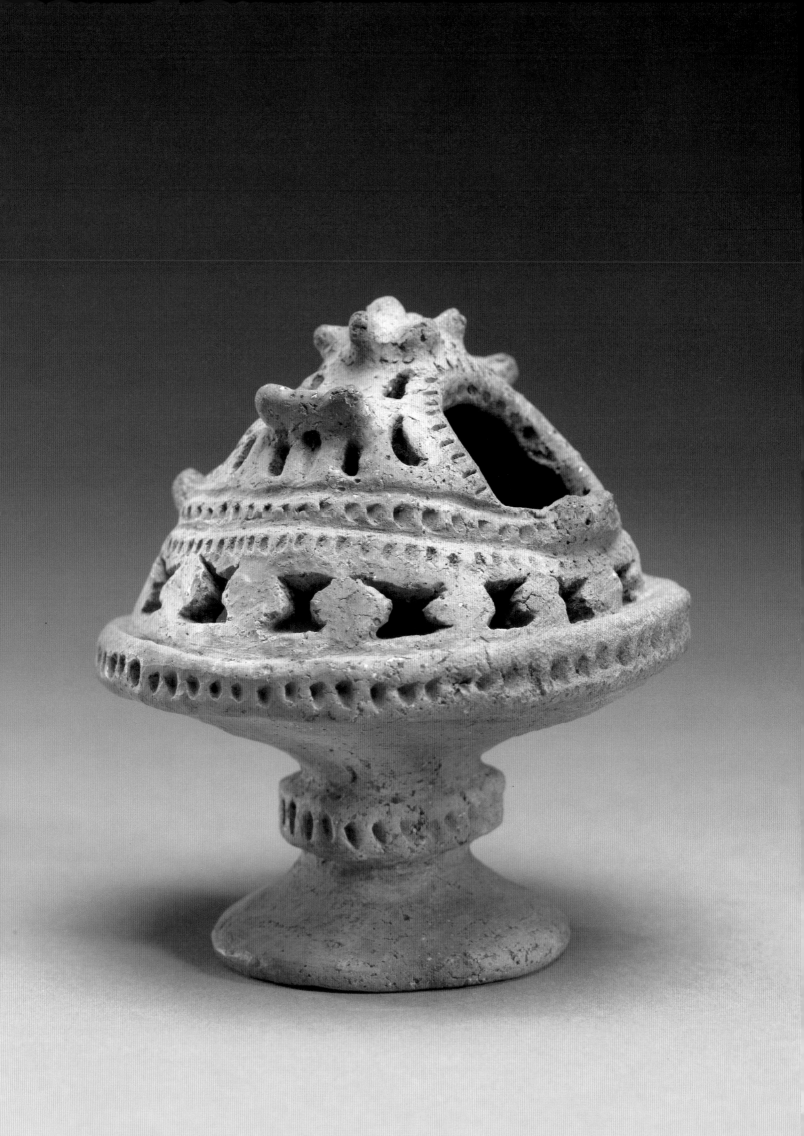

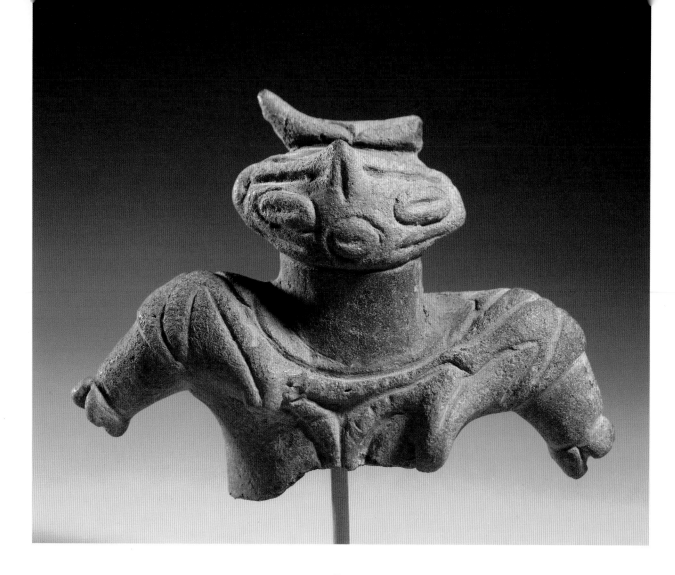

5

DOGŪ FIGURINE

Earthenware; Jōmon period, 5th stage, 1000–300 B.C.; H. 7.2 cm (2⅞ in.) W. 9.8 cm
(3⅞ in.); B69 S31, The Avery Brundage Collection

DOGŪ, CLAY FIGURINES, were produced throughout all stages of the Jōmon period. Examples from the first to third stages, mostly found in the northern and central Honshu sites, are flat, with a minimum of anatomical definition except for breasts and a navel represented with small bits of added clay. During the fourth stage, the production of these figurines increased greatly and spread westward. They also became larger, with greater physical detail. In central Honshu a single site has yielded more than one hundred figurines, although usually fewer than ten are ever found in one location.

The fifth stage was the peak period of *dogū* production. The typical figurines from this stage are traditionally called "goggle-eyed" because their eyes resemble the northern people's snow goggles. Some

examples of this type, excavated at the famous Kamegaoka sites, are more than a foot high and are well sculpted. The intricate surface decorations, using smoothed, pressed-cord patterns, are also taken from the Kamegaoka pottery type. Such large examples are usually hollow at the thicker parts of the body—the torso, head, and upper legs and arms.[1]

From more than ten thousand figurines excavated to date, some general characteristics of appearance, discovery sites, and burial circumstances may be summarized. The figurines have features of an adult female with full breasts and, frequently, indications of pregnancy. Most appear to have been purposely broken; only a very few have been found in complete form. Most broken figurines, however, have been found in disposal pits along with other discarded materials such as broken

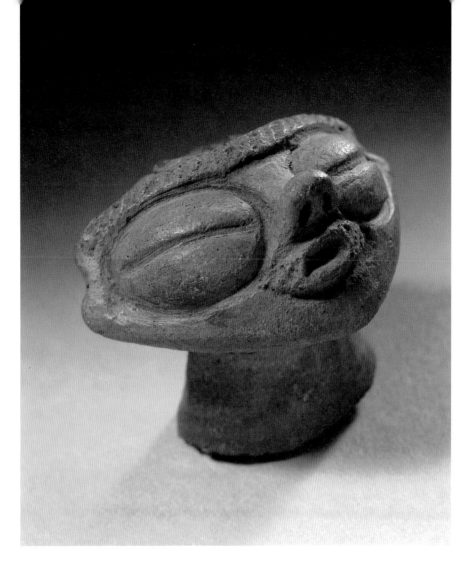

6

DOGŪ HEAD

Earthenware, Ōbora B-BC type; Jōmon period, 5th stage, 1000–300 B.C.; H. 6.3 cm
(2¹/₂ in.) W. 6 cm (2³/₈ in.); B62 P69, The Avery Brundage Collection

pots and food remains. A very few figures have also been found under stone slabs or placed within some structure, indicating that they may have been ritually entombed.[2]

Generations of scholars have speculated about the function and significance of these clay figurines in Jōmon society. The female-birth link has suggested their use in some sort of fertility ceremony. Some have speculated that the figurines were intentionally broken, perhaps as a substitute sacrifice. But there is no convincing evidence, and the most general speculation must remain simply that they were made for activities related to birth and, perhaps, death.[3]

The first figure, broken at mid-torso, has raised shoulders and short arms ending with stubby suggestions of hands (no. 5). On an extremely wide neck is a flat face with three coffee-bean shaped representations of eyes and a mouth. Atop the head is a small base of what once must have been a rather elaborate ornament. A few irregularly incised lines appear on the chest; more complete examples of the same type also have shoulder decorations.[4]

The second figure has characteristic large eyes, a small pointed nose, and a slightly open, protruding mouth (no. 6). The raised band with a smoothed cord pattern above the eyes gives the appearance of linked eyebrows. Atop the hollow head are two round openings; a third is at the neck where the head was broken off the hollow body. A headdress decoration has also been broken off.

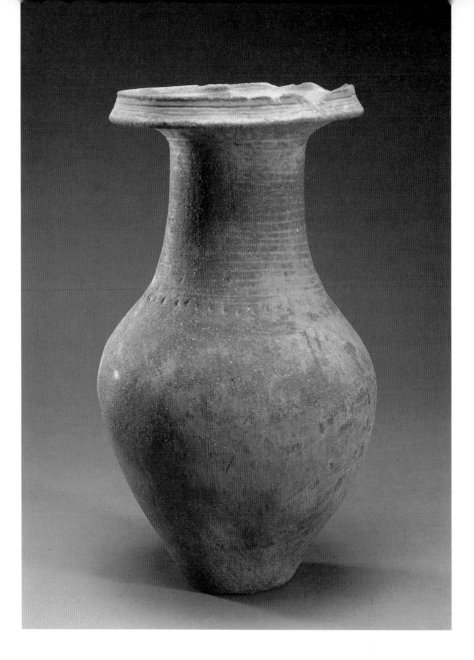

7

JAR

Earthenware, Jōtō type; late Yayoi period, 100 B.C.–A.D. 300; H. 40.6 cm (16 in.)
Diam. 22.8 cm (9 in.); B60 P2286, The Avery Brundage Collection

THE INTRODUCTION from the Asian continent of the well-advanced practice of wet-rice cultivation and of metal tools marked the beginning of a new period in Japan. It also marked the appearance of a new type of earthenware. The first example (no. 7), a jar quite different from the Jōmon group, was discovered in 1884 in the Yayoi-chō district of Tokyo, giving its name to the ware and the period.

The shift from the Jōmon to the Yayoi period was not so dramatic and violent as once believed. New settlers arriving from the Korean peninsula (considerably taller than the indigenous population, judging by their skeletal remains) were predominantly male, and as they peacefully spread eastward, they undoubtedly inter-married.[1] The agricultural Yayoi society developed rice fields in the lowlands by draining them of excess water.

Small stable settlements each had a communal well and a protective moat. As the social structure evolved, unavoidable conflict between communities developed over such issues as water rights and access to other natural resources important to developing agriculture.

Compared with the long and varied stylistic development of Jōmon ware, that of Yayoi was brief and showed few stylistic changes, either chronologically or geographically. Nevertheless, some subtle differences permit dividing the period into three chronological stages. The first stage saw the eastward spread of the new culture from northern Kyushu through western and central Honshu. The middle stage saw the emergence of regional differences distinguishing northern Kyushu, where this new culture originated, from eastern Honshu, where a strong Jōmon heritage remained.

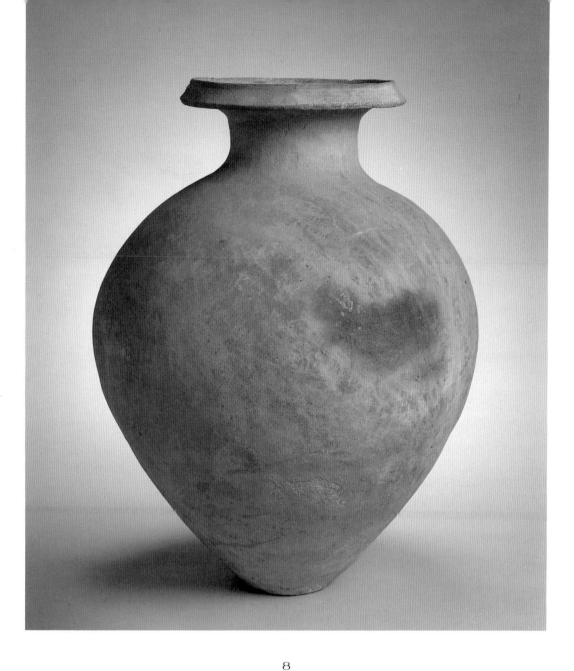

8

JAR

Earthenware; mid to late Yayoi period, 100 B.C.–A.D. 300; H. 48.6 cm (19⅛ in.)
Diam. 38 cm (15 in.); B60 P134+, The Avery Brundage Collection

Placed between these two strong forces, the Kinki district (west central Honshu) played an intermediary role through the first and second stages. However, during the final stage the Kinki district, blessed by a moderate natural environment, grew into a powerful agricultural community influencing other areas both politically and culturally. Thus regional differences were unified by the strong influence of the Kinki district.

Yayoi ware can be divided into three main functional groups — storage jars, cooking vessels, and stemmed serving dishes — usually used in combination. Unlike the Jōmon, Yayoi shapes are basically simple with occasional painted, lightly incised, or small applied clay surface decorations. Forming was still done by hand, but some final finishes and decorations were applied using a turntable.

The Jōtō jar from the Okayama area shows a typical decoration of shallow grooves around the neck and mouth rim (no. 7). Just below the lowest groove is a band of short vertical incisions.[2] Other examples of this type of jar have been excavated with accompanying tall stands and were most probably used for ceremonial occasions.

The second jar with a broad shoulder and a flaring mouth rim has a delicately incised band of triangular pattern around the rim (no. 8). This jar may have been for domestic storage of liquid or grain, or possibly for heating food, since there are carbon residue marks on the side.

DŌTAKU

Bronze; excavated at Ōiwayama, Koshinohara, Yasuchō, Shiga Prefecture; Yayoi period, 2nd–3rd century; H. 62.5 cm (24⁵/₈ in.) W. 30 cm (11¹³/₁₆ in.); B60 B14+, The Avery Brundage Collection

OF ALL THE BRONZE objects of pre-historic Japan (see nos. 23–27), by far the most impressive is the fully developed bronze bell (*dōtaku*). Almond-shaped in cross section, it has lateral flanges that merge at the top to form a large, flat, U-shaped handle with a small central opening. Its size varies from less than 12 inches to over 50 inches high.[1] The more than four hundred *dōtaku* known to date were produced in the Kinki district in west central Honshu, at a time when the newly organized agricultural society was becoming increasingly important. The area of production and distribution of these bells reached east to present-day Shizuoka and Nagano prefectures and west to Hiroshima in the northern part of Kyushu.

Dōtaku have been unearthed at locations that are all seemingly insignificant, not from such standard archaeological sites as burials, dwellings, and rubbish disposals. Rather, they have been found on hillsides, plains, and sometimes deep in canyons or high on mountaintops. Because of these peculiar and unpredictable sites, systematic excavation of *dōtaku* has been virtually impossible. Discoveries of them date as early as the seventh century A.D. The records of these early finds, which were all accidental, vary greatly in detail and accuracy.[2]

The Ōiwayama site is a case of accidental discovery. Here, in 1881, a group of fourteen *dōtaku* of varying sizes was unearthed from a hillside after a couple of teenagers noticed a few partially exposed bells. They had been buried with smaller ones placed inside the larger. In 1962 another group of ten *dōtaku* (now in the prefectural collection) was unearthed during construction work on the same hillside.[3]

On some *dōtaku* there remained traces of woven textile patterns, indicating they had been wrapped in cloth for burial. Otherwise there is little other circum-stantial evidence to tell whether the burials were to be permanent or only temporary, despite the obvious significance of the seemingly intentional ceremonial interment. Therefore studies of the origin, function, and ownership of *dōtaku* remain speculative. They most probably originated in a type of small bronze bell used on domestic animals in Korea and also found in Japan.

The stylistic development of *dōtaku*, along with the general increase in their size, may be seen most distinctively in the handles. The earliest examples have thick, strong, functional handles with lozenge-shaped cross sections. Once transplanted in Japan into a society which "seems to have had a strong religious tendency and to have been much occupied with magic and ritual,"[4] the bells became increasingly nonfunctional, although some were unearthed with metal clappers that once must have been used to create sounds.

The design development, basically linear and geometric, also shows gradual stages of elaboration. Of the geometric designs, two major types are *ryūsui-mon* (flowing water pattern) and *kesadasuki-mon* (priest's mantle pattern), consisting of squares and borders. Some later examples have pictorial motifs of animals, people, and buildings.

This *dōtaku* is of the *kesadasuki* type. Its wide handle is decorated with bands of various designs. The second band from the central opening shows a slight three-dimensional modeling, a reminder of the earlier thick, functional handle. Originally the double-swirl embellishments projecting from the flanges also extended to the handle proper, but the top three are now missing. The sets of holes and notches at the side and the bottom rim (identical on both sides) were left by the connectors of the outer and inner clay molds used for casting.

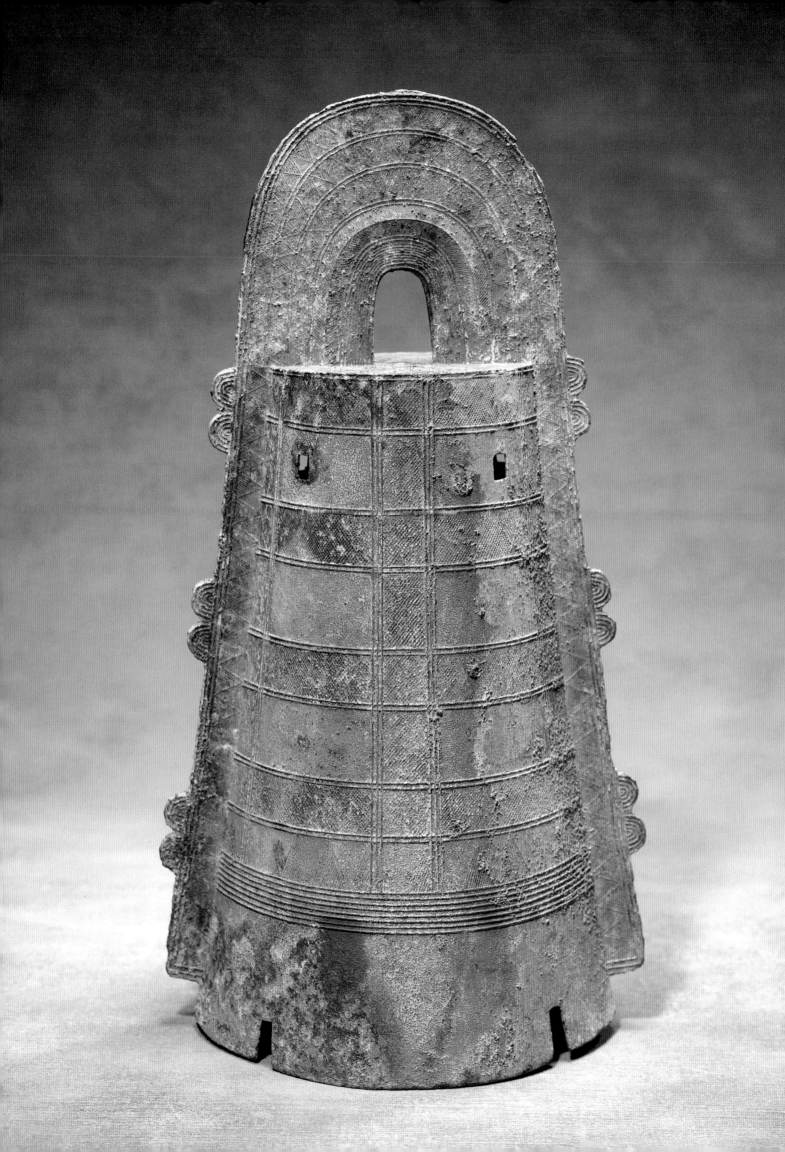

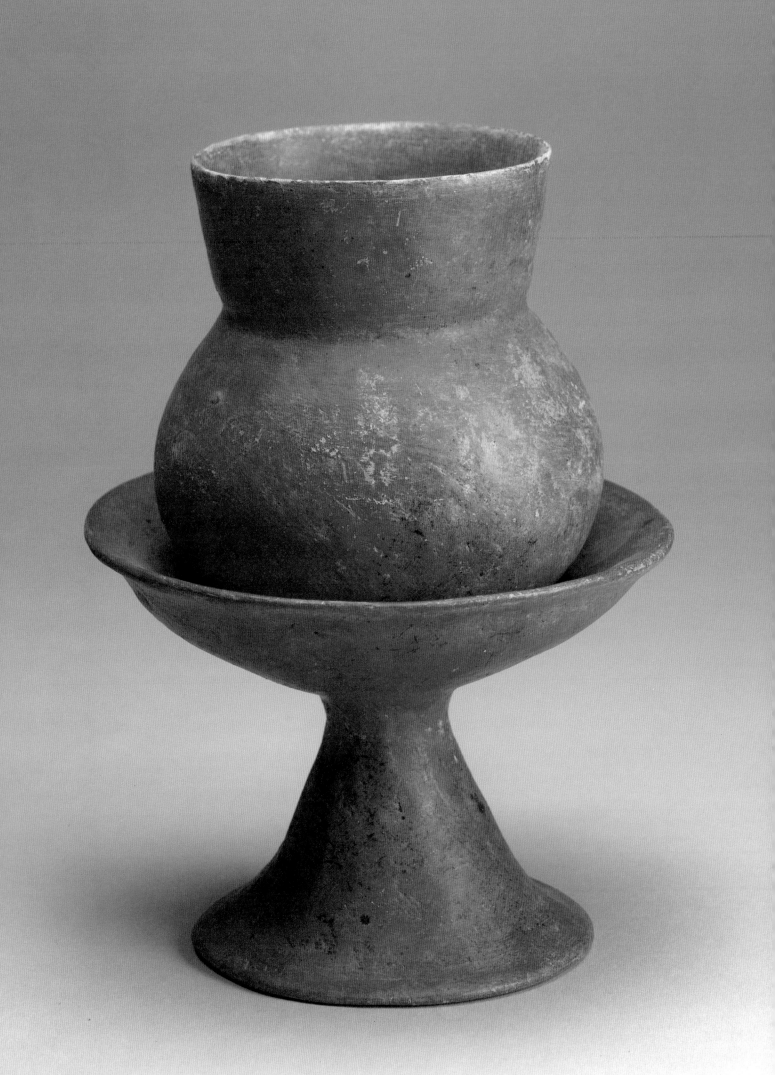

10
JAR AND STAND

Haji ware, earthenware; early to mid Kofun period, 4th–5th century; Jar: H. 14.9 cm
(5⁷/₈ in.) Diam. 14 cm (5¹/₂ in.), Stand: H. 13 cm (5¹/₈ in.) Diam. 17.5 cm (6⁷/₈ in.);
B62 P3+ (jar), B62 P4+ (stand), The Avery Brundage Collection

LOW-FIRED UTILITARIAN earthenware technically based on the Yayoi tradition continued to be produced during the Kofun period. It was made with a similar coiling method, shaped and finished on a crude turntable, or simply placed on a layer of large smooth leaves that served as a turntable, moving easily as the potter rotated the vessel. Unlike the newly developing Sue ware of the same period (see nos. 19–22), Haji ware was fired in shallow, open firing pits. A Haji kiln complex dating from the eighth century was excavated in Mie Prefecture at the end of the 1970s. The firing pits, rectangular or oblong in shape, are no more than a foot deep and average about 10 feet long. Several such pit-kilns have been found, along with the remains of other pits and buildings, possibly workshops.[1]

The precise distinction between Yayoi and Haji ware is not easily made except among those pieces with more pronounced characteristics. Haji-ware jars have round bottoms, and a finer consistency of clay is generally used for it. Vessels were finished by smoothing and beating, the same methods used for Yayoi ware. Since many Haji wares were made specifically for cooking,

the walls were well beaten and scraped to attain thinness in order to make the most efficient use of cooking fuel. In some districts this method of scraping the inside of vessels is considered as one distinctive characteristic of Haji ware.

Haji ceramics are seldom decorated, but when they are, patterns are simply incised or pressed. Some Haji ware, including this jar and its stand, is covered with an iron-rich slip that was polished to obtain a rich reddish finish when fired. This type of vessel is considered to have been made specially for some ceremonial use.

Other than such obvious differences as the size of vessels and the quality difference between ceremonial and everyday ware, there is very little stylistic and technical variation among Haji wares made in different parts of the country.

Written records of early Haji potters seem to record a female name as a potter who was assisted by male helpers. This may be the beginning of a long tradition of female potters making ceremonial earthenware around Kyoto, a custom that has continued into modern times.

11

HANIWA WARRIOR

Earthenware; excavated at Fujioka, Gumma Prefecture; late Kofun period, 6th century; H. 120.7 cm (47½ in.) W. 41.9 cm (16½ in.); B60 S204, The Avery Brundage Collection

THE KOFUN PERIOD is characterized by the burial mounds, *kofun* (literally, old mound), built for powerful clan leaders who emerged as outstanding individuals and commanded community respect. Throughout the country such new leaders formed an upper class, and the local leaders in turn came to be subject to the central power, the Yamato clan, the origin of imperial power.

Kofun changed greatly in size and style from the modest, natural hillside mounds of the fourth century to the grandest man-made ones in the fifth, when a *kofun* for Emperor Nintoku built on the Kawachi plain was nearly 1,600 feet long and 100 feet high. Later *kofun* on the plains were surrounded by one or more moats; Nintoku's *kofun* has three of them, each surrounding the entire site.

To mark the inner boundary of the sacred site of a *kofun* and to prevent possible earth slides, especially for the later artificial mounds, clay cylinders or *haniwa* were planted around the perimeter of the mound's base.[1] Bigger *kofun* might have multiple rows of *haniwa*, each successive row placed a little higher than the one below, thus truly preventing earth slides. The enormous number of cylinders needed to furnish a major *kofun* required a large number of craftsmen, who probably worked close to the building site.

Simple clay-cylinder *haniwa* soon acquired figurative tops. Their cylindrical bases still functioned to stabilize the mound, and the figures retained the name. The first representational tops were houses and a variety of status symbols and weapons: umbrellas, standards, shields, and swords. Unlike Chinese funerary figures, *haniwa* were placed above ground, the representational ones in the higher positions. The houses and umbrellas provided symbolic shelter; shields, swords, and sometimes armor continued to protect the once-powerful community leaders in the afterlife. Birds and animals such as horses in full trappings, monkeys, and dogs appeared in the late fourth to fifth centuries, followed by male and female human figures, in various activities and occupations (see nos. 11–15).

The figures, like the cylinders, were hand coiled. The basic vertical body structure was built from various-sized cylinders. The arms, small in proportion to the body, were made separately and crudely attached to the shoulders.

This large warrior dates from the last phase of the period, when the Kofun culture had expanded both west and east of Kinki (west central Honshu; see nos. 7–8) and was flourishing in the east central Honshu area. Dressed in formal attire, with a riveted helmet, shoulder plates, armlets, gauntlets, and *kabutsuchi*-type sword (see no. 27), the warrior stands erect on a barrel-shaped cylinder that has a round hole on each side. The trousers tied below the knees and bulging around the upper legs are similar to those worn by contemporary northern horsemen of the Six Dynasty period in China.

Arising naturally from a mastery of limited techniques and a sure control of basic materials, the unique sculptural characteristics of *haniwa* figures continue to inspire artists up to the present time.

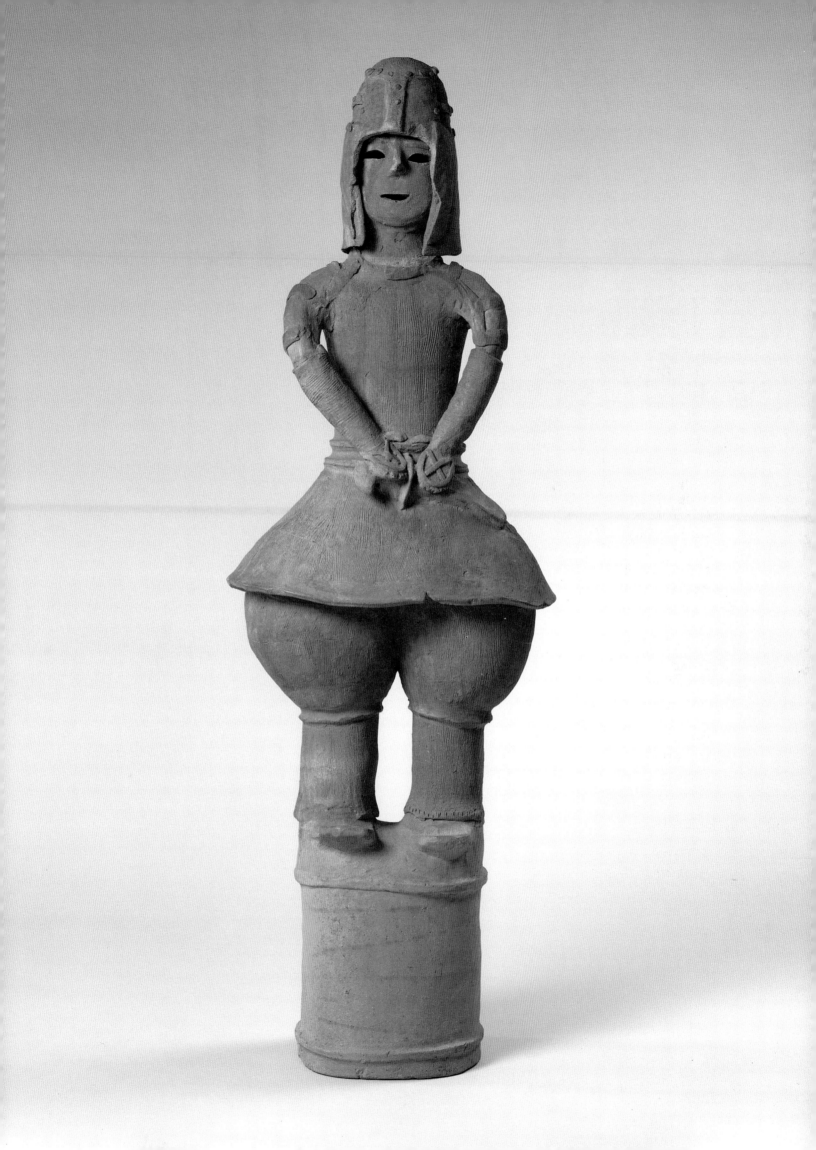

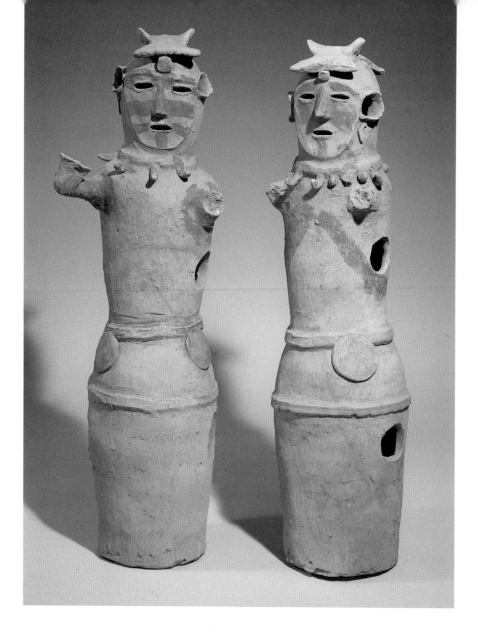

12

HANIWA FEMALE SHAMANS

Earthenware; late Kofun period, 6th century; Left: H. 61 cm (24 in.) W. 20 cm
(7⅞ in.), Right: H. 60 cm (23⅝ in.) W. 16.5 cm (6½ in.); B60 S164+ (left),
B60 S165+ (right), The Avery Brundage Collection

THESE TWO *HANIWA* came from the same workshop and were once part of a group placed on the same burial mound. Their flat hairdos extend over their foreheads, a fashion that identifies the figures as female. They wear circular hair ornaments, rather than the flat, comb-shaped one seen in no. 13. The colors on their faces may indicate some kind of decoration such as tattooing or temporary painting, which in turn suggests that these are not ordinary women but a pair of shamans. The circular disks on their waists most likely represent mirrors, another attribute of persons of so special an occupation.

The fang-shaped or claw-like pendants of the necklaces represent *magatama* (literally, curved gems). Usually known in the west as comma-shaped jewels, and made of jade or glass, they appeared in Korea and Japan around the middle of the first millennium B.C. and became quite popular during the fifth and sixth centuries A.D. In Korea they were used profusely in association with crowns, belts, necklaces, earrings, and other princely ornaments with shamanistic overtones. Korean shamans' paraphernalia also included bronze mirrors, prototypes for those seen in Japan and on these figures.

The painted colors on the torso may represent a scarf-like garment made of colored fabric, as there already existed a basic dyeing technique using simple vegetal colors.[1] The only remaining arm holds an object resembling a cup. Both the torso and cylinders, which for female figures might represent a long skirt, were pierced with large lateral holes, probably for the insertion of poles.

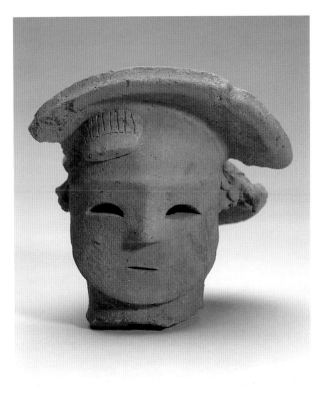

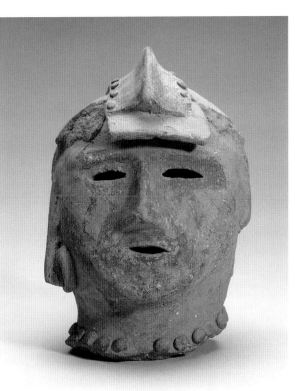

13
HANIWA FEMALE HEAD

Earthenware; excavated in Gumma Prefecture; late Kofun period, 6th century; H. 17.1 cm (6¾ in.) W. 16.5 cm (6½ in.); B62 P6+, The Avery Brundage Collection

14
HANIWA WARRIOR HEAD

Earthenware; late Kofun period, 6th century; H. 21.6 cm (8½ in.) W. 15.2 cm (6 in.); B80 S1, Bequest of Mr. Joseph M. Bransten

WITH EYEBROWS forming a continuous ridge, semicircular eyes, and a narrow slit mouth, this woman's head (no. 13) is similar to a published series of human *haniwa* originally produced in present-day Gumma Prefecture.[1] In characteristic female fashion, this head has a wide, flat hairdo with a small comb placed under the hair on the forehead. The only remaining accessory is a pair of bead earrings. Without seeing the body, there is no way to determine exactly what type of person the entire *haniwa* once represented, but its calm grace and innocent facial expression are typical of many surviving figures. It is unlikely that lack of skill in representation accounts for the absence of strong emotion or grief in these faces. Their expressions may, however, reflect the community's attitude of acceptance of death.[2]

The facial features of the warrior's head (no. 14) are far more emphatic than those of the female. His forehead is rather low, his eyebrows separated and well marked, and his eyes, as well as his partly open mouth, are narrow and almond-shaped. Conscious expression of masculinity or femininity does not seem to have been a great concern for *haniwa* makers, as indicated by the almost girl-like features of the warrior, a not uncommon depiction. Divergences among *haniwa* are essentially the result of local preference and personal style. The upper lip and chin of the warrior's head have been painted black, possibly to simulate a moustache and beard. The function or symbolism of the red slip on the eyes, nose, and parts of the cheeks is not as readily explained. It might have been a temporary coloring applied to add an extra fierceness at the time of a military attack or some similar occasion. The accessories are heavy ring-shaped earrings and a bead necklace.

Details were created with added clay and simple incised lines. Various headgear, hairdos, and other ornamental details were also added, while most of the facial features were created by cut-outs; bits of clay indicated nose and occasionally eyebrows. Reddish pigment was sometimes applied (see no. 12). The figures were apparently fired in semi-subterranean kilns to a temperature of about 800 degrees Celsius.[3]

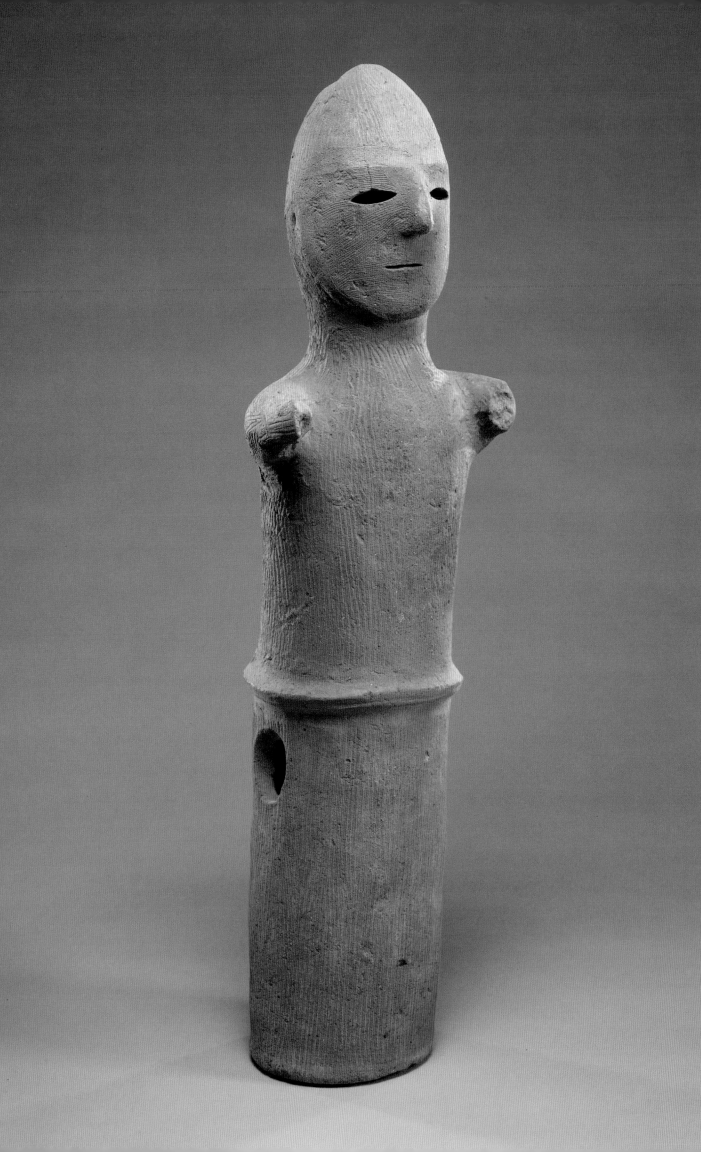

15
HANIWA FARMER

Earthenware; late Kofun period, 6th century; H. 61 cm (24 in.)
W. 19.1 cm (7½ in.); B80 S2, Bequest of Mr. Joseph M. Bransten

GIVEN MINIMAL DETAIL and show-ing only basic facial features, this standing male figure portrays a happy-looking farmer. A small sickle attached to his back above the clay band indicates his occupation, which by this period should be considered as distinctive, if not as special, as that of the falconers.

Rice cultivation greatly changed during the Kofun period.[1] With the introduction of iron, tradi-tional farming tools of wood and stone were revolution-ized. A pair of *haniwa* figures in a Japanese collection carry hoes on their shoulders and obviously represent farmers.[2] The sickle blade of this figure as well as the tips of the hoes carried by the other two were most probably made of iron. Large numbers of horseshoe-shaped iron hoe-tips and sickle blades remain in Kofun period sites. In fact, a hoe-shaped *haniwa* was excavated from a late Kofun period site in Chiba Prefecture, sug-gesting that this farmer's tool is as important an imple-ment as the warrior's weapons.[3]

The development of new iron tools and an organ-ized labor force not only allowed the establishment of Kofun period rice fields on higher land but enabled leaders to build their enormous tomb mounds.

16
HANIWA FALCON

Earthenware; late Kofun period, 6th century; H. 11.1 cm (4⅜ in.)
L. 17.8 cm (7 in.); B80 S3, Bequest of Mr. Joseph M. Bransten

HANIWA ANIMALS, and birds in particu-lar, were made as early as the middle of the Kofun period. Many kinds of birds were represented, with a preference for fowl such as chickens and ducks. As is clearly indicated by the bell tied to its tail, this is a bird of prey, probably a falcon, which was at one time part of the equipage of a falconer; the bird is similar to a famous piece representing a falconer with his bird, now housed in the Yamato Bunkakan of Nara.[1] What looks like a curved stand was in fact part of the falconer's arm. This particular example has lost some of its original fierce appearance because its heavy, curved beak was broken off and incorrectly restored. Marked with a hol-low tube, probably a bamboo stick, the eyes neverthe-less convey a distinctive character.

17
BRACELET (*sharinseki*)

Jasper; early Kofun period, 4th century; Diam. 15.2 cm (6 in.) Depth 1.5 cm (⅝ in.); B62 S56, The Avery Brundage Collection

18
CIRCULAR BRACELET (*ishikushiro*)

Jasper; early Kofun period, 4th century; Diam. 7.9 cm (3⅛ in.) Depth 1.8 cm (¾ in.); B62 S57, The Avery Brundage Collection

A VARIETY OF objects has been found buried with deceased leaders of the Kofun period. A typical *kofun* from the second half of the fourth century might yield Chinese bronze mirrors, armor, swords, shields, spearheads, jewels, stone replicas of bracelets, and other items. Bracelet replicas include three distinctive types: *kuwagataishi* (hoe-shaped stone), *sharinseki* (wheel-shaped stone, no. 17), and *ishikushiro* (stone bracelet, no. 18). All three derived from various shaped shell bracelets already widely used during the Yayoi period in the northern Kyushu area. The first type, the most decorative and stylized, originated in the shells called *tengunishi* and *suijigai*.[1]

The *sharinseki*, copying shell bracelets made of *kasagai* shell, have a flat, asymmetrical oval shape with a fluted surface. The *ishikushiro* type, as its literal meaning indicates, is closest to a simple ring-shaped bracelet. Turned and shaped on a cutting wheel, *ishikushiro* have a perfect circular contour and are decorated with striations and grooves.

A large group of shell bracelets was found on the forearm of a Yayoi period skeleton, indicating the early emergence of a class of individuals with special power, either social or spiritual, and having a select function in the community. As class division developed in the Kofun period, and burial patterns changed greatly, an increasing number of stone replicas of bracelets were buried along with the deceased. In the case of the Ishiyama *kofun* in Mie Prefecture, more than fifty stone bracelets, including all three types, were found, not worn by the deceased but placed along the body.[2] Unlike the Yayoi period remains of an individual who actually wore a large number of bracelets, this placement is simply evidence of emblematic symbols of the wealth and rank of the deceased.

JAR ON HIGH FOOT WITH FOUR SMALL JARS

Sue ware, stoneware with natural ash glaze; late Kofun period, 6th century; H. 45.7 cm
(18 in.) W. 28 cm (11 in.); B60 P537, The Avery Brundage Collection

DURING THE KOFUN period the Japanese began to make two types of ceramics, each for a specific use. One was Sue ware (*sueki*), the first high-fired ceramic in Japan, made with technology introduced from Korea, and the other was Haji ware (see no. 10). Beginning around the mid-fifth century in the Suemura area (near Osaka) of the Kinki district, the production of Sue ware lasted for several hundred years, spreading rapidly throughout Japan. The center of production shifted from the early kiln complex in the Suemura area to a later counterpart across the Bay of Ise in the Sanage area of the Tōkai district. More than two thousand *sueki* kilns have been located throughout Japan, and many have been scientifically excavated.

Sue ware is gray, hard-fired, and waterproof, with a certain amount of natural glazing formed during firing. *Sueki* potters combined the traditional coiling technique with the more efficient wheel-throwing, a technical innovation from Korea that replaced the primitive turntable used for partial finishing and decorating.[1] Finished vessels were fired in an *anagama* (hillside) kiln. These tunnel-shaped kilns produced temperatures high enough — exceeding 1000 degrees Celsius — to develop the stoneware body. The gray colors that range from light to nearly black came from the reduction (low oxygen) firing atmosphere created in the kiln by controlling air flow.

Sueki means "object to place, or set," and describes the primary function of these wares, which were placed at ceremonial altars in front of burial chambers of newly built mounds. Others were also buried within the chamber as grave goods placed alongside the casket. Some vessels were found containing remains of fish and shells, most probably offerings.

The earliest *sueki* closely resembled Korean prototypes from the Old Silla period (57 B.C.–A.D. 668) and were quite likely made by Korean potters who emigrated to Japan. The standard shapes of *sueki* reflected their function as ordinary vessels for storing, serving, pouring, and drinking, while other vessel shapes for more ceremonial uses were often mounted on high stands. Among the standard types, cooking vessels are notably absent, since the high density of the *sueki* clay body was not suitable for such uses; Haji ware was employed specially for that purpose.

A relatively early example of Sue ware, this high-footed ceremonial jar is from a period when some stylistic changes occurred among the indigenous potters. The spreading foot, with three tiers of rectangular and triangular cut-outs made to prevent warpage as well as for decoration, is distinctively Korean in tradition. (The jar's lid, a flattened dome shape with a center knob, is lost.) Around the main jar are four small jars alternating with four animal heads (probably deer), a decorative style often seen on Korean ware. One small jar is a recent replacement. The traces of glaze on one side are from falling ash carried by the kiln airflow and fused on the clay body during firing. Some loss of glaze is due to attrition because of burial.

The potters who produced Sue ware are considered to have been a professional group who lived close to the kilns, clay deposits, and sources of fuel. Their advanced techniques of fabrication and firing required more specialization than any other ceramics produced up to this period. There is, however, no way to know if those who worked as potters were completely freed from other everyday work such as farming.

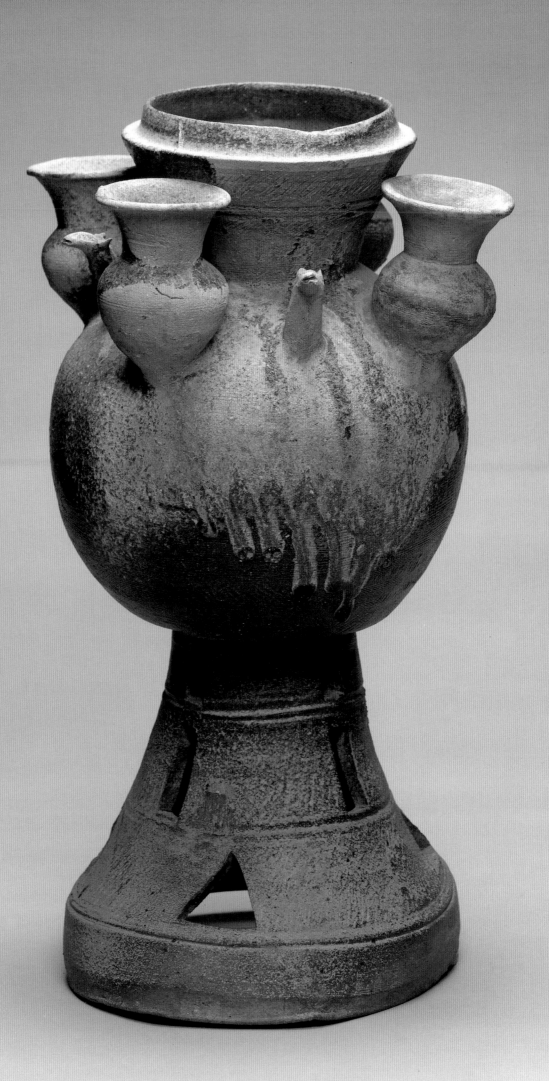

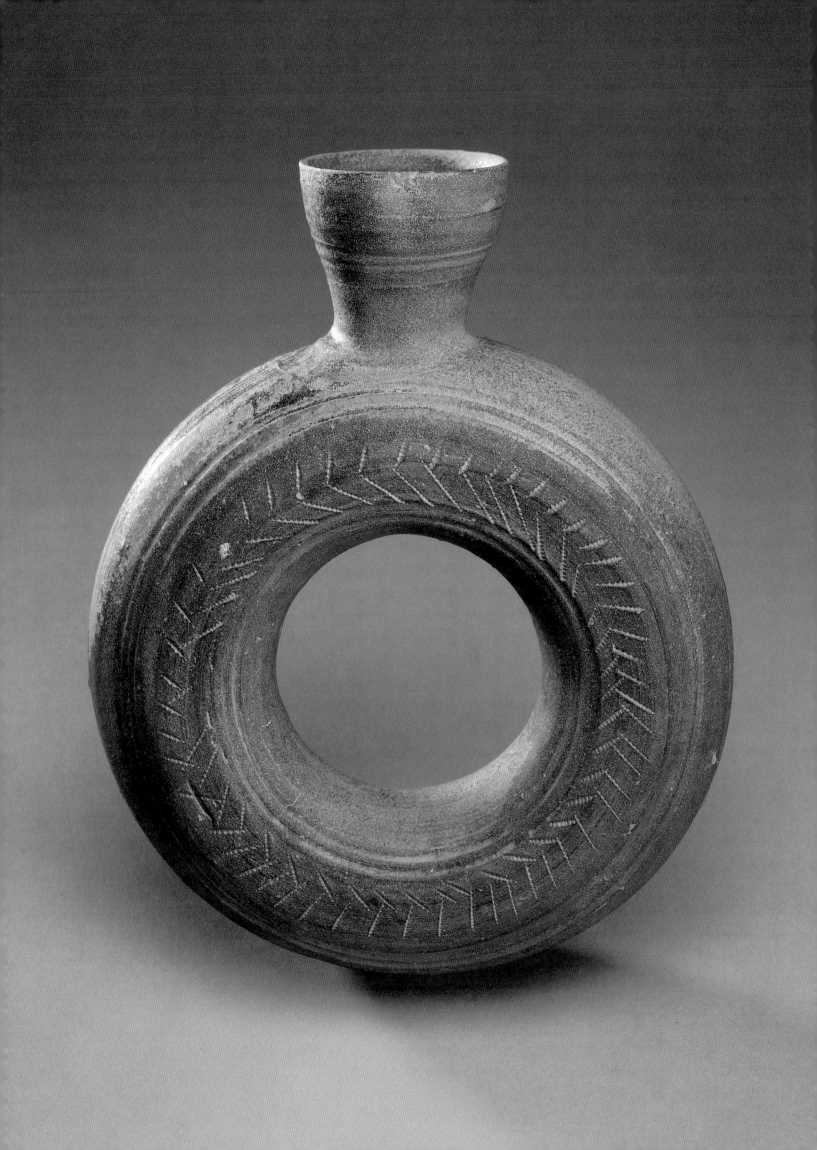

RING-SHAPED BOTTLE

Sue ware, stoneware; late Kofun period, late 6th–early 7th century; H. 27.1 cm
(10⁷/₈ in.) W. 22.2 cm (8³/₄ in.); B64 P33, The Avery Brundage Collection

THIS RING-SHAPED vessel, an unusual imaginative shape that is indigenous to Japan, comes from a small area near Hiroshima. Like the bird-shaped vessel (no. 21), it is made of two separate wheel-thrown parts joined to form the final shape. On the sides are finely applied line decorations, similar to a herringbone pattern and probably done with a tool, either a serrated shell or some other found object with an irregular edge.

Most likely a vessel like this was used to contain and serve liquid, probably an early version of fermented fruit or rice wine. This particular shape was easy to hang, with or without a cord for that purpose.

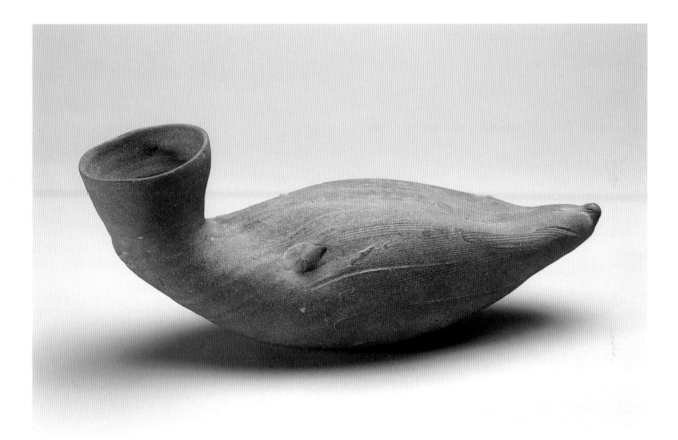

21
BIRD-SHAPED BOTTLE

Sue ware, stoneware; late Kofun period, late 6th–early 7th century; H. 13 cm (5¹/₈ in.)
L. 31.1 cm (12¹/₄ in.); B69 P35, Gift of Mr. Walter Goodman

DUCK-SHAPED *SUEKI* vessels come from just one small area around Hiroshima in western Japan.[1] Unlike their naturalistic Korean prototypes, the Japanese version tends to be quite abstract, with only a graceful body indicating the origin of its inspiration.

This bird-shaped *sueki* was created by combining two separate parts. This was generally a characteristic method of making Sue ware at a time when the potter's wheel did not have the full turning power of later models. Here the unusual shape required creative modeling. A shallow, flat bowl-shape was first thrown, and its two opposite sides were pulled together to form the body, which was smoothed with a spatula-like tool that left some tooth marks. On one open end, a separately thrown neck was attached to form the spout. Small bits of clay were attached to indicate wings.

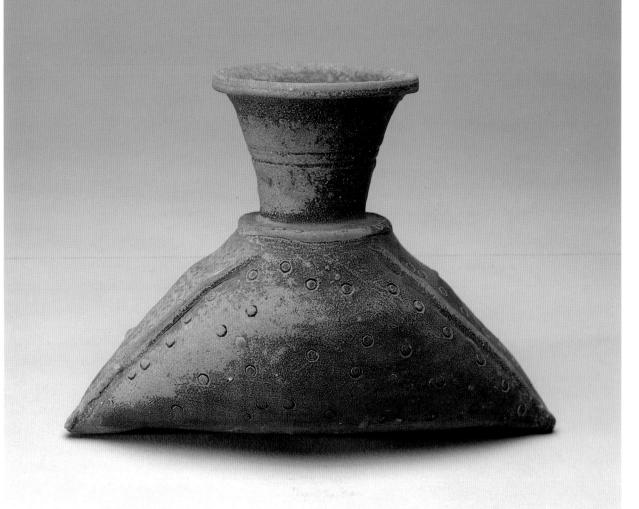

22
BOTTLE IN THE SHAPE OF A LEATHER BAG

Sue ware, stoneware; late Kofun period, late 6th–early 7th century;
H. 13 cm (5⅛ in.) W. 18.7 cm (7⅜ in.); B60 P1189,
The Avery Brundage Collection

NOT ALL SUE WARE of distinctive imaginative shape was the exclusive product of some small district. Unusual leather bag-shaped bottles, for example, were made in a wide area ranging from Kyushu to south central Honshu.[1] Seams on these clay bottles faithfully copy the sewn joints of the leather bags after which they were modeled. Quite often the surface quality of the leather was also simulated.

This representative piece shows those characteristics of *sueki* that replicate the leather bag. The small stamped circles covering the surface, probably applied with a small bamboo or similar hollow plant stem, suggest marks found on animal skins. This bottle was made by joining two separately made parts, the same method used for both the ring- and bird-shaped vessels (nos. 20–21).

23
CIRCULAR MIRROR

Bronze; early Kofun period, 4th–5th century; Diam. 17.8 cm (7 in.);
B64 B9, The Avery Brundage Collection

LIKE OTHER BRONZE objects from the Kofun period, mirrors originated on the Asiatic continent. Most have been excavated from the tombs of rulers. Earlier bronze mirrors from Han China first appeared in joined-vase coffins in public burials of the Yayoi period.[1] Apparently this indicates that such mirrors belonged to more influential individuals rather than to members of the community at large.

In the Kofun period there was a considerable increase in the number of buried mirrors. Although small and, when compared to modern glass counterparts, not as effective a reflector of images, the mythical value of bronze mirrors is beyond the imagination of modern minds. Chinese mirrors, given to Japanese rulers on important occasions, were treasured and handed down from one generation to the next. Highly regarded as status symbols, mirrors, swords, and jewels became the three sacred objects of Shintoism. Not only

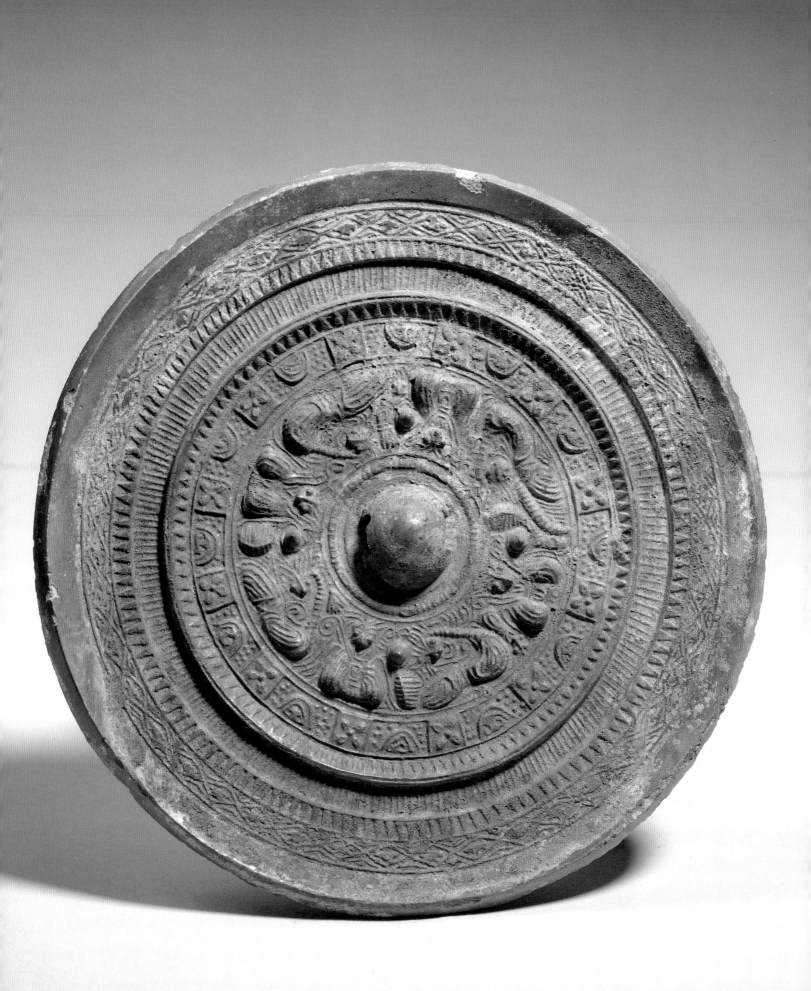

CIRCULAR MIRROR

Bronze; early Kofun period, 4th–5th century; Diam. 12.1 cm (4¾ in.); B64 B10,
The Avery Brundage Collection

was the mirror itself venerated, but the Japanese word *kagami* (mirror) also held symbolic connotations.[2]

Three types of mirrors have been found in a single tomb mound of the later part of the Kofun period: old Chinese mirrors, handed down and worn, new Chinese mirrors with back decorations still sharp and clear, and Japanese mirrors modeled after Chinese ones.

Some Japanese mirrors are identical copies of Chinese models, using molds made directly from the originals. Other copies were cast in molds made by Japanese craftsmen from Chinese patterns. The Japanese molds vary from the originals but the most faithful reproductions are the scallop type (no. 24), since they were usually small in size and simple in design. With the Japanese craftsmen's limited knowledge of Chinese characters, their first design deviation was in the inscription band of the concentric decorative bands on the mirror

back. With few exceptions, this band, containing such information as the occasion, purpose, and date of the mirror's manufacture, disappeared completely. In some designs the characters were transformed into a merely decorative band of geometric elements.

In the larger mirror (no. 23), the band next to the central decorative field shows this shift. From lack of knowledge of the tradition, the main design in the central area also suffered considerable simplification, as in this motif of seated animals and deities.[3] Four seated figures are still recognizable, along with recumbent animals. But in each mirror, the growing variation from the original concept can be seen as the beginning of a simplification process, which in its extreme form, became the "silkworm" design. In it, slightly curved worm-like patterns replaced all of what was once recognizable imagery, such as seated animals and figures.

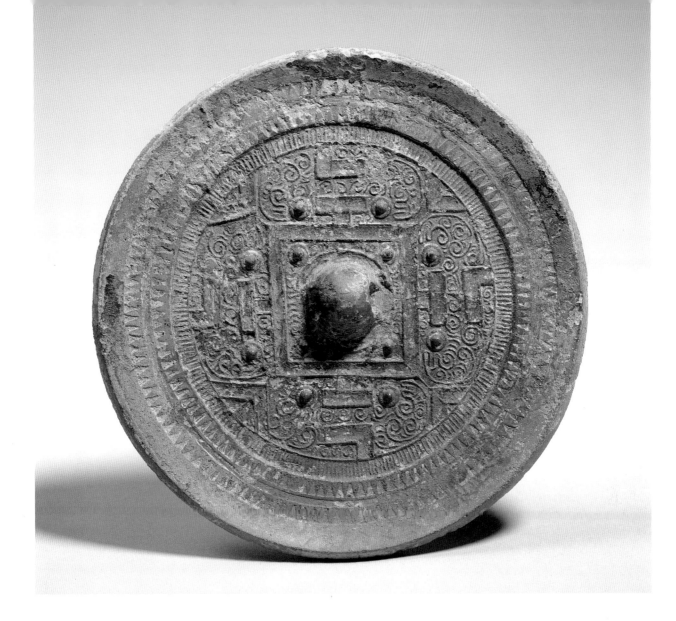

CIRCULAR MIRROR

Bronze; late Kofun period, 4th–5th century; Diam. 13 cm (5⅛ in.); B65 B1,
The Avery Brundage Collection

IN THIS so-called TLV-type mirror, the basic arrangement of design elements shaped like the letters T, L, and V remained more or less intact, while the linear figures of creatures, which survive from their Chinese prototypes, have been reduced to abstract spirals.[1] The random combination of decorative bands freely taken from various types of original Chinese mirrors is frequently seen and came to be characteristic of Japanese copies.

Many identical mirrors, apparently cast in the same mold, were excavated from tombs at widely sepa-rated locations, thus suggesting traffic and possible political relationships among those remote places. One set of mirrors cast from the same mold was found from tombs about 250 miles apart.

Although the majority of Japanese mirrors were made in styles similar to Chinese prototypes, original designs also can be found. Among those distinguished by composition and craftsmanship as well as their large size are examples with house designs, hunting scenes, and *chokko-mon* (straight line and arc) types.

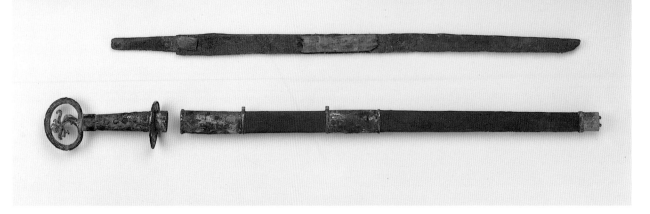

26

SWORD (*kantō* type)

Iron and gilt bronze; late Kofun period, 7th century; Blade: L. 69 cm (27¼ in.),
Scabbard: L. 62.2 cm (24½ in.), Hilt: L. 18.4 cm (7¼ in.); B64 W1,
The Avery Brundage Collection

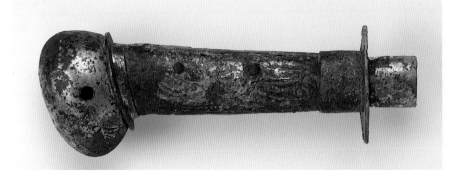

27

SWORD HILT (*kabutsuchi* type)

Iron and gilt bronze; late Kofun period, 7th century; Hilt: L. 22.8 cm (9 in.); B64 W2,
The Avery Brundage Collection

WHILE BRONZE AND iron were introduced from the Asian continent at the same time, the use of bronze was reserved primarily for ritual objects such as *dōtaku* (see no. 9), mirrors, and ceremonial blades of different types, made for burial. Iron, on the other hand, was the material for everyday tools used in farming and such crafts as woodworking and building. Weapons for actual fighting were also of iron, probably with little decoration.

Arms and armor of the Kofun period, both bronze and iron, have been found at burial sites. They protected warrior-leaders during their lifetimes and accompanied them to the afterlife to protect them from evil spirits. Fifth-century *kofun* in the Kinki district of west central Japan have yielded large numbers of arms and armor. For instance, the Mozu Ōtsukayama *kofun* in Osaka yielded more than three hundred swords of different types and another, also in Osaka, thirty-four breastplates. The differentiation between utilitarian and ceremonial weapons is obvious in sixth-century *kofun*, where a large number of ordinary swords have been found inside the burial chamber on the stone floor, while a decorative ceremonial sword was in the casket with the body.[1]

The ceremonial sword illustrated here has a ring-shaped gilt-bronze pommel and a small oval guard (no. 26). The ring frames a phoenix head in profile and has a dragon decoration in low relief; the phoenix holds a pearl in its beak. A long, straight iron blade was once sheathed in a wooden scabbard with gilt-bronze tubular fixtures in three parts[2] and gilt-bronze decorative panels (missing from this example). It is very similar to swords made in Paekche, in Korea, in the early sixth century, particularly to one of the weapons found in King Munyong's tomb.[3]

The shape and decoration of a second hilt and pommel suggest a different source of inspiration (no. 27). The egg-shaped pommel[4] is a native Japanese style with no direct continental prototype.[5] The name *kabutsuchi* appears in the *Kojiki*, the earliest written history of Japan, where a brief description refers to a *kabu* (lump) pommel.

SCULPTURE AND BUDDHIST PAINTING

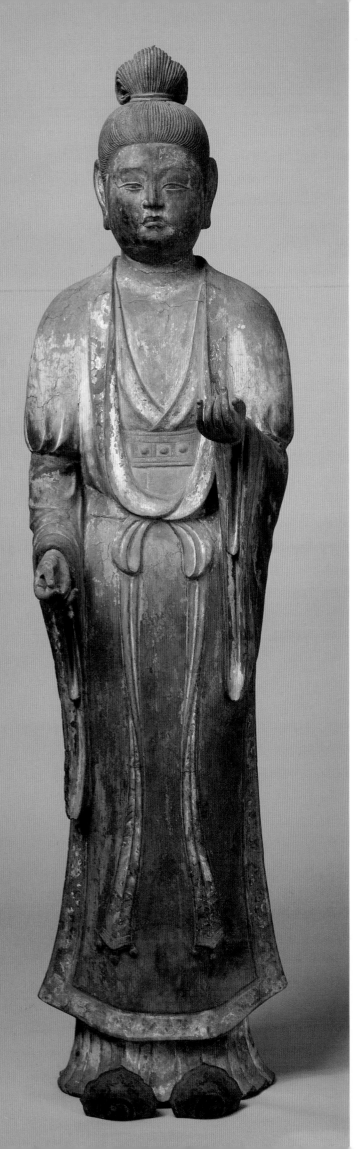

BONTEN

Dry lacquer; Tempyō period, 8th century; H. 141.6 cm (55¾ in.)
W. 36.8 cm (14½ in.); B65 S13, The Avery Brundage Collection

THESE STATUES ARE among the very rare examples of Tempyō sculpture outside Japan. In this dry-lacquer technique (*kanshitsu*), several layers of fabric are soaked in liquid lacquer and applied to a clay core, which is removed when the lacquer has dried. The process has the advantage of producing very light and durable sculptures, although as for all elaborate lacquer objects, it is extremely time-consuming and probably costly. This technique was originally introduced from China during the Tempyō period, during which it remained much in vogue.

Despite their serenity and seemingly classical simplicity of modeling, these figures reflect the esoteric influence that tinged the teaching of several of the six sects of Mahayana Buddhism, including the Hossō sect, which had its headquarters at Kōfukuji. Bonten and Tai-shakuten are Japanese transcriptions of the names of two Vedic deities: Brahma, the creator of all things and the central divinity in the Hindu trinity, and Indra, the thunder god whose main attribute is the *vajra*, symbolizing the thunderbolt (see no. 131). Adopted and paired by Indian Buddhism at an early point, these deities already appear in association with the Buddha Sakyamuni in Gandharan art.[1]

In the Japanese Buddhist pantheon, the two are also attendants of Shaka, the historical Buddha. The most famous pair, also of dry lacquer, belongs to the Tōdaiji temple in Nara and stands 12 feet high on the

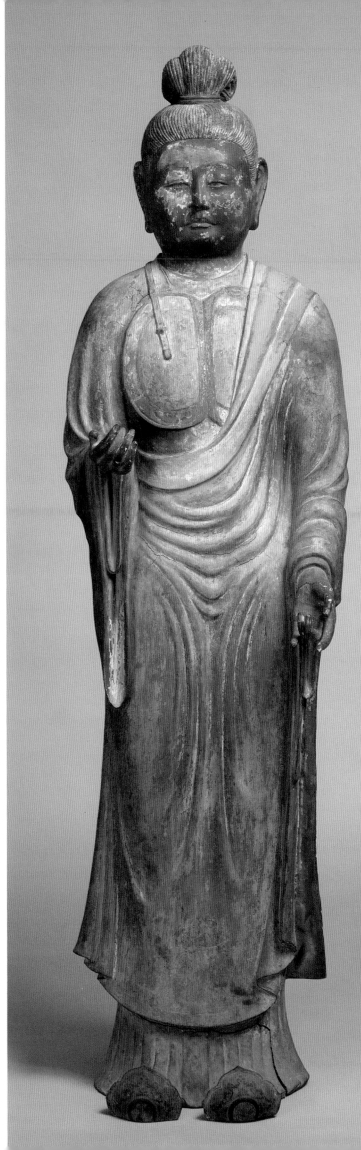

29
TAISHAKUTEN

Dry lacquer; Tempyō period, 8th century; H. 140 cm (55⅛ in.)
W. 39.4 cm (15½ in.); B65 S12, The Avery Brundage Collection

main platform of the Hokkedō. There they serve as attendants to Fukūkenjaku Kannon, an esoteric form of Avalokitesvara.[2]

Frontal and upright with graceful torsos, these statues are very close in style to those of the Hokkedō. Iconographical details are also similar, including the cuirass worn under a monastic robe.[3] This unusual apparel is an indication of the very special place that Bonten and Taishakuten occupied in the Buddhist pantheon of the period. On the one hand, as a ruler who resides atop Shumisen (Mount Sumeru), the center of the Buddhist universe (Taishakuten), they rank close to bodhisattvas. On the other hand, they oversee the Shitennō, the Four Heavenly Kings, true military figures who protect the Buddhist faith.

Probably because of its slowness and high cost, this lacquer technique did not remain popular after the Nara period, and very few examples have survived. These figures were once in the Kōfukuji, where a 1905 photograph shows them in a state of disrepair; the head and the left half of the face of Bonten and the entire head of Taishakuten were missing. The bodies, except for the hands, shoes, and part of the skirts are original, including some quite beautiful coloring, which probably escaped Kamakura or Edo period restoration.

NYOIRIN KANNON

(Cintamani-Cakra-Avalokitesvara)

Wood with traces of lacquer, pigment, and gilding; Jōgan or early Heian period, ca. 900;
Figure only: H. 65.7 cm (25⅞ in.) W. 51.4 cm (20¼ in.); B71 S3, Gift of Avery
Brundage and George F. Jewett, Jr.

WITH ITS BENEVOLENT, meditative expression and stately fleshiness, its relaxed, almost casual posture, and its six arms and high headdress, this Nyoirin Kannon (literally, Kannon of the Wish-Granting Wheel) is one of the main deities in the huge pantheon developed by the esoteric sects of Buddhism, particularly the Shingon. Its upright torso position places this statue stylistically very close to a small group of figures carved during the second half of the ninth century for temples belonging to the Shingon sect.[1] In addition to posture, facial expression, and overall plumpness, its garment is also quite characteristic of the style of this period. The main stylistic feature is seen in the treatment of the drapery, which takes the appearance of *hompa* (literally, rolling waves), achieved by alternating broad, high, rounded folds with narrow, low, ridged ones.

This statue has lost its four attributes — prayer beads, a jewel, a lotus flower, and a sacred Wheel of the Doctrine,[2] which were held respectively in its first, third, fourth, and sixth hands, starting from the right. The fifth hand, extended downward, is supposed to rest on Potala Mountain where Kannon resides. This complex iconography illustrates the bodhisattva's infinite compassion and willingness to help those who are suffering.

The figure is carved from solid wood with limbs joined to the torso. The high headdress and some hands have been replaced, as such extremities suffer damage easily. Recent X-ray examinations revealed that the statue was probably once fitted with crystal eyes (most probably during the Kamakura period, when such embellishment was in fashion). The crystal eyes were subsequently removed, and the figure was again given wooden eyes to bring it back to the style of the original period of creation. The lotus pedestal is a later replacement.

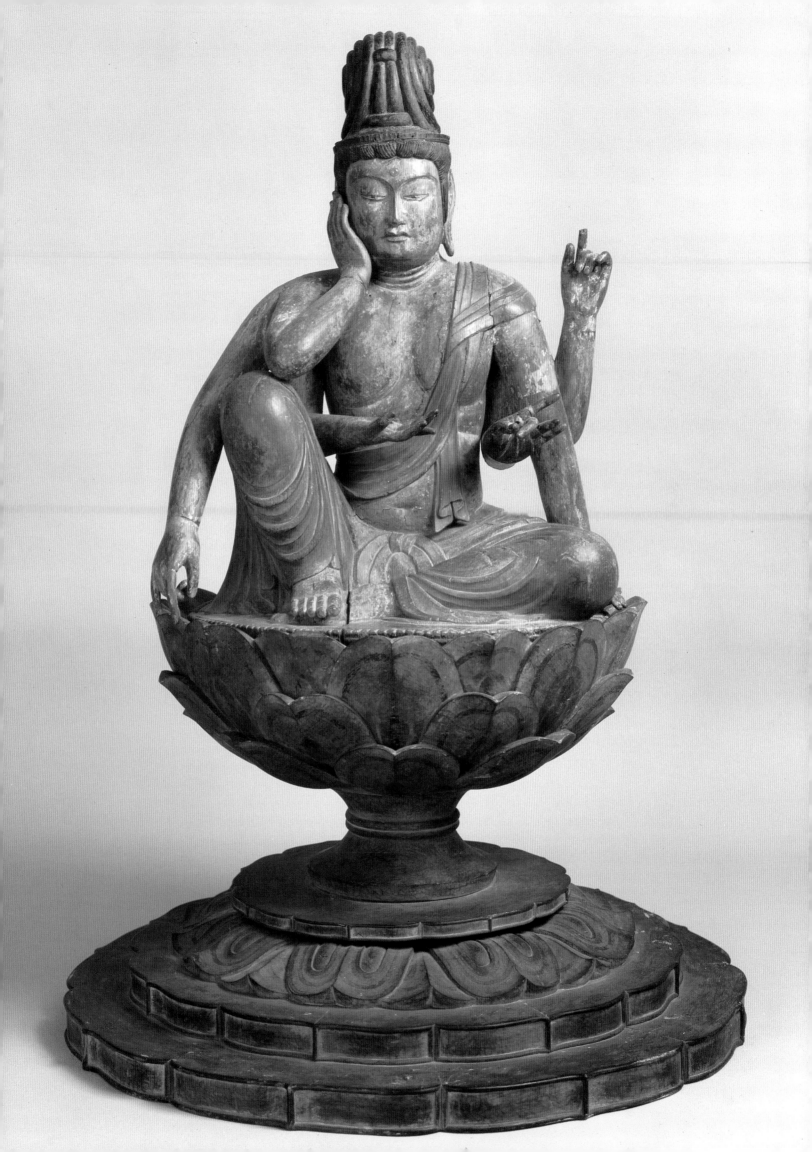

GUARDIAN KING

Wood with traces of lacquer and pigment; Heian period, 10th century; H. 94.6 cm
(37¼ in.) W. 31.7 cm (12½ in.); B67 S1, The Avery Brundage Collection

ORIGINALLY THIS GUARDIAN, a fierce warrior in full armor, probably belonged to a group of Four Heavenly Kings (Shitennō) who protected the four directions of the Buddhist universe. Guardian deities derived from early Indian sources and also occur in groups of twelve (the Jūnishinshō), each identified with an animal of the twelve zodiacal signs, thus corresponding to and protecting each two hours of the day.

Such figures may simply form a pair such as Jikokuten and Zōjōten;[1] sometimes they are singly worshiped, as is Bishamonten, a popular guardian deity in Japan. The guardians' costumes are like those worn by Chinese warriors and include a top, full trousers, chest and back armor, a tied sash and torso protector with a decorative lion face, and a tiger-skin loin cover. Leggings go to the ankles, and quite often a neckerchief is tied around the neck.

Carved from a single block of wood,[2] this guardian stands with his weight on his left foot, his right foot raised to rest on the head of a now-missing demon. The front part of the right leg was carved separately and joined, as was the left leg of the companion piece now in the Nelson-Atkins Museum of Art (see note 1). Following the ninth-century style, the body of the figure is extremely massive, giving this relatively small guardian an added sense of weight.

In order to further emphasize the figure's volume, the head was carved proportionately smaller. Its youthful, round contours and firm muscles make it appear fresh and innocent, despite its fierce expression. The body movement is also well portrayed, with strong articulation. The overall modeling of the body and face, however, shows stylization that places the figure in the tenth century. The original position of the missing arms and the type of attributes cannot be determined; thus the guardian's identity remains unknown. The topknot and rising tufts of hair on both sides of the forehead are later replacements, as are the front part of the right leg from a little above the knee down to the ankle, and the toes of the left foot. Starting on the back of the figure and continuing down to the lower part of the garment is a marking for a rectangular panel, which normally covers the cavity purposely carved into the torso to relieve stress and prevent the wood from cracking. Nonetheless some vertical cracks developed, which have been filled. The surface has also been filled and smoothed extensively, thus depriving the figure of a naturally developed surface quality.

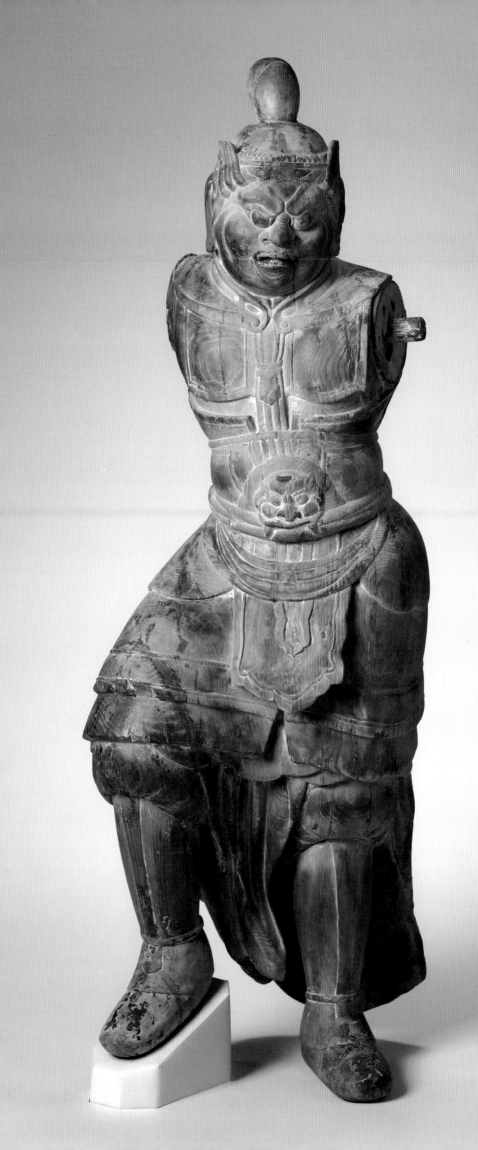

32
AMIDA NYORAI

Wood with traces of lacquer, gilding, and pigment; late Heian period, 12th century;
Figure: H. 91.5 cm (36 in.), Pedestal: H. 67.3 cm (26½ in.); B60 S10+,
The Avery Brundage Collection

JAPAN'S FUJIWARA PERIOD (ca. 1000–1185) is named for the Fujiwara clan, whose members not only dominated the imperial court but influenced the development of a new artistic style. Architecture, painting, calligraphy, sculpture, and other arts came to reflect remarkably well their gentle, compassionate Amidist ideals and aristocratic taste.

In sculpture Jōchō (?–1057) perfected the joined-wood (*yosegi-zukuri*) technique and established a great stylistic canon. Represented now by only one surviving work, the main deity in the Hōōdō, the Amida hall for the Byōdōin temple in Uji, his style became the classic model for sculptors of later generations.[1] In this technique, the parts of a statue are carved separately and joined, thus preventing the cracks that tend to appear over time from natural stress relief in sculptures carved from a single block of wood.

Amida Nyorai is seated cross-legged on a lotus pedestal, hands in the mudra (hand gesture) of meditation. A robe covers the back of the figure and both shoulders, draping down from the left arm over the lower body and legs. The folds of his robe are much gentler than those of earlier figures, such as the Nyoirin Kannon (see no. 30), and are treated more like patterning. The hair is represented in a typical coiffure for Amida, with many cone-shaped units, and the lips are painted with a red pigment. The expression, closely directed toward the worshiper, manifests the ideals of the Jōdo sect and suggests a feeling of proximity and intimacy between our world and Amida's Jōdo, the Western Pure Land.[2]

In technique and general style, this figure is based on Jōchō's model. The beginning of stylistic changes, however, can be seen in the slightly upcurved eyes and in a change in the proportion between the body and the width of the knee-to-knee span of the crossed legs. Here, the overall body height has slightly increased. The pedestal of this figure is unlike that of the Byōdōin example, but rather takes the form of a standard seven-layered lotus pedestal. Starting from the top, the pedestal elements include: *renge* (lotus), *soku* (column), *keban* (floral plate), *shikinasu* (flattened eggplant shape), *ukeza* (support board), *kaeribana* (everted petals), and *kamachi* (platform).

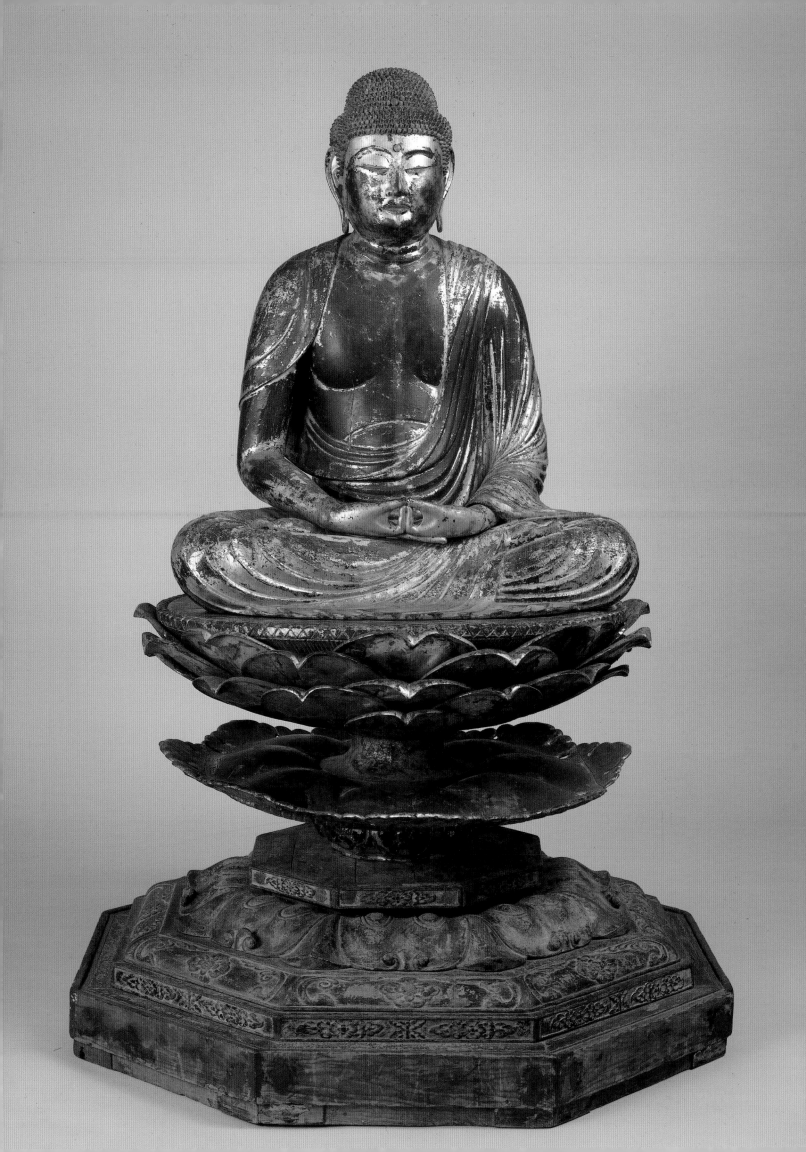

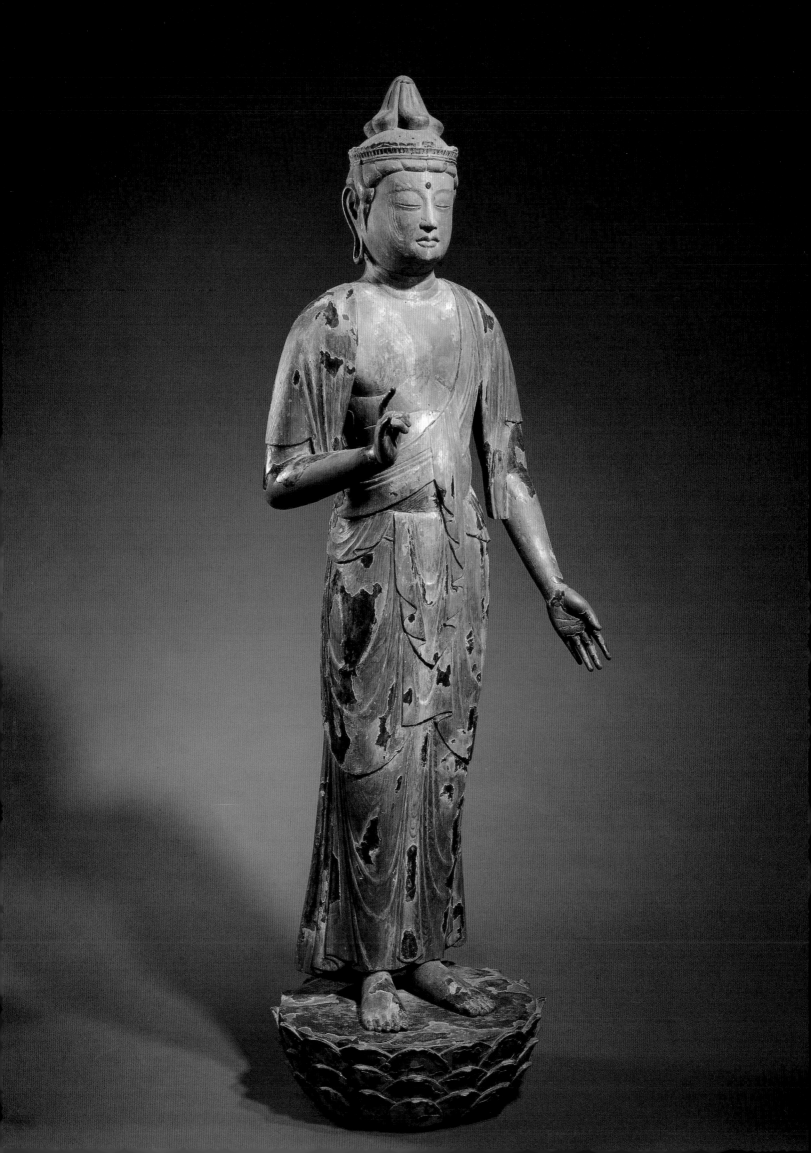

SHŌ KANNON (Avalokitesvara)

Wood with traces of lacquer and gilding; late Heian period, 12th century;
Figure: H. 167.7 cm (66 in.), Pedestal: H. 36.8 cm (14½ in.); B60 S420,
The Avery Brundage Collection

AROUND THE THIRD QUARTER of the twelfth century, with the foundation of the Jōdo (Pure Land) sect by priest Hōnen (1174–1212), Amida and his Western Pure Land began to gain prestige and immense popularity, which his cult still enjoys today.

Kannon, the bodhisattva of compassion, is one of the most widely worshiped deities in the Buddhist pantheon. As one of the principal attendants of Amida,[1] Kannon or Kanzeon (literally, The One Who Hears the Sounds of the World) occupies a major place in the liturgy of the Pure Land sect in Japan. When the term "Kannon" is used alone, it refers to Shō Kannon. Shō Kannon (literally, Pure or Sacred Form of Kannon) designates the unchangeable form of the deity, in contrast to his other changeable self, which can assume as many as thirty-three forms — the Eleven-headed Kannon, Thousand-armed Kannon, and so on. Kannon and Seishi, the two attendants of Amida Nyorai in the Amida triad, are enshrined at the center of the Amidadō (Hall of Amida) recreating Jōdo, the ideal Western Pure Land. Many Amidadō were built by court nobles as well as by samurai clan heads as a religious exercise. Along with the Byōdōin in Uji, built by Fujiwara Yorimichi (990–1072), an extremely elaborate example survives in Hiraizumi in northern Japan, where the high standard of craftsmanship of central Japan found strong patronage under three generations of another branch of the Fujiwara family.[2]

Standing on a lotus pedestal, Shō Kannon once held a lotus spray in the right hand, which is held forward at elbow height. The left hand is extended downward and slightly forward with fingers at ease. With half-closed eyes and delicate lips, the facial expression of this figure is rather feminine. Contemporaneous with the Amida Nyorai (no. 32), this statue shares with it many stylistic characteristics, including a stately stance and the relative shallowness of the carving. The gently flowing folds of the slightly flaring skirt are arranged symmetrically. The shawl and the scarf cover the shoulders and part of the torso. Around the head is the kind of simple diadem that usually served as a base for a more elaborate and detachable metal crown. A semiprecious stone inset on the forehead represents the *urna*, the so-called third eye of Buddha.

34

KAKEBOTOKE OF DAIITOKU MYŌŌ (Vidyaraja)

Gilt bronze and wood; reportedly from Wakayama Prefecture; early Kamakura period,
12th–13th century; Diam. 28 cm (11 in.); B69 B1, The Avery Brundage Collection

ONE OF THE FIVE FEROCIOUS DEITIES, or Five Kings of Light, Daiitoku Myōō is more particularly a protector of the western sector of the universe of esoteric Buddhism. Traditionally all five kings were worshiped separately. After the brief period during the Fujiwara period when worshiping Five Kings as a group was fashionable, Daiitoku Myōō again came to be widely venerated as a single deity. As a result there remain many images of him.

Daiitoku Myōō is normally depicted with six heads, six arms and legs, and seated on a water buffalo, which is more often recumbent than standing. One pair of arms is held in front of the chest with hands forming a *ken-in* mudra, one pair is held high, and the other to the side. His now-missing attributes were a sword with a three-pronged *vajra* hilt (upper right), a precious baton (lower right), a ringed rope of a coiled snake (lower left), and a trident (upper left).

Modeling of the image is strong and crisp, especially in the legs and arms, reflecting the style of the early Kamakura period. The head is proportionately larger than the rest of the body, while the head of the buffalo is also strongly modeled, a sturdy mount for this ferocious deity. The image is attached to the bronze plaque that originally covered the entire field, out to the remaining circular frame. At the lower left of the image is a small vase for flowers, probably one of the original pair, nailed to the plaque. The plaque was once hung by the rings attached to the decorative metal fittings remaining on the rim. The image and the frame still show a considerable amount of gilt.

Kakebotoke (literally, hanging Buddhist images) are votive plaques usually with one or more Buddhist deities, or sometimes Shinto deities. Since they evolved from bronze mirrors with simply painted or incised images, the majority are of circular format and made of bronze. There are also unusual examples of wooden images, some on fan-shaped and square plaques.

The making of *kakebotoke* was closely associated with the *honchi suijaku* theory, which prevailed from about the end of the Fujiwara to the early Kamakura period. According to this theory, all Shinto deities were considered merely as another manifestation of Buddhist ones, the true deities. These true entities (*honchi*) of corresponding Shinto deities were represented as *kakebotoke* and were placed in shrines to be worshiped. *Kakebotoke* therefore should more precisely be referred to as *mishōtai* (real entity), which is in fact the earlier term of reference.

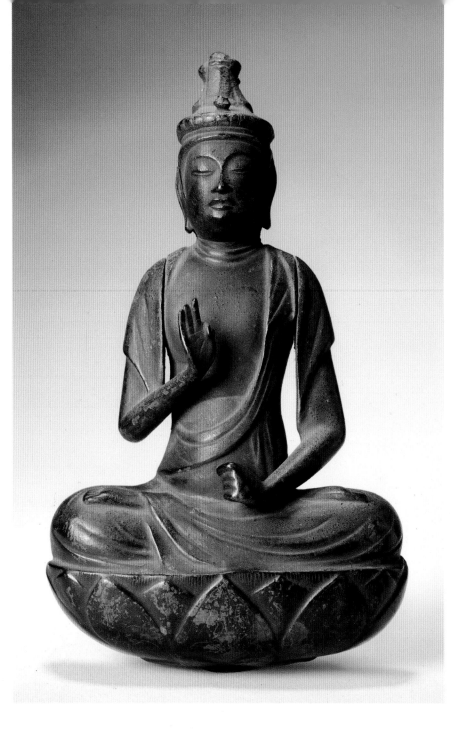

35

SEATED KANNON

Bronze with traces of gilding; mid Kamakura period, 13th century; H. 20.3 cm (8 in.)
W. 12.2 cm (4¾ in.); B65 B50, The Avery Brundage Collection

THIS SEATED KANNON was originally part of a *kakebotoke* (see no. 34). Seated cross-legged on a lotus pedestal, Kannon's body and the pedestal were cast in one piece, while the arms were cast separately and affixed to the shoulders by a tongue-in-groove device. The right hand is held in front of the chest in the mudra of consolation (*ani-in*), with the first finger and thumb joined to make the ring symbol. The left hand has a hole that probably held a lotus, the attribute of Shō Kannon.

The garment, as usual, consists of a skirt, a scarf, and a cape which covers the shoulders; folds are indicated by shallow, smooth relief. The high decorative topknot, a distinctive feature of the period, is derived from Chinese Song dynasty prototypes that strongly influenced Japanese Buddhist iconography of this period. The broken stump on the crown probably served to support a small image of Amida, Kannon's spiritual father.

The figure is rather slender, especially in the modeling of the torso and sinewy arms, giving it a light, young appearance. The facial expression is also calm and youthful, another characteristic of the images of the period.

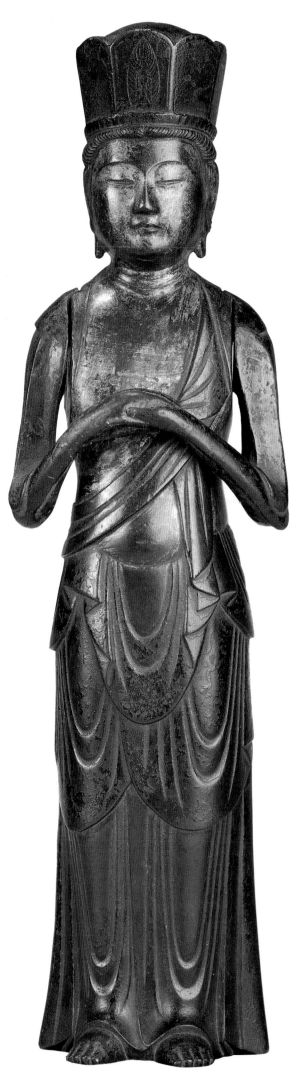

36
STANDING KANNON IN STYLE OF
ZENKŌJI TRIAD

Bronze with traces of gilding; Muromachi period, 15th–16th
century; H. 29.8 cm (11¾ in.) W. 8.2 cm (3¼ in.); B60 B355,
The Avery Brundage Collection

THIS STANDING KANNON, clad in the
standard skirt and scarf, wears a high octagonal
crown and holds her joined hands in front of the chest,
palms together. This style is known as the Zenkōji type,
after the famous Amida triad in the *raigō* pose (see nos.
45–46) housed in the Zenkōji temple in Shinano
Province (present-day Nagano Prefecture).

With the Jōdo sect's spreading influence over
Japan during the Kamakura period, numerous images
of the Amida triad in the *raigō* pose were produced. In a
practice peculiar to the late Kamakura period, famous
images with a rather characteristic style were replicated
and housed in many temples. Along with the standing
Shaka images of Seiryōji, with their strong stylistic
influence from China, the Amida triads of the Zenkōji
style were extremely popular. The typical triad, of
which there are many fine examples, is of cast bronze,
with the main image slightly less than 20 inches high.[1]
This design continued through the Nambokuchō into
the Edo period, with most examples of duplication from
the late Kamakura and Nambokuchō period. This phe-
nomenon of replicating must have been due to the resto-
ration project of the Zenkōji temple with the Kamakura
government office's strong patronage.[2] Among those
many triads, eight or more bear dates ranging from
1206 to 1304.[3]

This Kannon, now separated from the rest of the
triad, closely resembles the image in the Tokyo National
Museum dated to the sixth year of the Kenkyū era
(1254). The head is proportionately large and the face
plump, compared to the slender body and especially
slender and rather angular arms. The folds in the skirt
are well rendered but lack the three-dimensional mod-
eling of the prototype in the Tokyo National Museum
collection.[4]

Zenkōji-type triads are found throughout the
country, with their heaviest concentration in central to
northern Japan. The majority are cast bronze, with
occasional examples of wood, iron, and stone.

37

SHINTO GODDESS

Wood with traces of pigment; late Heian to early Kamakura period, 12th–13th century;
H. 97 cm (38³/₁₆ in.) W. 21.6 cm (8¹/₂ in.); B69 S36, Gift of Mrs. Herbert Fleishhacker

SHINTO DEITIES WERE not represented in sculpted images before the mid-eighth century, when Buddhist images lent a strong influence to their representation. This marked the shift from the period of primitive Shinto practice to that of the shrine (or organized) practice. Of the so-called eight million Shinto gods and goddesses that reside in all aspects of nature—waterfalls, mountains, large trees, and rocks—only a very few had been given any tangible image in the form of a human shape, and of those, even fewer are identified with specific deities. Identifications have been more often based on shrine documents than on particular iconographical characteristics.

Therefore an image like this one is only known as a Shinto goddess. In the late Heian and Kamakura periods, when Shinto sculpture carving reached its peak, a Shinto style had already been developed with marked technical and iconographical characteristics. Technically conservative, Shinto workshops of the period generally shunned the more versatile joined-wood technique (see no. 32) and continued to carve most statues from single blocks of wood.

Usually symmetric in their iconography, the deities were made to resemble noblemen and women of early periods. This goddess has a Tang dynasty Chinese coiffure and wears a garment popularly seen in the upper classes of Nara period Japan. Unlike the plump beauties of the Tang dynasty, this Shinto goddess reflects the more slender symmetrical style of Fujiwara period Buddhist sculptures in a position similar to that of a figure in the Royal Ontario Museum, Toronto.[1] Like all Shinto images, the goddess was not meant to be seen but was kept hidden in a portable cabinet behind curtains in a special part of the shrine where she was worshiped.

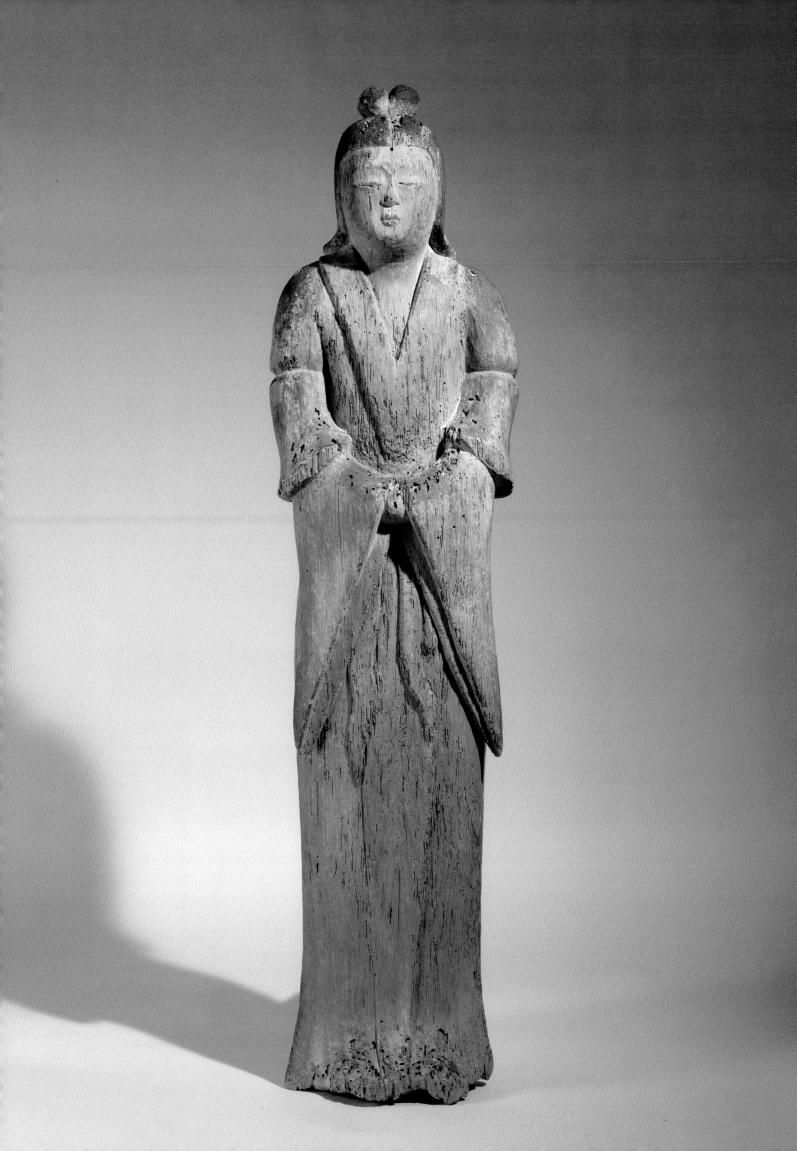

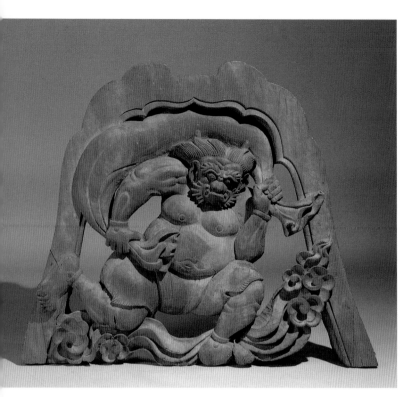

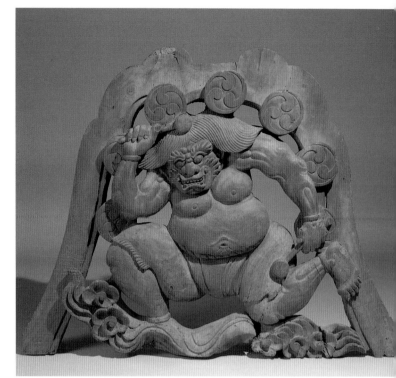

38
WIND GOD
Wood; early Edo period, 17th century; H. 99 cm
(39 in.) W. 114.3 cm (45 in.); B60 S2+,
The Avery Brundage Collection

39
THUNDER GOD
Wood; early Edo period, 17th century; H. 97 cm
(38¼ in.) W. 125 cm (49¼ in.); B60 S3+,
The Avery Brundage Collection

WOODEN INTERBEAM supports have been known in Japanese as "frog's legs" (*kaerumata*) from at least the Nara period. They are so named because their contours resemble a frog's wide-stretched hind legs. There are basically two types of *kaerumata*, the low type resembling a bow and the high type, like this pair. Ornamental *kaerumata* were made during the Kamakura period, but did not become popular until the Momoyama period.

The thunder and wind gods in this pair of *kaerumata* are carved in high relief. Horned Fūjin, the wind god, controls the wind by holding the air in a large sack and directing it from the sack's mouth in any direction he wishes (no. 38). Raijin, the thunder god, produces thunder by beating a number of small drums (five in this case) held on a frame around his back (no. 39). Introduced into Japan with Buddhism, these gods are frequently shown together and are sometimes listed as members of the Twelve Heavenly Beings, or Jūniten.[1]

These bearded, pot-bellied, demonic gnomes wearing only loincloths over furry pants, crude bracelets, and anklets are ferocious, yet almost comical. They are, iconographically, descendants of the celebrated lantern-bearing statues in Kōfukuji, Nara.[2]

In a manner characteristic of the early Edo period, the strong carving technique creates a sense of the massive volume of each body part rather than naturalistic musculature. Some attempt at depiction of muscles in the limbs resulted in an effect more like a stylized pattern, which verges on caricature rather than realism.

The cloud designs on each piece are excellently carved, giving the gods their appropriate mountings, which have depth and a sense of movement.

Detail

40

UTOKUNYO SHOMON DAIJŌKYO

(Mahayana Sutra of Questions of a Virtuous Woman)

Late Heian period, 12th century; handscroll, gold and silver on blue paper; H. 25.7 cm
(10¹/₈ in.) L. 251.8 cm (99¹/₈ in.); B60 D116, The Avery Brundage Collection

A RECTANGULAR vermilion seal in the first line of this decorated sutra indicates that the scroll once belonged to the Jingoji temple-monastery located northwest of Kyoto. Jingoji is the spiritual center of the esoteric Shingon sect. Kūkai (774–835), a Buddhist priest, went to China expressly to learn Shingon teaching, and upon returning began immediately, by imperial order, to teach the practice of Shingon Buddhism.

The temple once housed a set of 5,400 sutra rolls like this one, which was commissioned by the retired emperor Toba (1107–1122). Although the date of its commission is not known, the date 1149 is inscribed on the lining of one of the sutra wrappers.[1] At the major monasteries, copying sutras became an important religious exercise, and many similar sets were completed. Of the 4,722 scrolls once recorded in an Edo period inventory, only 2,317 presently remain in Jingoji. This sutra is complete in one scroll, and as its title suggests, it records the questions concerning faith asked by a certain virtuous woman from a Brahman family in Benares, India.

Following the general style of Jingoji sutras, the text and painting on the frontispiece are in gold and silver. The text is all in Chinese characters written in *kaisho*, a standard block style. The handwriting style, somewhat more relaxed and softened than that of earlier sutras showing a strong Chinese influence, is commonly called *wayō*, or "Japanese style."

The frontispiece is decorated with Buddha, two bodhisattvas, and two attendant monks seated in the foreground; before this group is an offering stand with an incense burner. In the distance is a bird-shaped hill, representing Vulture Peak, a sacred site near Rajagriha in India. Two flying musical instruments (perhaps flutes), dominated by decorative ribbons tied to them, appear in midair on each side of the peak. They can be identified only by another example of the Jingoji sutra in which the flutes are more clearly depicted.

This composition, a standard one for Jingoji sutras, is a greatly simplified version of more individualized, richer sutra decorations such as appear on the *Daihannyakyō* (Great Sutra of the Perfection of Wisdom).[2] The gold and silver paint of floral scrolls on the cover (i.e., the verso of the frontispiece) has penetrated the paper, and these designs are now also seen from the front.

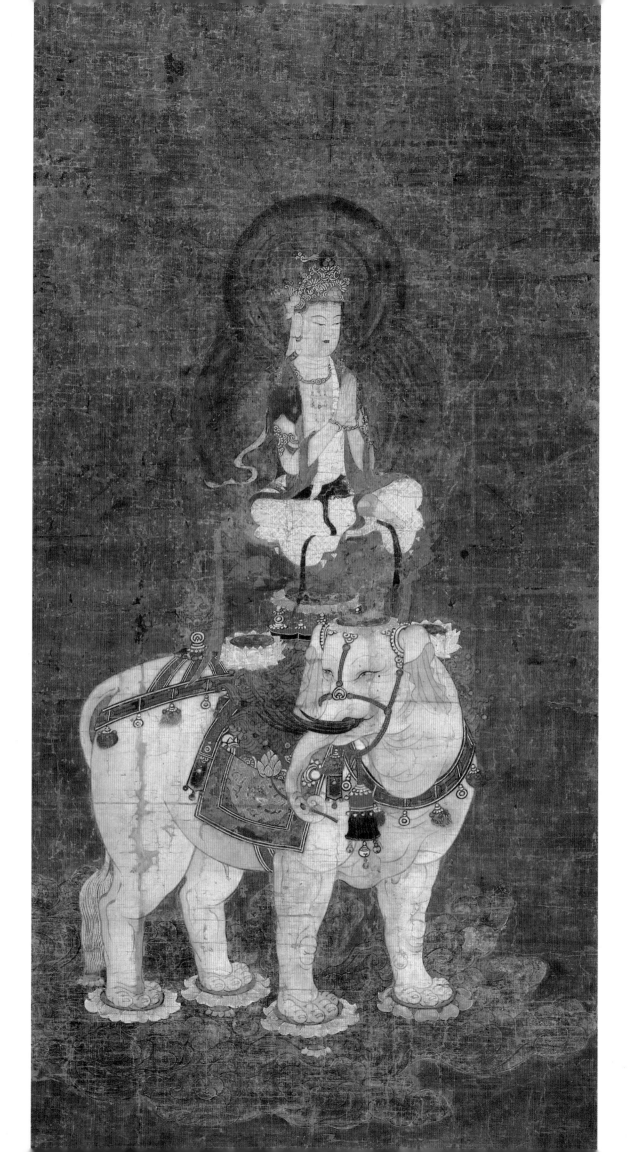

FUGEN BOSATSU (Bodhisattva Samantabhadra)

Early Kamakura period, 13th century; hanging scroll, ink, colors, and gold on silk;
H. 71.5 cm (28⅛ in.) W. 36.8 cm (14½ in.); B66 D2,
The Avery Brundage Collection

HISTORICALLY, FUGEN Bosatsu along with Monju, who rides a lion, were the two bodhisattvas who attended Buddha Sakyamuni. Fugen personified the dynamic aspect of Sakyamuni's life; Monju embodied the Buddha's insight and wisdom.

The patron bodhisattva who protects believers in the Lotus Sutra, Fugen is discussed in two sutras, Hokkekyō (Lotus Sutra) and Kan Fugenkyō (Meditation on the Bodhisattva Fugen). In these sutras, the Fugen Bosatsu is described as a white figure seated cross-legged on a lotus pedestal on the back of a white elephant with six tusks which stands on a cloud. The Bosatsu has descended from the Jōmyō-kokudo (Land of Pure Light) in the west, his hands folded in prayer as he comes to comfort and protect the faithful worshiper.[1]

Among many types of Buddhist paintings, this one is a fine example of an object of personal worship to be used in a specific devotional and ritualistic context (see also nos. 42, 45–46). A large number of paintings depicting Fugen Bosatsu began to be produced for this purpose as the *Hokke sammai* ritual (achieving complete mental concentration by reciting the Lotus Sutra) gained popularity among early Heian devotees.

For this ritual, special meditation halls were built where a devotee would spend days and nights before an image of Fugen Bosatsu, continuously reciting the Lotus Sutra. The priest Ennin (794–864), successor of Saichō (767–822, founder of the Tendai sect), is known to have practiced this ritual for the last thirty-seven days of each of the four seasons, thus cleansing his soul of mortal sins.[2]

The Lotus Sutra also promised salvation to women believers. Ladies of the Fujiwara court, therefore, became its ardent followers, commissioning paintings of Fugen as the object of their worship. As a result, an exceptional feminine delicacy distinguishes many of these works. Fujiwara noblemen also worshiped Fugen as the special protector who would prevail during the dreaded forthcoming era of *mappō*, or "End of the Buddhist Law," an event awaited and feared by the devout (see no. 128).

In this painting, a degree of tension and compositional interest is introduced by the turning of the elephant's head as he holds a lotus blossom in his trunk. Small lotus pedestals for Bosatsu's feet are provided on either side of the main pedestal, unused here because of the way he is seated. On the elephant's head is a small disk with three miniature figures. Near the four lotus blossoms on which the elephant stands are three smaller lotus pedestals. Located below the trunk, tail, and male organ, these pedestals are interpreted to be the resting places for these three sacred appendages.

Technical refinements that reached their height during the Fujiwara period are still well preserved in this painting. Delicate yet strong lines delineate the figure, the elephant, and all their adornments. Coloring is as sensitive as the lines in depicting the warm flesh of both Fugen and his elephant. Extremely fine, nearly hair-thin strips of gold foil adorn Fugen's garment and line the lotus petals in the *kirikane* (literally, cut-gold) technique.

FUDŌ MYŌŌ (Acala)

Kamakura period, 13th century; hanging scroll, ink and colors on silk; H. 172.3 cm
(68 in.) W. 108.5 cm (42¾ in.); B70 D2, Gift of Asian Art Museum Foundation
of San Francisco

T HERE ARE THREE TRADITIONAL applications of religious images in Buddhism. Classified as *sōgon*, *raihai*, and *kyōka*, their respective functions have been as interior temple decoration, objects of worship, and didactic items for teaching Buddhism. As in many other cultures, religious paintings in Japan have come to assume another and newer dimension or, as some believe, have been reduced to purely aesthetic objects.

Esoteric Buddhist paintings may be classified into two groups indicating basic manifestations of the divine. Images of the first group show a departure from human form with multiple heads and limbs. The deities in the second group all have expressions of wrath.[1]

Esoteric Buddhism was known to the Japanese as early as the Nara period. The eleven-headed Kannon in the mural in the Golden Hall of Hōryūji, the temple founded in 607 by Prince Shōtoku, is representative of the many similar images painted during this time. It was in the Heian period, however, that the eight Japanese priests who studied in China, including Kūkai (774–835), founder of the Shingon sect (see no. 40), introduced the so-called pure form of Esoteric Buddhism, which brought with it hundreds of deities. In two mandalas alone (complex diagrams representing the cosmos and hierarchies of deities), the Kongō or Diamond, representing wisdom, and the Taizō or Matrix, representing reason, Kūkai introduced over 1,800 deities.[2] Many of them had their origin in different Indian mythological figures, which were freely incorporated into this Buddhist sect.

Fudō Myōō (literally, the Immobile Bright King) was believed to be a messenger of Dainichi Nyorai (Mahavairocana), the central image and protector of the followers of the Shingon sect. Whether standing or seated, Fudō Myōō is always surrounded by flames as he holds a sword and rope, symbols of his power. In this painting, the flames appear in a stylized whirling pattern which had already developed by the middle Heian period (tenth to eleventh centuries). The image with its twisted hair hanging on the left side, its wide, staring eyes, and squarely frontal posture with torso somewhat twisted to the right is in the so-called Taishi (Great Teacher) style introduced by Kūkai, who came to be known more popularly by his posthumous name, Kōbō Daishi (Great Teacher Kōbō).

Open only to the initiated, the Esoteric ritual, which took place before the painted image, involved the burning of *goma* (a holy fire of cedar sticks). As a consequence, many of these paintings suffered severe damage, and this one is no exception. Details of the facial features and stylized flames are obscured or lost in the upper part of the painting, now blackened by oily smoke. In the better-preserved lower part, the pedestal supporting the deity is a typical formation known as *shitsu shitsu za*, which is made of blocks of wood to represent stylized piled angular rocks.

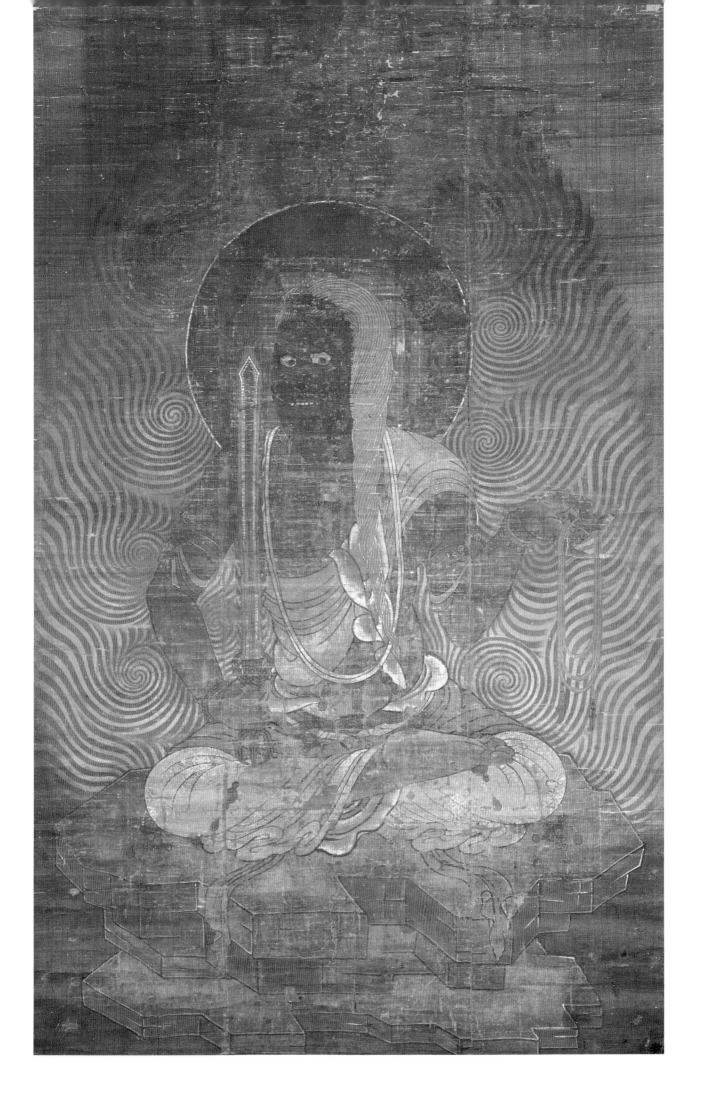

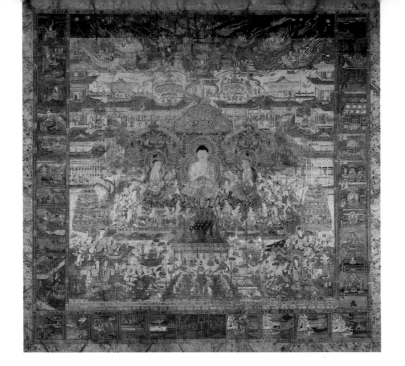

43
TAIMA MANDALA

Muromachi period, 14th–15th century; hanging scroll, ink, colors, and gold on silk;
H. 177.8 cm (70 in.) W. 170.8 cm (67¼ in.); B61 D11+,
The Avery Brundage Collection

THE MANDALA HAS been defined as a "pictorial version of the cosmos in which all things emanate from the great Sun Buddha, Dainichi Nyorai (Mahavairocana)."[1] The Taima mandala is the most complex of the three Jōdo or Pure Land mandalas.[2] Strictly speaking, it should have been called the Kangyō mandala, since it was conceived after the teaching of *Kanmuryōjugyō* (Sutra of Meditation on the Buddha of Infinite Life). Its popular name derives from Taima-dera, the temple where the original Nara period woven mandala, of which this is a copy, is housed.[3] A famous legend has it that this large mandala was woven overnight by a mysterious nun, from the fiber of a hundred pack-horse loads of lotus stems spun and dyed by another enigmatic nun, both of whom appeared to the Princess Chūjō, a devout Amida worshiper. Before disappearing, the spinner revealed that she was an incarnation of Amida, Buddha of the Western Pure Land, while the weaver was Kannon, the bodhisattva of compassion.

For some reason the original mandala remained unnoticed until it was rediscovered by the priest Shōkū (1171–1247), the principle disciple of Hōnen (1133–1212), founder of the Jōdo sect. Shōkū had copies of it made for distribution throughout Japan, and many small-scale replicas were produced as paintings and block prints.[4]

The mandala consists of a central field with right, left, and bottom borders, which are divided into smaller sections. The central field is a rich, precisely detailed portrayal of the Western Pure Land, the destination promised in the sutras to the faithful believer.

Surrounding the central Amida and two attendants, the Pure Land is filled with palatial buildings, lotus ponds, a dance stage, jeweled trees, canopies, and flying musical instruments arranged symmetrically. It is inhabited by several hundred bodhisattvas, attendants, musicians, and dancers. Some Pure Land followers in the lotus pond at the lower section are being reborn.

The eleven sections of the left border depict the story of the treacherous Indian prince Ajasasatru of Magadha who, in his attempt to take over his father's throne, imprisoned the king and tried to starve him to death. The story starts at the bottom and develops upward. The prince also imprisoned his mother, Queen Vaidehi, after discovering that she secretly delivered food to his father. It was in prison that Vaidehi sought salvation through Sakyamuni, who responded by teaching her the sixteen meditations through which one is reborn in the Western Pure Land of Amida. Thirteen of these meditations are illustrated in the right side border (reading from top to bottom).

The last three modes of meditation are further subdivided into nine scenes, represented in the bottom border, from right to left. There are nine possible ranks in which one may be reborn in the Pure Land. Depending on the rank and the elaborateness of the *raigō*, Amida's welcome of the departing souls of the dying varies. One of the most significant tenets of the Jōdo sect, the idea of *raigō* also inspired a major group of Jōdo paintings and sculptures (see nos. 36, 45–46).

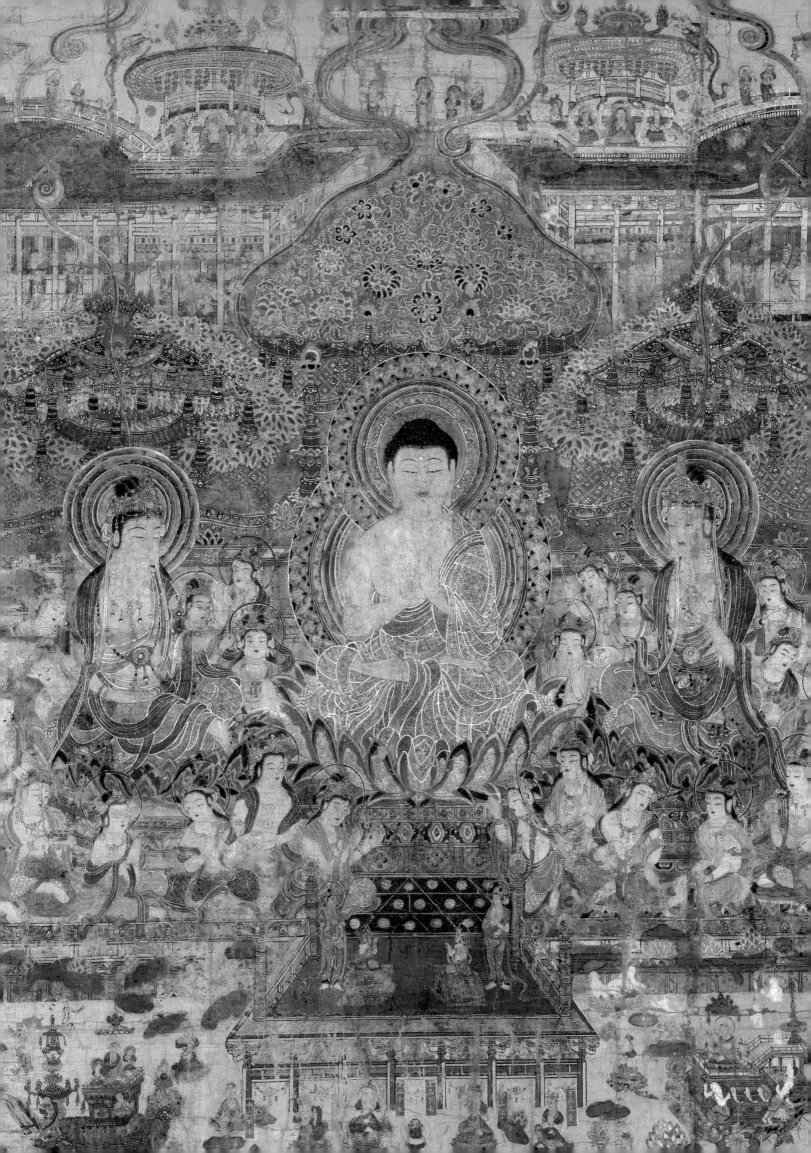

BUTSUGEN MANDALA

Kamakura period, 13th–14th century; hanging scroll, ink, colors, and gold on silk;
H. 84.6 cm (33¼ in.) W. 68.5 cm (27 in.); B62 D20, The Avery Brundage Collection

ESOTERIC BUDDHISM TEACHES that man is capable of attaining Buddhahood on this earth by meditating on the images of certain Buddhas and performing prescribed rituals.[1] To this end, complex iconographical series were developed in painted images, which were used in different ceremonies. They could be single images, such as that of Fugen Bosatsu or Fudō Myōō (see nos. 41–42), or mandalas representing a number of deities in a single composition.

In addition to the two basic mandalas depicting the Diamond World (Kongōkai), representing wisdom, and the Matrix World (Taizōkai), representing reason, many others were made for various rituals. This mandala has in the center Butsugen Butsumo (Buddhalocani), the personification of the eyes of Dainichi Nyorai (the central deity of Esoteric Buddhism). Surrounding this central image are three concentric rings of radiating lotus petals, covering an eight-spoked sacred wheel. Each petal holds a deity.

On the eight petals of the innermost ring, Shichiyō (the sun, the moon, and five stars) and Kinrin (The Golden Wheel-rolling King) are depicted. On the petals of the middle ring appear the eight manifestations of Bosatsu, while on the outermost ring, the eight forms of Myōō are depicted. The rectangular background of this lotus image is filled with geometric patterns of hemp leaves with finely cut gold leaves, or *kirikane*. In the corners of this background rectangle, and also in the corners of the lotus-pattern border surrounding it, appear two sets of venerating Bosatsu, each holding votive objects used to guide followers into the Buddhist world — incense burner, flower vase, candle holder — while others assume singing or dancing postures. In the lotus border, four more Bosatsu alternate with the venerating ones to complete this pantheon.

Very few examples of this particular mandala survive, and they all date from the Kamakura period.[2] The earliest reliable record of a ritual using this mandala, however, dates from the year 1136, when it was used to banish "natural disaster and evil spirits."[3] The ritual is known to have been used to attain peace and worldly gain and to assure safe childbirth. In an account nearly a century older, one Ohara Chōen (1016–1081) of the Tendai sect reported seeing such an image, suggesting an even earlier existence of this iconography.[4]

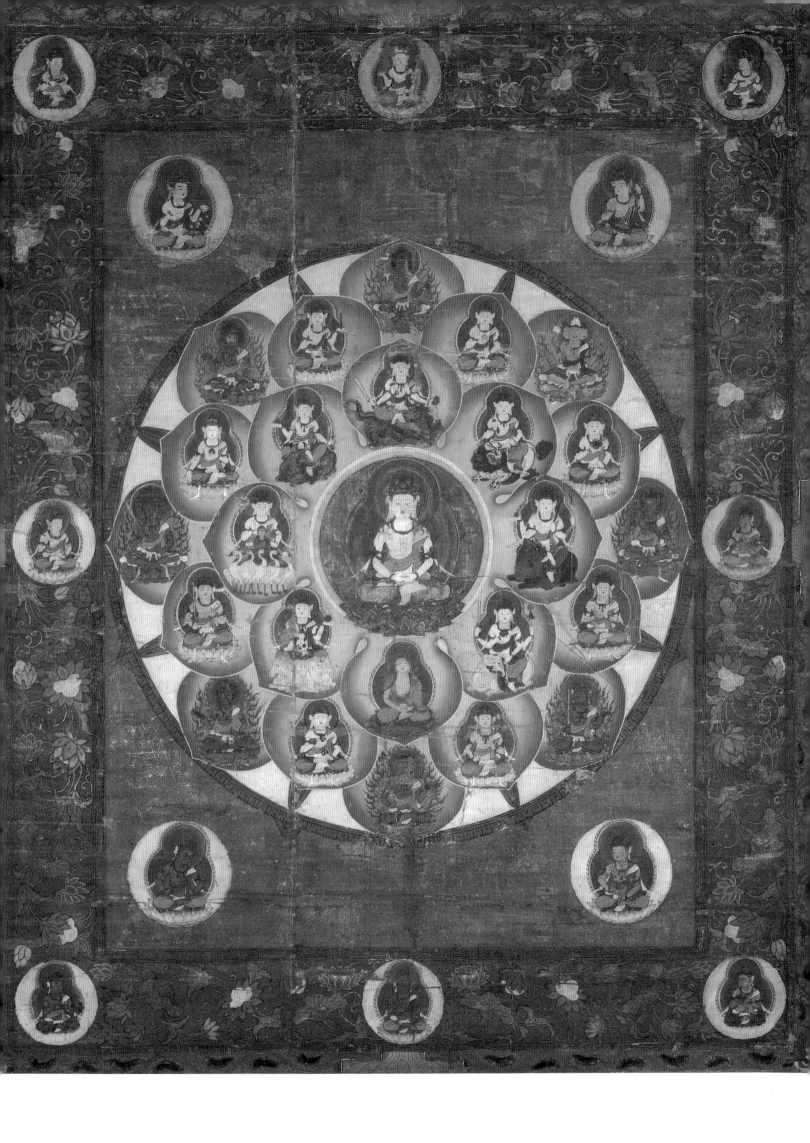

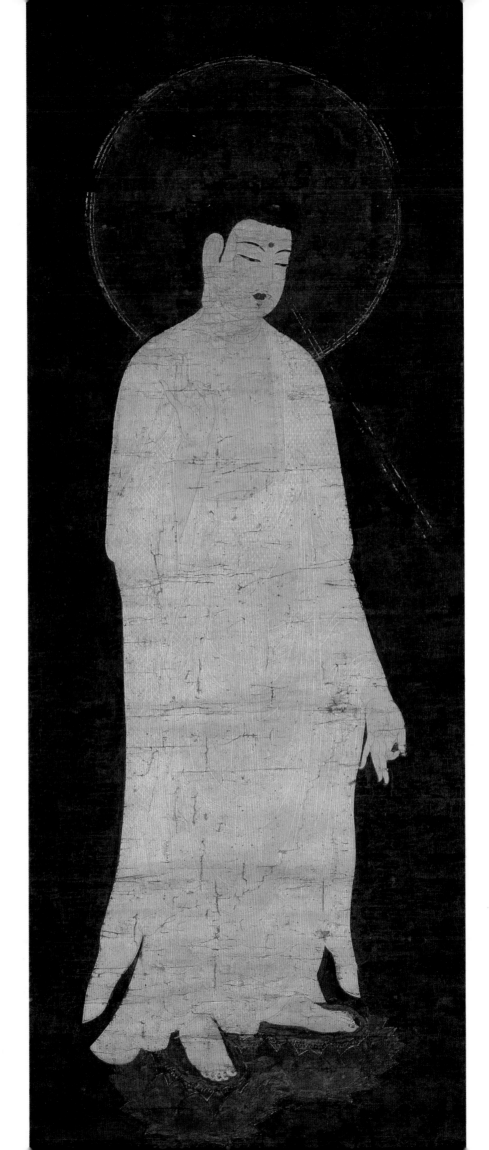

AMIDA IN *RAIGŌ* POSE

Kamakura period, 14th century; hanging scroll, ink, colors, and gold on silk; H. 98.1 cm
(38⅝ in.) W. 38.7 cm (15¼ in.); B64 D7, The Avery Brundage Collection

A SINGLE IMAGE OF STANDING Amida constitutes the simplest of all *raigō* paintings. Nearly always standing in three-quarter or frontal position, the Amida image appears as if it has simply stepped out of a *shōjūraigō* painting to welcome departing souls of the dying (see no. 46).

This most popular type of *raigō* image painted during the Kamakura period was primarily used by the priest Hōnen (1133–1212), the founder of the Jōdo sect.[1] Some Amida *raigō* of this type are flanked by the attendants Kannon and Seishi, each painted on a separate piece of silk and positioned toward a central, frontally posed Amida image. Therefore, it is safe to assume that an Amida image in the three-quarter posture, as here, was never the central figure of a three-part composition with attendants.

This type of Amida image is usually painted against a deep indigo background without landscape elements, a standard iconographic treatment. The Amida's *raigō* mudra, *jōbon jōsei*, indicates the first level of the first rank, that is, the highest possible level of rebirth into the Western Pure Land. From Amida's downward-cast eyes, which look toward the dying worshiper, there emanate beams of lights. Depicted in fine gold lines, they symbolize Amida's concern. The Amida figure is frequently of evenly painted gold, with details in the garments and decorations delineated with *kirikane* (cut-gold) lines. The image stands commonly on a *fumiwake-rengeza* (divided-step lotus pedestal) and is topped with a delicately painted golden halo.

This particular Amida *raigō* is virtually identical in all ways to the standing central image in the famous large painting *Amida Raigō with Twenty-five Bodhisattvas*, in the treasures of the Chionin monastery in Kyoto.[2] In the Chionin version, the speed of the descending Amida and attendants is marvelously depicted by a group of clouds supporting the figures.

AMIDA SHŌJŪ RAIGŌ-ZU
(Amida and His Heavenly Attendants Welcoming
the Departing Soul)

Kamakura period, 14th century; hanging scroll, ink, colors, and gold on silk;
H. 103.2 cm (40⅝ in.) W. 55.6 cm (21⅞ in.); B60 D34+,
The Avery Brundage Collection

A S ONE OF THE MAJOR themes of the Jōdo sect paintings, *raigō-zu*, the depiction of Amida welcoming the reborn to the Western Pure Land, holds an important place in late Heian and Kamakura period art. This theme, appearing as a depiction of the nine ranks of rebirth in the bottom border of the Taima mandala composition (see no. 43), inspired the earliest example of *raigō* painting in Japan.

A similar depiction appeared on the four walls of the special hall built for the practice of *jōgyō sammai*, a rigorous type of religious exercise. It consisted of constant chanting of a *nembutsu* (Buddhist invocation) for ninety days while walking and contemplating an image of Amida, a practice that induces a state of true concentration, or *sammai*. Formulated in China by the Tiendai sect, this practice was introduced into Japan by the priest Ennin (794–864; see no. 41). Later this exercise was gradually reduced to a ceremony involving only one week of chanting.[1]

Depiction of the *raigō* theme changed over time. Earlier Heian period compositions are symmetrical and frontal, with seated figures facing the viewer. Later Kamakura period examples have standing figures. Sometimes the scenes are drawn in three-quarter view, so that the descending group appears to be hurrying toward the departing souls rather than the viewer.[2]

The symmetrical compositions may be divided into three parts: a central group of Amida and the two attendants Kannon and Seishi, with two groups of bodhisattvas (*shōjū*) on either side. Such compositions are frequently made as three separate hanging scrolls; this example was once the right side of a set of three.

This portion of the *raigō* represents twelve of the twenty-five descending bodhisattvas including Jizō Bosatsu (Kitigarbha) in priestly attire and holding a staff. The bodhisattva in the uppermost part of the composition holds a long staff with an elaborate finial, perhaps of a type that would support a banner or a canopy. Other bodhisattvas hold (top to bottom) a bowl of flowers, a hand drum, beaters for a large drum, beaters for a *quei* (stone chime), a short vertical flute, a *koto* and a *biwa* (both string instruments), a horizontal flute, a *shō* (reed instrument), and a drum.

Use of *raigō* paintings in Buddhist life changed with time, becoming less theological and more popular. They were hung in rooms to help dying persons face death and to aid in their meditation on Amida. Sometimes the dying person held five colored threads attached to the hand of the Amida figure in the painting as an assuring guide into the Western Pure Land.[3]

The priest Genshin (942–1017), who was closely associated with the development of *raigō* imagery, may have actually made some *raigō* paintings. When Taira no Koremochi, an ardent follower, summoned Genshin to his deathbed, the priest gave the dying man a *raigō* scroll painting, which served as an object of contemplation while the *nembutsu* was chanted.[4] But Genshin was most influential through his essay *Ōjō yōshū* (Essentials of Rebirth), a powerful source of inspiration to artists and Jōdo followers.

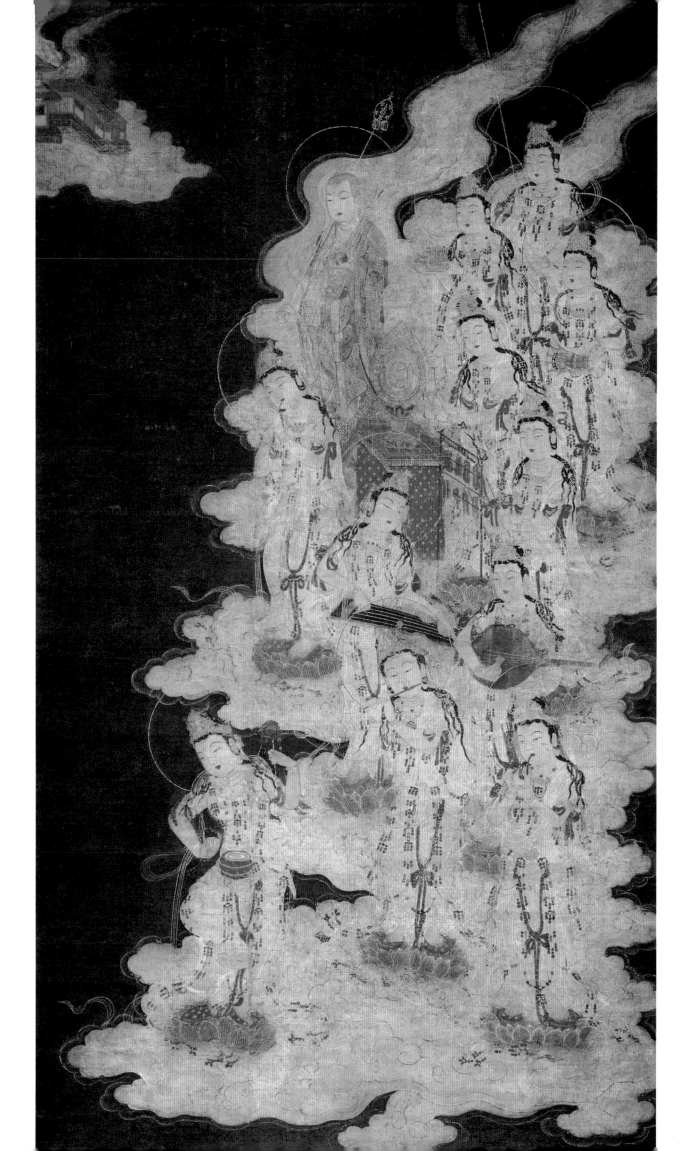

Detail

47
ZUZŌSHŌ
(Selections of Iconographical Drawings)

Kamakura period, 14th century; handscroll, ink and colors on paper;
H. 33.7 cm (13¼ in.) L. 1093.5 cm (430½ in.); B64 D5,
The Avery Brundage Collection

As EARLY AS the Nara period (645–794) an enormous number of Esoteric Buddhist deities were introduced into Japan from China. By the middle of the Heian period, around A.D. 1000, the staggering complexity of their identities, provenances, and symbols prompted Emperor Toba (1103–1156) to order a study of the iconography of the different Esoteric schools to produce a systematic collection of drawings and texts on the different deities. As a result, around 1140 the priests Yōgen and Ejū completed studies that were documented in a ten-scroll set, the Zuzōshō (Selections of Iconographical Drawings).[1] The first of a series of such attempts,[2] the Zuzōshō contained two volumes each on the various Buddhas, bodhisattvas, Kannon, and Tenbu (or devas), and one volume each on the sutras and the angry deities. The original texts are lost, but two versions of the older copies are extant in the Entsūji temple on Mount Kōya and the Jōrakuji temple in Kyoto.[3] Numerous copies have been made from them, since such iconographical studies were one of the important religious exercises required of priests.

Esoteric Buddhism taught that what the written word could not convey could be communicated visually.

This is not surprising in view of the abstract and arcane texts of the various sects. The result was a rich collection of images and mandalas. The line drawing of images in these scrolls represents a skill handed down from teacher to student and learned through copying. Usually the *zuzō* illustrations are drawn freehand. Some have color—light red, orange, brown, yellow, green, and blue. Esoteric Buddhist paintings are characterized by an absence of landscape background and visual depth. As objects of worship and ritual, the deities were represented away from their narrative contexts, appearing rather as absolute concepts and pure manifestations of the inner universe of Dainichi, the central deity of Esoteric Buddhism. In Japan such drawings came also to be appreciated as artistic expressions, influencing later artists in both religious and secular paintings.

In the scroll, the text for each deity identifies his Sanskrit name, secret name, symbolic Sanskrit character, attributes (the instruments with which he performs his role), posture, mudra, and mantra, and is accompanied by an illustration. The section illustrated here discusses the Thousand-armed Kannon, one of the most widely worshiped deities throughout Japanese history.

The first of the Kannon volumes presents his various forms, such as Nyoirin Kannon (see no. 30) and Shō Kannon (see no. 33).

48

MEMYŌ BOSATSU (Asavaghosa)

Nambokuchō to Muromachi period, 14th–15th century; hanging scroll, ink
and colors on paper; H. 29.8 cm (11¾ in.) W. 62.4 cm (24⅝ in.); B64 D1,
The Avery Brundage Collection

THIS IS A FRAGMENT of the fifth volume of the *Zuzōshō* iconographic handscroll (see no. 47) which has been mounted as a hanging scroll. In this section an illustration of Memyō Bosatsu, protector of sericulture (silkworm raising), is preceded by the last part of the text concerning this deity.

The origin of Memyō Bosatsu can be traced back to Chinese mythology. The deity was later adopted by Buddhism and gained popularity as sericulture spread in Japan. The six-armed deity holds a scale in one hand as he sits on a lotus pedestal placed on a white horse. Other hands hold a silk thread, silk reeler, and the sacred flame. Memyō Bosatsu is accompanied by a groom and a group of attendants, all identified with names related to sericulture. Facing the deity on the left is a praying man in the garb of a Chinese official. They all stand on a cloud that trails behind the group and partially frames Memyō.

In the Daigoji temple in Kyoto, founded in the second half of the ninth century, there remains a nearly identical drawing of Memyō Bosatsu. This temple became one of the great centers of iconographical studies around the eleventh century. The Daigoji version of Memyō Bosatsu shows somewhat greater care and accuracy in rendering than this one;[1] the horse, for instance, has more shading indicating its markings and more modeling. These circumstances imply that the Daigoji image may have been earlier than this one, which was drawn on lined paper, suggesting that it is likely a less formal copy.

SECULAR PAINTING
AND CALLIGRAPHY

49

JINNŌJI *ENGI*
(Legends of the Founding of Jinnōji Temple)

Late Kamakura period, mid 14th century; hanging scroll, ink, colors, and gold on paper;
H. 33.7 cm (13¼ in.) W. 54.9 cm (21⅝ in.); B66 D3, The Avery Brundage Collection

NARRATIVE PAINTINGS on *emaki*, long horizontal scrolls usually accompanied by a text, developed into an important Japanese art form. They may illustrate fictional or historical narratives; the latter often record the founding of temples or the lives of important priests.

This painting, now mounted as a hanging scroll, was originally part of a long narrative scroll. Many of its sections, none with proper text but seemingly from the same scroll, entered museums and private collections in the United States shortly after World War II, the probable time of the scroll's unfortunate dispersion.[1]

Through Terukazu Akiyama's research and publication,[2] the legend depicted on this scroll is now known. Akiyama was guided to a small temple called Jinnōji, near Osaka. There he located two scrolls, later copies of the original pair which had been taken from the temple, divided, and eventually dispersed. His reconstruction of some twenty-one segments is based on the two copy-scrolls as guides.

The copy-scrolls kept at Jinnōji fortunately also include the narrative texts, which were cut from the original scrolls and subsequently lost. The text of the first scroll narrates the founding legends of this temple, and that of the second, its reconstruction.

The first Jinnōji scroll relates how, in the seventh century, the famous monk En no Gyōja (643–?) met a local deity in Izumi Province, who asked him to build a temple there. Gyōja then traveled to Korea and met the Korean deity Hōshō Gongen, who agreed to return to Japan with him. With the help of Emperor Temmu, Gyōja built a temple but was then forced into exile, and in less than a century the temple was nearly deserted.

The second scroll deals with reconstruction of the temple by a Korean monk who came from Paekche and became known as Kōnin in Japan.[3] This segment, from the beginning of the second scroll, depicts Kōnin's search for the holy site and his eventual meeting with a green bull. From right to left, it shows Kōnin being led by this bull to the dilapidated temple. After meditating in the mountain shrine near a waterfall, Kōnin had a vision of Hōshō Gongen, who urged him to rebuild.

The priest Kōnin appears here four times in different places as the story unfolds. Each time he is identified (as are Hōshō Gongen and various landmarks) by a small blue cartouche. The device of repeating central figures is important for assuring continuity in a story conveyed in a long, horizontal format. Here, moving from one figure to the next through a continuous landscape, we literally follow the priest's footsteps.

Their style, with strong yet delicate brushstrokes, especially in the mountains and figures, and the sensitive coloring indicate that the original scrolls were produced toward the middle of the fourteenth century. Their fine condition is likely due to the remoteness of the temple, where they survived without much public attention. This particular section is notable for its excellent state of preservation and exceptional richness.[4]

50

THE POETS ISE AND FUJIWARA KIYOSUKE NO ASON from *JIDAI FUDŌ UTAAWASE*

(Competition between Poets from Different Periods)

Nambokuchō period, second half 14th century; hanging scroll, ink on paper;
H. 31.4 cm (12³⁄₈ in.) W. 61.5 cm (21¹⁄₄ in.); B62 D1,
The Avery Brundage Collection

WAKA POEMS combined with portraits of poets (both men and women) are known as *kasen-e* (pictures of Immortal Poets). The tradition of painting poets' portraits may have originated in the eighth century, when the image of Kakinomoto no Hitomaro was displayed as a deified poet during poetry competition gatherings.[1]

The earliest extant works of *kasen-e* date from the thirteenth century; even earlier prototypes may have been lost. Those works depict the Thirty-six Immortal Poets, a group of both ancient and modern master poets chosen by Fujiwara no Kintō (966–1041). Painted in the *nise-e* style (naturalistic portraiture), the poets appear seated, wearing richly decorated thirteenth-century costumes, though some of them in fact lived in much earlier periods. Many such paintings were produced in the ensuing several hundred years; a distinctive revival movement arose during the early Edo period.

Another famous group of one hundred poets from different times was titled *Jidai Fudō Utaawase* (Competition between Poets from Different Periods). It was the retired emperor Go-Toba (1180–1239) who, forced to spend nearly twenty years in exile on a remote island, sought comfort in compiling this imaginary poetry contest. Selected as competitors were fifty poets from the eighth to tenth centuries and another fifty from the eleventh to twelfth centuries. Many versions of this *utaawase* were painted during the Kamakura and Muromachi periods.[2]

This section of a handscroll (now mounted as a hanging scroll) shows two poets whose respective poems appear in the three decorated *shikishi*-shaped enclosures above them. (*Shikishi* is a nearly square writing paper, usually colored or patterned.) Ise is seated on the right, her face half-hidden behind her sleeve. Her competitor, Fujiwara Kiyosuke no Ason,[3] is seated on the left in a courtly garment. Their names appear on the outside margins.

Few of the once-numerous *Jidai Fudō Utaawase* scrolls have survived intact.[4] This scroll, known as the *Mokuhitsu Kasen* (Wooden Brush *kasen*), came to the Mōri family collection as early as 1726. The scroll was made of sheets of paper joined together, with two poets on each sheet; each panel could easily be separated and mounted as a hanging scroll. This very convenient format invited dispersion of this as well as many other *kasen-e* scrolls.

The *mokuhitsu* used here, a type of stiff brush, probably resembled a small spatula with a burnt, straight end. The widest part of each line indicates the width of the brush used. Many different-sized brushes may have been used to complete the portraits. *Mokuhitsu* created peculiar irregularities in the ink lines, revealing the white of the paper beneath them, an effect, called *hihaku* (flying white), also used in calligraphy. Very likely this technique appeared in *kasen-e* drawings of the Nambokuchō period as a much-needed novelty in a genre that, having reached its height in the Kamakura period, in its mannerism was now facing inevitable stagnation.[5]

51

TAMING THE OX
Sekkyakushi, fl. early 15th century

Muromachi period; hanging scroll, ink on paper; H. 47.8 cm (18 7/8 in.) W. 23.2 cm
(9 1/8 in.); B69 D46, Gift of Ney Wolfskill Fund

ZEN, A FORM OF BUDDHISM that regards meditation (*zazen*) and pondering of seemingly incoherent riddles (*kōan*) as the only ways to attain Buddhahood, was introduced to Japan from China in the twelfth century. Not until the middle of the thirteenth century did Zen became a major source of artistic inspiration. Following their Chinese Southern Song models and mentors, Zen priests by that time were practicing ink painting (*suibokuga*) as a spiritual exercise. This art form has remained to this day synonymous with Zen.

Initially Zen masters focused on figure painting, chiefly portraits of patriarchs of the sect and famous Zen priests as well as depictions of birds and flowers or animal subjects with immediate religious connotations. This painting belongs to the latter group.

One modern scholar states: "In Zen, the state of mind of one who has not seen the light is likened to the rampaging of a wild ox. The purpose of *zazen* is to tame the 'ox of the mind' by means of religious discipline and to bring it under control."[1] The ox is tamed in ten stages; this painting depicts the fourth stage.[2] In this composition an unkempt peasant boy is trying to mount the ox by stepping on its neck. Seizing the beast's horn, he uses all his strength to keep the head of the massive ox as near as possible to the ground. Strong diagonal movement toward the lower right corner is created by the slope of the hill and the position of the ox with its lowered head. To balance that movement, the bough of the tree above the ox extends in a series of swift brushstrokes toward the upper right. Forms are effectively delineated by using mixed stroke styles: those that are dry and deliberate in the hair of both boy and ox contrast with the wide, fluid brushstrokes in the tree limb.

Uninscribed and unsigned, the painting bears a seal reading *Sekkyakushi*, whose identity remained problematic until quite recently. The artist's assumed name Sekkyakushi (Red-legged Child) follows a peculiar Zen practice among Minchō school painters. They adopted names that referred to the leg or foot as an expression of humility; the famous Zen painter Minchō (1351–1431) himself used a name that meant "Torn Sandals."[3]

From the dates of a priest who inscribed another of Sekkyakushi's paintings, it appears that the artist was active during the end of the Ōei era (1394–1427) and was connected to the Tōfukuji temple of the Rinzai sect of Zen Buddhism.[4] It is now recognized that Sekkyakushi was not one of Minchō's alternate names (as once believed), but another excellent Zen priest-painter.

LI DABAI VIEWING THE WATERFALL
Sōami, 1485?–1525

Muromachi period; hanging scroll, ink on paper; H. 62.3 cm (24 1/2 in.) W. 35.1 cm
(13 7/8 in.); B62 D11, The Avery Brundage Collection

VIEWING OF WATERFALLS is a theme charged with Zen symbol-
ism (see also no. 51). It represents sudden enlightenment at the moment one
is lost in the fascination of the movement and sound of falling water.[1] This painting
depicts Li Dabai (701–762), a renowned poet of Tang China, gazing at the waterfall
at the foot of Mount Lu-Shan, one of four famous mountains in China. Behind the
cliff, a stream falls and cascades over tiered rocks into the lake on the lower right.
The boughs of an old twisted pine tree hang over the water below the mist that
separates the scenes from the distant peak. A young servant holds the master's
staff, indifferent to the poet's state of profound contemplation.

Zen followers considered the act of painting such themes to be a spiritual
exercise and a tool of meditation. The study of the essence of nature through its
various manifestations enabled the painter and the viewer to realize their own
essential inner nature and therefore Buddhahood.

The artist Sōami had charge of the Ashikaga shogun's art collection and
served as a cultural and artistic advisor. His hereditary and official title Ami was
derived from the Amida Buddha (the Buddha of the Western Pure Land), and the
very name was regarded as a profession of faith, especially for those of the Ji-shū,
or Timely sect. The shogun's collection included numerous Chinese paintings and
utensils for the tea ceremony, among them fine Song celadons and Jian (temmoku)
ware. Because of their position, the Ami had the rare privilege of studying Chinese
paintings firsthand.

Like his predecessors, Nōami and Geiami, who may have been directly
related to him, Sōami was skilled in Chinese-style landscape painting. He worked
in two distinctive styles. This example represents one in which he followed the so-
called Ma-Xia manner by using crisp, defining brushstrokes in a strongly struc-
tured composition.[2] (The other style, in the manner of Mu Qi, shows an extensive
use of misty effect and an almost total absence of incisive strokes.)

This painting is not signed but bears a vessel-shaped seal reading Kangaku,
Sōami's sobriquet, rather than his real name, Shinsō.

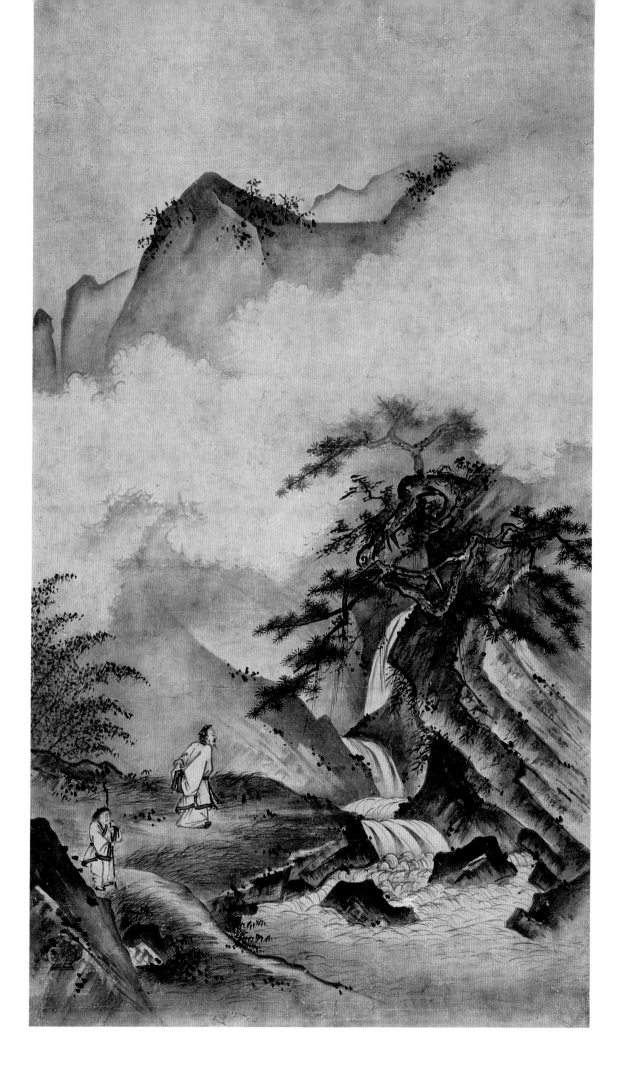

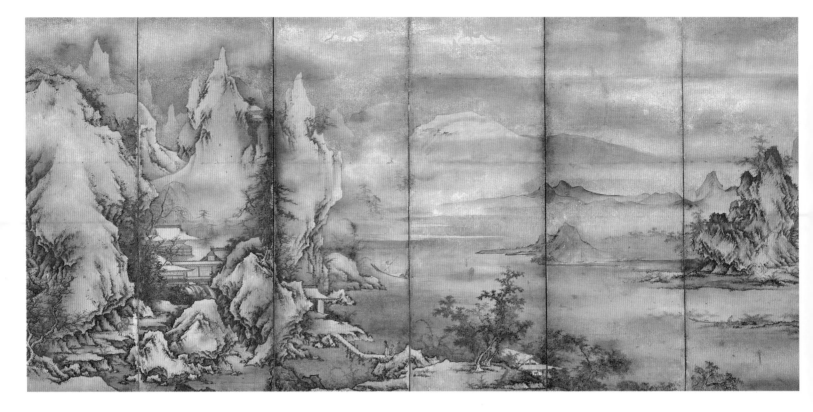

LANDSCAPE OF THE FOUR SEASONS
Shikibu Terutada, fl. mid 16th century

Muromachi period; pair of six-fold screens, ink, wash, and gold on paper; H. 153 cm
(60¼ in.) W. 324 cm (127⅝ in.) each; B60 D48+ (right), B60 D49+ (left),
The Avery Brundage Collection

XTENDING THROUGH THIS PAIR of screens from right to
left is a panoramic landscape with monumental rock formations, trees,
spreading lakes, a small village, waterfalls, and mists in a sequence showing the
subtle transitions of the four seasons. Palatial and humble buildings are tucked
under rugged cliffs, nearly hidden under the mist and foliage. Small human figures
appear, some distinguished, others quite ordinary, as they go about their tasks.

Details that define the seasons from scene to scene are so subtle that the
transition might pass unnoticed. The landscape in the first two panels on the right
has the bare branches of early spring. The thick foliage and people on the shore and
path amid a small village in the following scene reveal that it is now summer. A
solitary figure on the water and a subtle change of color in the trees introduce
autumn, before the towering cliffs and the rooftops white with snow complete the
cycle. The scenes seem to be strongly influenced by both Chinese style and techni-
cal execution.

Artistic representations of the changes in nature, either through the four
seasons or the more gradual progression of the twelve months, has been a major

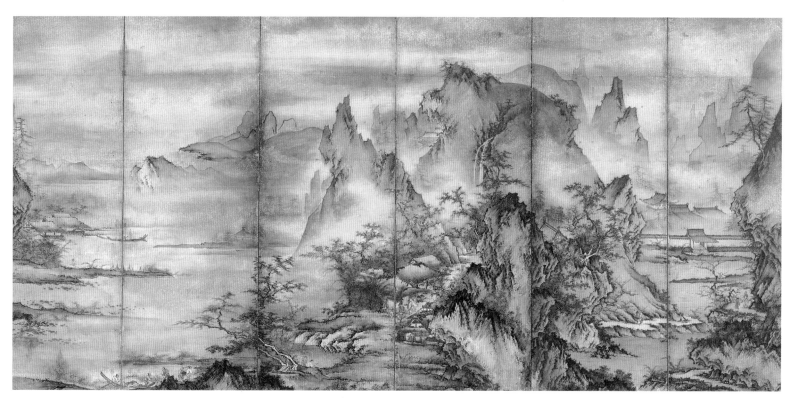

interest of Japanese artists, appearing in paintings as early as the Heian period and continuing throughout subsequent periods. The theme can appear in large continuous landscape compositions on screens, as here, or in twelve separate delicate compositions such as those in the Soken screens (no. 63), or even a set of twelve small, lacquered incense containers (no. 143).

These screens are considered to be the most monumental works executed by Shikibu Terutada. The artist did not sign them but impressed his two seals. The first double-line rectangular seal reads *Terutada*. The second, reserve-letter square seal reads *Shikibu*.[1] This artist's true identity used to puzzle researchers, but his activity in the mid-sixteenth century has been established by dating the Zen monks who inscribed Terutada's paintings. Details of his life, however, remain obscure.[2] Another recent study identifies other artists who may have had strong influence, if not personal contact, with Terutada, placing him as having been active in the Kamakura area in Kantō, or eastern Japan.[3]

Some thirty paintings of this artist survive, including three pairs of six-fold screens.[4] Among them are landscapes and figure and animal paintings, as well as bird and flower studies. Shikibu, who excelled in landscape, was meticulous in his rendering of rocks and trees, using short, precise strokes in the tradition of Ma Yuan and Xia Guei, famous Southern Song painters whose style was introduced into Japan by Shūbun (fl. 1414–1463).

Not part of the original composition, the gold in this pair of screens was added sometime shortly before it was shipped to the United States.[5]

54

BIRD WITH LONG TAIL FEATHERS

Kano Yōsetsu, act. third quarter 16th century

Muromachi period; hanging scroll, ink and colors on paper; H. 47 cm (18½ in.)
W. 44.3 cm (17⁷/₁₆ in.); B76 D6, Gift of Mr. and Mrs. Walter Shorenstein

REFLECTING AN ATTITUDE similar to that of the Chinese academic painters of the Song dynasty, the bird and flowers in this painting take meaning from their individual forms and colors, to be enjoyed for purely aesthetic reasons. Such a traditional composition does not include poetic inscriptions or additional semireligious tributes by admirers of the work. The way in which the subjects are presented and the intimate size of this painting suggest it was intended for viewing in a private, secular setting.

Yōsetsu is a little-known member of the Kano school. He was the adopted son of the famous Kano artist Motonobu (1476–1559), who was known for his large compositions of landscapes and his bird and flower paintings—themes usually associated with the Kano school. While Kano Yōsetsu also made large-scale paintings resembling his father's academic style,[1] this charming work of modest size is an excellent example of his artistic sensitivities.

Here a bird of Chinese origin with long tail feathers is perched on the end of a gnarled branch of a camellia tree. The graceful sinuous lines of the bird's neck, back, and tail dominate the well-balanced composition. This type of bird appears frequently in bird and flower paintings of the period. The bird is known in Japanese simply as *onaga* (long tail); its Chinese name, *shoudai* (ribbons), refers to the bird's tail feathers, which resemble the ribbons attached to an official seal or medal, a name that lends more significance to a pretty but otherwise rather ordinary bird.[2]

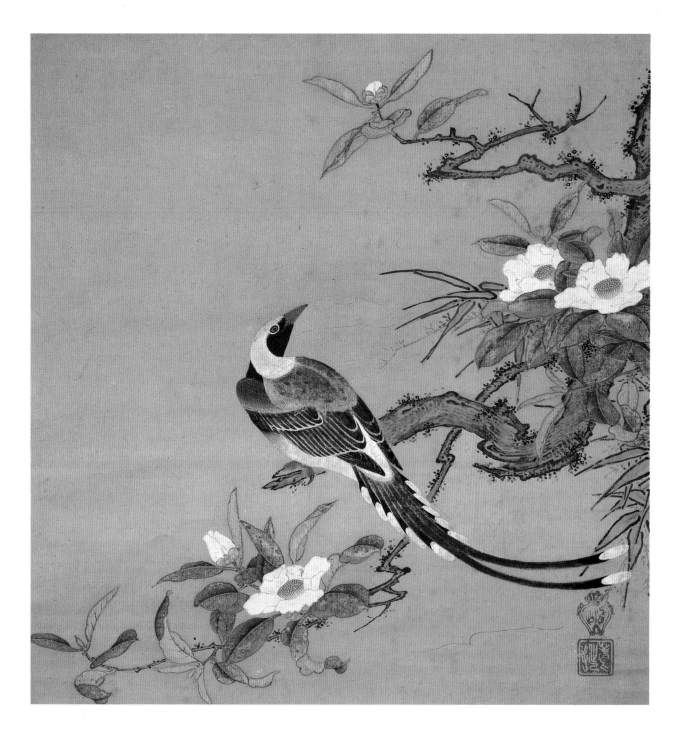

55
LANDSCAPE WITH FIGURES
Unkoku Tōgan, 1547–1618

Momoyama period; pair of six-fold screens, ink and wash on paper; H. 147 cm
(57⅞ in.) W. 358 cm (140¹⁵/₁₆ in.) each; B60 D74+ (right), B60 D73+ (left),
The Avery Brundage Collection

UNLIKE MOST MOMOYAMA period artists, who were attracted
to polychrome painting on a vast gold background, Unkoku Tōgan pre-
ferred to work primarily in ink. His original given name was Jihei; he was the
second son of the samurai family Hara, which was attached to the powerful Mōri
clan. After an initial introduction to Kano school techniques, he became inter-
ested in the celebrated fifteenth-century painter Sesshū. The Hara family followed
the Mōri clan, which was transferred from Hiroshima to Hagi when Jihei was in
his late fifties. In Hagi the clan head assigned Jihei the task of copying the clan
treasure, the so-called *Long Landscape Scroll* by Sesshū. Because of the excellent
manner in which he completed this task, Jihei was allowed to live in Unkoku-an,
Sesshū's old studio house, which happened to be in the vicinity. To commemorate
this honor, Jihei changed his last name to Unkoku, took one of the characters from
Sesshū's posthumous name (the *tō* from Tōyō), assumed the name Tōgan, and
claimed to be the third generation of the master. When his claim was challenged
by Hasegawa Tōhaku (1539–1610), a contemporaneous artist also known for his
ink painting, Tōgan won the dispute.[1]

Tōgan left several pairs of screens, mostly in ink painting. Very few of his works are signed, but many, including this pair, bear seals that read *Unkoku* and *Tōgan*. Two well-known Chinese figures in landscape settings are depicted on these screens. On the right, sitting in his studio, the poet Tao Yuanming (365–427) enjoys a drink while lost in the contemplation of his beloved chrysanthemums. On the left, Lin Hejing, the Song dynasty poet, and his boy servant look at their pet crane in full flight. Absent from these compositions are towering cliffs or palatial buildings. Instead, the figures and their modest dwellings are surrounded by more moderate natural settings consisting of soft, distant hills, shapely pine trees, and clumps of bamboo. The rocks are crisply delineated but by no means overwhelming in scale. The mellow intricacies in these figures and the landscape show a departure from the austerity and strength strongly reflected in other compositions by Sesshū.[2]

In his serious effort to perpetuate the accomplishments and style of Sesshū, Tōgan founded the Unkoku school, which included over fifty artists all carrying the character *tō* in their names.[3]

These screens were once in the imperial household and belonged to Dowager Empress Shōken, who gave them to Prince Fushimi before they were sent to the United States through another private hand.[4]

56

TARTARS PLAYING POLO AND HUNTING
Attributed to Kano Sōshū, d. 1601

Momoyama period, late 16th century; pair of six-fold screens, ink, colors, and gold on
paper; H. 165.1 cm (65 in.) W. 349.3 cm (137½ in.) each; B69 D18a (right), B69 D18b
(left), Gift of Asian Art Museum Foundation of San Francisco

L IKE THE CHINESE, the Japanese referred to the Tartars as
northern barbarians to distinguish them from Europeans (*namban*, or
southern barbarians). Although European foreigners were present in Japan in the
late 1500s, the northern nomadic peoples remained remote and strange to the
Japanese. Nevertheless, paintings depicting them were popular in Japan. More
than ten such screens, many in pairs, survive.

Two standard themes for these paired screens depict the northerners' favor-
ite pastimes: a hunt in a clearing at the foot of rugged mountains, and a vigorous
polo game. Both scenes are surrounded by spectators and groups of people
engaged in different activities. Stylized gold clouds, richly decorated with em-
bossed small cloud patterns, separate or enclose the vignettes, creating a setting
for the central subjects.

In the hunting composition, the hunters' energetic movements and the fran-
tic flight of their prey create a mass of energy with a dense depiction of people and
animals. In contrast, the surrounding hills and small vignettes are tranquil, con-
veying a sense of nature almost indifferent to the intense hunt. Within a curtained

area (upper right) an important-looking figure with attendants receives a messenger. Spectators on horseback (upper left) overlook the hunt from a cliff, while another group chases animals from the nearby hills. The people at the lower left are somewhat more animated as they reach the edge of the hunting field, anticipating the final kill.

The polo game is equally heated and is also surrounded by less animated observers. The family group in the curtained enclosure at the right shows a high-ranking man seated under a tent with attendants and a woman with two small children. Nearby, servants prepare food behind the curtained area. The scene may allude to the Chinese ballad *Wenji Guihan*: the Chinese princess Wen was abducted by a nomad chief, for whom she bore two children. But long after she learned to love her captor, she was rescued by the Chinese and again experienced the sorrow of parting.

Little information exists about Kano Sōshū except for an account comparing his bold style to that of Kano Eitoku (1543–1590), his famous brother.[1] When Eitoku was chosen to undertake the great project of decorating Azuchi Castle (near Kyoto) for Oda Nobunaga and was about to leave Edo, he chose his brother Sōshū as his successor to head the Edo studio. Eitoku must have held Sōshū's artistic talent in high esteem, as he even entrusted his son Mitsunobu to him as the boy's guardian and teacher.[2]

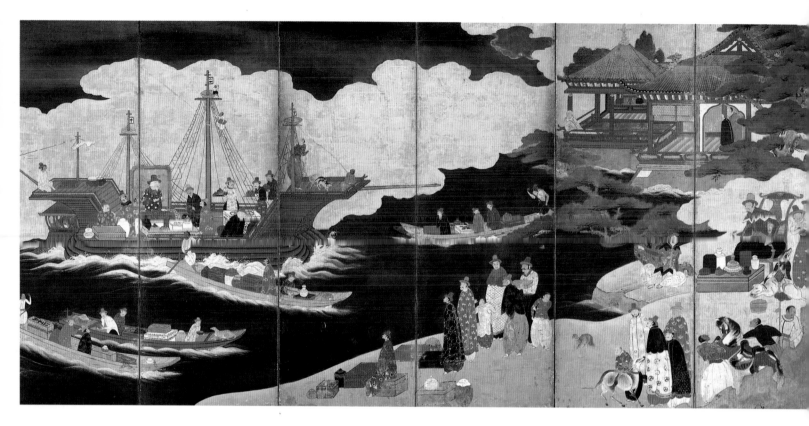

57

NAMBAN BYŌBU (Southern Barbarians screens)

Momoyama to Edo period, 16th–17th century; pair of six-fold screens, ink, colors, and
gold on paper; H. 147.6 cm (58 1/8 in.) W. 316.2 cm (124 1/2 in.) each; B60 D78+ (right),
B60 D77+ (left), The Avery Brundage Collection

THE CLASSICAL CHINESE TERM "southern barbarians"
(*namban* in Japanese) refers to foreign tribes living south of China. The Japanese came to use this word especially when speaking of the Portuguese, the first European foreign visitors to their country. In 1543, four Portuguese aboard a Chinese ship drifted onto Tanegashima Island. Five years later, the Jesuit missionary Saint Francis Xavier introduced Christianity into Japan. Eventually the establishment of commerce with the West introduced not only European goods but also exotic merchandise from other Asian countries. All these novel imports became a source of enchantment to influential samurai leaders such as Nobunaga and Hideyoshi. It is reported that Nobunaga was especially interested in European arts and learning and occasionally dressed in European clothes. Nagasaki and Sakai developed as ports for foreign trade; the resulting influence of Europe on Japanese arts and culture was inevitable.

These early visitors, their ships, and their activities provided inspiration for a group of screens, the *Namban byōbu*. Among genre themes, which included festivals and games, these most popular Namban screens survive in great numbers.[1]

Namban screens are grouped according to their basic composition.[2] The largest group, which includes these two, consists of pairs of which the left screen shows activities surrounding the foreign ship at its moorage, and the right depicts

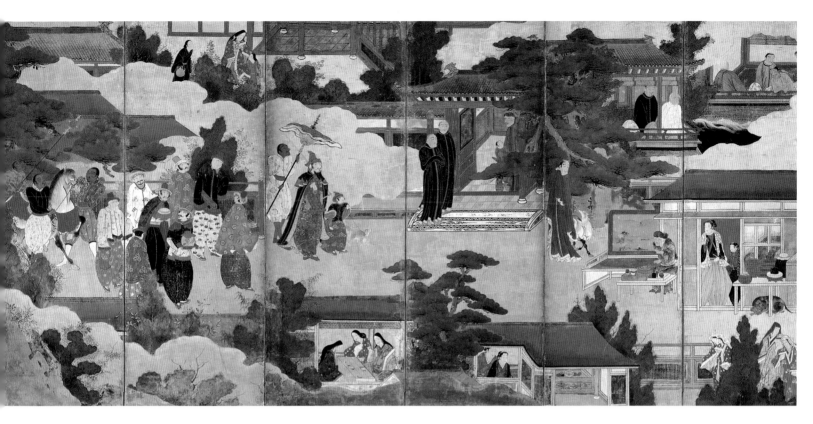

the captain and his company in procession through the city streets. In the left screen, a type of ship the Portuguese called a *nau* (carrack) is moored in a deep indigo sea against a gold cloud. Foreigners appear in the building at the upper right; a small group of people stand around unloaded cargo, while small boats continue to transfer goods to shore.

In the street scene, the captain, accompanied by a dark-skinned servant holding a parasol, leads a group of Portuguese who each carry exotic-looking goods. A large area of the screen (upper right) is covered with the structures of the Namban church complex. The priests in black are from the Society of Jesus, those in brown from the Order of Franciscans.[3]

Most Namban screens were painted in Kyoto or Osaka studios by skilled artists, of whom only a few would actually have witnessed these scenes in Nagasaki. The great demand for these screens found both Kano and Tosa artists turning them out, usually by carefully copying existing works. The copyists occasionally introduced slight variations and ran the risk of making mistakes. For instance, in this composition, the cross on the seaside building in the left screen identifies it as the Namban church, which was in fact located on a hill away from the coast. This is only one of the small landscape changes suggesting that the artist quite probably lacked firsthand knowledge of the city.

Early owners of these screens seem to have lived in the coastal area near prosperous ports. This pair, for instance, came from a certain Yoshino family in Toyama Prefecture on the Japan seacoast. The family may have been related to a prominent ship-owner family. Many screens of Namban themes appear to have come from this area.[4]

58

HAWK ON OAK

Soga Nichokuan, fl. mid 17th century

Edo period; hanging scroll, ink on paper; H. 119.8 cm (47¼ in.) W. 55.7 cm (?? in.);
B60 D18, The Avery Brundage Collection

RTISTS OF THE SOGA school, especially Nichokuan and his
father, Chokuan, are known for their paintings of birds of prey. Perched on
the branch of an oak tree, this large bird curls one leg beneath its body as its pierc-
ing eye and tense pose give the impression that it may be about to attack its prey.

The great accuracy with which they portrayed these birds suggests that,
unlike other contemporaneous painters of birds, Soga school artists worked
directly from nature. In fact this particular bird is rendered so faithfully that it can
easily be identified as a type of Japanese hawk-eagle (*Spizaetus nipalensis orientalis*).[1]

Hunting birds have always fascinated samurai. A famous portrait painting of
Takeda Shingen, now in the Jōkeiin temple in Wakayama Prefecture, shows him
with his sword and a hunting falcon.[2] An ancient courtly sport dating back at least
to the Kofun period (see no. 16),[3] falconing was revived by warriors of the Muro-
machi period and made for amusement and as a martial exercise. Like a stable of
fine horses, a collection of fine birds was a status symbol. Many artists of various
schools made paintings of such birds, including screens in which falcons are shown
individually in natural settings or resting on falconers' perches.[4]

Both Chokuan and Nichokuan lived in Sakai, a busy port city outside Osaka.
The little we know about Nichokuan indicates that he was closely associated with
the famous Zen painter Takuan (1573–1645), whom he may have met in Sakai.[5]
Although a well-established painter, Nichokuan nonetheless tried to forge genea-
logical ties with old masters such as Shūbun and Dasoku.[6] Such a practice may
have been common at a time when artists of considerable skill but without impres-
sive family ties attempted to establish links to prestigious forerunners.

This unsigned painting bears three seals, reading from top, *Soga*, *Nichokuan*,
and *In*.[7]

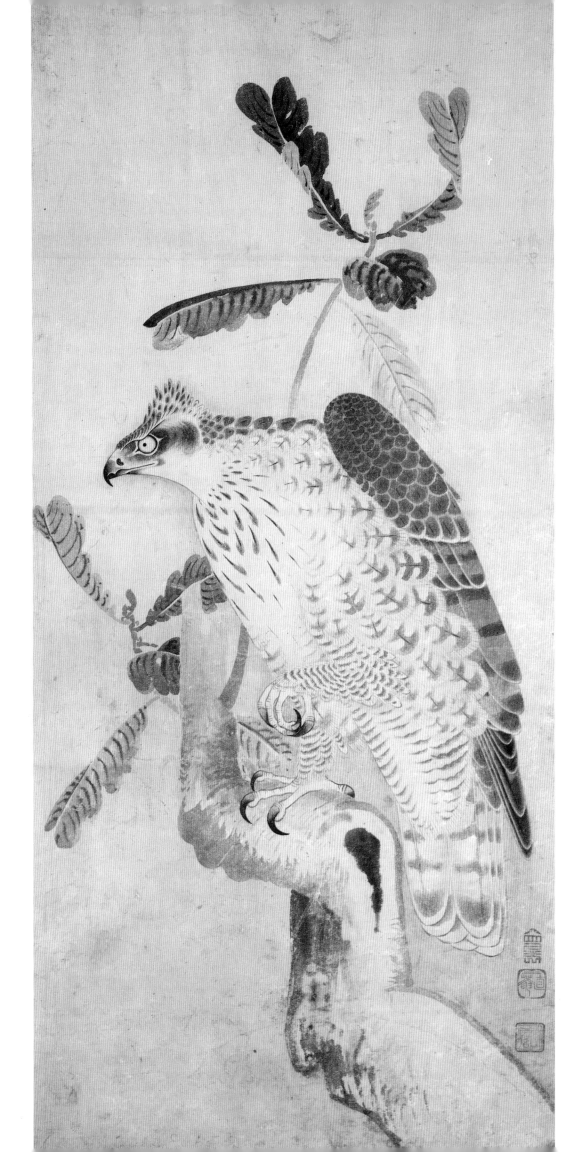

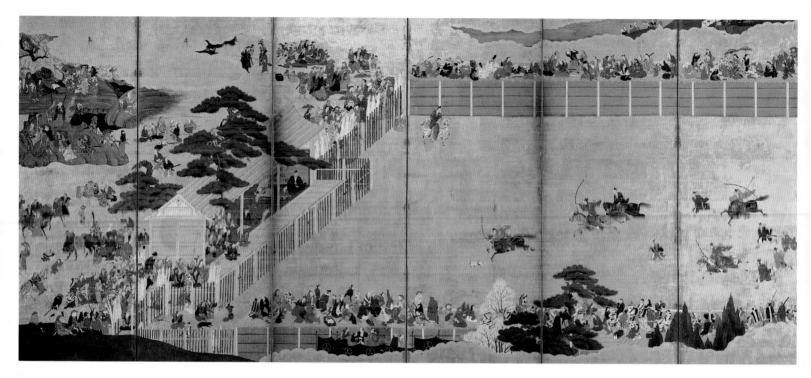

59

INUOUMONO (dog chasers)

Early Edo period, 17th century; ink, colors, and gold on paper; H. 156.2 cm (61¹⁄₂ in.)
W. 365.7 cm (144 in.) each; B60 D2 (right), B60 D1 (left),
The Avery Brundage Collection

INUOUMONO (DOG CHASERS) was one of three archery drills popular during the Edo period.[1] Originally an exercise to improve martial arts of the samurai, *inuoumono* and the two other drills required great equestrian and archery skill. Over the years they became highly organized, almost ceremonial events attracting large numbers of spectators.

According to the Edo period historian Ise Teijō, *inuoumono* was first mentioned in a historical account dated 1222.[2] Its codification as a game with a set of rules must have been completed during the Muromachi period. Manuals from the years 1342 and 1416 stipulate the size of the field and the number of dogs and participating archers for each game.

From the close of the Muromachi through the Momoyama period, this practice declined as the samurai were drawn from games into the civil wars of the time. When peace returned and the Edo shogunate restored traditional festivals, the Shimazu clan of Satsuma Province organized an *inuoumono* event in 1646.[3] The popularity of the game quickly revived, and it soon began to attract crowds of townspeople who regarded it as lively entertainment.

The painters of Momoyama period screens of this subject focused their interests on the game itself.[4] Later artists, as here, paid much more attention to depicting the spectators' activities.

The right-hand screen typically represents an early stage of the game. Around the circle formed by a heavy rope laid on the ground, archers wait for the dog to be released. (Described in early manuals but missing here is a smaller, inner circle of the same heavy rope.) Two additional groups of seventeen archers each are lined up along the fence on either side of the field. The rules of the game provide that when the dog passes over the rope it may be shot with heavily padded arrows, only in the torso, with hits on the head or limbs counting as errors with penalty points. If the dog escapes without being hit, the archers may pursue it into the outer field, as shown in the left-hand screen.

The recorder's booth on the left end of the field holds officials, a priest, a group of samurai in uniform, and messenger boys. The viewers' stands on three sides of the field are filled with spectators from all walks of life — samurai, housewives, children, monks, Shinto priests, nuns, doctors. Some are already enjoying their

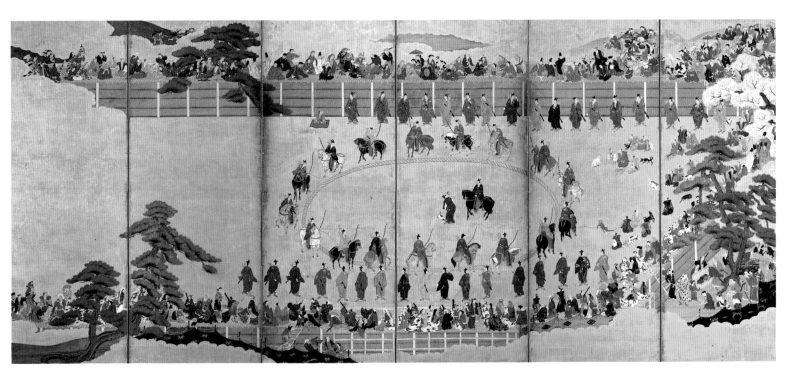

food as they watch the chase. Others are just unloading their lacquer picnic boxes (see no. 139), which have been brought in larger wooden containers.

Other spectators are standing behind the fence. Far beyond the field, on the hills on both ends of the screens, groups of people watch from a distance or simply go about their tasks. Priests and servants relax, while for the tea vendors and hairdressers it is business as usual. More than a pictorial documentation of an ancient military game, these screens show us a lively section of Edo society at play.

Having a similar composition emphasizing the viewers, a pair of *inuoumono* screens in the Honolulu Academy of Art[5] closely resembles this pair; another pair in the Nezu Art Museum in Tokyo[6] shows the referee on horseback carrying a bow and arrow, a mistake often made by uninformed painters.

Detail

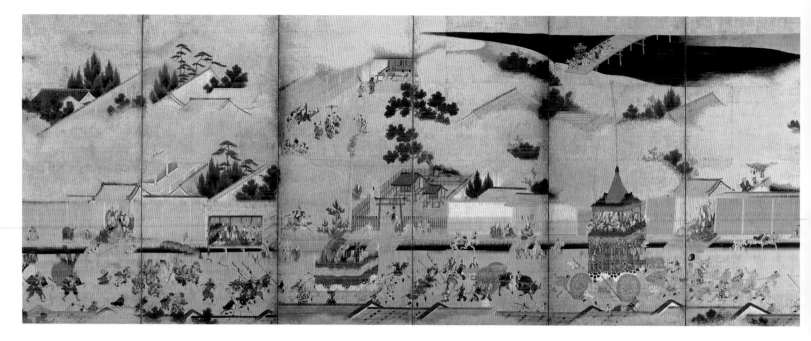

60
GION FESTIVAL

Early Edo period, late 17th century; pair of six-fold screens, ink, colors, and gold on
paper; H. 138.7 cm (54⅝ in.) W. 360.6 cm (142 in.) each; B60 D45+ (right), B60 D9
(left), The Avery Brundage Collection

THIS PAIR OF SCREENS depicts a scene from the Gion festival which takes place at the Yasaka shrine in Kyoto's Gion district. Under the old lunar calendar, the festival was held from June 7 to 14 (now July 17 to 26) every year.[1] It is believed that this festival originated in 869, when people sought to rid the city of an epidemic through a ritual that included a procession of tall halberds erected on floats. It was not until 970, however, that the Gion festival became an annual event. These celebrations were interrupted by insurrections during the Onin and Bunmei eras, but were resumed by popular demand in the ninth year of the Meio era (1500).[2]

The enthusiasm of the townspeople sustained the Gion festival through the centuries. The procession, which attracts thousands of spectators each year, makes it one of the most important festivals in Japan. At its peak, as many as fifty-eight floats took part in a procession through the Gion district.[3]

As a focus of energy and imagination, the procession of these floats became a natural subject for screen artists, who painted the excitement in the capital city with great detail and accuracy in screens called *Rakuchū rakugai* (literally, in and out of Kyoto). These screens first appeared in the late Muromachi period.[4] Both Tosa

and Kano artists produced them, and the festival is also represented in the group of thematic paintings known as Festivals and Customs of the Twelve Months of the Year (*Jūnikagetsu tsukinamie*). The traditional compositional arrangement of the Gion festival in the early screens divided the representation into two parts: the procession of the floats, and the return of the *kami* (Shinto spirits) on *mikoshi* (portable shrines) from their temporary abodes to the Gion shrine.

The procession of the floats is the chief subject of these two screens; each is divided into two levels, with the main theme in the lower level. In the upper register, beyond the areas covered with gold clouds, are roofs of buildings and a cityscape, which includes a shrine compound complete with priests and visitors. The water stretching across three right-hand panels of the left screen might be the Kamo River. On the bridge is a *mikoshi*, once a dominant feature, here seen at a distance.

In the procession, the prescribed *naginata-hoko* (float with a halberd) leads the way, followed by three other floats and the traditional umbrella. Interspersed are ox carts carrying long, flat boards which, if necessary, could be laid in the unpaved streets to allow the floats to negotiate particularly difficult turns.

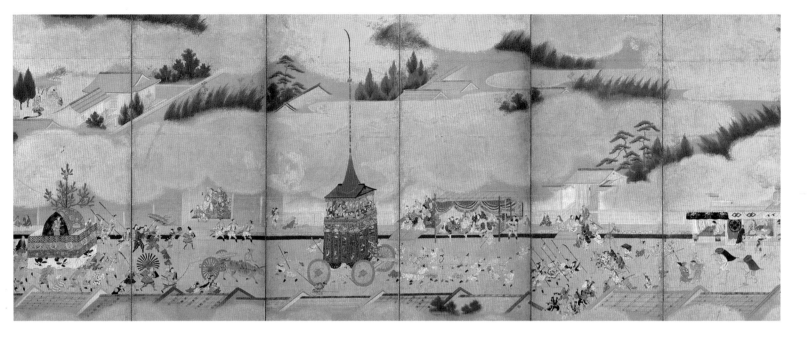

Spectators appear in outstanding detail. At the roadside, platforms provide a better view of the parade. Some of the residents are seated at an entryway that appears to lead to a complex of samurai-class residences. Their social status is apparent from their garments, especially those of the women, who wear *katsugi* (protective kimono) to keep the sun and dust away. In depicting different facial features and individualized patterns in garments, even in such figures as the casual melon vendor on the roadside, technical delicacy here shows considerable artistic quality, suggesting that this artist, though anonymous, belonged to a fine atelier of the early Edo period.

Shops lining the street can be seen on the first panel of the right screen. A bow maker and a fan maker can be easily identified. In this pair of screens, the artist has shown a large number of people carrying fans. Even with their small scale, many of them are minutely decorated in different styles, so much so that it is tempting to speculate that the artist may have had some special background and interest in fan painting.

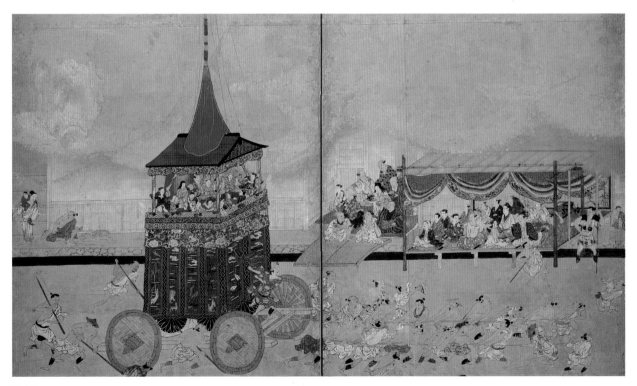

Detail

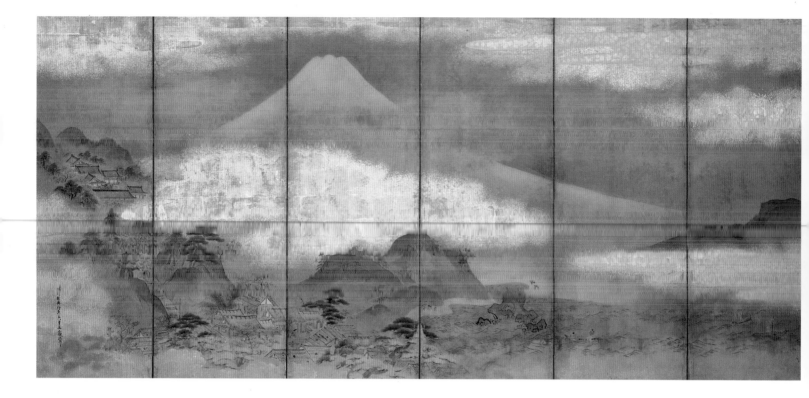

61

MOUNT FUJI AND SEASHORE AT
MIHO NO MATSUBARA

Kano Tanyū, 1602–1674

Edo period, dated to 1666; pair of six-fold screens, ink, colors, and gold on paper; H.
166.2 cm (65^{7}/$_{16}$ in.) W. 366.4 cm (144^{1}/$_{4}$ in.) each; B63 D7b (right), B63 D7a (left),
The Avery Brundage Collection

ANYŪ WAS ONE OF the most versatile and prolific Kano masters.
His command of a variety of styles and themes has continued to impress
artists and historians to the present day. Because of his fame, many painters imitated his style, producing works that became confused with his own paintings. But
Tanyū's reputation has survived this confusion, and his greatness as an artist and a
clan leader is now firmly established.[1]

The grandson of the famous painter Eitoku (1543–1590), Tanyū attracted
attention as a child prodigy. At sixteen he was already an official painter in the
shogun's court. When the shogun Hidetada's daughter became an imperial consort, Tanyū was in the group of top Kano artists who were commissioned to decorate her living quarters in the imperial palace. Between the demands of the
shogunate and the imperial court, Tanyū was expected to master the Chinese style
as well as *yamato-e* (Japanese-style painting) themes and their techniques.

Tanyū let his younger brother assume direction of the main branch of the
Kano family in Kyoto, while he continued to live and work as an official painter of
the shogun's court in Edo. Eventually he was given a large plot of land to use to
establish his own branch of the Kano school. That school came to be called
Kajibashi Kano, after a bridge located near his compound. Under Tanyū's leadership, the new school gained political and artistic power in Edo, and in time the

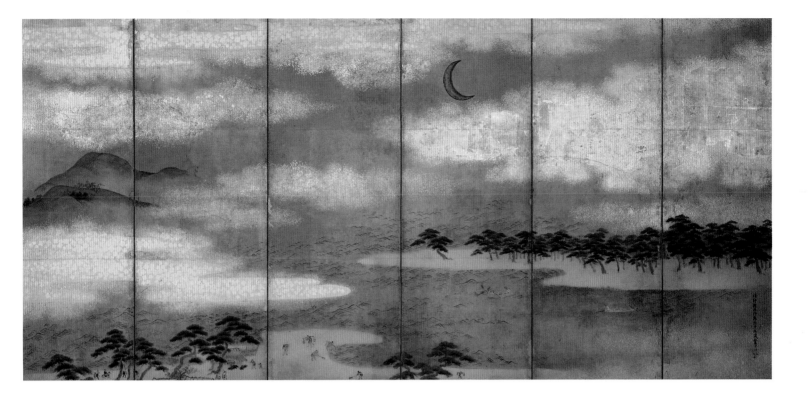

older main branch moved from Kyoto to Edo. Tanyū became the virtual leader of the entire school. He played such a prominent role that his responsibilities came to include the task of decorating the entire imperial palace, even to the very walls behind the throne.[2]

When he reached middle age, Tanyū became interested in Japanizing traditional Chinese themes to suit his countrymen. He also introduced the triptych format, which was eminently suitable for large samurai residences. He was famous for his numerous miniature renderings of old masters' works, which he kept as records to refer to whenever he was requested to authenticate such works; he produced enough to fill seven large storage chests.[3] As well as learning from the old masters, he regarded sketching from nature as an important training exercise. These sketches, showing acute powers of observation, are usually dated and contain notes concerning their origin.

This pair of screens, painted when he was sixty-five, depicts a famous subject, Mount Fuji and the shore at Miho, each occupying one screen as a central subject. On the Fuji screen, below the mountain in the middle ground, one can see the partly hidden buildings of the Kiyomidera temple. At the foot of the hill is the Kiyomigaseki, one of the travelers' checkpoints that survived from the Heian period, although it was not in use in Tanyū's time.

In depicting the pine forest at Miho, one of the famous scenic spots of Japan, Tanyū painted one lonely pine at the tip of the shore. This peculiarity is found in an earlier rendering of the shore of Miho by an anonymous artist; Tanyū faithfully followed this feature.[4] A depiction of everyday activities — the village scene on the left, and brine gathering on the right — conveys the kind of intimacy usually associated with genre paintings. This is a vivid illustration of Tanyū's Japanizing tendencies in both theme and style.

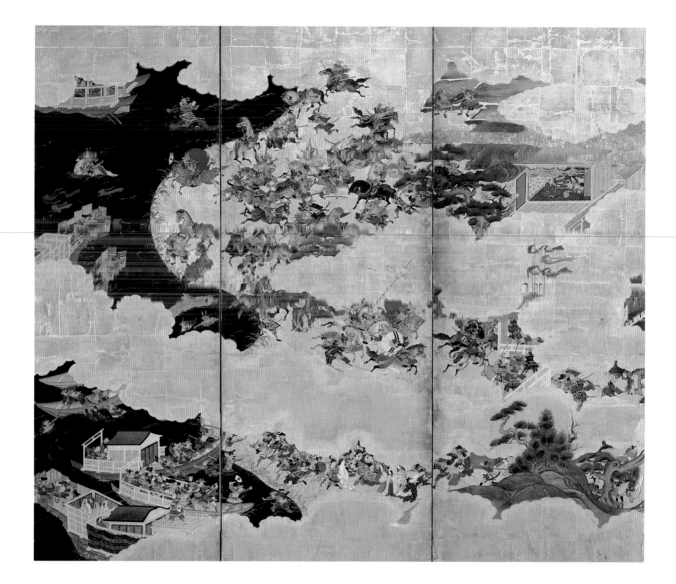

62
TALE OF THE HEIKE

Early Edo period, 17th century; six-fold screen, ink, colors, and gold on paper;
H. 152.5 cm (60 1/16 in.) W. 354.3 cm (139 1/2 in.); B80 D2,
The Avery Brundage Collection

THE *TALE OF THE HEIKE*, which re-
counts events from the twelfth and thirteenth
centuries, continued to capture the imagination of
Japanese artists for many centuries thereafter. Deeply
rooted in Buddhist philosophy, and at the same time
extolling the heroic and romantic aspects of war, this
saga follows the rise and fall of the Heike (Taira clan)
and its conflicts with the Genji (Minamoto clan).

Originally the story was narrated by traveling
blind *biwa* players and was compiled in a three-volume
literary work as early as 1221. By the fifteenth century,
there were different versions of the story, consisting of
six, twelve, and twenty volumes, of which the twelve-
volume version seems to have been the most popular.[1]

Ordinarily, historical events of medieval times
were first painted on handscrolls and then on screens,
but the *Tale of the Heike* may be an exception, as no
Kamakura or Muromachi period handscroll versions of
it are known.

The Heike screens fall into two categories. The
first group, to which this example belongs, depicts
scenes from a battle at Ichinotani (near present-day
Kobe) and a naval engagement at Yashima, at the north-
ern end of Shikoku Island. The second group depicts
incidents from various other parts of the tale.[2]

Screens of the first group from the sixteenth cen-
tury, and therefore the earlier examples of the type,
focus on famous combats between prominent indi-

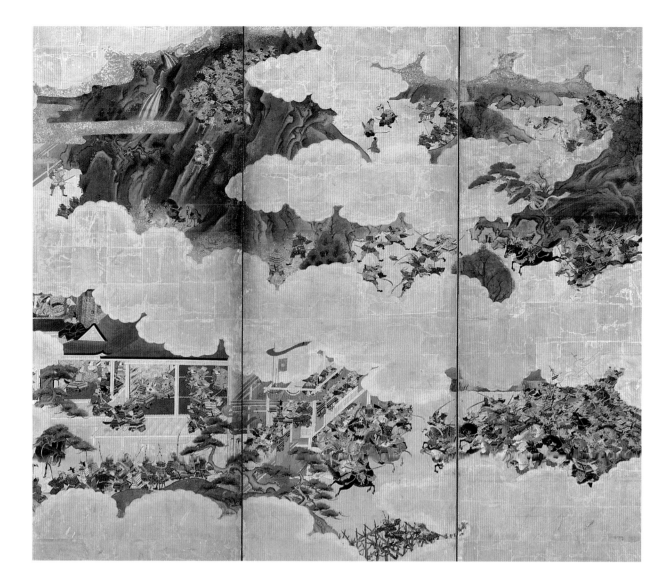

vidual samurai, whose names were sometimes written on small pieces of paper and attached to the screens to identify them.[3] Such depictions focus on details of the armor and action rather than on general decorative effects.

Conversely, most of the Edo period screens, including this one, are more decorative. They show a shift of interest from a faithful representation of the incidents in the story to the creation of a larger, more exciting battle scene, where a mass of anonymous soldiers and charging horses are partially covered with decorative gold clouds.

Yet depiction of the Ichinotani and Yashima episodes persisted, even in this context, because they continued to offer ideal settings: the former a steep hillside, the latter the sea. In this screen, buildings and human figures are laid against the indigo sea and malachite hills. The colorful armor and horse trappings are like

flowers studding the green cliff. Seen through the parted clouds (upper center) is the famous descent of the cliff at Hiyodorigoe by the Genji cavalry about to attack the defenseless rear of the Heike camp. On the left panel, the same colorful samurai appear against the indigo sea, again seen through gold clouds.

The tragic death of Atsumori, a young samurai, took place on this shore.[4] Here, on the extreme left panel, is depicted the moment when Atsumori, fleeing on horseback, turned to meet the challenge and certain death, in order that he not be labeled a coward.

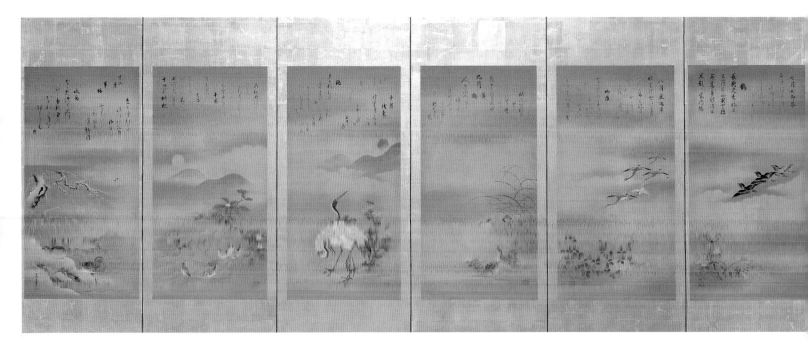

FLOWERS AND BIRDS OF THE TWELVE MONTHS
Yamamoto Soken, act. 1683–1706

Edo period, late 17th–early 18th century; pair of six-fold screens, ink and colors on silk;
H. 113 cm (44½ in.) W. 44 cm (17⅜ in.) each; B60 D82＋a (right), B60 D82＋b (left),
The Avery Brundage Collection

THIS SET OF SCREEN paintings exemplifies a format known as *waka-e* or *uta-e* (literally, poetry painting), in which poetry, calligraphy, and painting closely intermingle to form an indivisible whole.

The set consists of faithful representations of twenty-four *waka* poems composed by Fujiwara Teika (1167–1241), twelve each on plants and birds that were closely associated with each month of the year. In this set, and in many others produced during the Edo period (often as gifts), each composition is completed with the plant, bird, and two *waka* poems of the specific month.[1] The poems may be directly inscribed in the paintings, as here, or on separate sheets of *shikishi* paper pasted on the appropriate areas of a continuous landscape, within which the twelve themes are skillfully arranged.[2]

Following the usual manner of production of such *yamato-e* paintings, this set was probably commissioned by a courtier and painted by one painter, then inscribed by several calligrapher-courtiers. Part of the calligraphy in this set is attributed to Konoe Iehiro (1667–1736), a noted artist and a successful Edo period statesman.[3]

The painter Yamamoto Soken, the teacher of Kōrin (see no. 67), was trained in both the Kano and Tosa styles and succeeded in mixing them in an appropriate context. Here, for instance, the trunk of the cherry tree of the second month is done in characteristically strong Kano brushstrokes to suggest the roughness of cherry bark, while the bush-clover stems of the eighth month are done in graceful lines typical of the Tosa school.

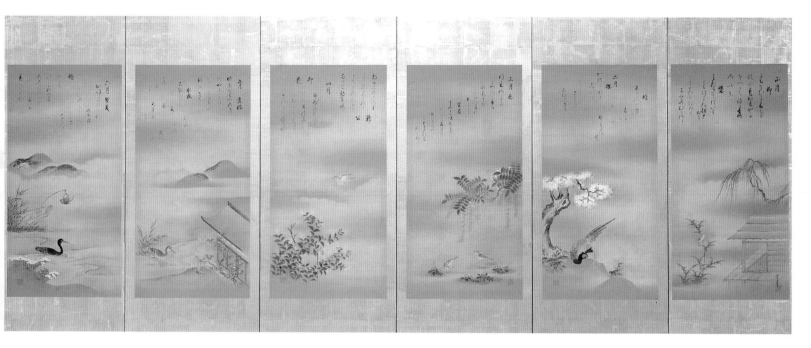

The inscription on each panel gives the month and the names of the specific flower and bird for that month, as well as the two *waka* poems. The second month, for example, shows a pheasant and a blossoming cherry tree. The poems, written in grass script, may be translated as follows:

CHERRY BLOSSOM
The February sky of cherry blossoms,
Fragrant reflections
On the sleeves of passers-by,
Sprigs in their hair.

PHEASANT
A springtime hunter,
His trail in the mist.
The cry of a pheasant
Calling his mate.

The eighth month has a flock of geese flying over a cluster of blooming *hagi* (bush clover):

HAGI
Autumn deepens
With the winds of many colors.
Soon the sparse hagi
Will change their coats.

GEESE
Half of autumn has passed,
Watching and waiting for
The first flock of geese;
Their sharp cries.

The calligraphic inscriptions show an interesting variety in which *manyōgana* (Chinese characters used as phonetic symbols) scripts are used for the seventh month, and *chirashigaki* (scattered writing) style for the fifth and tenth months.

The first and the last panels bear Soken's seal and signature with the title *Hokkyō*. The other panels have only one seal each, which also includes his title.

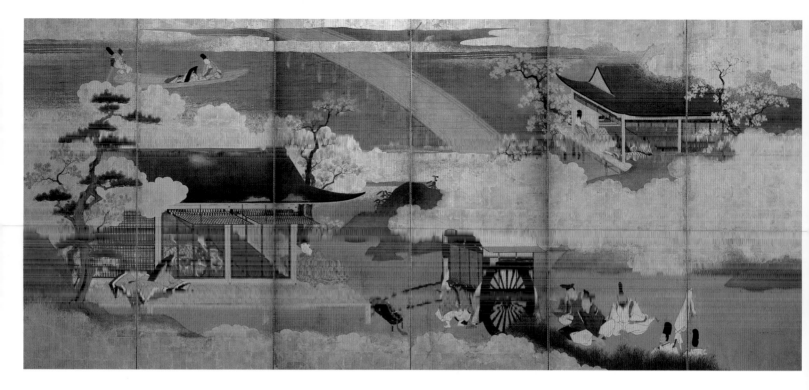

64
TALE OF GENJI

Edo period, late 17th century; pair of six-fold screens, ink, colors, and gold on paper;
H. 153.5 cm (60⁷/₁₆ in.) W. 350 cm (137³/₄ in.) each; B60 D47+ (right), B60 D46+ (left),
The Avery Brundage Collection

SINCE IT FIRST APPEARED, the *Tale of Genji*, the most famous romanic novel of Japan, has been a major source of inspiration for Japanese painters. The author, a Heian period (tenth to eleventh century) court lady, was allegedly a daughter of Fujiwara no Tametoki. Her traditional name, Murasaki Shikibu, derives from that of one of her characters, Murasaki, with her father's title *shikibu* added.

Large numbers of *Genji-e* (Genji paintings), dating from the twelfth century to modern times, survive in Japanese and Western collections. Their formats range from *shikishi* (a small square of paper) to long, narrow, horizontal-reading handscrolls, and even to pairs of very large screens (approximately 5 by 12 feet).[1] A pair of screens may depict all fifty-four chapters, with one famous scene from each chapter providing a quick overview of the entire saga.[2] Others may show only a few scenes, as in this pair, or may devote an entire screen to one scene.

On this pair of screens, scenes from four chapters of the *Tale of Genji* are arranged one above the other. On the right screen are, from chapter 5, "Wakamurasaki" (Lavender), and below it, from chapter 3, "Utsusemi" (The Shell of the Locust). On the left screen are, from chapter 51, "Ukifune" (A Boat upon the Water), and below it, from chapter 30, "Fujibakama" (Purple Trousers). Chapters 3 and 5 involve Prince Genji, while the male characters of chapters 30 and 51 are of later generations—Yugiri (Genji's son) and Niou (grandson of Princess Akashi, one of Genji's consorts).

Probably the most famous scene of the entire story, from "Wakamurasaki," is depicted. Genji, who was seeking treatment for his fever in the Northern Hills (Kitayama) in Kyoto, saw through a fence the young Murasaki, who was to become his principal consort. The second scene shows one of Genji's numerous encounters with other female characters. Here Utsusemi, the wife of a lesser officer away on duty, is playing a game of *go*, unaware of being watched by Genji, who had spent the previous night with her.

Artistic conventions in Genji painting changed little over the centuries but were skillfully combined with some modernization by Edo period artists. Diagonal lines repeatedly used in architectural elements, a basic traditional technique, are still used effectively. Here diagonal lines travel toward the upper right of the right-side screen, while those on the left-hand screen extend in the opposite direction and continue in the line of the bridge. Another convention, which depicts buildings with roofs removed to reveal their interiors, is followed in the lower episode on the right screen, while compositions for the other three episodes are in ordinary representational settings, an effective adaptation to the large-screen format.

A compositional characteristic that might help in dating these Genji screens is the use of gold clouds. Unlike the Momoyama period style in which scenes are seen through parted clouds, here they are arranged among them. The building in the lower left episode, for example, is set against a cloud used as a background, a style introduced during the early Edo period.[3] Moreover, two scenes from chapter 51, "Ukifune," normally painted separately,[4] are effectively combined in a continuous scene on the upper left on either side of the bridge, creating a feeling of spaciousness.

CONSORT MING (WANG ZHAOJUN)
ON HER WAY TO MONGOLIA
Iwasa Katsumochi, 1578–1650

Early Edo period, 1636–1643, hanging scroll, ink, colors, and silver on paper.
H. 58.4 cm (23 in.) W. 37.2 cm (14⅝ in.), B64 D3,
The Avery Brundage Collection

UNTIL RECENTLY obscurity surrounded the life of Iwasa Katsumochi, commonly known as Matabei. We now know, however, that he was the son of Araki Murashige who rebelled against Oda Nobunaga, the powerful daimyo then rising in central Japan. Eventually Murashige's castle was destroyed by Nobunaga and the entire family massacred; only the infant Katsumochi and his nurse escaped.

Katsumochi assumed his mother's family name, Iwasa, and was raised in a samurai community, but chose to become an artist. In mid-life he left Kyoto to settle in Fukui on the coast of the Japan Sea, where he lived for twenty years. His geographic isolation may have contributed to the development of his unique personal style. Later he left his family and moved to Edo to work on official commissions. He died there at age seventy-three.[1]

At least one of his teachers is known to have been a Tosa artist;[2] Katsumochi also incorporated Kano elements in his work. Yet his manner was so original that it is known today as "Matabei style." He achieved dazzling effects with the rich polychrome and gold he used to depict details of women's costumes and textiles in interior scenes of his genre paintings.

Katsumochi's cool and detached depiction of scenes of death and mutilation show the same passionate detailing of torn flesh and spilled blood. Some scholars associate his near-obsessive interest in gory details with his early personal experience of atrocities in battle. His best decorative narrative paintings frequently come close to vulgarity in his depiction of women, regardless of their social rank. Matabei is, in fact, considered to be the originator of a type of popular genre painting treasured by the public in the late Edo period, when it came to be known as ukiyo-e (see no. 74). Many unsigned ukiyo-e paintings have been traditionally and somewhat indiscriminately attributed to him, resulting in the use of the term "Ukiyo Matabei" to refer to him.

The central figure in this painting is Wang Zhaojun (Ō Shōkun in Japanese), the unfortunate consort Ming of the Han emperor, on her journey to Mongolia. The emperor had commissioned portraits of all his consorts in order to select the least beautiful woman as a gift for a nomad chieftain in a northern province. Aware of the plot, all the court ladies bribed the artist except Ming, the fairest. Consequently her portrait was not faithful to her real beauty, and she was chosen to be sent away.

Here she is shown on horseback with a few guards, seeking comfort on the lonely journey by playing her favorite instrument, the pipa. Typical touches of Matabei's style appear in the nomad guards' raised feet with toes pointed upward. The fullness of Ming's face is another characteristic of Matabei's figure drawings.

This painting was originally pasted on a panel of a small eight-fold screen belonging to the Masuya family.[3] In this screen and another similar pair (Kanaya screen), in which he used a separate composition of figures for each panel, Katsumochi freely combined unrelated Chinese and Japanese subjects. The Masuya screen is considered to have been painted during the second half of the Kanei era (1624–1643) or later, the period in which Katsumochi perfected his style in figure painting, combining the color gradation technique of ink painting and the romantic sentiments of yamato-e.[4]

66
CALLIGRAPHY MODEL BOOK
Shūkashō (Gleaning from the Mist)
Prince Sonchō, 1552–1597

Edo period, dated 1593; ink on decorated paper; H. 36 cm (14³/₁₆ in.) W. 27.3 cm
(10³/₄ in.); B64 M3, The Avery Brundage Collection

THE ORIGINAL VERSION of this calligraphy model book was compiled and executed in 1343 by a noted calligrapher, Prince Son'en, the fifth son of Emperor Fushimi, also an accomplished calligrapher. Son'en was the founder of the Shōrenin school of calligraphy, named after the monastery in Kyoto where he and his successors resided. Son'en's book, including his original colophon, was copied in 1593 by Prince Sonchō, ninth in the line of Son'en's successors. The original colophon states that the book served exclusively as a model for the student Chiyogiku, probably a nobleman's child, and that in giving the model to Chiyogiku, Son'en admonished him not to show it freely to others.

According to his own colophon, Sonchō gave this copy to his student Inagaki Shinnojō as a reward for his scholastic accomplishments. Although Sonchō included no admonition like Son'en's, this type of model book was nonetheless a private and special source of information for the calligraphy student.

Written on pages decorated with drawings of various plants and insects in gold, the contents are divided into twenty-six sections by theme. The longest section (the first seventy-four pages, about half the book) is devoted to basic vocabulary. Each word consists of two Chinese characters and is arranged according to Japanese phonetic order. Other sections give practical information—the names of provinces, streets in Kyoto, court offices, Zen temple offices, official garments, types of armor, household articles, items used in incense burning, tea ceremony utensils, metal decorations, names of musical instruments, and the titles of *bugaku* pieces and other types of musical works. A list of one hundred poetic titles, grouped under themes of the Four Seasons, Love, and Miscellaneous, constitutes another section so important to the original compiler, Son'en, that he cautioned his student that this material was to be guarded with extra reverence. The text concludes with a section on breeds of oxen and horses.

All the entries are in Chinese characters, or *kanji* (literally, Han writing), which the student would use along with *kana*, the Japanese syllabic writing system simplified from more complicated Chinese characters. The words are written in *gyōsho* style, a running semi-cursive script the Shōrenin school recommended to its beginning students.[1]

67

SHŪ MOSHUKU (CHOU MOUSHU)
ADMIRING LOTUS

Ogata Kōrin, 1658–1716

Edo period, 17th–18th century; hanging scroll, ink and wash on paper; H. 35 cm
(13¾ in.) W. 55.8 cm (22 in.); B76 D1, Gift of Asian Art Museum Foundation
of San Francisco

IN EDO PERIOD elite society, which was composed of a curious mixture of the imperial court, the Tokugawa family, and powerful merchants, the paintings of Ogata Kōrin were the epitome of artistic accomplishment and aesthetic refinement. Kōrin's skillful compositions and rich colors, which he literally poured onto the painting surface, turned simple flora and fauna, air and water, into a kind of decorative painting that later came to be called Rimpa (Rin school), deriving from the second syllable of Kōrin's name.[1]

Kōrin left a mass of documents that have allowed scholars to write extensively on his artistic and economic life, and even on his love life, which was apparently quite eventful.[2] Kōrin and his younger brother Kenzan (see no. 119) were blessed with an affluent and cultured family. The family's shop, Kariganeya, catered to the leading court ladies of the day, offering them fine kimono textiles, which in themselves were examples of the most colorful and extravagantly decorated crafts of the period.[3] With his share of the fortune left by his father, Kōrin lived for a while in grand style, frequenting the pleasure quarters of Kyoto and associating with courtiers such as those of the Nijō family, who enjoyed his polished wit and sincerity.

These early experiences provided a kind of refinement that characterized Kōrin's artistic production when, once his funds were exhausted, he began training to become a professional artist. He had previously stud-

ied painting as a hobby with Yamamoto Soken (see no. 63), an experience that proved particularly valuable when he started working with Kenzan to decorate pottery with paintings and calligraphy.

Although Kōrin's major works were rich polychrome paintings, he also left a series of gem-like monochrome works, probably done in his late forties. This change in style is thought to reflect changes in his life by which he became more introspective and concerned with the inner qualities of his subjects.[4]

This small painting is a good example of Kōrin's monochromatic work. Chou Moushu sits at the edge of a pond, leaning on an armrest and gazing at lotus blossoms. Thin horizontal lines suggest still water, while broad washes define the land. The round tops of five lotus leaves form a pattern below three buds, which look as though they are about to open under Chou Moushu's intent gaze.

Touches of color enhance this otherwise rather austere ink painting. The signature *Hokkyō Kōrin* includes the artist's title Hokkyō, which was bestowed upon him in 1701.[5] The seal reads *Kansei* and is the same as that which appears on a portrait dated 1704.[6] The calligraphy closely resembles that on another of his monochrome paintings of a similar subject.[7] Therefore, this work was probably painted between 1704 and 1716, the year of Kōrin's death at the age of fifty-eight.

LETTER TO ISSHI MONJU

Karasumaru Mitsuhiro, 1579–1638

Edo period, datable to 1632; hanging scroll, ink on paper; H. 15.9 cm (6¼ in.) W. 94.3
cm (37⅛ in.); 1988.28, Gift of Elizabeth and Allen Michels, Yoshiko Kakudo,
and Peter Drucker

WHILE CALLIGRAPHY of *waka* poems on Twelve Months screens
(no. 63) is a good example of the formal artwork by Edo period courtier-
calligraphers, this letter from Karasumaru Mitsuhiro to his young religious men-
tor Isshi Monju (1608–1646) is a fine example of calligraphy as an informal and
private expression. It is an individual's handwriting, simply executed as a means of
communication and meant to be seen only by the initial recipient.[1] Other official
letters are much more formal in style and sometimes even written by calligraphers
other than the original writer.[2]

In the *Tale of Genji* (see no. 64), Lady Murasaki's keen interest in private let-
ters is established by her frequent allusions to those written by her characters. As
well as commenting on a beautiful calligraphic handwriting, the author noted that
one such letter was written on delicate blue paper and delivered tied to the stem of
a pink blossom. It was an elegant custom to send a note on a branch, as is observed
in another literary source, *Makuranosōshi* (Pillow Book), which describes a letter
written on blue-green paper and tied to a freshly budding willow branch. Simi-
larly, contemporary writings mention a note on red paper tied to a red plum
branch, and a purple note on a blossoming wisteria stem, indicating a preference
for matching color schemes.[3]

During the Kamakura and succeeding periods, letters were not so fanciful as
those of the Heian period, but much work was done to compile model styles and

forms of letters for various occasions. These models were used partly as educational reference books, collectively called *ōraimono*, to learn Chinese characters and to enrich vocabulary, and more generally as guides to master manners and protocol to be followed in both formal and private letter writing.[4]

Edo period letter writers still followed many stylistic and formal conventions, even in private correspondence. One such convention, used effectively in this example, utilized the space at the right margin and between the lines at the beginning of the letter. In these spaces, between the dark and large character lines, are smaller and lighter lines, which were added to the first set. Here, after the main body of correspondence, in which Mitsuhiro inquired about his young mentor's health, he composed a *waka* poem on the same theme. He even changed one word in his poem after he inscribed the original version, indicating that he considered his to be very private. Mitsuhiro's incidental reference to his pending trip to Edo to attend the first anniversary service of the late second shogun Hidetada dates this letter to 1632.

Many private letters survived much longer than originally intended. Often, in such cases, the writers were emperors or famous priests who were not only great historical figures but recognized as accomplished calligraphers. Others were eminent members of religious organizations or military clans, or were extraordinary lovers involved in impossible romantic situations. The circumstances in which Isshi, an important religious figure, received this private letter from Mitsuhiro, an accomplished calligrapher, poet, and painter with many followers, very likely contributed to its survival and appreciation as an artwork.

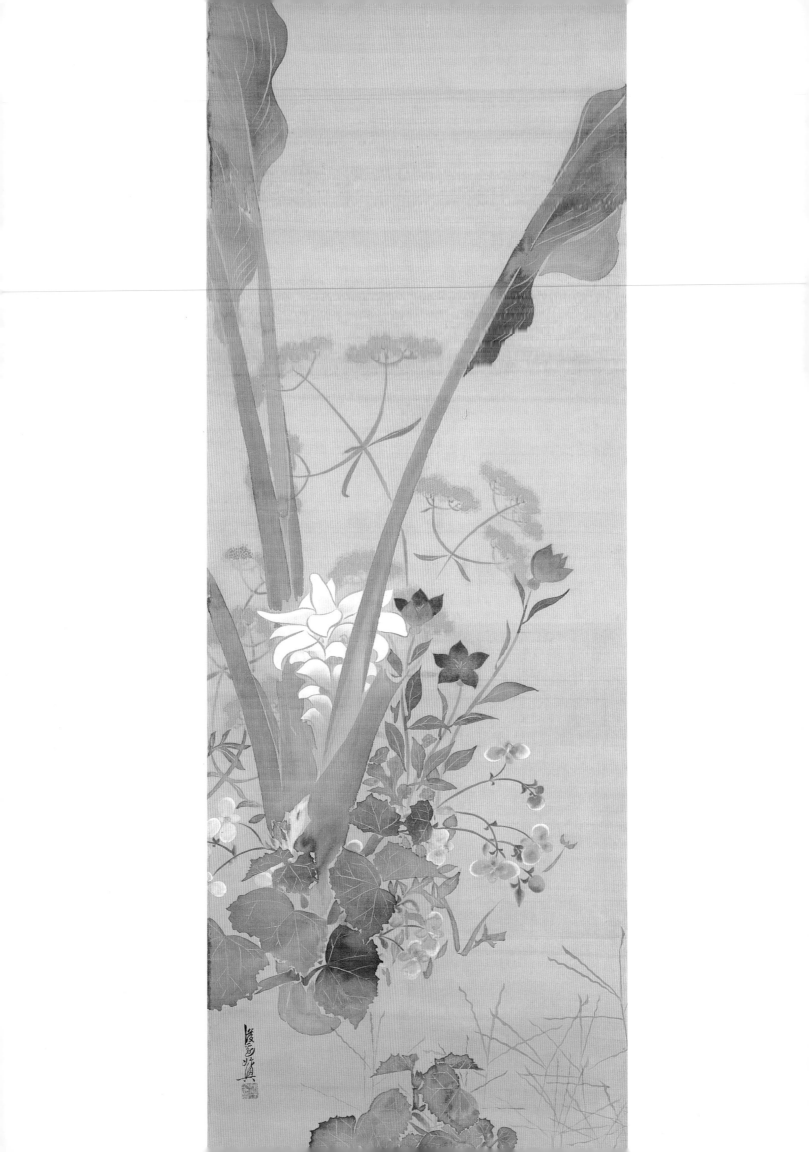

FLOWERING PLANTS
Watanabe Shikō, 1683–1755

Edo period, 18th century; hanging scroll, ink and colors on silk; H. 98.8 cm (38⁷/₈ in.)
W. 35.9 cm (14¹/₈ in.); B72 D40, The Avery Brundage Collection

BORN IN KYOTO, Watanabe Shikō at an early age studied under Yamamoto Soken, an artist who combined the styles of Kano and Tosa. When he was twenty-five, Shikō assumed a position as painter in Konoe Iehiro's household (see no. 63), which no doubt brought him into closer contact with more eclectic styles and tastes. Many of his flower paintings, at least at first encounter, also show a strong stylistic resemblance to those by Kōrin. A pair of six-fold screens by Shikō, with a more unusual and nearly experimental composition, add yet another aspect to this artist's already varied repertoire.[1]

This painting of flowering plants bearing both the signature and seal of Watanabe Shikō is typical of his work in the Rimpa tradition. Many examples of such flower paintings by Shikō survive, ranging from a small hanging scroll to a pair of six-fold screens. One of a diptych,[2] this painting shows five different plants displayed around the central tall turmeric plant with a large white blossom. Blue-bells (kikyō), begonias, ominaeshi (Partinia scabiosaefolia), a yellow flower widely known in Japan, and a type of delicate green grass complete this arrangement of familiar autumnal plants.

The composition moves from the lower left to the upper right corner. In a companion painting now in private hands in Seattle, summer plants—wisteria, peonies, and iris—appear in reverse arrangement from right to left, so that the original pair created a fully balanced composition.

Traditionally Shikō's flower paintings were considered to be mere faithful exercises which never departed from Kōrin's models.[3] More recent scholarship has recognized Shikō's keen interest in detail and realism and his skills in delineation.[4] Shikō is considered to have had a greater role as a forerunner of Maruyama Ōkyo (see no. 72), the artist so closely identified with a style based on the study of nature.

During the time Shikō was in Konoe Iehiro's artistic circle, he was exposed to Iehiro's keen interest in the serious study of nature, particularly botany. Iehiro left a scroll of sketches of birds and flowers that he himself painted. Shikō also left a scroll of nature sketches of birds and flowers, which Maruyama Ōkyo later studied by faithfully copying line for line.

At the very least, Shikō sensed the taste of the new class of townspeople (chōnin) that emerged during the eighteenth century and turned his artistic efforts to satisfy their demands for paintings of birds and flowers. Most of these paintings on silk, a precious material by the day's standard, were hung and enjoyed in the home as successful portrayals of naturalistic beauty.

70
ELEPHANT AND CHINESE CHILDREN
Nagasawa Rosetsu, 1754–1799

Edo period, after 1794; hanging scroll, ink and wash on paper; H. 118.9 cm (46⅞ in.) W. 30.9 cm (12³/₁₆ in.); B80 D1, Gift of Martha and William Steen

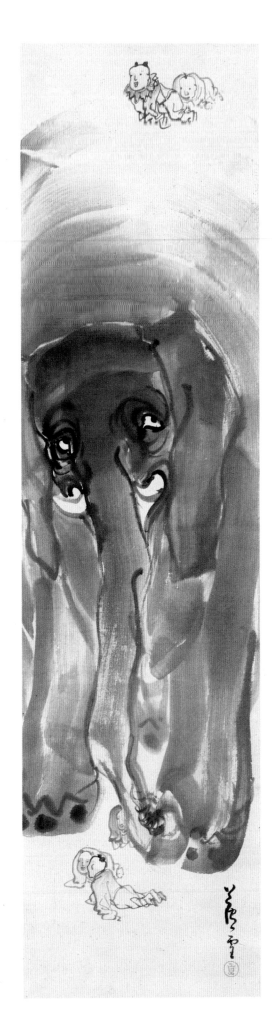

THE ECCENTRICITY, humor, and accomplished draftsmanship of Nagasawa Rosetsu are apparent in this painting. Born to a samurai family named Uesugi and later adopted by the Nagasawa family, Rosetsu studied painting with Maruyama Ōkyo, founder of the Maruyama school (see no. 72). He soon developed a style different from that of his teacher, and his volatile temperament shortened his stay in his master's circle, although the two artists maintained a professional relationship until the elder's death. Rosetsu's dramatic and creative life ended at age forty-six under unusual circumstances — either by murder or suicide — but the facts are not well documented.[1]

Rosetsu was a master of contrasts, whether spatial, chromatic, or thematic, and was at his best in large screen paintings. One such famous composition on a pair of screens features an elephant.[2] Even in the vertical format of this work, his compositional skill and basic wit is apparent. The elephant's bony skull, floppy ears, voluminous body, column-like legs, and dangling trunk are depicted with swift strokes made by using two types of brushes, the wide, flat *hake*, and the round, more ordinary *fude*. His skillful use of the *hake* in particular reflects his earlier association with the Maruyama school and his mastery of its typical technique. Rosetsu's successful combination of the *hake* with the *fude* for a more realistic rendering of details, along with his witty, contrasting compositions, places him among the master painters.[3]

The elephant's dark face sets off the white of the eyes and tusks, and a subtle ink gradation defines the body, leaving a blank space atop the beast where a pair of children crawl about as if on a playground. Three more children scramble in front of the elephant, one half-hidden by its trunk. These *karako*, a Japanese term for Chinese children, were a favorite subject of the Sinophile artists of the Edo period (see no. 110).

Two other published elephant compositions, in which a large animal fills an entire length of each six-fold screen, are dated to sometime after 1794 based on an impressed seal.[4] Although the seal on this elephant painting is not the same, the signature style is from Rosetsu's later years and thus helps to place this painting to that part of his life.[5]

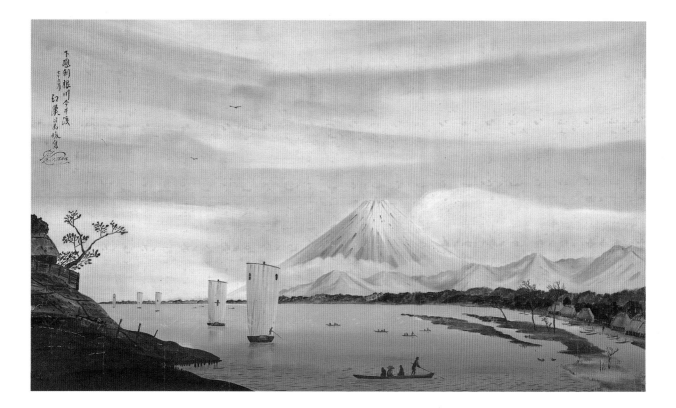

71

FERRY AT IMAI ON THE TONE RIVER
Shiba Kōkan, 1747–1818

Edo period, first quarter 19th century; hanging scroll, oil colors on paper; H. 57.7 cm
(22³/₄ in.) W. 98.5 cm (38³/₄ in.); B66 D18, Gift of Mr. Junkichi Mayuyama

SHIBA KŌKAN was one of the most versatile and adventurous artists of the Edo period. All the scholarly research spent in writing his biography does not quite explain why he was subject to so many different influences. As a painter he studied the Kano, Nagasaki, and *ukiyo-e* styles, the last in the celebrated Harunobu style.[1] He tried Western etching, oil painting, and even clay sculpture.[2] His voracious appetite for art began with Chinese culture but took him far afield into Western studies of cartography, astronomy, terrestrial phenomena, and geography.

This view dominated by Mount Fuji is an example of his *doro-e* (mud painting), a Japanese medium Kōkan concocted in order to reproduce the effect of the European oil paintings he so admired. Kōkan records his observation that Western oil paintings are "painted with pigments that used 'wax-oil' instead of the traditional Japanese medium *nikawa* (hide glue), with the advantage that when in contact with water the images did not dissolve."[3]

In addition to scenes he copied directly from European models, Kōkan created many Japanese landscapes. Mount Fuji was one of his favorite native subjects, and he rendered it from different viewpoints in varying media and formats.[4] He loved this sacred mountain and wrote passionately and with great scientific precision about its geological formation and volcanic activities. He criticized the traditional Tosa and Kano depictions of Fuji for their lack of accuracy.

Many of Kōkan's paintings of Mount Fuji show the same general composition in which the mountain is seen at a distance, with a long shoreline stretching to the right or left.[5] In this painting, the shoreline reaches to the lower right in a gradual curve. Sailboats of diminishing sizes dot the sea and lend a Western perspective to the scene. The inscription reads "Ferry at Imai on the Tone River in Shimōsa Province. Portrayed by Shiba Kōkan Shun, a seventy-five-year-old man."

Kōkan's statements about his age have been quite confusing; for unknown reasons, he started adding nine years to his actual age when he reached sixty-two. Therefore, this painting was done in 1812 when he was sixty-six years old. If this seems bizarre, one must consider that Kōkan sent out his own death notice several years before he actually died.[6]

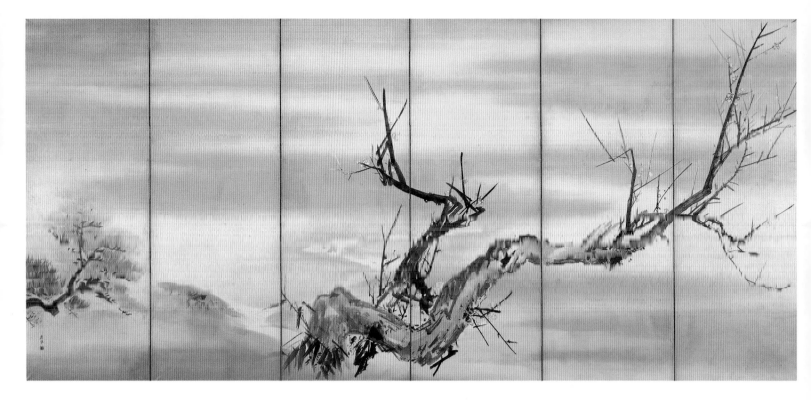

72
PINE, BAMBOO, AND PLUM
Maruyama Ōkyo, 1733–1795

Edo period, ca. 1750s; pair of six-fold screens, ink and gold on paper; H. 164.5 cm
(64³/₄ in.) W. 363.8 cm (143¹/₄ in.) each; B60 D55+ (right), B60 D56+ (left),
The Avery Brundage Collection

THE LIFE OF MARUYAMA ŌKYO is an extraordinary success
story. A talented child born on a farm in a small village near Kyoto, Ōkyo
began as a mere decorator of wrapping paper and finished as an artist who
changed the course of Japanese painting. The naturalistic style of the Maruyama
school, which he established late in life, had such public appeal that it swept the
artistic society of Kyoto and eventually influenced Edo artists as well.

Accounts tell us that during his youth, Ōkyo's creative urge was so strong he
could think of nothing except sketching on any available surface, including the
field that he was supposed to be tilling.[1] After moving to Kyoto as a teenager,
Ōkyo worked at odd jobs peripherally associated with decorative crafts before
beginning to study painting with Ishida Yūtei (1721–1786), an eclectic artist who
introduced him to the Kano and Tosa styles. He also practiced Western perspec-
tive while preparing *megane-e* (literally, eyeglass pictures), for a kind of newly pop-
ularized stereopticon.[2] He became acquainted with Watanabe Shikō's decorative
works and nature-sketch scrolls, which he copied diligently.[3]

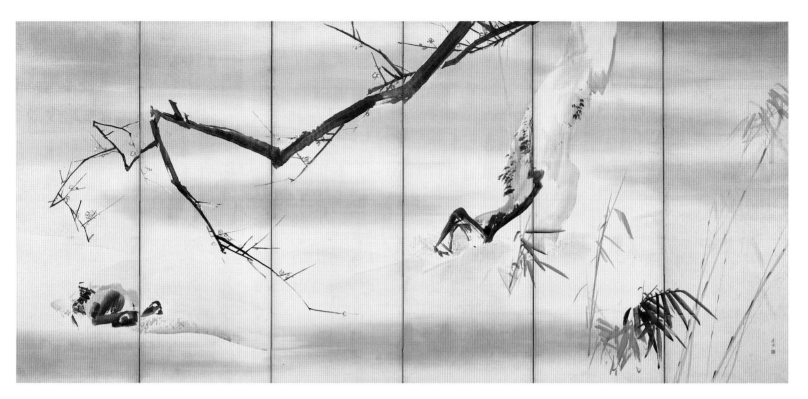

Exposure to so many different styles might have confused another artist, but Ōkyo turned it to his advantage to develop his own style to its fullest. Ōkyo's interest in nature grew so strong that he was able to produce what have been described as "the finest Japanese sketches of the natural science type."[4]

In this pair of screens, which illustrates the traditional theme of the Three Friends, *shō chiku bai* (pine, bamboo, and plum),[5] the emphasis is placed on two old plum trees, one on the left screen in full view, the other on the right screen showing only a long, projecting branch zigzagging downward to the left. This seems to be one of Ōkyo's most successful compositional formats; it appears again in another famous pair of screens, *Pine Tree Covered with Snow* (Mitsui collection, Japan), done when the artist was in his early fifties.

The screens are not dated but bear signatures reading *Ōkyo*. The writing is similar to that of signatures on works dated the seventh year of Temmei (1787), when Ōkyo was fifty-five.[6] When compared to two other paintings entitled *Plum in the Snow*,[7] these screens show more fluid and less structured brushstrokes, a feeling more evident in another screen, *Rainy Landscape*, in the Yamato Bunkakan, Nara.[8]

LANDSCAPE
Ike Gyokuran, 1728–1784

Edo period, 18th century; hanging scroll, ink and wash on silk; H. 112.1 cm
(44⅛ in.) W. 48.7 cm (19¼ in.); B76 D3, Gift of Asian Art Museum
Foundation of San Francisco

GYOKURAN WAS the youngest of three generations of very talented female waka poets in Kyoto. Her mother, Yuri, and Yuri's adoptive mother, Kaji, ran a small tea house in the Gion district, where young Gyokuran, who was called Machi, also helped. All three exchanged their *waka* poems with their customers. The three women's talents and beauty were much appreciated by Kyoto art lovers, who frequented their modest roadside tea house to enjoy artistic pursuits as well as the tea they served. Both Kaji and Yuri were published poets, while Machi, who married a painter, came to be known first as a painter, although she continued *waka* composition and sometimes inscribed them on her paintings.[1]

Machi married the young painter Ike no Taiga (1723–1776), who was trying to support himself and his mother by selling his fan paintings. Young Machi must have had an interest in painting, since her first painting teacher was Yanagisawa Kien (1704–1758), once also her husband's teacher. Kien gave her the studio name Gyokuran, reflecting the first part of his other studio name, Gyoku-kei.

After their marriage, Taiga, who established himself as one of the greatest Nanga painters, was a strong influence in Gyokuran's artistic development. He created painting manuals for her to study, thus providing her with a source of continuous learning for years after his death. After being widowed, Gyokuran supported herself by teaching reading and writing to children as well as by selling her fan paintings.

Gyokuran also developed her own style in landscape and flower paintings. Her style as well as certain peculiarities found more in her larger-scale landscape paintings often drew criticism and condescending treatment from male scholars.[2] Others recognized these same qualities as her creative process that "sought to achieve an otherworldly quality" and "enjoyed adding elements of surprise."[3] Here, for instance, she had obvious difficulty depicting rice fields able to hold water, and her travelers seem insecure on their precarious path. Yet her animated brushstrokes and fluid composition seem to vibrate with a warm inner energy without being too feminine. Her use of color is distinctively less inhibited and more carefree than her husband's.

On her nature studies, where she used ink quickly and skillfully in portraying bamboo or chrysanthemums, Gyokuran often inscribed her own *waka* poems. On other paintings Gyokuran invited her equally accomplished mother to inscribe her poems.[4]

Gyokuran's life with Taiga was quite unconventional. They devoted most of their time to painting, poetry, and music. But certain bizarre behaviors as well as strange incidents apparently attracted the attention of their contemporaries, whose somewhat exaggerated accounts of them no doubt contributed to the legendary status of this unusual couple.

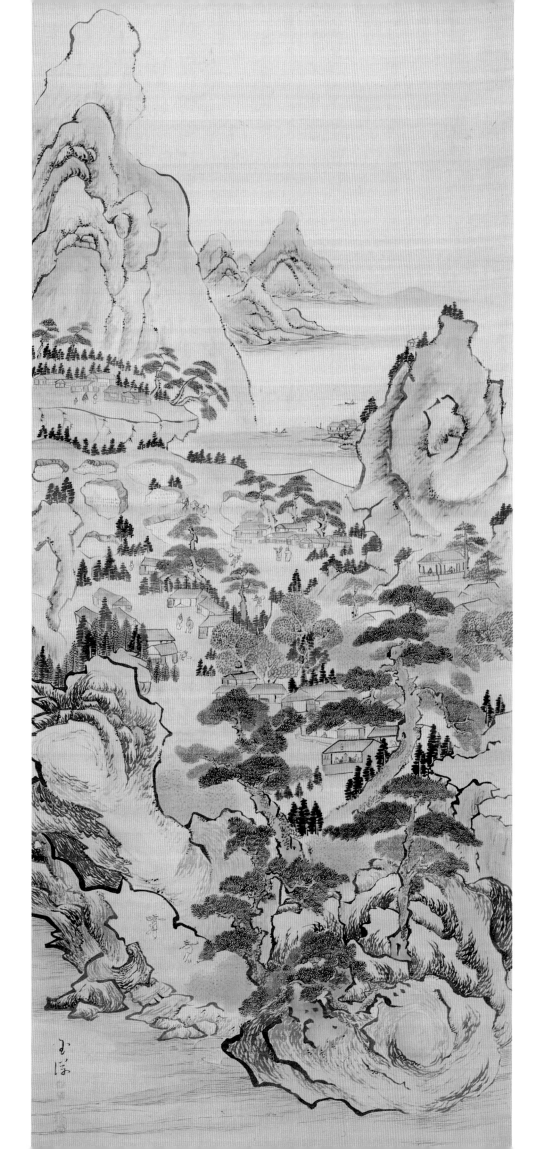

74
STANDING WOMAN
Baiyūken Katsunobu, fl. 1716–1735

Edo period, early 18th century; hanging scroll, ink and colors on
paper; H. 88.6 cm (34⅞ in.) W. 41.9 cm (16½ in.); B60 D119, The
Avery Brundage Collection

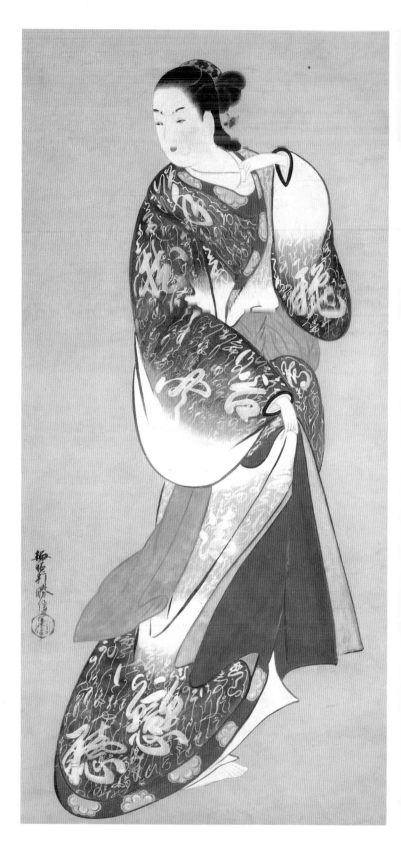

BAIYŪKEN KATSUNOBU worked in the
style of the Kaigetsudō school of the *ukiyo-e* tradi-
tion. This school consisted of a small inner circle of
select painters working directly with Kaigetsudō Ando
(fl. early eighteenth century) and of a larger circle of as
many as twenty other painters, including Katsunobu.[1]
All these artists produced portraits of courtesans
standing in a rather standardized pose without any sug-
gestion of a background setting. The paintings were
probably sold near the pleasure quarters as "pin-up"
souvenirs. Individually painted by hand—and yet not as
expensive as other *ukiyo-e* paintings, hanging scrolls, or
screens with more complex compositions—these por-
traits were for a time in great demand.

In this painting a woman, standing in a graceful if
somewhat stereotyped S-shaped curve, holds the front
of her tucked kimono and lightly touches her neck as
she looks over her shoulder. Her face is full and youth-
ful, her hand small and delicate. Her hair is simply deco-
rated with a matching tortoise shell comb and *kanzashi*, a
hair ornament with a long pin. The outlines of her fash-
ionable garment are heavy in contrast to the thinner,
softer lines that define her face and hands.

Katsunobu frequently used cursive Chinese char-
acters to decorate the garments of his figures. Here they
appear in white against a background in different shades
of blue. Bold characters reading "love" and "to listen"
are superimposed over small *kana*, or Japanese sylla-
baries, written in finer brush lines.

75

ŌTSU-E OF AN ONNA KOMUSŌ

Mid Edo period, 18th century; hanging scroll, ink and color on paper;
H. 58.2 cm (23 in.) W. 20.7 cm (8 ⅛ in.); B65 D18, The Avery
Brundage Collection

ŌTSU-E IS THE name given to souvenir
paintings sold at roadside shops along the Tō-
kaidō Road near Ōtsu. The first station outside Kyoto
on the long Tokaidō route to Edo, Ōtsu was a strategic
sales point. Many travelers heading home to the north
would stop there to make a last-minute purchase.

Initially paintings of this type were called *oikawa-e*
or *otani-e*, after the villages around Ōtsu where the
shops were located. Later the term *ōtsu-e* was applied
generically to all these works.[1] Mass produced in family
shops, these simple but charming pictures in later years
caught the eye of discriminating connoisseurs, among
them Sōetsu Yanagi of the *mingei* (folk art) movement
(see no. 121).

Early *ōtsu-e* were mainly Buddhist images, often
with hand-painted borders to give the illusion that the
picture was already mounted as a hanging scroll. During
the height of persecution of Christians by the govern-
ment, many people bought these inexpensive, ready-to-
hang Buddhist images to display prominently to dis-
prove their Christian faith and thus avoid persecution.[2]

Later the gradual introduction of secular subjects
and some themes of allegorical significance enlarged the
ōtsu-e repertoire. Some paintings are accompanied by
inscriptions, proverbs, or admonitions on everyday
behavior, even suggestions on practical matters. Popular
subjects included the real and imaginary, men and
women of varying status, and animals—foxes, cats, and
mice. Represented here is an *onna komusō*,[3] a female lay
Buddhist priest, playing her *shakuhachi* (bamboo flute)
and wearing a deep straw hat to cover her face, a device
used by her male counterparts, who often had reason to
hide their identities.[4]

The earliest written record of these paintings
dates from 1661 and refers to a painted image of Tenjin,
the patron of literature and poetry, which was men-
tioned as being hung at a small poetry gathering.[5] Later,
in a notable passage in one of Ihara Saikaku's (1642–
1693) novels, he described a screen on which five *ōtsu-e*
paintings were pasted. The screen in question was seen
in a small village in northern Japan, indicating the wide
distribution of these paintings from their point of ori-

gin. Saikaku recorded important information in this
description when he noted five different subjects. Of
these, only one is known to have survived. If that were
to be the survival ratio of subjects—one in five—the
number of different themes painted by *ōtsu-e* painters
must have been very large, since several hundred sub-
jects have been accounted for to date.

PLAYING KIN UNDER A PINE TREE

Uragami Gyokudō, 1745–1820

Edo period, 18th–19th century; hanging scroll, ink and wash on paper; H. 28 cm (11 in.)
W. 23.5 cm (9¼ in.); B69 D49, Gift of Ney Wolfskill Fund

THE RELATIVELY RECENT recognition of Uragami Gyokudō may be due to his extremely individualistic painting style, which has been summarized as "powerfully appealing to the twentieth-century eye and sensibilities."[1] An eccentric who abandoned his role and responsibilities as a samurai, Gyokudō threw his creative energies into the late eighteenth-century Nanga movement, making it a truly monumental epoch.

Uragami Gyokudō was born to a middle-ranking samurai in the service of a small Ikeda clan in Okayama, in western Japan. He studied Confucianism and Chinese literature in the clan's school for samurai children. Only seven at his father's death, he nevertheless became the head of the family and a vassal to the young lord, to whom he had a strong devotion.

In his early thirties in Edo, Gyokudō began to study the seven-string *kin* (Chinese: *qin*) with a physician named Rankei. This marked the beginning of his lifelong pursuit of music, and shortly after this time he acquired a *kin* inscribed *Gyokudō seiin* (Jade Studio of Pure Rhyme). He became so attached to this instrument that he took on the same name and later named his sons Shūkin (Autumn *Kin*) and Shunkin (Spring *Kin*).

When in service, especially after his young master's early death, Gyokudō was known to have been reserved, introverted, and unsociable to the point that he could not perform his duties properly.[2] At the age of forty-nine, a year after his wife died, he resigned his position, a bold and extraordinary act at the time, and taking his beloved instrument, led the life of a restless eccentric, constantly traveling, composing, and painting, lured onward only by his love of nature and disciplined only by his creative urge.

The title of this small and pleasant painting refers to a tiny figure of a *kin* player under a pine tree, most probably Gyokudō's own image in an ideal setting. Scarcely noticeable, he sits under a large branch that spreads out to the lower right. Unlike many stormy and almost unruly paintings by Gyokudō, this one is clear and sober. His dry but long and sensuous brushstrokes outline and shade, portraying the volume and weight of the mountains, high cliffs, and rocks. Short repeated strokes delineate the pine needles, shrubs, and grasses. The water, the sky, and the mist are rendered in broad wash strokes. This painting resembles another dedicated to the mother of a friend.[3] Apparently he painted both in his sixties, when his dry-brush style is considered to have reached maturity.

The signature reads *Gyokudō* and the seals *Kinshi* (*Kin* Player) and *Hakusen Kinshi* (White-bearded *Kin* Player), the playful names Gyokudō used to refer to himself.

HERONS AND REEDS
Yamamoto Baiitsu, 1783–1856

Edo period, 19th century; hanging scroll, ink and colors on silk; H. 134.6 cm (53 in.)
W. 42.5 cm (16¾ in.); B65 D14, The Avery Brundage Collection

BAIITSU WAS BORN in Nagoya, a town located midway between Edo and Naniwa (Osaka). The son of a sculptor, he studied conventional paintings under the Shijō school painter Chō Gesshō (1772–1832).[1] He was still in his teens when Kamiya Tenyū, a rich Nagoya merchant and famous collector-connoisseur, took him and another local artist, Nakabayashi Chikutō (see no. 78), under his wing, allowing them to live in his residence where they could study and copy Tenyū's collection of Chinese paintings at firsthand.[2]

In his twenties Baiitsu, again with Chikutō, moved to Kyoto, where they became acquainted with other literati artists. Baiitsu specialized in birds and flowers, and the range of his colors shows his early Shijō school training. He handled brush and ink with utmost skill, and even with the rather subdued colors he selected for paintings, his birds and flowers could be dazzling.

In this composition, Baiitsu focused on a pair of herons standing among autumn plants and intently looking toward the left, as if they had heard a sudden splash of water. The birds are framed in a cell-like space between the main cluster of reeds behind them and a smaller one in front. The predominantly vertical reeds emphasize the erect bird's posture; the more horizontal lines of the leaves in front follow the second bird's form, except for one sharp blade of grass that cuts across its body. With its rhythmic elan and subtle colors, this painting ranks among Baiitsu's most successful works.

LANDSCAPE

Nakabayashi Chikutō, 1776–1853

Edo period, dated 1835, hanging scroll, ink on paper; H. 98.4 cm (77 7/8 in.) W. 91.4 cm (36 in.); B67 D16, Gift of Asian Art Museum Foundation of San Francisco

CHIKUTŌ'S EARLY ARTISTIC path paralleled very closely that of Yamamoto Baiitsu (see no. 77). The son of a physician, Chikutō was also a native of Nagoya. Seven years older than Baiitsu and with a great interest in scholarship, he received the younger artist's deep respect and friendship. Chikutō and Baiitsu spent many rewarding years under Kamiya Tenyū's guidance. Fair-minded and caring, Tenyū inspired both young artists and helped them in many ways, letting their individual talents develop naturally.

In Kyoto, where he moved with his now-inseparable friend Baiitsu, Chikutō developed his scholarly interests in different subjects and authored many books, including his famous *Chikutō garon* (Discourse on Painting). He established himself as a landscape artist, although he also produced many sensitive floral paintings.

In this composition, tall trees in the foreground stand on a flat land projection on which two seated persons engage in conversation. The general land mass forms a somewhat odd lozenge shape within the rectangular format. Surrounding the flat middle ground, distant hills rise straight up from the misty atmosphere while another hill in the foreground climbs steeply to the right. Dotting these hills and the shoreline are clusters of small square blocks, a compositional element that came to be Chikutō's visual trademark. A few palatial buildings and some humble huts dot the hillside and a faraway shore; a waterfall appears in the upper right.

The poetic inscription, in a basic Chinese poem style of seven-character, four-line composition, describes the painting:

> Beyond the water, mountains are high
> Near the stream old trees enclose the mist.
> One leisurely old man receives another,
> and they enjoy flocking geese.

An additional inscription states the date as "Tempō six, Otu hitsuji (1835), winter in the eleventh month." Chikutō further noted that he painted this scene in the style of Dong Beiyuan's brush;[1] although the resemblance can be seen only in the trees in the foreground and in the way the shoreline recedes in a zigzagging manner.

Chikutō painted another landscape a month earlier in the same year.[2] A commissioned work in colors on silk, this earlier painting is otherwise in nearly the same format and is of an artistic inspiration very close to the ink version.[3] In similar fashion, within the inscription following the poetic lines, he stated that he had painted it in the style of Wen Zhengming, another famous Chinese painter.

In the inscription on this ink painting, the artist also noted that he was influenced by the poetic feelings of Wu Zhong-gui, a little-known Chinese poet. The inscription ends with his signature *Chikutō Sanjin Shigemasa* and is followed by two seals reading *Shigemasa no in* and *Chikutō Sanjin*.

PURE VIEW OF STREAM AND HILLS
Takahashi Sōhei, 1803–1834

Edo period, 19th century; hanging scroll, ink on satin weave silk; H. 118.4 cm (46⅝ in.)
W. 43 cm (17 in.); B76 D2, Gift of Asian Art Museum Foundation of San Francisco

TAKAHASHI SŌHEI WAS born in Bungo Province in Kyushu, where his precocious talents were discovered by the noted literati painter Tanomura Chikuden (1777–1835). Sōhei became Chikuden's student and soon was accompanying him on frequent trips to Kyoto and Naniwa (Osaka).[1]

Sōhei's landscape paintings faithfully reflect the style of his teacher, except that his brushwork can be more detailed and at times appears slightly overwrought. In this river landscape, a small boat carrying a family is about to leave an overgrown shore, its trees heavy with foliage. The woman sits under a cover holding a baby, while the man pushes the boat off with a long pole. The trees, rocks, and vegetation, meticulously brushed in Sōhei's trademark detail, make a strong contrast to the refreshing spacious relief of the sky and water. This work has an inscription stating that it was done at a retreat in Akamagaseki during the fifth month of the year corresponding to 1832. That year was one of the most productive in Sōhei's short life. He died a few years later, his full potential as an artist unrealized.

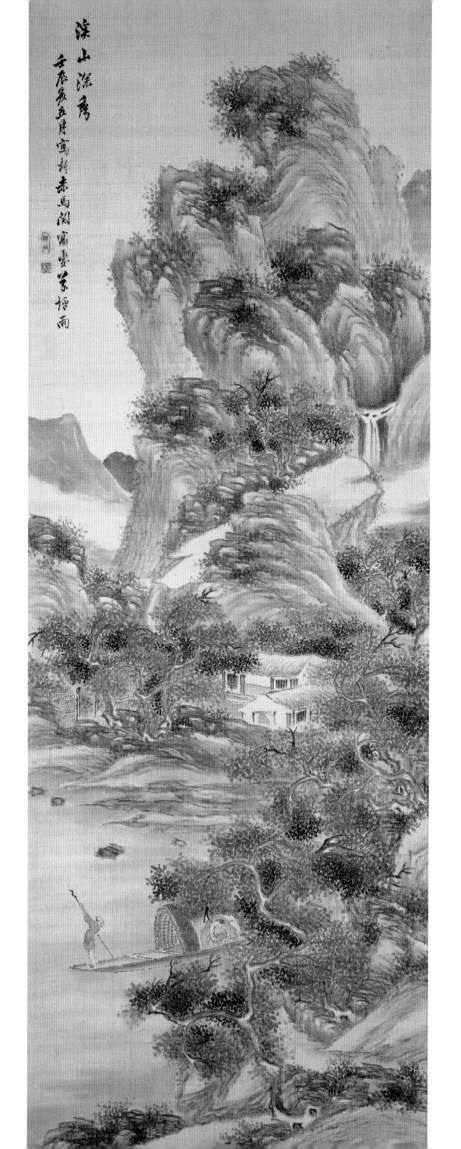

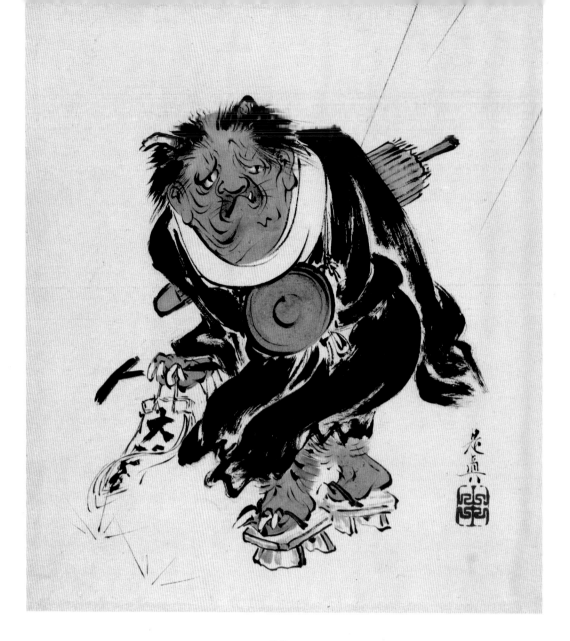

80
ONI
Shibata Zeshin, 1807–1891

Late Edo to early Meiji period; album leaf, lacquer on paper; H. 22.6 cm (8⅞ in.)
W. 18 cm (7⅛ in.); B65 D5l, The Avery Brundage Collection

AN EXTREMELY talented, versatile, and prolific artist, Shibata Zeshin was successful in adapting his artistic activities to the changing social and political climate of the late Edo to early Meiji periods, without aesthetic compromise. Zeshin was born to a family of varied talents. His grandfather was a skilled carpenter and his father a wood carver and amateur painter, but it was his mother, a singer-composer and one-time professional entertainer in the pleasure quarter of Nihonbashi, in Edo, who instilled in her son the basic concept that influenced his entire professional life—namely, that personal artistic judgment is more important than slavish attention to current fashion.[1]

Zeshin's early painting instruction from Suzuki Nanrei (1775–1844), a distant student of Maruyama

Ōkyo, was intended to improve the design of his lacquer work (see no. 141), a skill he learned from Koma Kansai (1766–1835). At age twenty-four, Zeshin continued his study of painting in Kyoto with Okamoto Toyohiko (1773–1845), who was regarded as one of Maruyama Ōkyo's ten best students.

A few years later, illness prevented Zeshin's attempt to go to Nagasaki to experience foreign culture, and he returned to Edo. When he made his second trip to Kyoto, in nearby Nara he met the famous historian Hoida Tadatomi, who let Zeshin copy his own sketches of lacquer treasures in the Shōsōin treasury.[2]

Zeshin returned from his next major trip, to northern Japan, with a series of sketches of both landscapes and human figures encountered during his

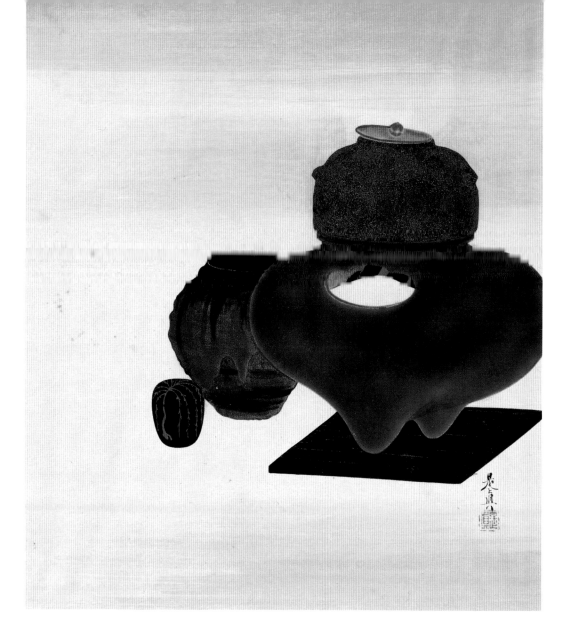

81

TEA UTENSILS
Shibata Zeshin, 1807–1891

Late Edo to early Meiji period; album leaf, lacquer on paper; H. 22.6 cm (8⅞ in.)
W. 18 cm (7⅛ in.); B65 D5m, The Avery Brundage Collection

travel. He seems to have treasured this sketchbook as a source of inspiration, since a painting he finished when he was eighty-four is based on a subject found in it.[3] He repeatedly returned to this book when he worked on his lacquer pieces and paintings.

This *shikishi*-sized lacquer painting on a small album leaf depicts a comical *oni* (a little devilish creature) wearing a fund-raiser priest's garb, going around with a Buddhist gong hung from his neck and an umbrella on his back (no. 80). His right hand, with ugly long nails, grasps a T-shaped gong-striker and a bound ledger. Judging from his expression, obviously this poor *oni*, who is trying to do good deeds by raising funds for a good cause (perhaps casting a new bell or fixing the temple roof), is in distress. It has even begun to rain.

Zeshin's skillful use of this difficult medium, lacquer, in swift calligraphic lines is quite remarkable in giving separate strokes completely effortless, light effects.

The second composition is an arrangement of tea utensils, one of Zeshin's favorite themes (no. 81). His masterful rendition of different surfaces and materials, the result of his craftsmanship as a lacquerer, range from the matte-textured surface of a cast-iron tea kettle to a rich and smooth lacquer tea caddy minutely decorated with a gold *makie* design of a cascading willow tree. Against the plain background, Zeshin's tea utensils in this composition seem monumental, as the artist turned his entire attention to their shapes and volumes as well as the amazing surface effects achieved through painting with lacquer.

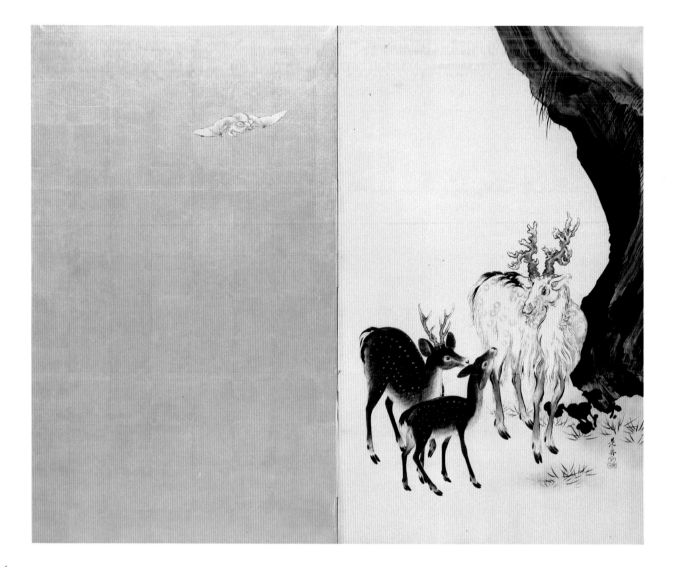

82
DEER AND BAT
Shibata Zeshin, 1807–1891

Late Edo to early Meiji period; two-fold screen, lacquer and gold on paper; H. 136.2 cm
(53 5/8 in.) W. 165.7 cm (65 1/4 in.); B60 D59+, The Avery Brundage Collection

WHILE ZESHIN'S *shikishi*-sized lacquer paintings are rich and decorative in their surface treatments (see nos. 80–81), his large-scale lacquer paintings as well as ink paintings show his sure sense of space and compositional balance.

In the right panel of this two-fold screen, an old stag with a white coat and gnarled horns stands with two younger deer near a cliff. Except for his antlers, which reveal his real identity, the shaggy old stag looks almost like a goat. The delineation of his coat is in marked contrast to the naturalistic color and soft texture of the younger animals.

In the left panel, against a gold background, a white bat appears, the Chinese symbol of happiness (*fuku* in Japanese), looking as if it had been transferred from a Chinese enameled porcelain decoration. The

deer is the symbol for rank (*roku*), and the fungi growing at the old stag's feet as well as the young pine trees on the screen's reverse side are all symbols of longevity (*ju*); thus the entire composition stands for *Fuku roku ju*, the three good wishes of Chinese tradition. We may safely assume that this screen was made for some auspicious occasion. Under his signature, *Zeshin*, the double gourd-shaped seal reads *Tairyūkyo* (Residence Facing Willow Tree).

Blessed with an early start and longevity, the prolific Zeshin created a staggering number of works. Considering his versatility and the time required by his elaborate lacquer technique, which he applied to all his works regardless of size, his international reputation is well deserved.

CERAMICS

LONG-NECKED BOTTLE

Sue ware, stoneware with natural ash glaze; early Nara period, 7th century; H. 28.5 cm
(11¼ in.) W. 20 cm (7⅞ in.); B60 P526, The Avery Brundage Collection

BY THE SIXTH CENTURY, Sue ware production had spread to many centers of population throughout the country (except Hokkaido). The early site of production, the Suemura kiln complex near Osaka, declined as methods used there became known in other communities, where groups emerged to support local production. The uniform forms and high technical standard of the Suemura products, which had influenced other kilns, gradually gave way to local variations of different styles (see nos. 20–22) and mixed technical levels. The Suemura wares also declined in quality as they began to compete with a greatly increased output at large.

In central Honshu in the Tōkai district, another production center began during the fifth century and eventually rose to great fame with a new type of ash-glazed ware (nos. 85–86). This type of bottle, with its long narrow neck, appeared at the Tōkai-area Sue kilns by the first half of the seventh century and became one of the characteristic shapes of the area. Many of these bottles were brought to eastern and northern Honshu; a few examples were also found in the area near present-day Osaka.[1]

This bottle's long flaring neck is attached at the side of a barrel-shaped body made separately, which was probably thrown on a potter's wheel. The opening at its top (where the potter completed the shape) was sealed with a thin clay disk, and a new hole cut on its side, where the wheel-thrown neck was attached. The apple-green natural glaze runs over the potter's hand marks to create irregular lines with beautiful beaded ends.

Absence of a functional bottom, either in the form of a flattened bottom or an additional flat foot rim, may indicate that this type of vessel was intended for tomb furnishing. Most likely, they were simply placed on the sandy floors of burial sites. Two other long-necked bottles nearly identical to this one have been excavated from sites in Yokohama and Miyagi Prefecture,[2] and all examples of this particular type seem to have been excavated from *yokoana* (hillside cave) burial sites, indicating that Sue ware shipped from some distance was exclusively reserved for burial use.[3]

84

FLAT BOTTLE (*heihei*)

Sue ware, stoneware with natural ash glaze; early Nara period, 7th century; H. 22.2 cm
(8³/₄ in.) Diam. 23.6 cm (9¹/₄ in.); B67 P9, Gift of Asian Art Museum Foundation of
San Francisco

THIS FLAT BOTTLE was made using the same techniques as no. 83 and very likely was made for similar use. The body and the neck were thrown separately and joined when leather-hard. The flatness of the upper body must have been achieved in part by gently patting it down while the clay was still wet enough to be plastic. The original opening was sealed with a thin clay disk and smoothed over; a new opening was cut to accommodate the neck.

This bottle's squat, flat body is described by its Japanese name *heihei* (literally, flat bottle). It shows a considerable ridge at the shoulder, and the spout is intentionally placed off-center. At the base of the spout are two small, flattened clay beads, as if simulating metal rivets, although no such metal prototypes are known to date. The clay body is light and smooth, and the vessel's body has a much better finish than no. 83.

The geographic distribution of this type of Sue ware ranges from Shizuoka Prefecture in central Honshu down to Fukuoka in northern Kyushu, including other areas such as Kyoto, Gifu, and Okayama prefectures.[1] Among published examples, a bottle from Shizuoka Prefecture was excavated from a *yokoana* burial site and has the same functional pattern as that of no. 83. Most probably at the time of burial such a vessel would have contained some form of beverage offered to the deceased.

85

LONG-NECKED BOTTLE

Stoneware with ash glaze, from the Sanage kilns; Nara to Heian period, late 8th–early
9th century; H. 24.1 cm (9½ in.) Diam. 19.7 cm (7¾ in.); B65 P39, The Avery
Brundage Collection

DEVELOPED AROUND the middle of the eighth century in Owari Province, ash-glazed ware (*haiyūtō* or *kaiyūtō*) was developed by a group of potters working near Mount Sanage. This new type of ware was the first Japanese ceramic with a deliberately applied pale green ash glaze. This first major technical experiment in glazing was probably prompted by requests from the imperial court and the central government, which were issued to ceramics centers along with samples of imported Chinese ware with a light green glaze.

Ash glazes were only one of the technical innovations introduced around this time. The Sanage potters had discovered a large deposit of superior clay near their kiln site which could withstand the 1240-degree Celsius temperature needed to mature an ash glaze. In order to further refine this clay, they began using another new method, levigating the clay in shallow pools of water to reduce impurities. This process also increased the clay's plasticity and lightened its body color, thus enhancing the color of the glaze.

The greater plasticity of the clay thus treated per-mitted a much wider use of the potter's wheel. The body and the neck of this bottle were made separately, thrown on an improved potter's wheel that made it possible to achieve sharper contours. The technique also allowed potters to model some of these ash-glazed vessels, such as water flasks, after the more clearly defined shapes of earlier Chinese and Japanese bronze vessels.

The body opening of this vessel was first sealed by a clay disk, making a double-thick base in which to cut a new hole of the desired size,[1] to which the neck was then joined. This method complemented a still-developing unitary construction method using the potter's wheel.

As recently as 1954, excavations during the construction of a water system in Aichi Prefecture gave archaeologists and ceramic historians the chance to explore the kiln complex more carefully than had been previously possible. The result was a series of publications and a completely new identification of ash-glazed ware.[2] A number of ash-glazed pieces were unearthed at a Heijō palace site in Nara, suggesting their use by the elite.[3]

FLAT PITCHER WITH HANDLE (*heihei*)

Stoneware with ash glaze, from the Sanage kilns; Heian period, ca. 800–850; H. 8.4 cm
(3¹/₄ in.) Diam. 13.4 cm (5¹/₄ in.); B87 P2, Purchased by Asian Art Museum General
Acquisition Fund

THIS TYPE OF *HEIHEI* (flat bottle) traces its early forms back to a series of round-bottomed and spouted Sue ware jars of the Kofun and Nara periods, dating from the mid-third to late eighth centuries. Its immediate predecessor can be seen in a type of round-bottomed vessel (see no. 84) to which a stabilizing foot ring has been added, a reasonable stylistic adjustment to the flat surfaces of wooden furniture and floors. The addition of a handle made of a flat clay band might indicate some sophistication in the manner of handling the vessel when serving from it, since the earlier forms without handles made it necessary to grasp the neck firmly, or to hold the vessel with both hands.

Pitchers of this type, made in the Sanage kiln complex, have been excavated from Heijō palace sites.[1] Like the earlier versions, they were used to serve sake during feasting and must have been a popular household item among the elite.

Following the usual technique, this *heihei* is made of at least three separate parts: body, neck, and handle. The circular foot was attached to the bottom, probably as a clay coil, and shaped and smoothed by turning on the wheel. This standard method resulted in a hairline crack between this vessel's body and foot, a result of the differential dryness of the body and the later-attached foot. An irregular green ash glaze covers the top, and a reddish brown glaze covers part of the spout and lower body. The piece is nearly perfect except for bare areas resulting from long burial in the unrecorded excavation site, probably the user's residence.

87
LARGE JAR

Shigaraki ware, stoneware with natural glaze; Muromachi period, 15th century;
H. 54 cm (21¼ in.) W. 48 cm (18⅞ in.); B66 P38, The Avery Brundage Collection

POTTERY MAKING during Japan's medieval period was carried on in areas where traditions of *sueki* production were already present. Six such areas — Bizen, Tokoname, Tamba, Seto, Echizen, and Shigaraki — were the first group of old kilns to be located as archaeological sites; collectively they are called the Six Ancient Kilns. In the past few decades, however, an additional fifteen or more kiln sites, including those of Suzu, Atsumi, and Kameyama, have been discovered and added to the original six.[1] Except for Seto, where potters produced glazed ware after Chinese models for their socially prominent patrons, other kilns mainly supplied farm and household utilitarian wares in three standard shapes: the *tsubo* (a narrow, short-necked jar), *kame* (a wide-mouthed jar), and *suribachi* (a shallow bowl with fine sharp ridges on its inner surface for grinding food).

Shigaraki, about 19 miles southeast of Kyoto, became the seat of the imperial court after Emperor Shomu built a palace there in A.D. 742. Here *sueki* was made from the fifth to the twelfth century; some of the ware was sent to the court as official tribute. However, there has been no scientific excavation of the area to establish a direct relationship between *sueki* production and that of medieval Shigaraki ware.

By 1967, about fifty medieval Shigaraki kilns, grouped into several centers, had been located in the valley.[2] Only a small number have been scientifically excavated; none are datable to Kamakura or earlier.[3]

The *anagama*, the standard subterranean hillside kiln used in many medieval sites, shows distinctive characteristics in the Shigaraki valley. Here the boat-shaped firing chamber was divided into two narrow corridors by a long wall, about 24 inches thick, running lengthwise.[4] These Shigaraki kilns achieved higher temperatures and an oxidation atmosphere, unlike the *sueki* reduction-fired kiln.

Large storage jars like this one were coil-built in stages. Clearly visible on this jar are three horizontal lines where the potter stopped to let the pot dry enough to support the weight of the next rise of coils. Assuming that the flaring neck was added in the same manner, this jar was built in four separate stages. Its profile, with rather angular and full shoulder lines and a flaring and relatively thin, yet strong mouth rim, places this piece safely in the fifteenth century.

Scattered against the reddish brown surface of the local clay, shining spots of melted quartz and feldspar create the distinctive texture associated with Shigaraki ware. A light green, natural ash glaze enhances some surface areas. This particular rustic quality was appreciated by a group of early *chajin* (tea practitioners) and gave rise to a complete, developed aesthetic. Many otherwise utilitarian objects then came to be treasured as tea ceremony vessels by these *chajin*, who also became eager customers for wares produced specifically for the tea ceremony (see no. 90).

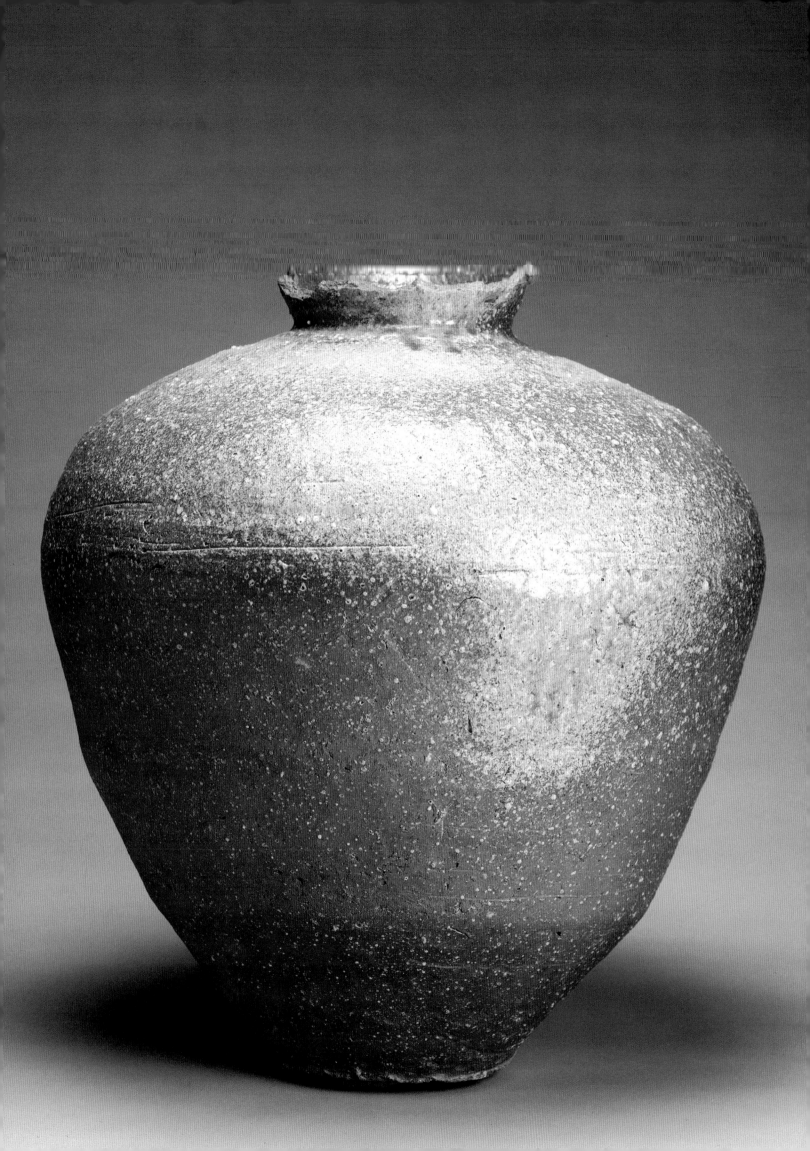

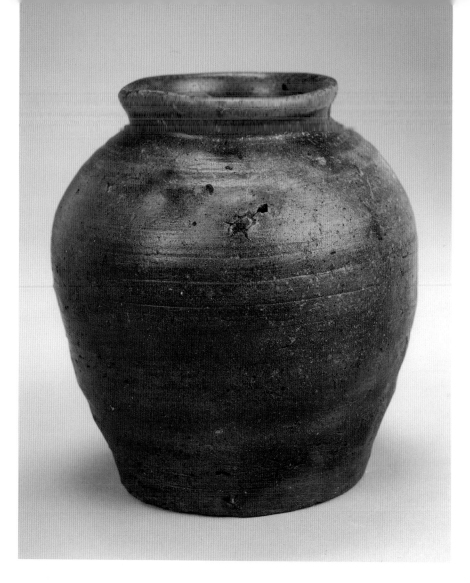

88
SPOUTED JAR

Bizen ware, unglazed stoneware; Muromachi period, 15th century; H. 15.8 cm (6¼ in.)
Diam. 15.2 cm (6 in.); B76 P3, Gift of William S. Picher

UNGLAZED, HIGH-FIRED stoneware similar to Shigaraki ware was produced, for daily household use, in other western kilns such as Tamba and Bizen, following much the same development pattern as Sue ware (see no. 87).

The largest kiln complex in western Japan, Bizen is also the best known of all medieval kiln sites. About eighty Bizen kilns dating from the late Heian to the Muromachi period had been located by 1972.[1] By 1977 this number increased by another twenty sites.[2] The rise of these kilns followed the fast decline of Sue ware production in the early Heian period and may have been stimulated by an increase in the farming population and the demand for roof tiles for temple buildings in western Japan.[3]

Early ceramic production in the late Heian period still shows a resemblance to Sue ware. It was only around the mid-Kamakura period that Bizen ware began to assume a reddish brown surface, the result of oxidizing conditions in the kilns. By the fifteenth century, the kilns were consolidated into four major sites on the hillsides near Imbe village.[4] Their production concentrated on the three standard shapes (see no. 87), but in Bizen, extra large *kame*-type storage jars were made to meet the needs of the farming community, where human waste was an important source of fertilizer. The Muromachi period saw an increase in the variety of Bizen shapes, including this spouted jar. The size of these shaped jars was large at first and gradually became smaller. Collectively called *abura tsubo* (oil jar), they no doubt were used for a variety of purposes.

The characteristically dark and smooth clay, typical of the region, was dredged from the bottom of rice fields. The lip of this wheel-thrown vessel was shaped into a spout by simply pushing and pulling the soft clay by hand. The five short lines incised by a sharp stick on its shoulder are probably a kiln mark, used to identify potters who shared the communal kilns.

89
POWDERED TEA CONTAINER (chaire)

Mino ware, stoneware with iron glaze; Momoyama period, late 16th–early 17th century; H. 5.3 cm (2⅛ in.) Diam. 5.7 cm (2¼ in.); B85 P11, Gift by transfer of the Fine Arts Museums of San Francisco

CHAIRE WERE MADE to hold a small portion of freshly ground green tea powder for the tea ceremony. The use of such small jars began during the thirteenth century with imported Chinese jars that most probably originally contained spices.[1] Those adopted as *chaire*, as well as later ceramic jars made for this purpose, were fitted with ivory lids.

The great popularity of Chinese tea utensils — celadon and *temmoku* bowls, and lacquer wares — gave rise to the esteem in which these insignificant-looking jars of glazed stoneware were held. They were named with reference to their shapes, or according to some significant historical background or literary allusion. Ranked on the basis of quality, finer jars were worth as much as a small fiefdom in Japan and given as rewards to samurai for distinguished accomplishments. They were fitted with *shifuku*, protective decorative sacks.[2]

Although the general preference for Chinese imported tea wares shifted to the more subdued *wabi* taste for Japanese utensils, the need for *chaire* in the Chinese style remained part of the new and simpler style of tea ceremony. In a much smaller tea room, with the host actually preparing tea before a small number of guests, the setting became more intimate. *Chaire*, incense containers, and other tea utensils became more important, maintaining the popularity of Chinese jars and stimulating the production of Japanese *chaire*.

Seto potters, who were already replicating imported jars for the tea community during the fourteenth century, escalated production to keep up as the taste for tea spread rapidly during the Muromachi period. Potters in several other communities were also busy making small tea containers. Of the domestic production, old Seto jars were by far the most sought after,[3] although Mino potters also produced good examples, like this one. In Mino, *chaire* in the old Seto style were made mostly during the Momoyama period.[4] The energy of the Mino potters, however, shifted more toward food-serving dishes in the early Edo period; consequently, far fewer Mino *chaire* remain.[5]

This *kubinaga* (long-necked) *chaire*, made according to a standard technique, was thinly thrown on the wheel and covered with a dark brown glaze down to the lower body, where there is a slight ridge. A narrow area toward the bottom of the body is left uncovered; here the glaze line irregularly exposes the clay body, which is somewhat softer and less dense than that of Seto ware. The cutting mark still remains on the bottom of the piece, where a length of twine was used to cut through the clay, leaving behind a mound of unformed clay for the next pot.

TEA-LEAF STORAGE JAR

Bizen ware, unglazed stoneware; Momoyama period, early 17th century; H. 27.3 cm
(10¾ in.) Diam. 23.5 cm (9¼ in.); B67 P10, Gift of Asian Art Museum Foundation of
San Francisco

PROMPTED BY THE discerning taste of tea connoisseurs for utilitarian wares, potters in Bizen and Iga began producing early *wamono* (domestic tea ware) in the late sixteenth and early seventeenth centuries. At this time, Bizen production was reorganized into three extremely large community kilns shared by many potters. The first discovery and excavation of one of these kilns in the southernmost Bizen site took place in 1951. According to a scale drawing made in 1954, the largest kiln in this site measured 150 feet long by 15 feet at its widest point. It was a large, rather primitive single-chamber construction without a dividing pillar in the front part.[1] Numerous marks on Bizen ware from this period (see no. 88) indicate that potters marked their wares to identify their own work and also the orders of special customers,[2] some of whom were the new clientele interested in tea ceremony wares.

Along with the kiln mentioned above, Bizen community kilns in the northern and western areas were each fired about seven times a year, a continuous firing lasting thirty to forty days and requiring a well-organized cooperative effort.[3] Six designated families were in charge of the operation; some of their descendants are still active in modern ceramic manufacture.

This ovoid jar with a straight neck and four loop handles on the shoulder was probably a tea-leaf storage jar, though somewhat smaller in size than the standard jars used for this purpose. The upper two-thirds of the body is covered with *hidasuki*, a fire-mark pattern. Originally these marks were left by the rice straw in which pots were wrapped to prevent them from sticking together in the kiln, where they were closely stacked. The silicates in the rice straw, fluxing on the clay surface, formed glassy patterns that came to be greatly admired by Japanese collectors.

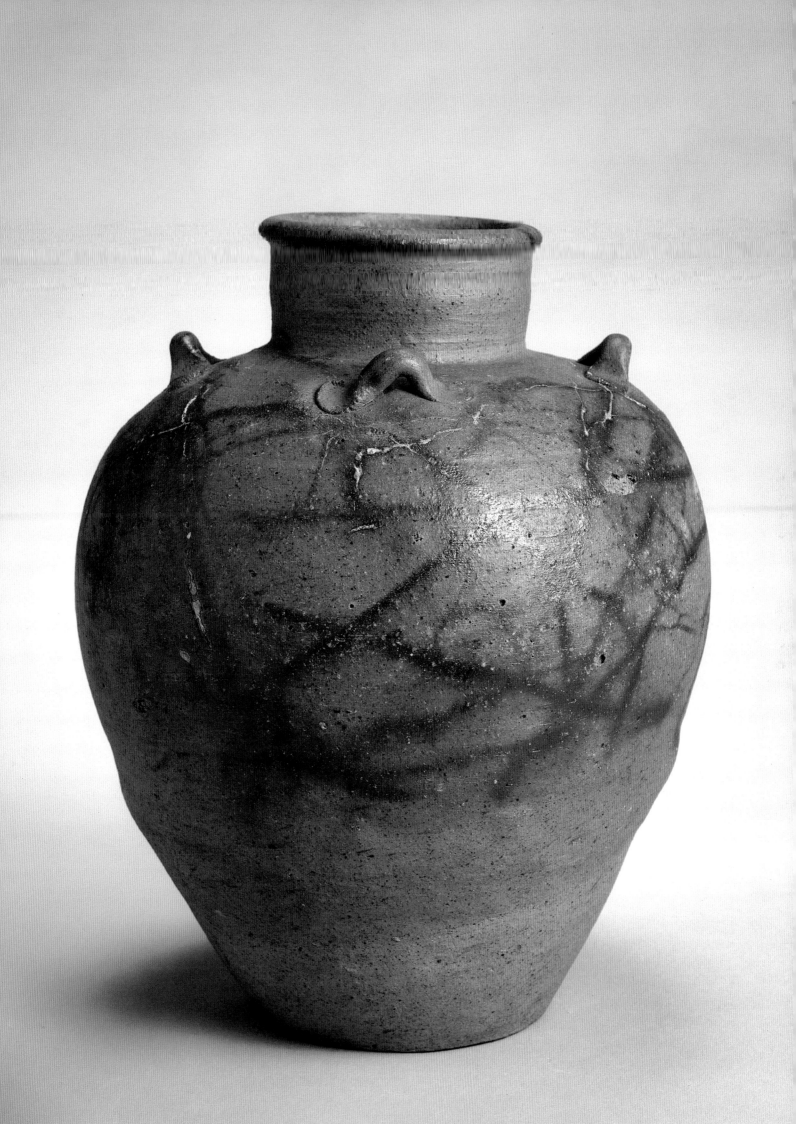

JAR

Tamba ware, stoneware with natural ash glaze; Momoyama period, late 16th century;
H. 44.5 cm (17½ in.) Diam. 35.6 cm (14 in.); B62 P30, The Avery Brundage Collection

ONE OF THE PHYSICAL characteristics of early Tamba ware is a rich greenish color of the natural glaze where it pooled as it cascaded down the sides of jars and bottles. Despite the relative abundance of ware considered to originate from Tamba, and its early recognition as a major kiln site, there has been little organized effort to investigate and excavate even the known sites.[1]

Shōichi Narasaki, one of the foremost authorities on medieval ceramics in Japan, speculates that Tamba followed much of the standard developmental pattern of other kilns of the medieval period.[2] Situated in a historically and geographically important location between Kyoto and western Honshu, Tamba located its ceramic production on the hillsides along the route connecting major communities.[3] Medieval production most probably took place near the sites of the earlier sueki kilns but does not represent a direct continuation of that ware.[4]

The five located Tamba sites (consisting of only ten kilns) must date from medieval times, that is, from middle Kamakura to early Muromachi, since potters then were busiest meeting local mass demand.[5] Although scholars differ somewhat in their interpretations of the evidence, the Tamba kilns must have been close in basic styles to those used by other communities.[6]

Tamba potters produced wares mostly of the three basic shapes and their variations—wide-mouthed jars, narrow-necked jars, and grinding bowls (see nos. 87–88). In Tamba, however, fewer suribachi were produced, unlike Bizen, where many of these grinding bowls were made. Tamba also added the oke (barrel shape), as well as shallow bowls, wine bottles, and small dishes.[7]

Judging from surviving examples, Tamba potting techniques resembled those of potters in other provinces. Local, little-refined clay was used. Vessel bodies were formed on a turntable by the coil method, usually in three stages, from the bottom to the top. When the first, lower section was hard enough to support the additional weight of the clay, the next level was added. Sometimes four or even five coiling stages were required for larger pieces. The mouth rim was shaped by using the turntable in a manner closer to wheel throwing.

The shoulders of this jar are covered with a characteristic greenish glaze running down the side and forming a triangular point. The glaze is spotted on one shoulder with fallen bits of kiln flaking. The somewhat tapered high neck has a rim slightly flattened but finished in a simple, straightforward manner, all characteristics of Momoyama period craftsmanship. The noticeably constricted low waist is not intentional but is the result of uneven potting, where slightly drier clay coils may have been used.

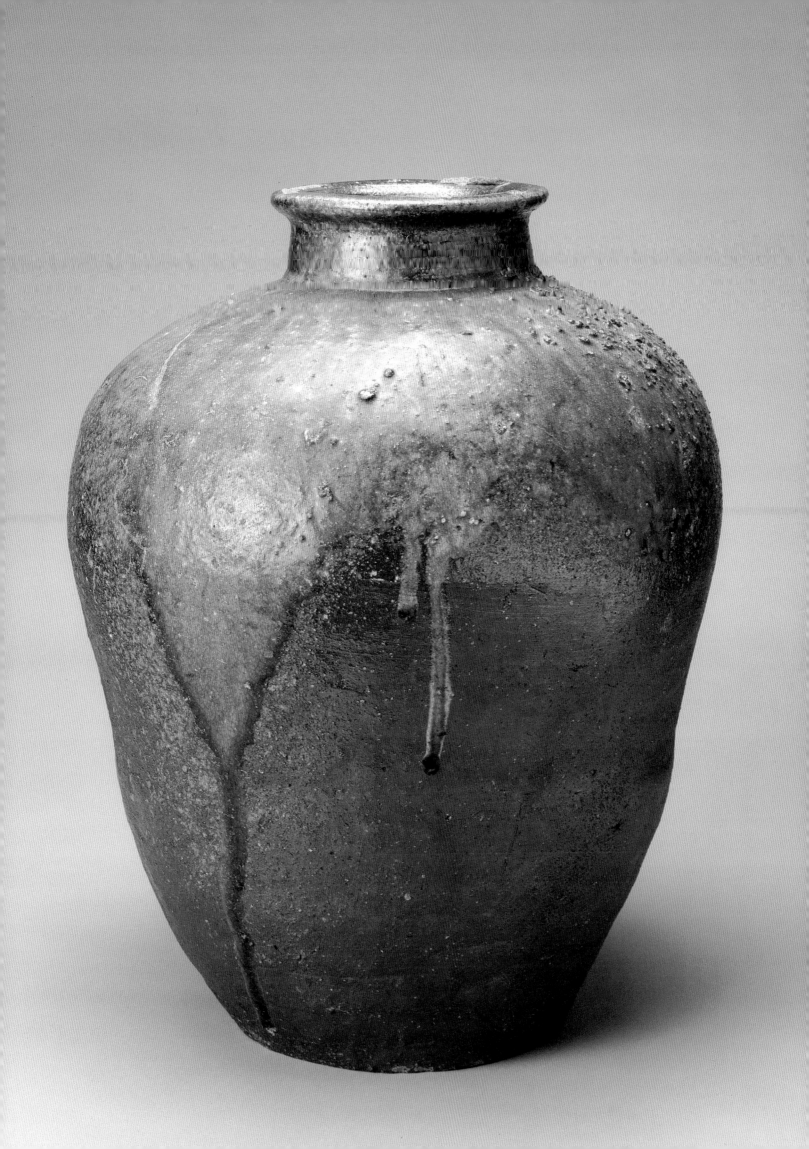

FRESH WATER JAR FOR TEA CEREMONY

Iga ware, stoneware with ash glaze; early Edo period, 17th century; H. 19.7 cm (7³/₄ in.)
Diam. 19.7 cm (7³/₄ in.); B68 P4, Gift of Asian Art Museum Foundation of
San Francisco

CERAMICS FROM THE two neighboring provinces of Iga and Shigaraki are so alike in appearance that they are not easily distinguished. So few old Shigaraki and Iga kiln sites have been identified and examined to date that it is virtually impossible to differentiate them on the basis of broad evidence. Given the occasionally disputed and shifting borderline between the provinces, and the similarity of medieval stoneware in general, early ceramics from these two provinces were simply treated alike, although probably Iga was more often confused with Shigaraki ware.

It was only in the Momoyama period, when both locations began to make wares for the tea ceremony, that their styles became a little more discrete. Iga ware has a finer and whiter clay body, with minute iron oxide spots, and a smoother natural glaze than Shigaraki ware.[1] The lighter Iga clay also shows the greenish color of the natural glaze to much greater advantage.[2] This quality may have been a piece of luck for the Iga potters, who quickly moved into tea-ceremony utensil production for the fast-developing market. The firing temperature of Iga ware was also so high that the fine clay became extremely vitreous, an advantage for wares made to hold water.

Iga potters, like those of many other ceramic centers of the period who responded to the taste of tea masters like Furuta Oribe (see nos. 97–99), produced a diversity of tea-related ware of great strength and beauty: tea bowls, incense containers, tea-leaf storage jars, and other utensils. Distinctive among them, however, are fine flower vases and fresh water jars, most of which were highly treasured in Japan.

Many pieces were commissioned by feudal lords in the Iga area. Such commissioned items came to be called by the patron's name—Tsutsui Iga, Tōdō Iga. Tsutsui Sadatsugu (1562–1614), a provincial lord and a student of Sen no Rikyū and Oribe, contributed a great deal to the aesthetic advancement of Iga ware. The lord Takatora (1556–1630) of the Tōdō family, who resided in the province after the Tsutsui family was exiled to a northern province, was also very much interested in tea ware and was a close friend of Oribe. It is no accident that some Iga ware is closely related to Oribe ware.[3]

This particular fresh water jar shows a strong Momoyama style in its modeling. The jar was wheel thrown, then freely shaped by hand and further embellished with sharp spatula marks. The characteristic natural green glaze that covers areas on the lip and sides is especially thick where it pooled in the indentation, showing rich shades from light green to caramel brown.

LARGE DISH WITH PLANT DESIGN

E-Shino ware, stoneware with feldspathic glaze; Momoyama period, ca. 1600; H. 8.3 cm
(3 1/4 in.) Diam. 37.5 cm (14 3/4 in.); B66 P37, The Avery Brundage Collection

MOMOYAMA CERAMICS are characterized primarily by decorative light colors, which reflected the taste of a new urban society in Japan. A long, devastating civil war had come to an end, and the country was rebuilding under the new powers of the daimyo (provincial war lords). This ascending class was dependent on the support of merchants, whose strength rapidly increased, creating an urban culture that favored a taste for the light and colorful. In the peaceful capital city of Kyoto, the Kabuki theater, *renga* (linked verse), and a newer style of tea ceremony were becoming popular arts, their influence extending even into more distant provinces. Contemporary with these arts, and for the first time in the country's history, Mino potters produced ware that can be regarded as wholly Japanese in style: Shino and Oribe.

Departing from the medieval austerity of Shigaraki and Bizen wares (nos. 87–88, 90), Mino potters were inspired by new materials and techniques. They made many fine tea-ceremony pieces, although the ceramic industry as a whole was still supported by production of vast quantities of utilitarian wares. Tea bowls, *chaire* (tea caddies), water jars, incense containers, and flower vases constituted the more important tea utensils. Of secondary importance were food-serving dishes. Shino is renowned for both tea ware and food dishes, while Oribe was more treasured for food dishes.

When first introduced to tea masters in the late 1500s, Shino ware was called "Seto" or simply "white ware," confusing the newer wares from Mino with these of nearby Seto Province, the older and more established ceramic center. The description shows a keen awareness of the recent emergence of a white glaze, a native invention.[1] A few surviving white tea bowls from the Tembun era (1532–1555), in the much-treasured Chinese *temmoku* shape, and appropriately called *shiro temmoku* (white *temmoku*), are believed to be a distant inspiration of this genuine Japanese ware.[2]

The thick, milky effect of the Shino glaze resulted from the application of a simple feldspar glaze to a white clay, which in the early years was fired in a large *ōgama* kiln,[3] a much-improved version of the single-chamber *anagama* (trench kiln, see no. 87). Frequently the oxidizing iron content of the local clay, used without much preparation to reduce impurities, produced varying orange-brown streaks, giving the plain Shino unexpected natural decoration. This subtle quality, greatly prized by the Japanese as *hi-iro* (color created by fire), may have prompted potters to use iron oxide for intentional decoration.

Shino ware is grouped into several categories based on decorating techniques and the range of iron-oxide color developed during firing. Color can vary from a bluish gray to bright orange to nearly black, owing to variable kiln conditions and depending on the thickness of the iron-oxide slip decoration and the glaze applied over it. A prized type is *beni* Shino, or rouge Shino, with a bright orange body.

The largest and probably most popular group is E-Shino, or painted Shino. This large flat dish shows a row of five slender, sparsely leafed plants, with other vegetation painted around the flange in swift brushstrokes. Its relatively thick walls and soft, organic sculpted quality including the rolled feet are characteristic of Momoyama period pieces. Unlike the early group of tea bowls and water jars with decoration obscured under thick glazes, this dish has a more translucent glaze resulting from good, consistent glazing and mature firing in a further improved kiln, the *noborigama* (hill-climbing kiln) introduced from Karatsu (see no. 97). Its more stable temperature and firing atmosphere produced an even glaze quality more suitable for food vessels, on which a wide range of poetic decorations might appear.

While smaller dishes were wheel thrown, this large dish was constructed by adding sides (probably by coiling) to the flat clay disk forming the base, leaving a visible seam. The dish was then finished on a slow-turning wheel to create the soft, somewhat irregular shape preferred by Momoyama taste.

94
MUKŌZUKE DISH

E-Shino, stoneware with underglaze iron; Momoyama period, 1573–1615; H. 4.7 cm
(1⅞ in.) W. 16.8 cm (6⅝ in.); B69 P1, Gift of Asian Art Museum Foundation of
San Francisco

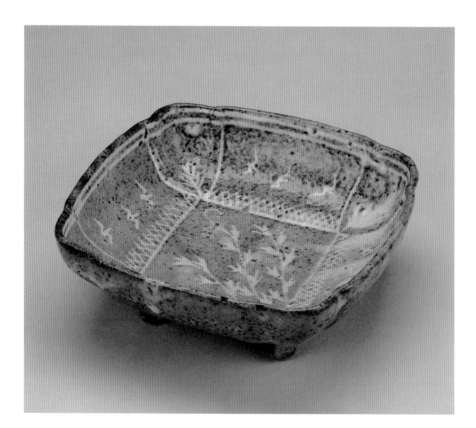

95
MUKŌZUKE DISH

Gray Shino, stoneware with iron slip sgraffito; Momoyama period, 1573–1615; H. 6 cm
(2⅜ in.) W. 16.2 cm (6⅜ in.); B69 P2, Gift of Asian Art Museum Foundation of
San Francisco

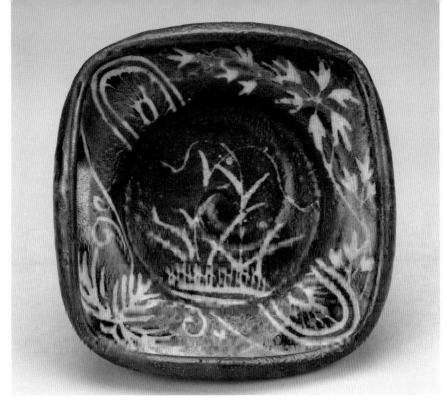

MUKŌZUKE DISH

Gray Shino, stoneware with iron slip sgraffito; Momoyama period, 1573–1615; H. 6 cm
(2³/₈ in.) W. 15.8 cm (6¹/₄ in.); B76 P2, Gift of Asian Art Museum Foundation of
San Francisco

THESE SMALL DISHES usually held an appetizer such as marinated fish or vegetables. The term *mukōzuke* describes their use in a uniquely Japanese way. Literally it means "placed on the opposite side (of the serving tray)" from the guest; closer to the guest on the tray are the rice and soup bowls. *Mukōzuke* dishes are most commonly made in groups of five, or sometimes ten. These examples are two of the most popular of several types, gray Shino and E-Shino. Rarer types are pink Shino, marbled Shino, and rouge Shino.

E-Shino (painted Shino) has a white background to accommodate pictorial decoration (no. 94; see also no. 93). Recent studies by art historians and archaeologists define the Shino glaze and decorative style as being of indigenous Japanese origin, not influenced by or derived from foreign models.[1]

Gray Shino or *nezumi* (mouse) Shino has a range of gray background color with white decorative motifs, an effect achieved by first covering the ware with a slip containing iron oxide, then scratching the design through the half-dried slip to reveal the lighter clay body. When the piece was covered with the same white glaze used for E-Shino and fired, the glaze that pooled into the pattern acquired the same milky-white appearance. Differences in the amount of iron oxide in the slip, its thickness and that of the glaze, and probably other variable firing conditions, like temperature, placement, and kiln atmosphere, resulted in a wide variety of grays. The true gray of this plate (no. 95), with its slightly lobed corners, provides a good background for the finely incised designs of swaying vines, cross-hatched grasses, and flying birds.

Occasionally gray Shino ware takes on a rich dark brown color, as on this dish with its decoration of reeds, vines, and underbrush (no. 96). Its motifs also include a pair of *katawaguruma* (half wheel), a design inspired by wooden cart wheels that were left half-submerged in rivers in Kyoto to prevent drying and cracking. From the Heian period on, this theme was repeatedly used on textiles and lacquers made for high-ranking clientele. Its appearance on this gray Shino dish indicates that Shino potters were familiar with traditional motifs of a courtly, sophisticated repertoire.

Each dish has three loop feet and spur marks on the base. In addition, the base of the first dish is marked by a distinct ridge. These types of dishes were sometimes fired with Oribe ware (see nos. 97–99) in large *noborigama* (hill-climbing) kilns with multiple chambers (see no. 93).

DISH WITH HANDLE

Ao-Oribe ware, stoneware with glaze; Momoyama period, 1573–1615; H. 14.9 cm
(5⁷/₈ in.) W. 22.5 cm (8⁷/₈ in.); B64 P34, The Avery Brundage Collection

IF IN ITS BASIC monochromatic pattern, Shino represented the lightness of Momoyama period ceramics (see nos. 93–96), Oribe ware, distinguished by its colorful asymmetrical design, gives us the essence of Momoyama decorative arts. The glaze, obtained by adding copper oxide to the basic feldspathic glaze, ranges from soft grass-green when thinly applied to deep opaque green when thickly pooled. Copper oxide, used sparingly, makes the small green dots on yellow Seto ware, another type of Mino tea ware.

This handled dish and no. 98 are classified as Ao-Oribe (green Oribe), pieces partly covered with a green glaze, with reserved areas decorated with painted patterns in iron-oxide brown. This decorative device of contrasting tones, often used diagonally, appears frequently in other Momoyama period crafts such as textiles and lacquers.

The dish was made with the help of a mold in which thin clay slabs were shaped into this complex form. The texture of a piece of flat-weave cloth, used to prevent the clay from adhering to the mold, appears on the piece, visible under the glaze. Two corners of the tray and the handle that diagonally connects them are covered with a glaze which has pooled into a rich dark green in some areas. Plum blossom patterns decorate the other two corners. The center motif, suggesting a checkerboard and some young fern shoots, curiously harmonizes geometric and organic elements, a combination of patterns exemplifying the playful nature of some Oribe designs. The underside of the tray has four loop feet and is decorated with a horizontal line and stylized scrolls.

The name Oribe seems to have come from the Samurai tea practitioner Furuta Oribe (1544–1615), the most devoted student of Sen no Rikyū (1522–1591), one of the most famous tea masters in Japan. Unlike Rikyū, who treasured subdued, unpretentious ware, Oribe preferred bold, colorful, irregular-shaped ware decorated with imaginative designs.[1] Contemporary records do not use the term "Oribe" but simply list "contemporary ware" or "Seto tea bowls," even though the pieces were actually produced in Mino Province. This was simply due to the greater popularity of older Seto ware and the confusion of two ceramic centers so close to each other.

The urban communities of the Momoyama period, with their newly powerful merchant class, were fully acquainted with colorful, imported ceramics, which stimulated the desire for similar domestic ware. To meet this demand, the Mino potters adopted from Karatsu a new type of kiln, the *noborigama*, built on a hillside. One such kiln at Motoyashiki, in Mino, was built sometime around 1597 on the outskirts of the present-day city of Toki by a certain Katō Kagenobu. Longer than other kilns and with numerous chambers that could be fired directly through side openings, it measured 72 feet long and 7 feet wide. The floor of each of the fourteen chambers followed the 10- to 20-degree incline of the hillside, creating conditions conducive to better firing at higher temperatures.[2] This type of kiln was also much more fuel efficient and made possible mass production of ceramics.

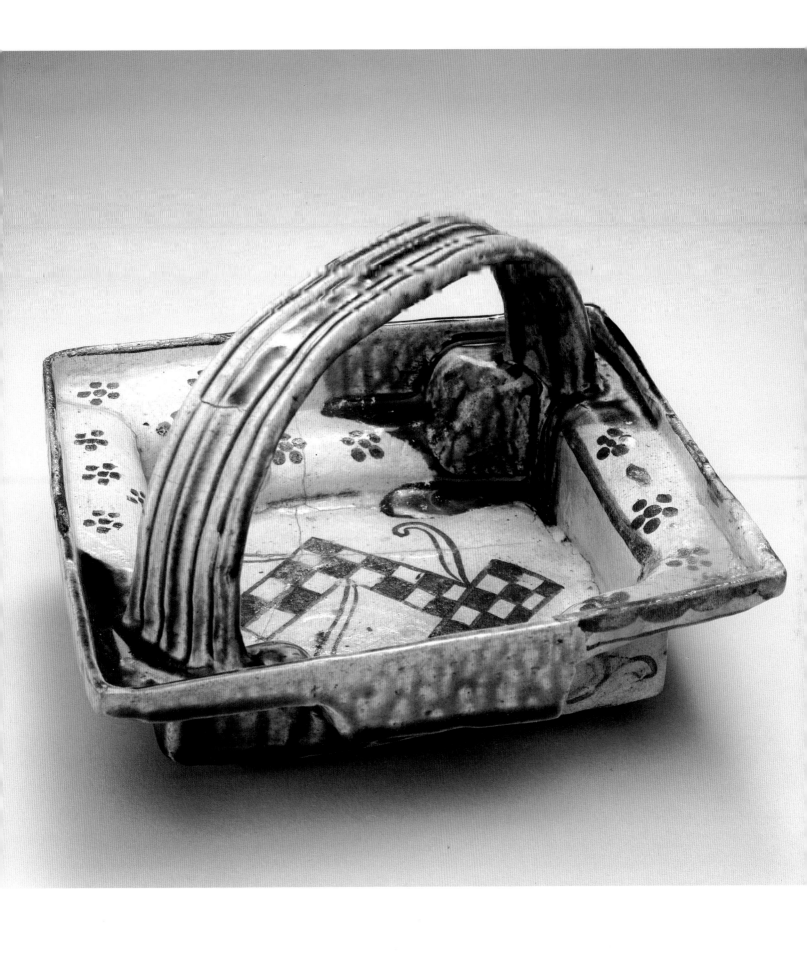

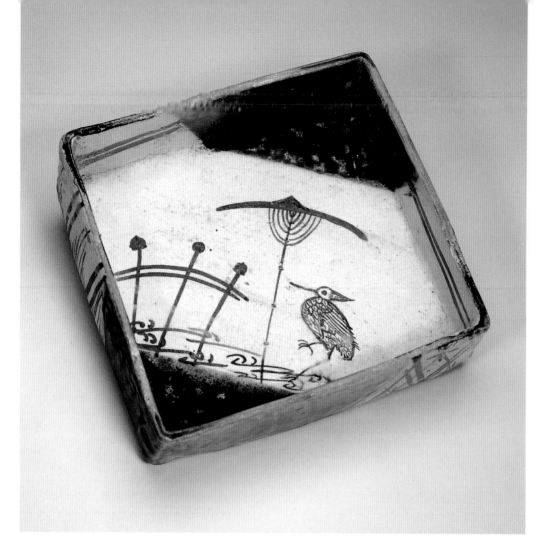

98
SQUARE DISH

Ao-Oribe ware, stoneware with glaze; Momoyama period, 1573–1615; H. 5.7 cm
(2 1/4 in.) W. 19 cm (7 1/2 in.); B67 P8, Gift of Asian Art Museum Foundation of
San Francisco

THIS DISH DISPLAYS the diagonal composition, green glaze, and underglaze iron oxide painting seen in no. 97. Among pieces more typically complex, however, its simpler decorative composition is less usual. Here a naturalistic pattern depicts an arched bridge over a stream, a parasol, and a perching bird that somewhat resembles a decrepit heron.[1] On opposite outer corners are stylized irises and a geometric diaper pattern.

By the mid-sixteenth century, the wares of the Mino kilns were supplanting those of Seto in popularity. The greater success of the Mino potters was due to their timely development of original designs — made possible by technological advances such as the recently adopted multichamber kiln and colorful new glazes — that

appealed to the emerging daimyo population. The economically strong daimyo directly controlled the rice crops of their fiefdoms, unlike the imperial household, court officials, and temples, who were the traditional Seto patrons. The old regime was rapidly losing control of its revenues from distant farmlands entrusted to hired and generally uninterested, if not outright dishonest, managers, and its traditional support of the Seto kilns diminished.

This dish is constructed of clay slabs. The feet are two long strips of clay extended on opposite sides underneath, ending just short of the full width of the base. The dish originally had a similarly decorated cover, which is missing.

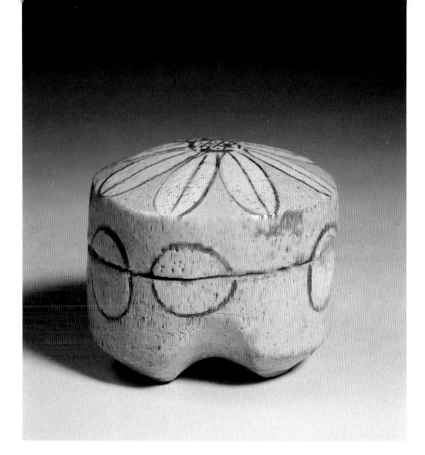

99
INCENSE CONTAINER

E-Oribe ware, stoneware with glaze; Momoyama period, 1573–1615; H. 4.4 cm
(1 ¾ in.) Diam. 5.2 cm (2 in.); B74 P4, The Avery Brundage Collection

UNLIKE OTHER ORIBE pieces (nos. 97–98), this covered container does not have the ware's characteristic green glaze, but its softer palette and intimate format make it a fine example of E-Oribe (painted Oribe). Decorated with subtle colors ranging from buff to brown, this covered container was made to hold a small amount of incense to be used for the tea ceremony. On the slightly domed cover is a single chrysanthemum-blossom decoration, outlined with iron-oxide brown and filled with light-colored slip. The sides of the lid and container are linked by circles casually drawn with iron-oxide slip.

As the setting for the tea ceremony changed from a large to a smaller room during the Momoyama period, the selection of even practical utensils came to be carefully considered. In a smaller space, tea was prepared right in front of the guests. The event started with the host ceremonially preparing charcoal by adding fresh pieces to the hearth along with a small portion of specially prepared incense. The incense container, formerly part of an incense burner set away from the guests in a larger room and often unnoticed, became a focal point. With participants in close proximity, viewing and admiring small utensils, including the charcoal container and the metal chopsticks for handling the charcoal, became part of the ceremony.

A complementary aesthetic balance between the incense container and the charcoal container was desirable, and much smaller incense containers, easy to hold in the palm of the hand, came to be preferred.[1] Tea practitioners became much more selective in choosing imported containers, and domestic production reflected this partiality as potters became aware of the economic potential of the new market.

Incense containers made of plain wood, lacquered wood, papier-mâché, bamboo, and ceramics of various origins and types came to be treasured. Their popularity was actually charted by tea connoisseurs during the Edo period in a manner similar to the way in which enthusiasts charted their favorite *sumō* wrestlers' championship bouts.[2]

100
LARGE BOWL

E-Karatsu ware, stoneware with underglaze iron; Momoyama period, 1573–1615;
H. 12.4 cm (4⁷⁄₈ in.) Diam. 41.9 cm (16¹⁄₂ in.); B84 P1, Gift of Alice C. Kent

KARATSU, A PORT community on the northern Kyushu coast, is situated near one of the most picturesque beaches in Japan. Though the name "Karatsu" is used collectively for all ceramics made in the area and shipped out of this port, production spread throughout communities south of Karatsu, to Imari, Takeo, Arita, all of Saga Province, and even to Sasebo in Nagasaki Province.[1]

Ceramic production of this area, because of its geographic location, developed in close association with that of southern Korea and is generally believed to have started around the early part of the sixteenth century. Later it was revitalized by Korean potters newly arrived in Japan either as hostages or voluntary immigrants, following Toyotomi Hideyoshi's ill-fated attempt to invade Korea in the mid-1590s. Generally protected by provincial lords, these skilled Korean craftsmen and their offspring spread over western Japan. They established kilns, and many successfully settled in communities still famous, such as Satsuma and Hagi, as well as the villages near Karatsu.

Although the most celebrated examples of Karatsu ware relate to the tea ceremony and are treasured by tea practitioners, the success of any potters' community depended on production of utilitarian ware that served a wider population. From Karatsu, with its advantageous sea route, distribution spread so widely throughout western Japan that Karatsu-*mono* (wares from Karatsu) became a generic term for any ceramics in this vast area, whatever their origin.

Karatsu ware with underglaze iron decoration may be the most popular, simply because of its more overtly decorative quality. While the origin of this decoration technique is unclear, most scholars agree that the Korean potters brought it with them.

The so-called Korean-Karatsu tea-ware style most strongly reflecting Korean taste has an opaque blue-gray glaze. Korean influence emerges not only in shapes and glazing style but in a more pronounced fundamentally utilitarian approach, as seen in this strong, wheel-thrown bowl. A cluster of swaying reed-like plants was swiftly painted with a group of three flying plovers, also painted in strong, free brushstrokes. Another large bowl in Japan, an extremely disfigured kiln discard excavated from the Kameya-no-tani site in Matsuura district, has a painted design of similar birds combined with a free plant form.[2] This clearly suggests the probability that this bowl, which survived firing in relatively good condition, was from the same kiln and was saved for the market.

The white spots along the circular mark (on the inside bottom) left by another object placed in the bowl during firing are from the shell fragments used to separate pieces while firing.[3] The marks are considered part of the bowl's charm and the crack that developed during the firing did not discourage its first purchaser.[4] The aesthetics of early tea practitioners such as Furuta Oribe (see nos. 97–99) and his followers also encouraged the preservation of this bowl.[5]

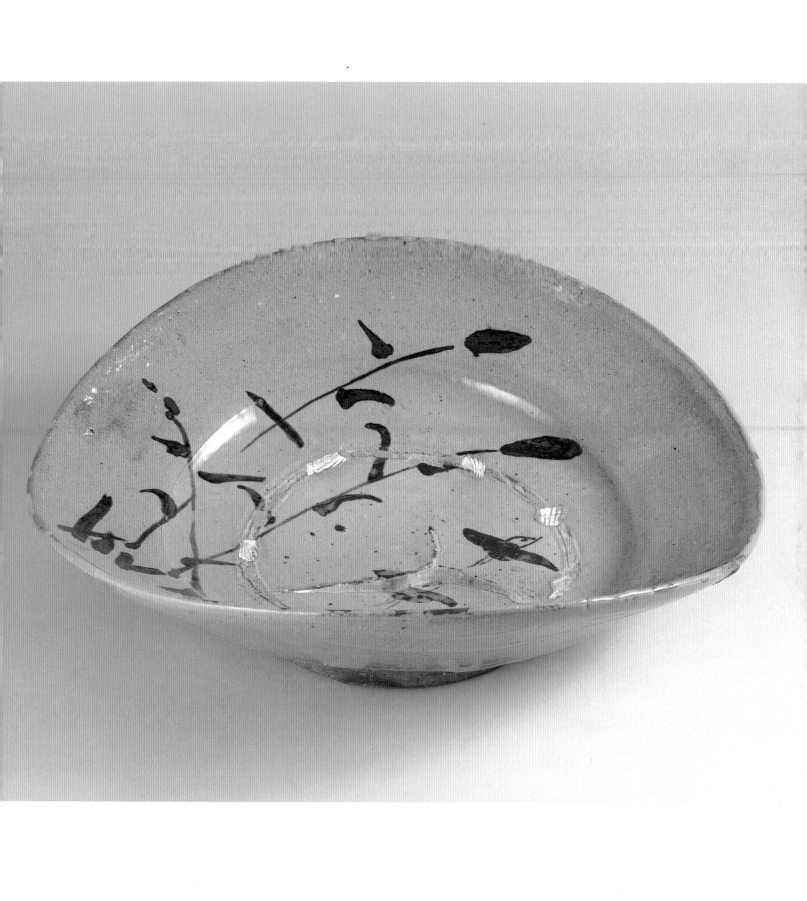

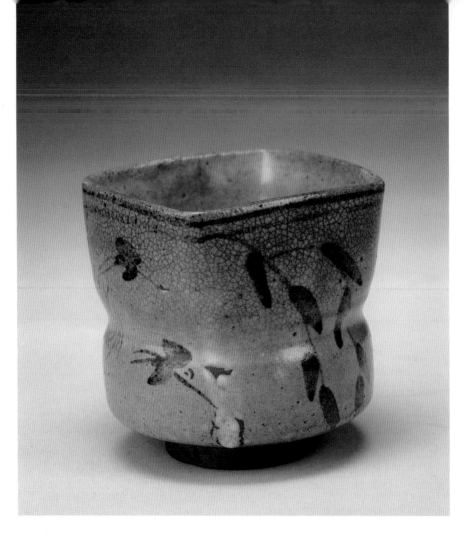

101

MUKŌZUKE DISH

E-Karatsu ware, stoneware with underglaze iron; Momoyama to Edo period,
early 17th century; H. 9.5 cm (3¾ in.) W. 8.9 cm (3½ in.); B74 P7,
The Avery Brundage Collection

OF ALL TYPES of Karatsu ware, painted Karatsu may be the most popular in Japan because of its simple, charming patterns, which appear softly through a thick and milky feldspar glaze or quite sharply under a more nearly transparent ash glaze.

This deep *mukōzuke* dish was probably once a part of a set, likely of five pieces. Its relatively deep shape, usually associated with drinking vessels in the West, is actually another shape for serving solid food. Other examples of Oribe *mukōzuke* are even taller.

Because of the relatively plastic clay they used, Karatsu potters usually relied on wheel production. This *mukōzuke* was wheel thrown with a constricted middle and later shaped by hand to form the four-sided mouth. The design—a branch of willow, two types of conventionalized plants, and stylized swallows—is painted in iron oxide under a soft, translucent glaze. The clay is a warm, dark chocolate-brown, visible in the unglazed low foot, the inside of the foot rim, and a narrow area just outside it.

The glaze on this *mukōzuke* is evenly well matured

except for a small area on the corner at the constricted ridge. Crawled and pooled glaze turned milky white, indicating that this may be a feldspathic glaze. The typical poetic design of various subjects in spontaneous and skillful brushstrokes, however, is clearly visible under the glaze and crazing that appeared after firing.

E-Karatsu ware was fired in many kiln complexes. Ichinose-Kōraijin and Kawaraya-tani are kilns that fired such famous examples as those in the Suntory Museum and Umezawa Memorial Museum collections in Japan.[1] This piece is attributed to Uchidasaraya kiln.[2]

This particular piece was once inventoried as a *hiire*, an ash container of a tobacco set. But the fact that the entire interior is carefully glazed indicates that it was not originally a *hiire*, since their interiors are not ordinarily glazed to the bottom. This suggested use, however, is in keeping with tea connoisseurs' practice of adapting odd pieces surviving from original sets to whatever uses might be appropriate. The former owner of this *mukōzuke* must have used it as a *hiire* as he enjoyed puffing his tobacco.

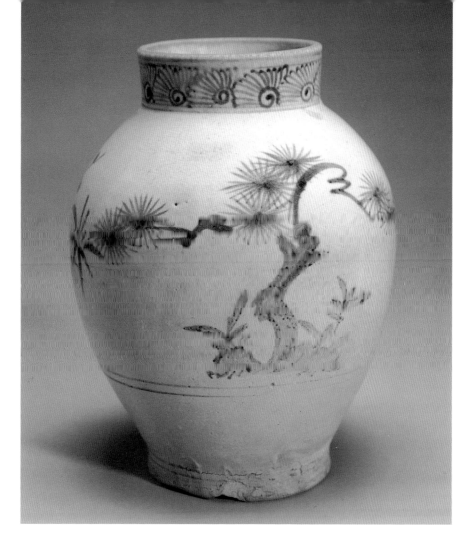

102
JAR WITH WIDE MOUTH

Early Arita ware, porcelain with underglaze blue; early Edo period, mid 17th century;
H. 21.3 cm (8³/₈ in.) Diam. 16.5 cm (6¹/₂ in.); B64 P28, The Avery Brundage Collection

TRADITIONALLY IT was believed that porcelain in Japan was first fired around 1615, shortly after kaolin was discovered in Arita by Li Sampei, a naturalized Korean potter working in nearby Saga Province. From 1965 to 1970, however, a series of excavations at the Tengudani site in Arita unexpectedly unearthed three layers of multichamber kilns, each new one built on top of an abandoned older kiln.[1] Two sets of three layers of kilns situated side by side were revealed in the excavation.

Through scientific dating, the closing of the second-oldest of these kilns has been determined to be around 1614 or 1615. Some porcelain shards and complete examples collected from the lowest (oldest) kiln, reflecting the influence of widely imported Chinese Nankin ware with its poetic cobalt blue decorations, establish that porcelain production was already well under way by that time.

A few well-developed though stylistically still rather simple celadon pieces were found in the earliest kiln level, attesting to the technical advancement of this early production.[2] Korean influence is apparent in some styles and decoration of early wares. Therefore, it is now believed that porcelain production began before Li Sampei's time and under other unknown Korean and possibly Chinese potters.

This jar reflects Korean influence in its decoration and form—shoulderless ovoid contour, thick foot rim, and vertical neck. Along with these stylistic characteristics, a soft orangish tinge in the clay color and a translucent glaze with small pittings help date the jar.

The auspicious theme of Three Friends, *shō chiku bai* (pine, bamboo, and plum), is found in many different stylizations. Here the design has been applied in swift calligraphic strokes, resulting in an unstudied quality with instant appeal. Fragments bearing similar decoration have been found in various Arita kiln sites, including the complex at Tengudani.

103
LARGE JAR

Arita ware, Imari type, porcelain with underglaze blue; Edo period, late 17th century;
H. 59.1 cm (23¼ in.) Diam. 43.7 cm (17¼ in.); B62 P146,
The Avery Brundage Collection

FROM ITS BEGINNING Arita porcelain made steady progress in production and distribution. The usual supply and demand system that stimulates any economic situation played its basic role in Arita. In addition, when the Izumiyama kaolin deposit was discovered in the early 1670s, the provincial government of Hizen was quick to take full advantage of this enormous and readily accessible supply of fine clay. The Sarayama Daikan (officials in charge) divided Arita porcelain production into roughly three areas: Uchiyama, Sotoyama, and Ō-Sotoyama (the Inner, Outer, and Greater Outer mountains).

The Inner Mountain, an area about 2½ miles long, contained the Izumiyama kaolin deposits on the east end, the officials' quarters and meeting hall in the center, and nearby, the red enamel workshops, including that of Kakiemon (see no. 105). Using the best quality clay, potters at the Inner Mountain produced the finest porcelain, which was reserved for the imperial household or other prestigious customers. Kilns at Hiekoba (see no. 104), Sarukawadani, and Omasu all fired export ware and were also located in the Inner Mountain.

In the Outer Mountain area to the northwest was the Kakiemon kiln and others — Hyakken, Yanbeda, and Tenjin-no-mori. Except for the Kakiemon kiln, the rest continued to produce rather simple blue and white ware, as recent excavations show. Among their ordinary household items were various bottles for sake and hair oil as well as molded dishes. In Greater Outer Mountain a low-quality clay was used to make large quantities of rather coarse porcelain, also for the domestic market.[1]

By the beginning of the 1670s, the Arita production pattern was well defined and established, with each area specializing in supplying a different market. Occasional assistance was sought from the domestic-ware workshops by the export-ware makers to meet large orders with strict deadlines placed by the Dutch East India Company.

Blue and white and polychrome jars of this size, most probably made in the Inner Mountain, were extremely popular in Europe. The patterns followed sketches provided by dealers specifically to replace discontinued Chinese export ware. One standard design is of a garden with fantastic rocks and plants. This particular jar has a decoration somewhat Japanized, with oak trees and chrysanthemums replacing, on one side of the jar, the usual peonies. The scrolling clouds and layered mist hanging in the main decorative field also show some derivation from the Chinese prototype.

A hexagonal jar in the John D. Rockefeller III collection,[2] though a few inches shorter in height than this example, shows the same dragon in the cloud and chrysanthemum-petal decorative bands on the shoulder. The main decorative theme on the Rockefeller jar is decidedly more Japanese in spirit and is considered to have been made for the Japanese market during the Genroku era (1688–1703).[3]

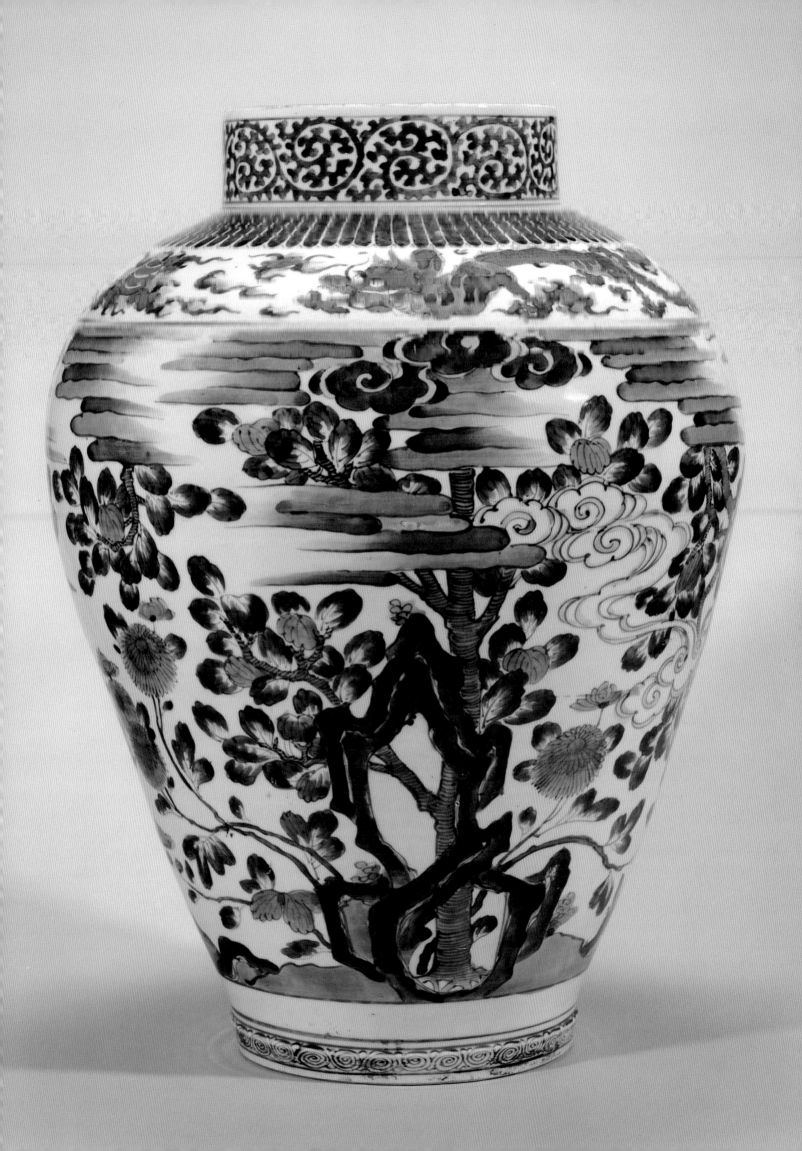

104
LARGE PLATE WITH VOC MARK

Arita ware, Imari type, porcelain with underglaze blue; Edo period, second
half 17th century; Diam. 36.2 cm (14¼ in.) H. 6 cm (2⅜ in.); B60 P974,
The Avery Brundage Collection

PRODUCTION OF porcelain in Arita grew steadily as potters' groups gathered to take advantage of the huge kaolin deposit at Izumiyama. Development was so rapid that in 1637 the provincial government officer in Arita set limitations on the operation, claiming that unlimited cutting of trees for fuel was devastating the nearby forests. With few exceptions, all non-Korean workshops were ordered shut. Potters from the eleven closed shops sought employment at the remaining ones. The provincial government then secured its share of the profits from the lucrative business by imposing increased taxes on the remaining shops.[1]

By the second half of the seventeenth century, Arita production had been developed and organized to the point where it could meet the increasing demand for fine porcelain, both in Japan and abroad. Originally ware was exported through Imari, a small port near Arita, a name subsequently associated with Arita porcelain in general.

From 1633 on, the Tokugawa shogunate gradually enforced its policy of absolute isolation, and by 1639 the country was completely closed to foreigners, leaving only the Dutch East India Company as the official European trader. The Dutch conducted a brisk business from a small artificial island specially built for them offshore at the port of Nagasaki. Starting from the small purchase in 1650 of 145 pieces of coarse ware, picked from samples brought to Nagasaki by speculating merchants, the company's annual purchase increased steadily as the supply of Chinese wares diminished at the fall of the Ming dynasty. In the first few years, orders consisted simply of the items to furnish company headquarters and pharmacies in Batavia (present-day Jakarta, Indonesia). As the quality of Japanese porcelain improved and its beauty gained a reputation in Europe,

special orders started to arrive from Batavia. Normally, written orders with sketches were sent to middleman traders. To avoid miscommunication, popular items of the earlier shipment were kept as samples for more precise orders. By 1659, the annual order for these wares grew to 56,700 pieces.[2]

The ornamental scheme of this large platter with the company monogram VOC (Vereenidge Oostindische Compagnie) was originally inspired by contemporaneous or earlier (late sixteenth to early seventeenth century) Chinese export ware, and was probably supplied by a Dutch trader. The blue is more intense and the clay body much finer than the ovoid jar discussed in no. 102. Surrounding the central monogram are pomegranate and peony sprays and two phoenixes. The rim is divided into six panels with narrow blue borders, in which three panels of tree peonies and orchid leaves alternate with stylized bamboo and plum. The back of the platter was left completely undecorated, possibly an oversight on the trader's part. Within the short and triangular foot rim, on the glazed undersurface of the plate, are five regularly arranged small spur marks surrounding a sixth in the center.

Numerous examples of this type of platter with basically identical decoration exist in Western collections.[3] Variations appear mainly in the style and quality of brushstrokes and are probably the result of the different individual skills of seventeenth-century decorators, rather than of chronological separation.

Shards with the same design as this plate have been excavated from the Hiekoba kiln site in the Inner Mountain area of Arita (see no. 103). There were also other shards of fine export ware showing variations of a similar basic design taken from Chinese export ware of the *fuyō-de* (carrack ware) type dating from the late sixteenth or early seventeenth century.[4]

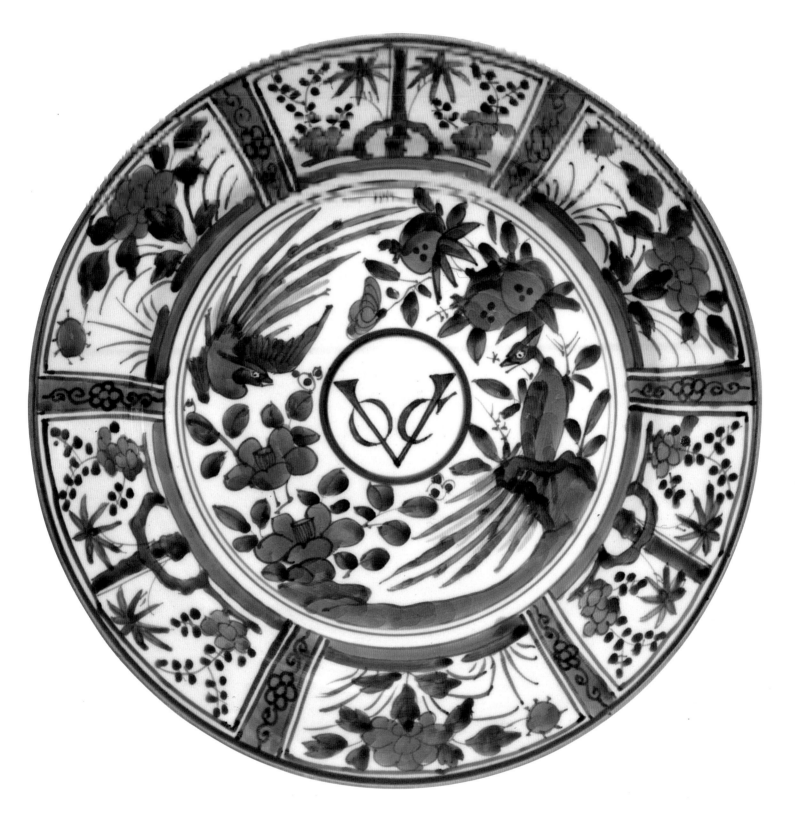

105
JAR

Arita ware, Kakiemon type, porcelain with polychrome enamel; early Edo period,
second half 17th century; H. 25.4 cm (10 in.) Diam. 16.5 cm (6 1/2 in.); B60 P1206,
The Avery Brundage Collection

SOME THIRTY YEARS after Li Sampei discovered the Izumiyama kaolin deposit and started firing porcelain, the Arita potter Sakaida Kizaemon began experimenting with a red enamel formula provided by an Imari merchant who had obtained it from a Chinese potter in Nagasaki. After long effort, Kizaemon finally created a beautiful red enamel similar in color to a ripe persimmon (*kaki*), a dramatic addition to the Arita decorator's palette. To celebrate his success, Kizaemon was given the name Kakiemon. His perseverance and accomplishment became a famous success story told on the stage and taught to generations of school children.

All Sakaida descendants, from the first Kakiemon to the present fourteenth generation, have continued to improve and produce the same porcelain with overglaze polychrome decoration. To maximize the effect of the enamel colors, a special glaze was perfected by the 1670s to create a soft, warm milky-white ground called *nigoshide*.

This continuity in developing techniques and style, seen as well in the Raku family and many other potters' families, seems to be a Japanese experience not only confined to the arts. Unlike the Raku family, the Kakiemons did not mark individual pieces, and it is virtually impossible to tell their products apart. Even recently, two generations of potters—father and son—often collaborated on major commissions, so that there is no definite sense of the individual artist normally seen in other media. Kakiemon XIV is today the recognized leader of the group, which preserves a traditional technique recognized and protected as an Intangible Cultural Property of Japan.

The Sakaida family preserves a celebrated memorandum written by the first Kakiemon, documenting the year of his successful firing of red enamel as 1647, "when the Portuguese galleons came to Nagasaki." Other family documents record orders, methods of clay preparation, and enamel formulas, some manuals with the strict note "not to be viewed by outsiders."[1]

Against its typically seventeenth-century *nigoshide* glaze, the decoration on this jar is a stylized garden scene, also a favorite of the period. Among fantastic rocks, blossoming chrysanthemums, orchids, and violets are delicately painted in light yellow, green, blue, and red. The composition is further accentuated with occasional delicate black lines, placing the piece to the best period of Kakiemon output. It was just such fine examples from the Inner Mountain kilns that inspired European potters at Delft, Meissen, and Chantilly.

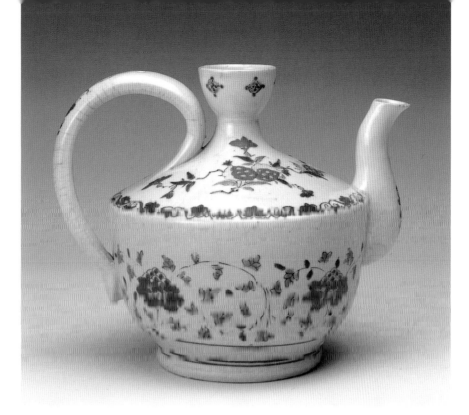

106
EWER

Arita ware, Kakiemon type, porcelain with overglaze polychrome enamel; early Edo
period, 18th century; H. 15.5 cm (6⅛ in.) W. 19.7 cm (7¾ in.); B65 P59, The Avery
Brundage Collection

THE ENAMELED porcelain developed in Arita marked a dramatic change in Japanese ceramics. At first the porcelain body was somewhat gray, and the colors needed refinement, but it was clearly different from the earthy color range that the earlier Arita potters had to accept. Wares decorated with red enamel as well as green, yellow, and blue all came to be called *akae* (red painted) simply because the persimmon red enamel was considered so precious.

This technique called for repeated firings. First the porcelain body was fired with clear glaze, applied either after bisque firing or directly on the dry clay body, at over 2200 degrees Celsius. The enamel decoration was then applied on the smooth surface for subsequent firings, their number depending on the color combination and each enamel's temperature requirements. The small enamel firing kilns were called *nishikigama* (brocade kiln), as these rich polychrome wares were called *nishiki-de* (brocade type).

Despite efforts to keep enamel decoration technique within the Kakiemon family workshop, where only the oldest son was permitted to assist in glaze mixing and enamel preparation, other workshops in Arita learned the new technique and shifted part of their output to polychrome wares. The number of workshops increased so rapidly that the government sought to control production by imposing a strict licensing system. Control was especially strict on *akae-ya* (specialist enamel studios). Only eleven licenses were issued in order to protect quality and prevent the technique from spreading to other provinces, thus securing an important source of provincial revenue.[1]

Information on some domestic distribution of *akae* ware appears in the diary *Kakumeiki* (see nos. 117–118), where polychrome Imari was first mentioned in 1652. Entries between 1639 and 1668 make 135 references to Imari ware, but only five mention colored ware, confirming that most early polychrome wares which copied Chinese Swatow ware were sent to Southeast Asia.[2]

While seventeenth-century records kept by the Dutch East India Company of exports to Europe contain descriptions of pieces clearly of Kakiemon origin, it was not before the late nineteenth century that Europeans associated the term Kakiemon with these wares. Pieces such as this ewer, made specifically for the European market, simply remained "Japanese porcelain."[3]

The shape of this ewer is quite outside Japanese tradition. The order must have been placed along with a model, most probably a drawing, following some prototype of either European or Chinese origin (or both), which could have been freely interpreted. The shape is quite functional and well balanced with tasteful decoration using the *akae* palette.

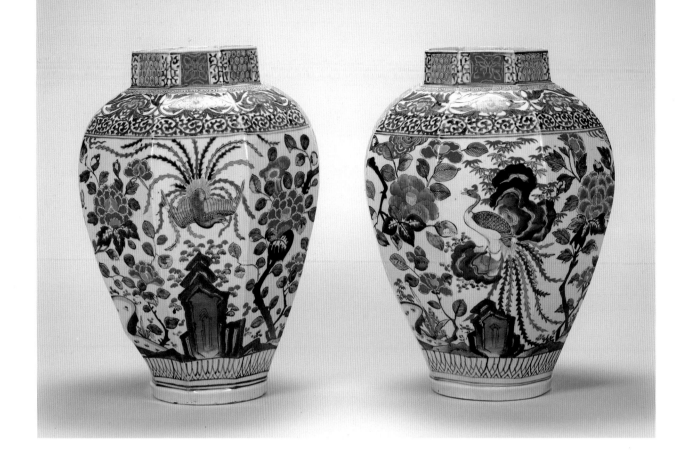

107
PAIR OF JARS

Arita ware, Imari type, porcelain with underglaze blue and overglaze polychrome
enamel; Edo period, late 17th century; H. 60.3 cm (23¾ in.) Diam. 34.3 cm (13½ in.)
each; B62 P60, B62 P61, The Avery Brundage Collection

FROM THE FIRST modest sale of Arita ware in 1650 to its decline in the late 1750s, its producers enjoyed a remarkable official export business.[1] By far the most captivating of the various types for Europeans was polychrome ware, which they preferred to Chinese exports that had been essentially monochromatic — blue and white, white, and unglazed brown ware. During this period, two distinctive styles of polychrome ware, Kakiemon (nos. 105–106, 108) and Imari, emerged. These Imari jars represent one of the most popular export items.

Large jars were exported in pairs; three such jars and two slightly flared cylindrical ones also formed a set of five, intended for mantlepieces in European interiors. Sometimes a porcelain room was set aside in palaces or mansions; the most magnificent and famous is the Porcelain Room at Schloss Charlottenburg in Berlin.[2]

The main areas of this pair of octagonal jars are decorated with a continuous pattern of phoenixes and peony and camellia bushes. One bird is perched on a fantastic rock, reminiscent of the Chinese prototype,

while the other flies over another rock with tail feathers fully displayed. The neck of the jar, the upper part of the ovoid body, and the lowest part near the foot are decorated with a series of geometric bands, including a peony scroll and a plant scroll. The fine brushwork in these intricate patterns and the general strength of execution are characteristics that easily date these jars. Other jars nearly identical in decoration and size still have their original domed covers, indicating the possibility that these two might once also have had them.[3]

Other surviving blue and white jars nearly identical in the size and decoration of their main fields indicate the popularity of this design in Europe.[4] The painted ceiling of the Porcelain Room at Schloss Oranienburg (completed in 1695) includes such a blue and white jar with a phoenix design.[5] Judging from the same plant scroll band around the shoulder and the finish of the foot rim, it is safe to assume that the traders wasted no time in placing orders for the polychrome version of such a popular export item.

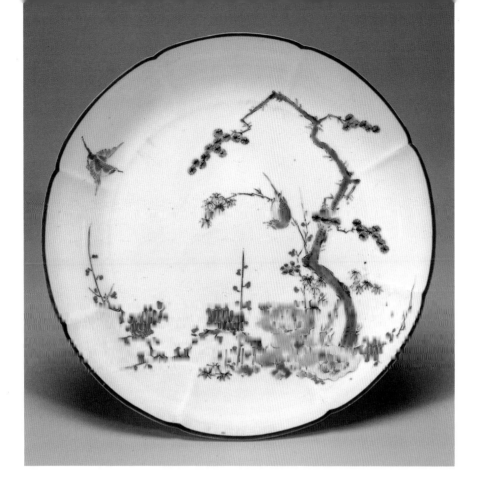

LOBED PLATE

Arita ware, Kakiemon type, porcelain with overglaze polychrome enamel; mid Edo
period, late 17th–early 18th century; Diam. 21.6 cm (8½ in.) H. 3.5 cm (1⅜ in.);
B62 P47, The Avery Brundage Collection

AT ABOUT THE same time that the production of polychrome Imari ware (see no. 107) increased to meet foreign orders, around 1675, Kakiemon kilns expanded their output to satisfy a growing and rapidly changing domestic market. Intensified commerce gave rise to a new class of merchants. Samurai were adopting a new life-style as castles, once fortresses situated on hilltops, became strongholds built on flat lands, with permanent quarters for the lord, his consorts, and their respective families and servants.

The festivals and entertainment that enhanced an otherwise routine life of the merchant and feudal lord required fine furnishings and tableware. Traditional lacquer ware was gradually replaced or simply supplemented by the new polychrome porcelain. Eight-lobed plates like this one were made from molds in sets of ten, twenty, or more. Colorful enamel appeared also on many decorative items: figurines, candlesticks, incense burners, flower vases, and water droppers for calligraphers (see no. 110). Sculptural objects and asymmetrical pieces were also molded.

When the Sakaida family's holdings were investigated in 1957 by a group of historians headed by Nabeshima Naotsugu, of the former provincial gover-

nor's family, as many as 850 clay molds were discovered under the family house. They range widely in styles and sizes, quite a few having incised dates.[1]

On this eight-lobed plate with a slight ridge at each point of notching, a very well composed decoration of the Three Friends motif, *shō chiku bai* (pine, bamboo, and plum), is painted in enamel. A small Chinese-style rockery and a pair of birds, one in flight and the other perched on a bamboo stem, transform this bird and flower motif into a rich garden theme. A number of examples of this plate, with nearly identical decoration and equally fine brushwork, exist both in Japanese and Western collections.[2] They seem to have similar, small, neatly arranged spur marks (four to five each). With an even, good quality milky glaze to show the white clay body and enamel to their best advantage, all these plates can safely be attributed to the peak period of the Kakiemon workshop.

The foot rim is short and triangular in section; within it, on the undersurface of the plate, are four small spur marks. The rim of the dish is colored with iron oxide, the style of finish called *kuchibeni* (lip rouge), said to have first been used to cover small imperfections on the rim.

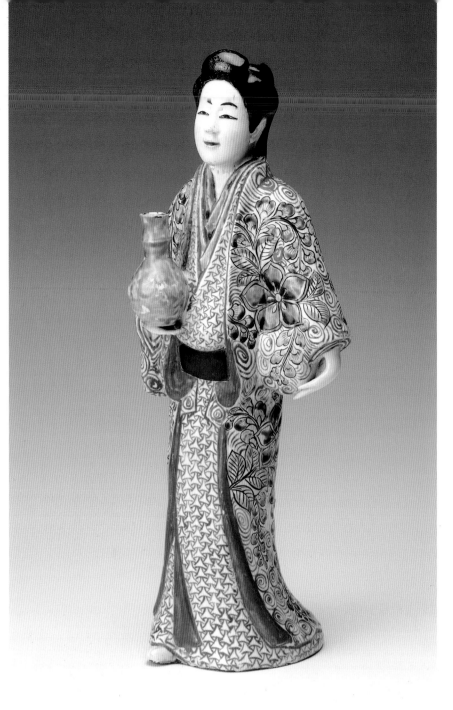

109
FIGURE OF A WOMAN

Arita ware, Kakiemon type, porcelain with overglaze polychrome
enamel; early Edo period, late 17th century; H. 36.2 cm (14¼ in.)
W. 14 cm (5½ in.); B62 P5+, The Avery Brundage Collection

IN THIS STANDING figure, the characteristic white of Kakiemon porcelain serves as a perfect medium to render a woman's fair skin. Her stance, with the right foot slightly forward and the right hand holding a vase, is a variation of the basic standing pose in which one hand is at the side and the other lightly touches the collar of the kimono. Apparently many figures were made from one mold and later decorated individually with varying kimono patterns that reflected the fashion of the day.[1] This figure's outer robe, the *uchikake*, is decorated with a floral pattern of wisteria,

with other flowers in various colors including the famous persimmon red (see no. 105).

Many of these beautiful kimono-clad figures, highly prized among European collectors, were displayed in special rooms devoted to porcelain (see no. 107). These figures also seem to have been popular in Japan; they are mentioned in an essay written in 1807.[2] This source associates the figures with the name Kakiemon, while Kakiemon-style tableware continued to be considered a type of Imari and was simply called polychrome ware or red ware.

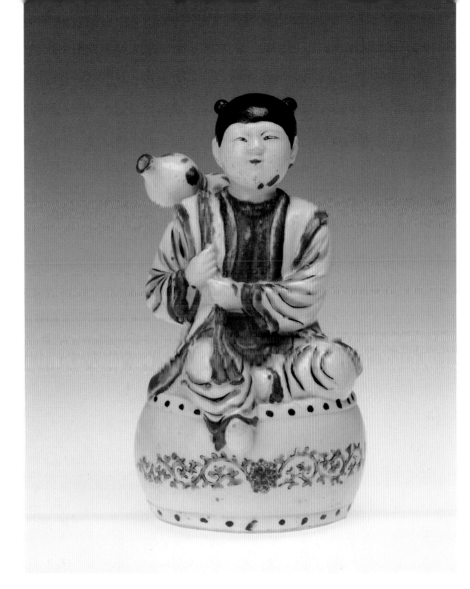

110

WATER DROPPER

Arita ware, Kakiemon type, porcelain with overglaze polychrome enamel; mid Edo
period, 18th century; H. 14 cm (5½ in.) W. 8.3 cm (3¼ in.); B69 P30, The Avery
Brundage Collection

IN THE EXPORT porcelain market of the middle Edo period, decisions on what types of ware to produce were made by ceramic merchants rather than by the kiln or shop owners. These merchants, including the famous Higashijima Tokuzaemon, who helped Kakiemon develop his red enamel (see no. 105), were close to the art dealers and therefore well informed of their customers' changing tastes.

This seemingly ordinary water dropper in the form of a boy carrying a gourd is a good example of this designer-producer relationship. Chinese youth (called *karako* in Japan) were one of the favorite subjects of Edo period painters, as can be seen in the elephant painting by Nagasawa Rosetsu (no. 70). This young boy carries a gourd on his shoulder and sits cross-legged on a drum. Two holes, one on his shoulder and the other at the mouth of the gourd, suggest the piece is a water dropper, although it is larger than most. Such oversized

pieces may have been made more with decorative rather than utilitarian effects in mind.

The piece was probably molded in two parts, the figure and the gourd, and later combined. Except for the flat bottom, which has imprinted plain-weave textile marks, most probably left from the molding process, the piece is covered with a good quality milky-white glaze, the same kind seen on the prized Kakiemon female figures (no. 109). The stylized floral-scroll decoration on the drum, often seen on other eighteenth-century dishes, has been finely painted by one hand. Coloring and lines on the clothes are spontaneous, and perhaps careless, as some enamels were left uncleaned on the figure's chin. The facial features on closer examination reveal extremely delicate, masterful lines, indicating that yet another principal craftsman participated in finishing this export piece into a charming figure full of warmth.

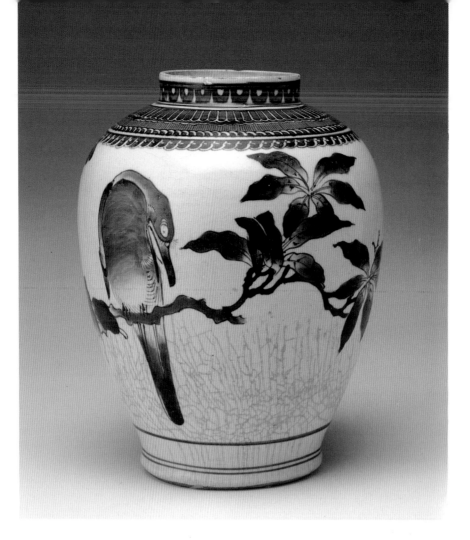

111

JAR WITH WIDE MOUTH

Arita ware, Kakiemon type, porcelain with underglaze blue; Edo period, mid–late 17th
century; H. 28 cm (11 in.) Diam. 22.8 cm (9 in.); B64 P37,
The Avery Brundage Collection

WHILE THE NAME Kakiemon is most commonly associated with polychrome wares distinguished by a persimmon red hue (see nos. 105–106), some blue and white porcelains of Arita can be attributed to the studios of the Kakiemon family. They are stylistically quite different from blue and white Imari (see nos. 103–104).

A loquat branch and two birds of uncertain species, painted with cobalt oxide, enhance the white porcelain surface of this jar. The combination of rich, concentrated cobalt-blue outlines and wash tones, skillfully painted to show a very smooth transition in density, gives the decoration an impression of a painting on warm, soft silk. One bird perches on a branch, head down, while the other makes a downward flight. Similar to polychrome Kakiemon, large unpainted areas emphasize the whiteness of the clay body. The

distinctive richness of the cobalt places this jar safely in the seventeenth century, a time also generally associated with a more painterly approach in composition and execution.

Decorative borders of petal shapes, short vertical hair-thin lines, and another resembling a stylized cluster of wisteria blossoms encircle the neck. This conventional decorative scheme was carried over from contemporary Imari-type ware, here creating an effect similar to the decorative silk borders of a painting mounted as a hanging scroll.

The foot rim is proportionately quite heavy, almost bulky, and its trimming is not quite finished in the refined manner of the mature period. Some crazing occurred in the glaze on one side of the jar, probably due to firing temperature idiosyncrasies.[1]

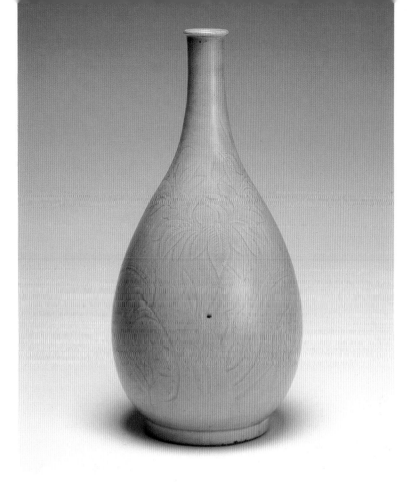

112

BOTTLE

Arita ware, Imari type, porcelain with celadon glaze; early Edo period, 17th century;
H. 29.5 cm (11⅝ in.) Diam. 14.6 cm (5¾ in.); B62 P65, The Avery Brundage Collection

THE PRODUCTION OF celadon ware seems to have started as early as that of porcelain in Arita during the first quarter of the seventeenth century (see no. 102). While polychrome ware received much attention as a major Japanese export to Europe, celadon continued to be produced for both the domestic and foreign markets.

Compared to those examples from about 1615 excavated from the earliest strata of the Tengudani kiln complex (see no. 102), this bottle has a smoother gray-green glaze with more fluid, matured decoration—both signs of technical advancement. It is thinly potted and decorated with an incised pattern of a garden with rocks, tree peonies, and orchid leaves. The area within the short triangular foot rim is also glazed.

Such bottles, most probably made for serving sake, must have been shipped to many parts of Japan through the port of Imari. In the diary *Kakumeiki* (see no. 117), of the 135 notes made on Imari between 1639 and 1668, only five mention polychrome wares, indicating that the rest were blue and white, celadon, or white porcelain.[1] Entries dealing with blue and white Imari sometimes mention sets containing as many as fifty pieces. These sets were used as gifts, and since they are referred to in several consecutive years, they must have been regarded and treated as consumer goods. Undoubtedly celadon and white wares were similarly in high demand.

The popularity of their wares prompted Arita potters to industrialize production and search out the easiest sea lanes to ship their merchandise to every interested market. Recently, well-documented scientific excavations have been carried out in all parts of Japan by groups of urban archaeologists. They have investigated sites where previous users resided—temples, castles, samurai and merchants' residences, shops, and even discard dumps. Arita porcelains of Hizen Province are distributed throughout Japan from Hokkaido to Okinawa, revealing the well-established trade routes of the distributors.[2]

If more extensive excavation of the Arita porcelain kilns is carried out, or publications of what has been excavated to date become available, it will be possible to attribute this incised celadon bottle to a probable kiln site. But today we can only compare it with a few shards of incised celadon with similar plant motifs, which were found at the limited number of sites that have been published.[3]

DISH WITH STRING OF CAMELLIAS

Arita ware, Nabeshima type, porcelain with underglaze blue and overglaze polychrome
enamel; Edo period, early 18th century; Diam. 20.3 cm (8 in.) H. 5.7 cm (2¼ in.);
B60 P46+, The Avery Brundage Collection

NABESHIMA, THE THIRD highly distinctive style of Arita por-
celain, is named after the provincial governor for whom it was exclusively
made, to be used by his family or given as very special gifts.

Nabeshima porcelain followed traditional Chinese models in many respects
and came closest to being, in Japan, what is known in China as "official ware." The
kiln and workshop were established in 1628 in the Inner Mountain area at
Iwayagawachi (see no. 103); Soeda Kisaemon, a samurai, was appointed as head
officer. At first they produced primarily blue and white porcelain and celadon
ware of some charm, but technically it was less than perfect.

In 1661 the Nabeshima operation was relocated to Nangawara, in the vicinity
of the well-established Kakiemon kiln, a move perhaps prompted by the desire to
be nearer the best craftsmen in polychrome decoration. After fourteen years, the
workshop and kiln were moved again to Ōkōchi, a remote spot not far from
Kurokamiyama, the highest mountain in this region.[1]

Here, far from the outside world, hand-picked craftsmen lived and worked
in a secluded compound. Severe restrictions were imposed upon them in order to
maintain production quality and the secrets of their techniques. These highly spe-
cialized and carefully selected craftsmen were given ample wages in the form of
rice and cash, and in some cases were allowed to wear a short sword, a symbol of
the samurai class.

Around 1716 the entire Nabeshima workshop group consisted of eleven pot-
ters, nine decorators, four sculptors, and seven helpers, a division of skill and num-
bers maintained until 1891.[2] Headed by the Soeda family, which held a hereditary
position, the craftsmen worked under the supervision of the Tōkikata (official in
charge of porcelain), using designs provided by the provincial governor's office.
The secrecy surrounding Nabeshima production made it possible for the provin-
cial governor to present unique gifts that could not be duplicated.

Nabeshima ware is best known for round dishes in standard sizes, but it also
includes incense burners, wine cups, and ewers as well as asymmetrical dishes and
bowls. Its decoration, generally more sophisticated and delicate in color than that
of Imari ware, consists of a fine underglaze blue pattern enhanced with light red,
green, and yellow enamels. Occasionally celadon glaze is used in part of the design.

The motif of this dish, most probably made at the official kiln at Ōkōchi, was
inspired by camellia blossoms strung on thread like a Hawaiian lei, a popular pas-
time of Japanese girls. Here blossoms of various colors and pattern create a
sprightly decorative effect appropriate for such occasions as the Girls' Festival.

The plate backs are decorated with a three-part design of Chinese coins tied
with ribbon (six ribboned-cash), the most commonly used plate-back pattern of
the Ōkōchi period. The stylized, swaying ends of the ribbon,[3] along with the stan-
dardized rendering of a sawtooth pattern on the high foot, indicate the piece was
made during the first decades of the eighteenth century.

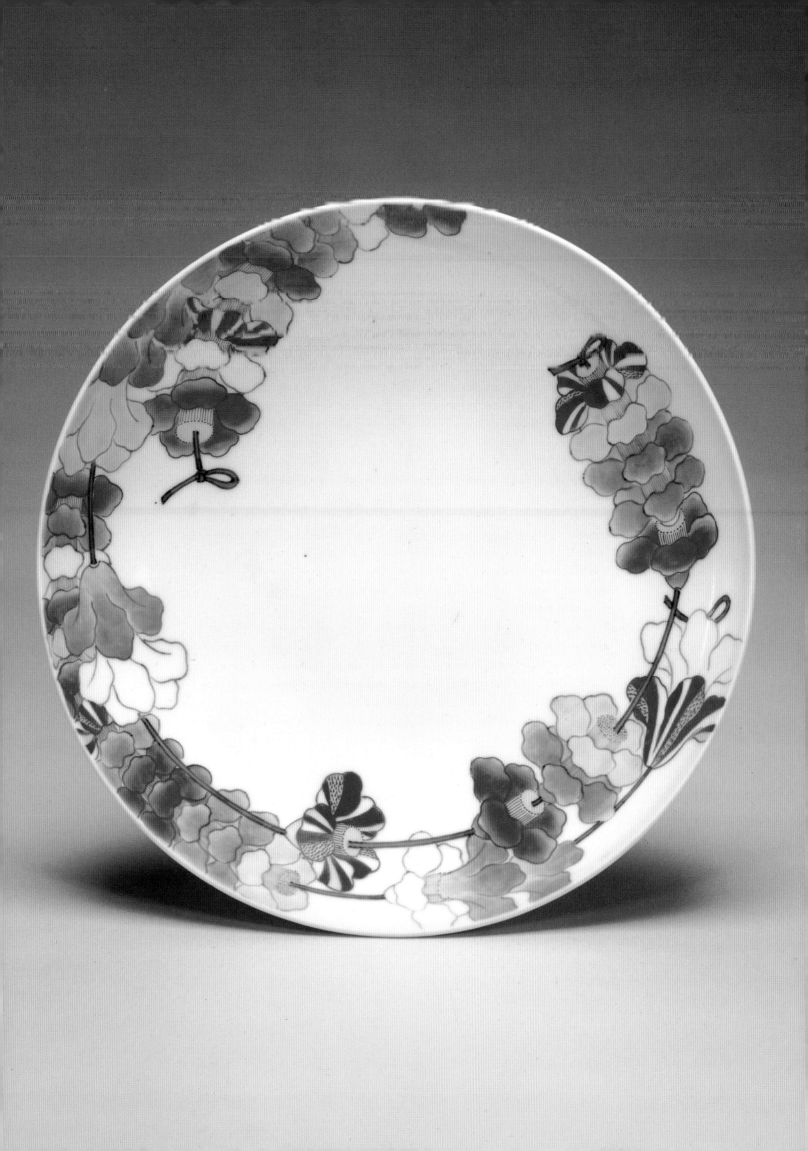

DISH WITH FLOWER BASKET DESIGN

Arita ware, Nabeshima type, porcelain with underglaze blue and overglaze polychrome
enamel; Edo period, early 18th century; D. 15 cm (5⅞ in.) H. 4.5 cm (1¾ in.);
B62 P23, The Avery Brundage Collection

NABESHIMA WARE IS best known for elegantly decorated dishes that stand on a characteristic high cylindrical foot. The profile resembles that of traditional wheel-turned wooden sake cups, which were normally finished with either plain red lacquer or highly decorated. The dishes are of four standard sizes ranging from 9 to 30.5 centimeters.

Nabeshima patterns are first drawn on paper with a special charcoal ink obtained by burning gourds. The drawing is inverted on the bisqued surface and transferred by gentle rubbing. One drawing could last through as many as forty transfers, an ideal way to assure a perfect match for sets of ten or twenty plates.[1]

With almost machine-like precision, fine underglaze blue lines were drawn over the pattern, even where red enamel was to be applied later. The same unmistakable Nabeshima control can be found on the plate backs with their characteristic decoration, a three-part pattern using flowers with leaves like peonies and roses or Chinese coins tied with ribbons (see no. 113). This plate is decorated on the back with a three-part design of peony and leaves. The floral pattern is considered to have preceded the ribboned-cash design.[2]

On these high-footed pieces one frequently finds an evenly drawn comb-tooth pattern, one of the trademarks of Nabeshima ware, especially from the peak period, as is this example.

As well as naturalistic plant designs, Nabeshima ware has more imaginative patterns similar to those found in contemporary textile design. On this dish appear bamboo baskets full of fallen cherry blossoms set in flowing water. The water is in traditional, stylized wave patterns often used as a decorative background on Nabeshima dishes and seen as well in textiles and decorated paper for fans and book covers.

Another unique Nabeshima technique creates fine lines like those in this stylized wave pattern. They were drawn with charcoal on the bisqued surface and glazed over with cobalt blue, the charcoal acting as a glaze resist. After firing, the lines revealing the white clay body are just as delicate as the original charcoal lines. This use of resist is a basic technique of textile dyeing, an understandable connection when one realizes that Nabeshima designs were directly borrowed from contemporary textiles.

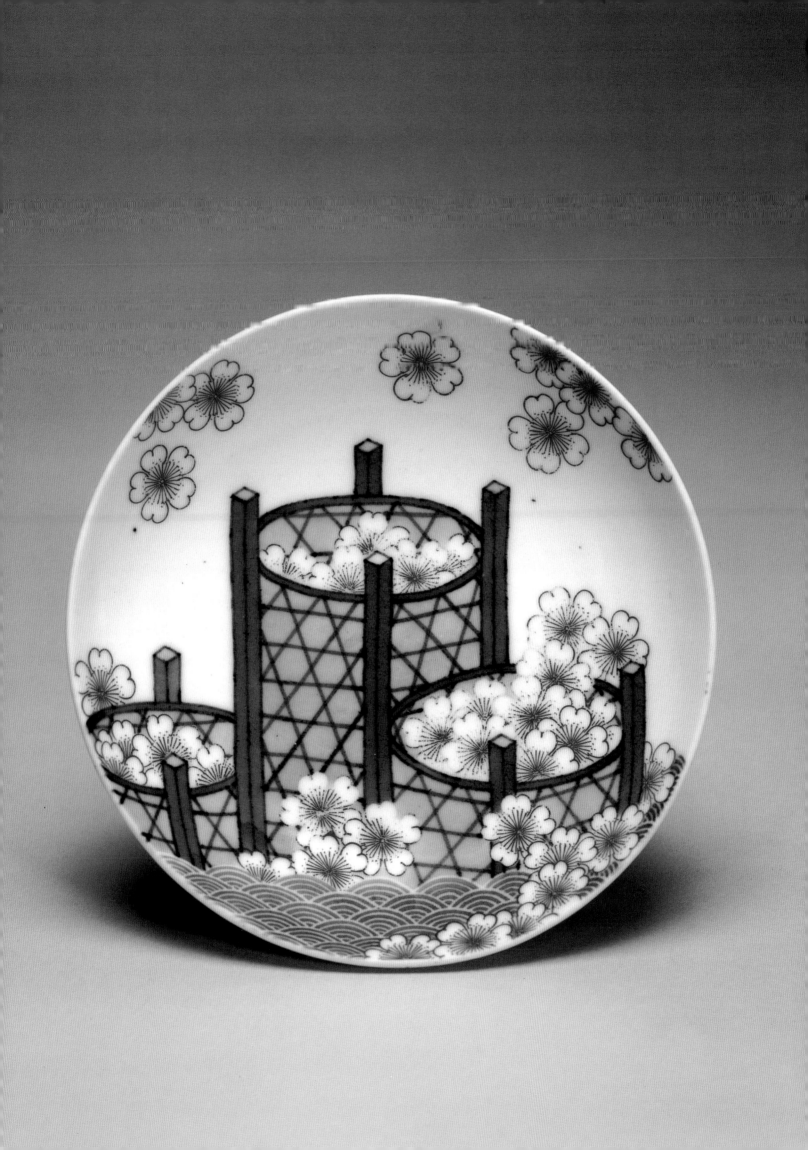

115
LARGE PLATE

Kutani ware, porcelain with overglaze polychrome enamel; early Edo
period, 17th century; Diam. 40.3 cm (15⁷⁄₈ in.) H. 6.6 cm (2⁵⁄₈ in.); B64 P31,
The Avery Brundage Collection

A GROUP OF POLYCHROME porcelains reportedly made in the
small village of Kutani (Nine Valleys) facing the Sea of Japan has been
praised for its unique bold and imaginative decorative style. The question of where
this group was actually made has become a major controversy.[1]

A long-awaited series of scientific excavations carried out at Kutani between
1970 and 1974 confirmed the dates of Kutani production to have been from
around 1659 to around 1725, matching dates mentioned in historical documents.
But the question of where the porcelain bodies were fired and decorated remains
unanswered.[2] Shards collected from the Kutani kiln show little resemblance to
the design and style traditionally accepted as Kutani ware. There were no shards of
finished ware, a probable indication that these kilns were not used for firing
enamels.[3] But full evidence is not available, as all the Kutani kilns are not yet com-
pletely excavated.

Historical documents, some objective, some fanciful, record the names of
individuals associated with Kutani production. Maeda Toshiharu (1618–1669) was
the first daimyo of Daishōji, a district in Kaga Province where the Kutani kiln is
believed to have been located. Born in a culturally rich environment, with a
powerful father (Maeda Toshitsune [1593–1658], the third daimyo of Kaga
Province) and a mother who was the daughter of a shogun, Toshiharu used these
advantages to start fine porcelain production in his district.[4] In the same docu-
ments, another name, Saijirō, also appears more than once, each time associated
with skills such as sword making and gold refining, both with techniques some-
what related to porcelain firing.[5]

This plate is an example of Ao-Kutani (green Kutani), a large subgroup of
Kutani ware with a characteristic green enamel that prevails in its decoration. The
richness of this decoration may reflect the cultural and artistic backgrounds of the
people associated with Kutani production.[6] Through friends such as Honami
Kōetsu (1558–1637) and Kanamori Sōwa (see no. 117), Maeda Toshitsune kept in
close contact with Kyoto art circles, and it is quite probable that Kutani potters
were aware of early Kyoto polychrome wares, especially those made after the
three-color provincial Chinese ware called Kōchi in Japan.[7] The polychrome
enamel technique itself might have been introduced from Kyoto.[8] Some shards of
small dishes collected in Kutani reveal that the typical Kyoto underglaze blue dec-
oration was exactly duplicated.[9]

A striking strength of Kutani design is clearly seen in this plate with fern
shoots against a background filled with a diaper pattern of miniature sunbursts. A
few shoots are left uncolored, effectively showing the white clay body. The back of
the plate is covered with thin green enamel and decorated with black C-shaped
plant scrolls that cover the entire outer band. Within the foot a double square
encloses a *fuku* (happiness) seal character, all hand-painted with black enamel.

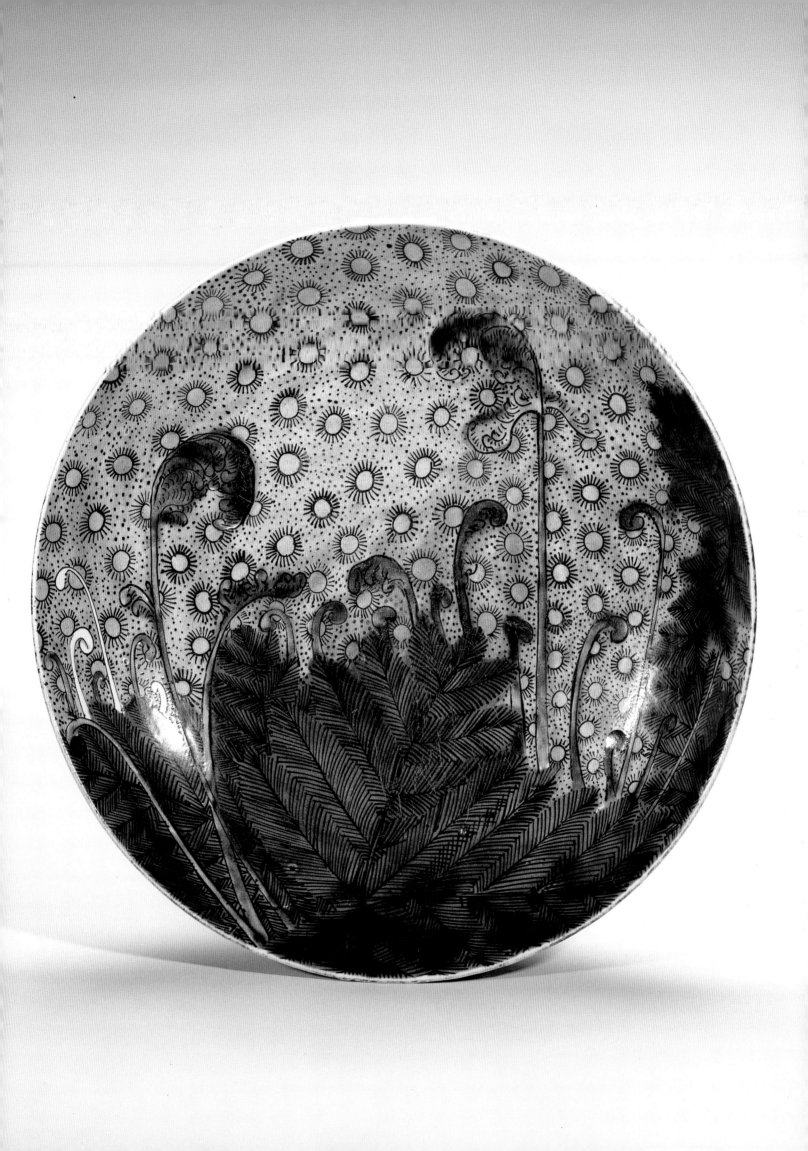

BLACK RAKU TEA BOWL
Attributed to Raku Sōnyū, 1664–1716

Earthenware with glaze; Edo period, late 17th–early 18th century; H. 5.5 cm (2³/₁₆ in.)
Diam. 14 cm (5½ in.); B76 P5, Gift of Mr. William S. Picher

RAKU TEA BOWLS, celebrated above all others by Japanese tea connoisseurs, are unique among Japanese ceramics. The techniques of Raku ware go back to Sen no Rikyū (1520–1591), Hideyoshi's chief tea master, who charged his student Chōjirō, son of a naturalized Korean roof-tile maker of Kyoto, with the task of making tea bowls for his own austere ceremony. Rikyū's approach to tea aesthetics was best exemplified by his own tea rooms, plain small spaces of wood and bamboo, with clay walls and a few tatami mats. Some measured only 6 by 6 feet.

Chōjirō's efforts produced a series of hand-built, simply glazed tea bowls fired individually in a small kiln fueled by charcoal. His glazes, whether black, red, or buff, were fired to give the dry surface quality Rikyū most admired. He especially preferred black bowls for the effect of their contrast to the frothy green tea.

Those early tea bowls were first called Juraku ware, after the castle Juraku-dai for which Chōjirō was firing roof tiles. The shortened form "Raku" was given to Chōjirō by Hideyoshi as a family name and has been passed on through generations of potters, along with the social status it confers. The craft has been a closely guarded family secret with unchanged basic techniques handed down to the present day. Slight variations in modeling, style, and glaze formulas were developed by successive generations of Raku potters who worked in close relationship to the Sen families.

This shallow black tea bowl is attributed to Raku Sōnyū, the fifth-generation potter who headed the Raku family. Sōnyū was born to the famous Kariganeya (see nos. 67, 119) and in his infancy was adopted by Ichinyū, a fourth-generation Raku potter. He married Ichinyū's daughter and after Ichinyū's retirement assumed the family leadership at age twenty-eight.[1]

The dry glazes of Sōnyū's black tea bowls are close to those of the famous bowls made by Chōjirō. The dry look in Chōjirō's glazes originally was believed to result from immature firing. But Sōnyū here deliberately re-created Chōjirō's glaze style, since carefully controlled firing techniques had already been perfected by the third-generation Raku potter.[2] Sōnyū's tea bowls are conservatively modeled with little additional shaping, also after Chōjirō's style. The entire surface of this tea bowl is glazed, including the foot. Marks of the tongs used to pull the bowl out of the fire appear on the side.

According to the Japanese practice among tea connoisseurs and owners of fine art works, including swords and musical instruments, this bowl was named "Natsu kagura" (Summer Festival Music) by a previous owner.[3] Shallow bowls allow prepared tea to cool off faster and are usually used during the summer months.

117

INCENSE CONTAINER

Seal of Nonomura Ninsei, act. second–third quarter 17th century

Stoneware with underglaze iron; early Edo period, mid 17th century; L. 12.2 cm
(4⅞ in.) H. 2.5 cm (1 in.); B74 P5, The Avery Brundage Collection

ALTHOUGH NONOMURA Ninsei is bet-
ter known for his polychromatic wares with gold
and silver, his monochromatic pieces are frequently
imbued with sophisticated elegance. This incense con-
tainer in the shape of a sponge gourd is made of a finely
textured light gray clay and sensuously crafted in a
slight S curve. A few leaves and tendrils painted with
iron oxide in delicate brushstrokes appear beneath a
transparent neutral glaze. The piece separates into two
horizontal halves. On the gourd's narrower end, a thin
coil of clay indicates a stem, which connects to the
painted tendril. On the outer bottom, a seal reads *Ninsei*
in the same manner as many other works known in col-
lections in both Japan and the West.[1]

Ninsei spent his early years in apprenticeship
partly in Seto, famous for its skilled though mostly
anonymous craftsmen, who produced the much sought
after *chaire* (tea caddy) after celebrated Chinese models.
No doubt Ninsei there acquired the wheel-throwing
technique for which he became famous.

As a young and talented potter, Ninsei came to
Kyoto shortly before 1648 and established a small
workshop near Ninnaji temple.[2] This temple was head-
ed by Prince Kakushin, an older brother of Emperor
Gomizunoo, a noted literary figure of the period who
had a keen interest in various arts. With the help of
Kanamori Sōwa (1584–1656), a tea connoisseur who
belonged to the inner circle surrounding Kakushin,
Ninsei gained the patronage of the prince's entourage.

Because of his closeness to literary high society,
many records of Ninsei's work still survive. Numerous
diaries of well-known contemporaries mention him,
including the *Kakumeiki*, kept by Hōrin Shōshō (1592–
1668), head priest of the Rokuanji temple in Kyoto.
In this extraordinary diary (Shōshō kept it from 1635
until his death in 1669), Ninsei's works are mentioned
thirty-five times between 1649 and 1668, establish-
ing his active years as well as the significance of his kiln
and work, then known as Omuroyaki, Ninnajiyaki,
or Ninseiyaki.[3]

This incense container came in double wooden
storage boxes. On the lid of the inner and older of the
two are inscriptions by Kanamori Sōwa. This may indi-
cate the part Sōwa played as an informal agent, either by
suggesting a design he knew would be salable or by con-
necting Ninsei with a purchaser. Both boxes were made
by two earlier owners: the first to safeguard the incense
container, the second obviously to protect the original
box with Sōwa's inscription.

118
FAN-SHAPED PLATE

Ko-Kiyomizu ware, stoneware with overglaze polychrome enamel; Edo period,
18th century; L. 38.1 cm (15 in.) W. 23.4 cm (9¼ in.); B62 P17,
The Avery Brundage Collection

LONG BEFORE SUCH famous potters as Ninsei, Kenzan, and Eisen (nos. 117, 119, 120) were active in Kyoto, many other talented potters worked in the city in complete anonymity. The ceramics made by them are known collectively as *kyōyaki* (Kyoto ware) and include pieces dating from the late Momoyama through the Edo period. Different subgroups are named after their place of production—Awataguchi, Kiyomizu, Mizoro. *Kyōyaki* normally exclude Sue and other early ware as well as contemporaneous but specialized groups like Raku (see no. 116).

There are many historical accounts of the origin of Kyoto ware. Some place it as early as the mid-fifteenth century, but the finer Kyoto ware most likely did not appear until the late sixteenth century, when the tea ceremony was firmly established in the city.[1] In the diary *Kakumeiki*, kept by the priest Hōrin Shōshō (see no. 117), Kyoto ware is first mentioned in an entry dated 1640, noting that it was being made at Awataguchi, the kiln that apparently specialized in tea utensils. Shōshō and other tea connoisseurs such as Kanamori Sōwa (see no. 117) sent patterns to that kiln to be used in their custom-made tea utensils.[2] Shōshō also tells of "shopping in town" for tea utensils; apparently by the late 1630s, these ceramics were being sold by merchants in small shops on Kyoto's busy streets.[3]

Not limited to tea ceremony pieces, Kyoto ware includes food vessels, fancy incense burners, flower vases, and even inkstone boxes, many in unusual and imaginative shapes. Kyoto residents had a passion for the Kabuki theater, where they ate and drank as they watched day-long performances, as well as for year-round outdoor picnics, where they could appreciate the passing seasons. It was thus only natural that the Kyoto potters were primarily occupied with making vessels for food and drink. Quite often they would reproduce in fine clay shapes borrowed from other materials—wood, bamboo, or paper—decorating them with elegant patterns in polychrome enamel and gold, with results visually similar to lacquer designs.

Kyoto potters used a transparent ash glaze that developed a very fine crazing over the characteristic light clay with its slight yellow cast. Their decoration is almost exclusively representational. When geometric patterns appear, they reproduce textile designs or those of metal or lacquer ware.

This fan-shaped plate is a fine example of how Kyoto potters skillfully recreated everyday objects in clay, using molds. The auspicious decoration of the Three Friends, *shō chiku bai* (pine, bamboo, and plum), in the Kyoto palette's standard colors of green, blue, and gold, is painted on the fan as if it were a decoration on paper. Five jewel designs are painted on the back, and three small feet support the plate.

The spreading fan shape is considered auspicious, symbolizing growth or future expansion. Further embellished with the Three Friends motif, this plate must have been made for an important occasion.

119

BOWL WITH HANDLE
Signed Kenzan, 1663–1743

Stoneware with glaze; Edo period, 18th century; H. 14.3 cm (5⅝ in.) W. 17.2 cm
(6¾ in.); B69 P32, Gift of the Ney Wolfskill Fund

KYOTO'S GENTEEL environment tradi-
tionally allowed personal talent to be developed,
recognized, and rewarded. Kenzan, another gifted
Kyoto potter, was even more fortunate than the young
Ninsei (see no. 117) in that he came from a rich mer-
chant family, the Kariganeya, who dealt in the finest
textiles. They were related to Honami Kōetsu, the
versatile artist who excelled in calligraphy, pottery,
lacquer, painting, and sword polishing.[1] The family
also patronized the Nō theater and practiced the tea
ceremony.

In 1687, after receiving a sizable inheritance fol-
lowing his father's death, Kenzan settled in Omuro in
Kyoto. Unlike his painter brother Kōrin (see no. 67),
who frequented the pleasure quarters of Kyoto, Kenzan
turned to study under the Zen priest Dokushō. Ken-
zan's modest dwelling was located near the pottery
shop headed by Ninsei's son, and it may be that his asso-
ciation with Ninsei II prompted his return to pottery, a
craft he had learned earlier from Kōetsu's grandson.

Kenzan's approach is based on Kyoto ware (see
no. 118). He worked mostly with low-fired pottery often
covered with white slip to emphasize the decoration.
Kenzan's modeling, generally not as precise as Ninsei's,
served primarily as a medium for his unique and strik-
ing decorative effects—polychrome paintings of plants
and flowers, often highlighted with gold and silver, and
strong calligraphic inscriptions in subtle but rich black
ink. He frequently left the wheel throwing and firing to
other experienced craftsmen, including Ninsei II.[2]

In 1699, Kenzan opened his own workshop in
Narutaki, northwest of Kyoto, where he collaborated
with his brother Kōrin to produce fine dishes and plates
with calligraphic monochromatic decoration.[3]

This bowl is decorated inside with stylized camel-
lias against a green background. The blossoms are
yellow, white, and aubergine, with yellow and auber-
gine dots representing pistils. The exterior is covered
with green disks against an aubergine background. A
rectangular section left uncolored on the outside car-
ries the artist's signature, written in bold script with
iron oxide.[4]

Kenzan's decorative and technical approaches
reflect his early exposure to fine textiles. The camellia
pattern of this bowl was applied with a stencil, a basic
tool of textile decoration. Kenzan repeatedly used this
design or variations of it, always in a simple flower shape.

After closing his workshop in Narutaki, Kenzan
moved to another location in Kyoto only to meet with
business difficulties. He then moved to Edo, gaining the
patronage of one of the princes of Emperor Higashiyama
(1675–1709). He died in Edo at the age of eighty-one.

120

STEM BOWL

Okuda Eisen, 1753–1811

Porcelain with polychrome enamel; Edo period, c. 1781–89; H. 14.5 cm (5¾ in.) Diam.
20.3 cm (8 in.); B60 P1234, The Avery Brundage Collection

THE WORK OF Okuda Eisen, an independ-
ent Kyoto potter, marked the beginning of a new
stylistic approach that flourished during the second half
of the Edo period. Unlike his forerunners Ninsei and
Kenzan (see nos. 117, 119), who found inspiration
primarily in traditional Japanese themes, Eisen looked
back to China. This interest may have emerged because
Eisen was born to a family named Yingchuan, emigrants
from China. In addition, a generally pro-Chinese
intellectual climate existed in the Edo period, when the
Shu (Chinese: Zhu) school of Confucian thought
permeated the Tokugawa *bakufu* (feudal government),
and refined gentlemen pursued the study of Chinese
classics and arts.

In his youth Eisen was adopted by a childless
uncle anxious for an heir. His new family name became
Okuda, his first name was Moemon. In time he took
over the flourishing family pawnshop.

Much like Kenzan, Eisen approached ceramics as
a gentleman experimenting in art. However, unlike his
predecessor, who late in life was forced to become a
commercial artist as his inheritance dwindled, Eisen
always enjoyed financial independence.[1] In complete
peace of mind he could study his beloved and highly
prized collection of Chinese export wares — Swatow,
Kōchi, Ko-Akae — of the Ming and Qing dynasties as

models, in order to recreate them.

Eisen also possessed a natural perseverance,
which contributed to his success in handling difficult
materials. He was the first member of the Kyoto school
to apply polychrome enamel to porcelain bodies. As this
bowl shows, he was particularly good at simulating
Swatow ware. But he was no servile imitator. Eisen's
red, green, and black enamels are very close to those of
the originals, but he also created original shapes, new
ornamental schemes, and a slightly bluish glaze entirely
his own.

The swiftly painted phoenix on the interior bot-
tom of this stem bowl is a central motif in many of
Eisen's works. The stylized flower accompanying the
phoenix is identical to those appearing on a brush tray
inscribed *Temmei Nensei* (made in the years of Temmei),
that is, 1781–1789, when Eisen was in his early thir-
ties.[2] The stem bowl is signed with his studio name,
Rikuhōzan Eisen, followed by a painted seal, *kao*, with the
character *Tsune* from his given name.[3]

Many of Eisen's works have survived in the Ken-
ninji temple in Kyoto, where he maintained living quar-
ters away from the family house. Many famous potters,
such as Mokubei, Ninnami Dōhachi, and Shūzan, began
their training in Eisen's studio and later led a group of
young craftsmen in shaping the new fashion in Kyoto.[4]

PLATE, *ISHI-ZARA* TYPE

Seto ware, stoneware with underglaze blue and iron; Edo period, 19th century;
D. 27.6 cm (10⁷⁄₈ in.) H. 4.7 cm (1⁷⁄₈ in.); B64 P29, The Avery Brundage Collection

AS EARLY AS the thirteenth century, Seto in eastern Japan was the center of high quality glazed stoneware in the style of Chinese Song ware. It slipped into a secondary position in the sixteenth century, when civil wars devastated Seto Province and ceramic centers were emerging in neighboring Mino Province (see nos. 93–99).

When peace returned in the seventeenth century, Seto production was revived under the patronage of the Tokugawa family, who had a special kiln built to fire fine tea ware for their exclusive use.[1] It was the making of ordinary wares during the eighteenth century, however, that reestablished Seto as an important ceramic center. Just as "china" in English means porcelain, in eastern Japan *setomono* (wares from Seto) means pottery, regardless of where it is produced.[2]

While Kyushu polychrome porcelain (see nos. 108, 113–114) was replacing lacquered wood food-servers in upper-class households, Seto ware was taking the place of plain wooden vessels in the kitchens of plebeian homes. Licensed potters and kiln owners produced a variety of everyday ware—large storage jars, small dishes, spouted bowls, plates, cooking pots, mortars. The most popular items were plates similar to the one illustrated here. Its crane design, swiftly and skillfully painted with cobalt and iron, belongs to the category variously called *ishi-zara* (stone plate), *nishin-zara* (herring plate), or *nishime-zara* (cooked vegetable plate). The first appellation may be due to the solid, heavy

appearance of these plates. The other two names probably relate to the ware's specific use in the home and by roadside food vendors. Regardless of terminology, a main characteristic is the thick rim, perhaps a feature developed to withstand the impact of similar dishes hitting each other and to prevent chipping during everyday, ordinary use.

The wide range of design and skillful execution give these plates a value and interest far beyond their mere function. As industrialization swept across Japan in the Taishō era (1912–1925), connoisseurs were captivated by the simple charm of these plates. An inspired pair of craftsmen, Shōji Hamada (1894–1978) and Kanjirō Kawai (1890–1966; see no. 124), joined Sōetsu Yanagi (1889–1961) and his English colleague Bernard Leach (1887–1979) to form the group solely responsible for the *mingei* movement, the spectacular revival in Japan of the simple crafts created in the past by generations of unknown craftsmen.[3]

These three artists' purely aesthetic, almost religious admiration for Seto wares has been borne out in recent years by the scientific excavation of kiln sites. Shards of such plates were discovered mainly at the Hara kiln site in the southwest end of the Seto complex,[4] and in sufficient number to indicate their popularity during their period of production, which seems to have been from the late eighteenth to early nineteenth century.

PAIR OF GUARDIAN LIONS

Seto ware, stoneware with light celadon glaze; Edo period, dated 1782; H. 31 cm
(12⅛ in.) L. base 20.4 cm (8 in.); B64 P43 (left), B64 P44 (right),
The Avery Brundage Collection

D**URING THE ASUKA** period, along with Buddhism from China and Korea, guardian lion images were introduced to Japan in sculptures and paintings.[1] Some were used to guard the imperial throne, and smaller ones served as curtain weights, an idea the Heian court may have borrowed from the Tang court. In time such figures were placed in pairs before the main building or the gate of temples and shrines. The majority of temple lions are either stone sculptures, as those at the south gate of Tōdaiji,[2] or painted wooden sculptures, like those at the Daihō shrine.[3] Many are now designated Important Cultural Properties by the Japanese government.

Large ceramic centers like Seto and Arita made ceramic lions to guard their local temples and shrines. In Seto province, where high quality glazed ceramic production was first developed and was well underway by the late Kamakura period, religious objects such as flower vases, votive lamps, and incense burners were made. The patrons who encouraged such fine glazed ware also commissioned lions for use as votive figures.[4]

Because of their nonprecious material, these ceramic lions escaped the serious attention of scholars in the past. Only very recently have archaeologists attempted a scientific dating of this type of ceramic work.[5] Some examples of Seto lions from the Kamakura period are nearly identical in size and style, as if cast from the same mold. Similar lions were produced throughout the Muromachi and Momoyama into the Edo period, when the custom of inscribing them began.

Many bear dates, names of donors, and their place of residence. This pair is dated to the second year of the Temmei era (1782); the donor is Takashima of Seto.

All Seto lions are glazed with variations of celadon or "caramel glaze" (*ame-yū*) with shades from light yellow to a very dark brown that appears nearly black. Sometimes a combination of two colors or a Shino glaze was used. This pair was glazed with still another variation, Ofuke glaze, made by mixing wood ash with a local clay containing some iron.

Both animals are squarely supported on cylindrical legs. They are intended to be positioned facing each other. Typically they have exaggerated facial expressions; protrusions around the neck represent extremely stylized manes. The original tails, now missing and replaced with restorations, were very likely also highly stylized.

Like many other guardian lions, one of this pair has its mouth open while the other's is closed, Buddhist iconography also seen in human guardian figures. Occasionally lion pairs consist of a male and a female, but this is unusual in ceramic examples.

The presentation of lion figures to temples and shrines in the Seto area seems to have followed local calamities, when village leaders gave them as votive or thanksgiving offerings.[6] Whatever occasion inspired the commission of this pair, there is a touch of humor in their faces and an exuberance about their chunky bodies that convey some of the happiness and gratitude the donor might once have felt.

SQUARE PLATE

Kitaōji Rosanjin, 1883–1959

Bizen-style stoneware with some natural glaze; Shōwa period, ca. 1950; L. 35.5 cm (14 in.)
W. 33.7 cm (13¼ in.); B80 P8, Bequest of Mr. Joseph M. Bransten

ROSANJIN WAS AN extremely talented individual with skills in various media, including calligraphy, ceramics, painting, wood and seal carving, metal and lacquer work, textiles, and cooking. His early training and accomplishments in calligraphy gave him the basic aesthetic foundation that guided his sense of design in other media.

The self-centered Rosanjin's famous arrogance in exploiting those of good-will and influence may have been the result of his miserable childhood, an experience that also may have contributed to his determination to succeed. His natural talent as a calligrapher allowed him to earn a living painting shop signs, which also greatly strengthened his skill in carving signs and seals and later became the foundation for his other artistic activities.[1]

Rosanjin's ceramic work began as a casual experience at the kiln of Seika Suda (1862–1927), his client for a shop sign. From the start, he was successful in decorating pottery surfaces with pictorial and calligraphic designs. He later returned to ceramics as a successful restaurateur and chef, supplying dishes for his own establishment and beginning his lifetime commitment as a potter. After a temporary setback due to the great Tokyo earthquake of 1923, Rosanjin opened his famous Hoshigaoka Club, where the rich and famous of Tokyo gathered after the disaster to enjoy fine dining.

To meet yet larger needs, Rosanjin opened a kiln in Kamakura, where he hired and housed a number of potters who assisted him.[2] He wasted no time on chores like clay preparation, slab making, or even wheel throwing. For these he employed some of the best potters, including Toyozō Arakawa (who was later designated a Living National Treasure). Rosanjin concentrated only on final shaping and decorating.

In 1945, assisted by Tōyō Kaneshige (1896–1967) of Bizen, another Living National Treasure, Rosanjin created a series of Bizen-type stoneware ceramics. In 1953 Kaneshige assisted Rosanjin in building a Bizen-type kiln in Kamakura.[3] Here Rosanjin successfully recaptured highly treasured characteristics of traditional Bizen stoneware (see no. 90) with excellent firing results.

This large square plate is strong in modeling, a typical Rosanjin touch, with an irregularly settled natural ash glaze. A circular area where another round vessel was placed during firing is unglazed, a usual Bizen decoration. The circle and the glaze lines may remind Japanese viewers of an autumn field with tall grasses and a full moon.

124

BOTTLE WITH SPLASHES OF GLAZE

Kanjirō Kawai, 1890–1966

Stoneware with glaze; Shōwa period, 1960s; H. 21.5 cm (8½ in.) W. 19.6 cm (7¾ in.);
1988.58.2, Gift of Miss Yoshiko Uchida

A T THE TIME OF his first successful one-man show in 1921, Kanjirō
Kawai was a young and accomplished potter who won the hearts of the art-
loving public overnight. He was praised by the leading critic Seiichi Okuda as "a
bright comet that suddenly appeared in the sky of the world of ceramics."[1]
Although he sought artistic and aesthetic inspiration and a technical foundation in
the works of China and Korea, Kawai succeeded in creating a distinctive personal
ceramic style. Years of study and experiment supported his accomplishments.[2]

After his third successful one-man show, Kawai determined to stop making
ceramics based on various Asian courtly traditions in favor of those based on the
spirit and practice of the common people. The change meant that he walked away
from his established studio work into the still-unknown and as yet unnamed *mingei*
craft movement.[3]

Kawai then established a valuable friendship with the leader of this move-
ment, Sōetsu Yanagi (1889–1961), whom he met through his old potter-friend
Shōji Hamada (1894–1978) and Bernard Leach (1887–1979). In making this
radical aesthetic shift, Kawai was extremely fortunate in having understanding
friends and patrons, many of whom provided steady interest and support through-
out his life.[4]

Kawai grew up in Shimane Prefecture where the tradition and practice of tea
culture were very strong. At an early age he was also interested in writing. His
literary accomplishments and talent as a teacher placed him in a unique position
among potters. He gave a public lecture at the Kyoto National Museum in 1924 and
had many other opportunities to promote and educate the public in the ideas and
intentions of the *mingei* movement. Through friendship with a Japanese-American
writer, Yoshiko Uchida, one of his books of essays was translated and published in
English;[5] this bold bottle was his token of appreciation.

The rectangular body and neck were most probably made of thick slabs,
with the neck molded separately. The shape is reminiscent of traditional lacquered
wooden sake containers popularly used on ceremonial occasions in the northern
provinces of Japan. On this bottle Kawai applied three strong-colored glazes
splashed on with a tool, perhaps a heavy brush. This is one of the few basic deco-
rating techniques, along with *hakeme* (brush marks), *tsutsugaki* (trailing with slip),
neriage (marbling), and *rō-nuki* (wax resist), that Kawai practiced after he turned to
the *mingei* movement.

125

SAKE CUP

Kitaōji Rosanjin, 1883–1959

Stoneware with overglaze enamel; Shōwa period, ca. late 1920s; H. 3.2 cm (1¼ in.)
Diam. 5.7 cm (2¼ in.); B81 P79, Gift of William S. Picher

MORE THAN ANY other potter, Kitaōji Rosanjin succeeded in bringing ceramics closer to their basic function as food servers. One author refers to Rosanjin's work as "dressing up his lovely daughter with complimentary clothes."[1] In this description the "lovely daughter" refers to Rosanjin's first love, his highly skilled culinary creations, which he placed to their best visual advantage in his own ceramic dishes.

Rosanjin's ceramics for his restaurant business blossomed under the force of his usual great vitality. They included a wonderfully dynamic mixture of shapes, colors, and decorations which recreated traditional physical characteristics of various ceramic types — Bizen, Oribe, and Shino — with his unmistakable modern decorative touch.

On this small sake cup of fine buff-colored clay, three star-shaped maple leaves (one on the side and two inside) are painted in red enamel on a clear glaze. Each leaf is barely the size of a dime. Rosanjin's calligraphic use of the brush reveals the touch of a master. Every section of the leaf clearly shows each brushstroke, its entering point and direction. Whether large or small,

Rosanjin's leaves are almost his signature.[2] Placed against this soft buff-colored cup, the small maple leaf decoration is the essence of *kyōyaki* (Kyoto ware), its distinctive elegance most eloquently revealed in its understatement.

On the underside of the cup is one of Rosanjin's marks, a star shape, which he used in his early period.[3] The star (*hoshi*) stood for the artist's exclusive Hoshigaoka Club restaurant (see no. 123).

Rosanjin learned from antique models, and for that purpose he collected some ten thousand ceramic pieces, which he called his "teacher at my side." He was a genius at capturing the essence of fine works regardless of style or technique; rather than simply copying, he was able to create his own expression through interpretation of the model. In his early fifties, at the peak of his career, Rosanjin was removed from his position as art director and chief chef in the prospering restaurant by his business manager, as he knew no practical limitations and had no sense of the need to balance the books. His only desire was to acquire antiques for the pleasure they provided in his artistic pursuits.

METALWARE

126
EIGHT-LOBED MIRROR WITH BIRDS
AND FLORAL SCROLL DESIGN

Bronze with high silver content (*hakudō*); early Fujiwara period, early 12th century;
Diam. 13.3 cm (5¼ in.); B65 B56, The Avery Brundage Collection

IN THE YAYOI period (250 B.C.–A.D. 250), Chinese bronze mirrors were already known in Japan, where the production of replicas began shortly afterward (nos. 23–25). The influence of Tang dynasty mirrors manifested itself in Japanese mirrors of the following Asuka and Nara periods in a type of design lasting well into the Heian period, as seen in this eight-lobed mirror. In an extremely crisp and well-defined inner ridge that follows the eight-lobed contour of the mirror, a pair of mandarin ducks face each other across a large knob. The heavy modeling of the birds' heads and bodies creates a strong three-dimensional quality. Between the birds, *hōsōge* (auspicious floral scrolls) in a finer and more linear style fill most of the inner decorative field. In the outer space between the ridge and the rim is another band of delicate floral scrollwork.

In this mirror, the ridge plays a minor decorative function as it defines the inner and outer fields. This feature, carried over from earlier mirrors, appears in some Muromachi period revival designs (see no. 132). In mirrors of the Fujiwara and later periods, however,

this ridge does not seem to have a clear functional or decorative significance. The rounded, truncated cone-shaped knob is relatively heavy and is surrounded by a chrysanthemum flower decorative band.

The *Engishiki* (Procedures of the Engi Era, 901–922), fifty volumes of supplementary government regulations, records the production of bronze mirrors. Among the raw materials listed, wax — the mold material used during the Nara period for the production of mirrors similar to this one — is notably absent. Soft clay molds came into use during the Heian period. Designs were created directly on them while the clay was still wet. With this new method, a much more lively design resulted when the mirror was cast.[1]

Historically, mirrors were used primarily at home by both men and women for grooming purposes but still carried deep spiritual overtones. Mirrors were frequently used in religious contexts (nos. 24, 127). The flat reflecting surface was regularly polished, an exercise considered to be more than utilitarian — it was an act of keeping one's soul bright and clear.

127

CIRCULAR MIRROR WITH
MATSUKUI-ZURU MOTIF

Bronze; Fujiwara period, 11th–12th century; Diam. 8.1 cm (3³/₁₆ in.); B60 B339,
The Avery Brundage Collection

DURING THE FUJIWARA period, after the Japanese government discontinued official missions to China and isolated itself from strong Chinese influence, a definitive Japanese style emerged in all types of decorative arts. Traditional bronze mirrors were no exception; their general appearance became much less weighty, and their decorative motifs much lighter and more pictorial. All sorts of floral patterns flourished, as if blossoming fields had been transplanted onto these tiny bronze mirror-backs.

This thin, circular mirror with a pair of cranes with pine twigs typifies Heian mirrors. The *matsukui-zuru* design (literally, pine-eating crane) covers the entire field, spilling over and across the narrow circular ridge. In this version, cranes carry a few pine needles in their beaks, rather than twigs. The knob is small and sits in the center of a stylized floral base.

This type of mirror is called *Hagurosan-kyō* (mirrors from Mount Haguro), although this example was not recovered through systematic collection from that famous site.[1] *Hagurosan-kyō* were found in the Mitarai-ike, a pond near Mount Haguro, south of the Dewa shrine in Yamagata Prefecture. This pond is commonly called Kagamiga-ike (Pond of Mirrors), since over six hundred mirrors, dating from the Heian to Edo periods, have been collected from its bottom.[2]

The surface of the polished mirror is as pure and clear as that of the still surface of a pond, and because of this association, throughout Japan the practice of throwing mirrors into ponds became a votive act. This was especially true at Mount Haguro, one of the auspicious sites of Shugendō Buddhist practice, in which priests undertook rigorous, ritualistic climbing of the steep and rugged mountain. After praying and viewing themselves, Heian court nobles believed their spirits were transferred to these mirrors, which were then thrown into the pond as offerings.[3]

SUTRA CASE

Bronze; Fujiwara period, 12th century; H. 27.3 cm (10³/₄ in.) Diam. 8.9 cm (3¹/₂ in.);
B60 B310, The Avery Brundage Collection

THE PRACTICE OF BURYING sutras became popular during the later part of the Heian period and continued well into the Edo period. The custom originated as a precaution against the approaching era of *mappō* (end of Buddhist law), calculated to occur in 1054.[1] Buddhists fervently hoped the preserved sutras would be excavated and used when Miroku, the Maitreya bodhisattva, descended to this world some five billion years after the *parinirvana* (passage to a state beyond reincarnation) of Sakyamuni. In later periods the motivation was less spiritual and more self-centered, as the devotee's rebirth in the Buddhist paradise, the Western Pure Land, and even material prosperity, became the goals of this ritual. It is not known exactly when sutra burial began; it can only be placed sometime during the ninth or tenth century.

A container with sutra rolls was usually buried under a small mound in a simple stone chamber or within a slab enclosure of modest size. Some containers are known to have been placed in ceramic jars, probably for direct burial in the earth without stone enclosures. The most common containers were bronze, sometimes gilt, and a number of examples bear inscriptions giving the date, the donor's name, and the purpose of burial.

A variety of other materials — stone, iron, pottery, and porcelain — were also used to make sutra containers. Burial chambers were often stuffed with pieces of charcoal to prevent decay of the various buried objects — swords, mirrors, cedar fans, and small Buddhist images.

This case has a typical cylindrical body divided by three sets of raised horizontal bands, a design that makes the cylinder resemble bamboo segments. It is set on a low spreading base and fitted with a hexagonal umbrella-shaped cover topped with a jewel-shaped knob. At each point of the hexagon is a small hole which once may have held a suspended decoration.

This case contained a few fragmented paper sutra scrolls with texts written in reddish ink. The surface encrustation includes small fragments of charcoal used at the time of burial. The style is close to other examples excavated from northern Kyushu.[2]

To meet the original purpose of the preservation of Buddhist teaching, more durable materials, such as tiles or bronze plaques, should have been favored for inscribing sutra texts, but most of the buried sutras known to date are handwritten on paper scrolls, the standard material for such texts. But a few sutras of other materials survive, including natural stone slabs, boards, pebbles (each bearing one character), and even seashells (used in the same way as pebbles).[3]

Although sutra burial was practiced throughout Japan, the areas with a greater concentration of burial sites are Kinki (west central Honshu) and northern Kyushu. The latter is noted for its large mounds. The superior quality of accompanying objects found in these sites seems to indicate a high level of cultural and material achievement in these particular areas.

CIRCULAR MIRROR WITH
CHRYSANTHEMUM DESIGN

Bronze; Kamakura period, 13th–14th century; Diam. 11.4 cm (4½ in.); B60 B24+,
The Avery Brundage Collection

DURING THE LATE Heian and the Kamakura periods, bronze mirrors underwent subtle yet distinctive stylistic changes. This mirror shows the late Heian period predilection for a more naturalistic approach to the arrangement of flowers and birds, a forerunner of a standard composition in Kamakura period mirrors.

A field of blossoming chrysanthemums dominates the upper half of the composition. A pair of birds appears among the flowers to the left of the knob. In a small area to the right is a meandering stream with waves as well as ground with quatrefoil diaper patterns, probably indicating pebbles.

The circular inner ridge that used to define the central field of the mirror back no longer serves this function (see no. 126). It has become a mere vestige of the traditional device, largely ignored by the decorator even though an obvious obstacle to a fully integrated design. Kamakura mirrors became gradually heavier, their rims thicker, and their knobs larger.[1] Knobs are either nearly hemispherical or in the shape of truncated cones and are provided with a hole to accommodate a decorative cord handle.

Details such as flower petals and bird feathers were impressed with small tools on soft clay to create a mold with subtle variations in depth. The result was a more substantial and realistic three-dimensional design, even if less delicate and poetic than earlier ones.

130

CIRCULAR MIRROR WITH
HŌRAISAN DESIGN

Bronze; Kamakura period, 13th–14th century; Diam. 11.4 cm (4½ in.); B60 B337,
The Avery Brundage Collection

KAMAKURA PERIOD mirror designs show a great variety of subject matter. The favorite new motifs were chrysanthemums and sparrows, insects, and amphibians, and — borrowed from Chinese mythology — Hōrai (Chinese: Penglai), the mountainous sacred isle in the Eastern Sea, also became quite popular. Seen here with a pair of cranes and a tortoise, both symbolizing longevity, the mountain is believed to be the home of everlasting life; thus the entire design represents the wish for ultimate longevity.

One of the cranes carries a pine twig in its beak, reminiscent of the Heian period design *matsukui-zuru*

(see no. 127). A small nest with two baby birds peeking out introduces a light touch into this otherwise formal composition, which was probably created for an auspicious occasion, most likely a wedding. In this mirror an inner circle has been nearly obliterated, giving the design more prominence.

A hole in the upper-right field might have been made with the intention of offering this mirror as a hanging votive. Kamakura period mirrors came to have a somewhat thicker rim and were generally more substantial in weight than earlier ones.

131

GOKOSHO AND *GOKOREI* (thunderbolt and bell)

Gilt bronze; Kamakura period, 13th–14th century; Thunderbolt: L. 18.7 cm (7⅜ in.)
W. 4.4 cm (1¾ in.), Bell: H. 19 cm (7½ in.) Diam. 8.2 cm (3¼ in.); B60 B357a
(thunderbolt), B60 B357b (bell), The Avery Brundage Collection

EVER SINCE BUDDHISM was intro-
duced to Japan, various ritual objects of different
materials were developed for a flourishing Japanese
Buddhist religious practice, but by far the most impor-
tant were those of gilt bronze. They are especially sig-
nificant in Esoteric Buddhism, which believes in and
relies on a human's five senses as the means to attain
Buddhahood. This sect inspired the creation of a large
number of ritual objects whose primary function was
to induce the unity of the worshiper's hidden personal
Buddhahood with that of the deity being worshiped.

These ritual objects may be grouped into four
types according to their function. The first group con-
sists of items that protect the worshiper and his defined
space for worshiping, including the *kongōsho* (thunder-
bolt) and a few other symbolic weapons. The second
group is for pleasing and satisfying the main deity and
comprises the bell and other types of musical instru-
ments. The third includes offering vessels, such as
flower vases, candlesticks, incense burners, and food
servers. The last group contains vessels for materials
that cleanse both the image and the worshiper, such as
holy water and perfume.[1]

During the Heian period, many Chinese ritual
objects were brought back to Japan by priests, such as
Kūkai and Saichō, and were well recorded in their

inventories. Traditional bell and thunderbolt sets, both
those imported into Japan and those made in Japan
according to Chinese models, are accompanied by a
matching gilt bronze tray in a stylized leaf shape.[2]

The *kongōsho* ("diamond baton" or thunderbolt),
was originally an Indian weapon with sharp ends for
throwing at enemies. In symbolic shapes they can have
pointed ends ranging in number from one to nine. This
thunderbolt has five (*go*) such prongs (*ko*) on each end
and is thus called *gokosho*. Of all the types, this is the
most popular, representing as many as 80 percent of
surviving examples.[3] The middle part of this *gokosho* is a
decorative band of multiple oval motifs called devil's
eyes, a simplified version of an earlier motif represent-
ing human faces. On the prongs are small cloud-shaped
decorations. The tapered parts of the handle are cov-
ered with overlapped lotus petals.

The accompanying bell (*rei*), though not originally
a set with this *kongōsho*, also has a five-pronged thunder-
bolt handle and is called accordingly *gokorei*. The handle
is decorated with motifs similar to those appearing on
the thunderbolt except it lacks cloud shapes. Encircling
the body of the bell are multiple raised lines. A bell
almost identical to this one and dating from the Kama-
kura period is in the possession of the Shōmyōji temple
in Kanagawa Prefecture.[4]

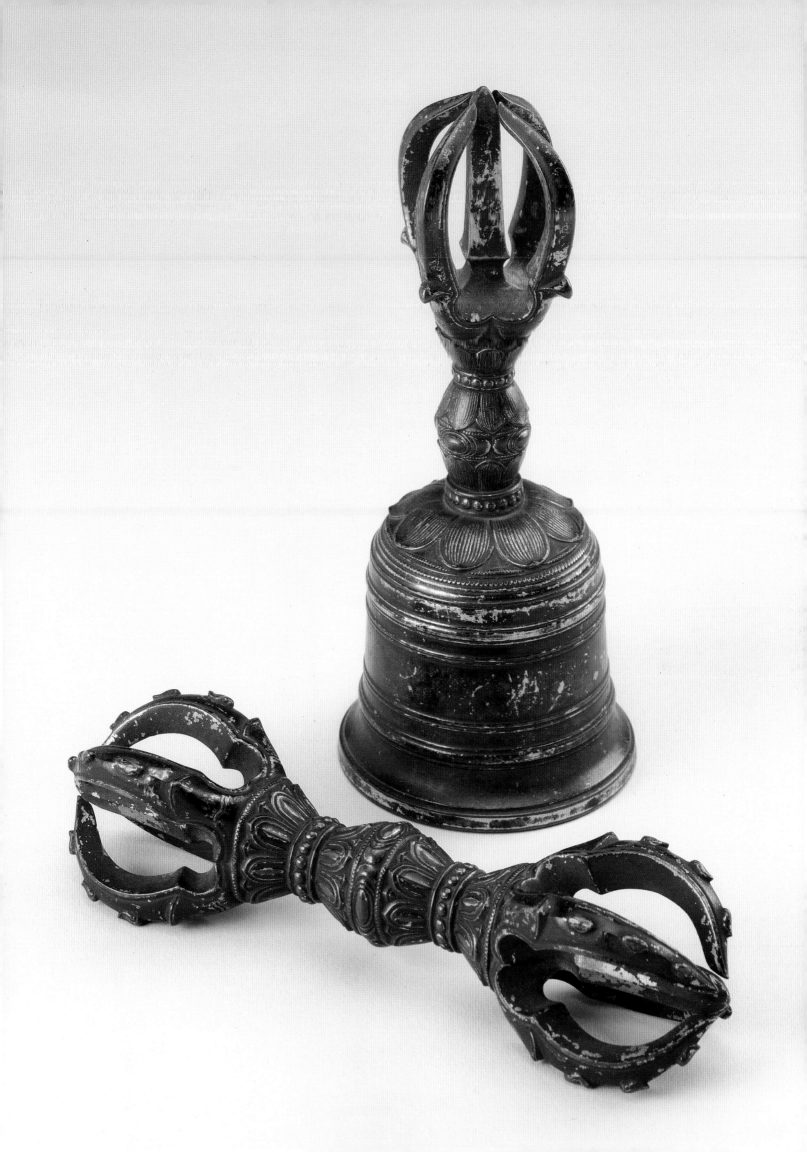

132
EIGHT-LOBED MIRROR WITH
BIRD AND FLOWER DESIGN

Bronze; Muromachi period, 14th–15th century; Diam. 12.4 cm (4⅞ in.); B60 B21+,
The Avery Brundage Collection

MUROMACHI PERIOD mirrors made no particular contribution to the stylistic or technical development of Japanese mirrors. Basically, they continued the conventions established by the Kamakura period craftsmen, along with the revival of some old stylistic features based on Chinese mirrors and the addition of a few new decorative themes.[1]

This eight-lobed mirror (no. 132) is a classic revival of a style popular during the Heian and earlier periods (see no. 126). The decoration, however, adapts a more Japanized motif and arrangement. The main field within the ridge following the contour is filled with a bird and flower design. In the upper half is a pair of birds, not true renditions of the Chinese phoenix, but rather a peculiar hybrid having a sparrow's body and thin, stiff-looking, long tail feathers. The floral motif is more successful, with delicate vine scrolls and full blossoms resembling clematis.

The large circular mirror (no. 133) displays a version of a new Muromachi period motif based on the Chōseiden (Palace of Longevity) theme. The thematic elements — a stream and sandbanks (*suhama*), the palace

133
CIRCULAR MIRROR WITH
LANDSCAPE DESIGN

Bronze; Muromachi period, 15th century; Diam. 22.7 cm (9 in.); B65 B55,
The Avery Brundage Collection

building, a small rocky hill with a pine tree, and a pair of flying cranes and a turtle — are all represented. The turtle, a customary feature, forms a decorative knob. This version has an added bridge that rises in an elegant slight curve over the stream, and the palace building with its simpler pillar-and-wall structure with *en* (open verandah) around the front is more Japanese than the Palace of Longevity, which is usually elaborate in detail and Chinese in style. On this mirror the craftsman added more rocks in the foreground water, giving the composition a sense of expansion and depth as well as making the design more like an ordinary Japanese landscape than the prescribed auspicious theme.

Up to the Muromachi period, mirrors were all equipped with knobs with holes for a cord used both for decoration and as a handle. As recorded in contemporary drawings, handled mirrors appeared sometime during the Muromachi period.[2] In only a century or so, the standard mirror size became as large as this mirror and also acquired a bronze handle. By the Edo period, the inner circular ridge, which in this composition has no design function whatsoever, practically disappeared.

134
CENSER WITH LONG HANDLE

Gilt bronze; Muromachi period, 15th–16th century; L. 39.3 cm (15¹/₂ in.)
Diam. 11.4 cm (4¹/₂ in.); B65 B49, The Avery Brundage Collection

COMPARED TO THE COMPLEXITY and range of instruments used in the mysteries and rituals of Esoteric Buddhist services, those for Exoteric Buddhism (or Middle Path, emphasizing piety and ethical conduct) appear simpler, although they are not necessarily less elaborate in their style, decoration, and technical refinement. Basic furnishings for the altar consist of vessels for offerings, a pair of candlesticks, flower vases, and an incense burner, all having much the same function as those found in Esoteric Buddhism rituals.

The incense burner for the altar is stationary and normally a vessel with or without feet. This gilt bronze incense burner has a long handle for carrying it during the ceremony. The end of the handle bends downward and supports the censer when not being carried; in this type, it is often decorated with a small sculptural work such as a seated lion or a simple geometric ornament. Probably the oldest and most celebrated examples of this type of incense burner are those found among the Hōryūji and Shōsōin treasures.[1]

The cover of this censer has a knob in the shape of an open lotus bud surrounded by pierced, decorative lotus motif scrollwork, which allowed the incense smoke to flow through. The long handle is likewise decorated with sharply chiseled lotus scrolls, creating a delicate effect against a background filled with minute circular patterns called *nanako* (fish roe).

LACQUERWARE

NEGORO WARE EWER

Lacquer on wood; Momoyama to Edo period, early 17th century; H. 36.5 cm (14³/₈ in.)
W. 28.2 cm (11¹/₈ in.); B60 M1+, The Avery Brundage Collection

THE USE OF LACQUER in Japan began in the early part of the Jōmon period, some several thousand years before the Christian era. The lacquer used in Far Eastern artworks is made from a gummy sap collected from the lacquer tree *Rhus vernicifera*.[1] The refined sap may be colored by a great variety of pigments, and it is applied to a core commonly made of wood, although other materials also serve as substrate (see no. 136). The use of red and black coloring agents in lacquer for wooden vessels and other common articles dates long before Japan's medieval period, as clearly indicated by the presence of lacquer objects in twelfth-century paintings such as one depicted in a scene from the *Tale of Genji*.[2]

This red-lacquered ewer is a type commonly called Negoro ware,[3] after a temple complex where it was made primarily for internal use. An inscription on the ewer, *Konzōin*, names an otherwise unidentified subtemple of the complex. This vessel was used to hold hot water as one of the meal-serving utensils in a religious setting. The Negoro complex in Ki Province was headquarters for the Shingi Shingon sect (New Doctrine Shingon sect), a newer faction of the Old Shingon sect, a branch of Esoteric Buddhism (see no. 40). Located atop Mount Negoro, this compound consisted of over 80 subtemples with some 2,700 separate buildings; it flourished until Hideyoshi's troops destroyed it in 1587. Consequently the site has yielded little evidence of lacquer manufacturing since it was nearly reduced to ashes. However, a few surviving Negoro examples bear inscriptions that include the names of individuals who once resided on Mount Negoro and who had had a part in lacquer-ware manufacture.[4] They are cited as evidence that some Negoro ware vessels were in fact made on Mount Negoro.

Fine Negoro lacquer is characterized by the beautifully crafted forms of its basic cores. They may be wheel turned or bent and secured, but they are always made of wood and securely reinforced at joints with linen or some other durable material. Many undercoatings of black lacquer build up a strong body. Negoro ware's most immediate charm, especially admired by tea practitioners, is the subtle beauty of black showing through an often single coat of red lacquer applied as a finish. Over the years the red coat rubs off, revealing the black undercoat, particularly at edges and corners.

When the temple complex burned, some of the priests and lay residents, along with wood and lacquer craftsmen, fled the mountain to smaller temples in different parts of Japan. They continued their craft wherever they settled but established larger settlements in areas such as Yoshino and Kyoto. The lacquer ware made in these areas came to be called Yoshino-Negoro and Kyoto-Negoro. Word of this fine yet functional and sturdy lacquer, with its beautiful wooden shapes and pleasing colors, spread to other areas. In recognition of its origin, the term "Negoro ware" came into general use for virtually all lacquer of this style during the Edo period.

Made in the bright cinnabar color of traditional Negoro ware, this ewer, along with three other nearly identical ones in collections in the United States, represents the *karayō*-type, a style influenced by Chinese forms.[5] Those influences are seen in the lobed lid, the decorative ends of the handle, and the cloud-shaped feet, although to date no direct prototype vessel of Chinese origin is known.

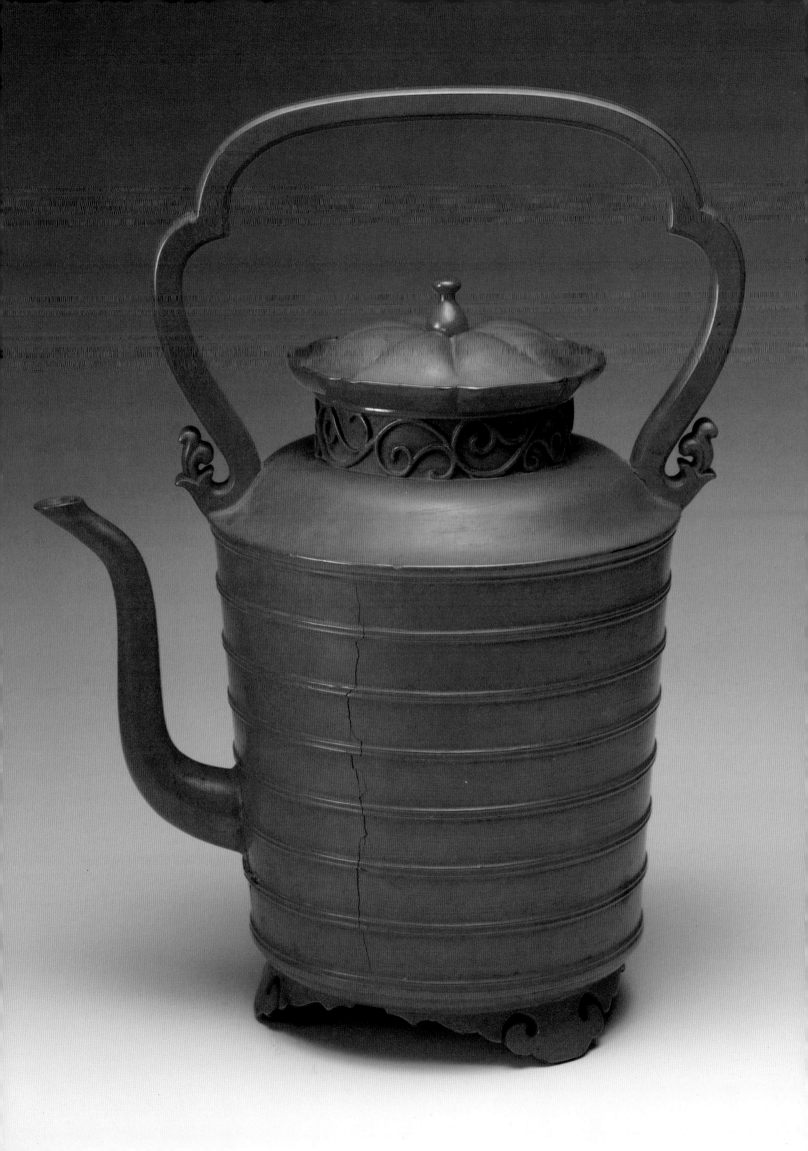

136

RYŌSHIBAKO (box for writing paper)

Lacquer and gold on woven bamboo; Edo period, 17th–18th century;
L. 31.8 cm (12½ in.) W. 23.5 cm (9¼ in.) H. 10.5 cm (4⅛ in.); B60 M162,
The Avery Brundage Collection

JAPANESE LACQUERWORK reached the height of technical accomplishment during the Edo period (1615–1868). Known as "Japanned" ware in Europe, many fine exported examples graced princely residences. While many other Asian countries produced fine lacquerwork, Japanese lacquer is distinguished by the decorative technique called *makie*.

In addition to wood, base materials for lacquer include bamboo (as for this box), leather, paper, and woven cloth; even horsehair (the base for Korean men's hats) can be lacquered with beautiful results.

This writing-paper box exemplifies three basic Japanese lacquer decoration techniques: *taka-makie*, *hira-makie*, and *kirikane*. In the *makie* process, silver or gold powders are sprinkled on the painted lacquer pattern while it is still wet and can act as an adhering agent. The process is repeated to build a desired thickness of lacquer saturated with metal powder. The last coats of lacquer applied over the design are polished to obtain a soft glowing finish.

The basic *makie* is relatively flat and most commonly applied on an already lacquered surface. When the decoration is raised to some thickness with repeated applications of lacquer and gold (or silver), the finished work is called *taka-makie*, or high (raised) *makie*. *Kiri-*

kane, small pieces of gold, are arranged on the *makie* surface as additional decorative elements.

Split bamboo, the base material for this box, was favored for both its light weight and flexibility. Several examples of such bamboo boxes with elegant and individualistic designs survive, suggesting the popularity of the material among people of discriminating taste during the Edo period.

The pictorial motif of various flying birds behind a net or within an aviary was fashionable in the early Edo period and can be found in some paintings.[1] The design continued to develop and appear in other crafts with some decorative variations. Textiles of the mid to late Edo period, for instance, show nets and fish or other sea creatures.

The combination of the bamboo base and the bird-and-net design on this box might indicate that it was made for an individual with refined taste, perhaps to hold choice rolls of paper or precious letters. The lightness of the woven bamboo and a certain softness to the touch somehow seem to suggest that this was a prized possession of a lady with fine calligraphic talent. The interior of the box is finished with plain black lacquer. Originally cloisonné fittings with rings held silk cords for securing the cover.

137

SUZURIBAKO (inkstone box)

Lacquer, gold, and mother-of-pearl on wood; Edo period, early 18th century;
L. 24.1 cm (9½ in.) W. 21.9 cm (8⅝ in.) H. 5.3 cm (2¹⁄₁₆ in.); B60 M440,
The Avery Brundage Collection

B Y COMPARING THIS Edo period *suzuribako* with one depicted in the "Yūgiri" chapter of a twelfth-century *Tale of Genji* scroll, it becomes apparent that the basic shape of this box did not change over the centuries, nor did its function as a container for an inkstone, water dropper, and a brush tray or two.[1]

The earliest surviving *suzuribako* date back to the Kamakura period (1185–1333), and only a few are still in existence.[2] In all likelihood, earlier pieces were damaged through daily use and discarded. A great many more examples from the Muromachi period (1392–1573) survive; some of the finer ones are considered personal treasures, while the best are nationally designated as Important Cultural Properties.

During the Muromachi period, especially during the era of Shogun Yoshimasa (1435–1490), *suzuribako* became objects of great reverence. Yoshimasa's keen appreciation of Chinese art and antiques and his collection (most of which still remains as the Higashiyama collection in Japan) laid the basic foundation for the admiration and study of these boxes. One of Yoshimasa's literary activities, social gatherings for composing *renga* (linked verses), provided a setting for appreciating fine writing utensils. At such gatherings participants created long poems of "linked verses," each contributing a line

that continued the poetic imagery and connected the preceding lines. Such a party might continue for hours, even days. To welcome a specially invited famous poet and other guests, a host would display his special writing instruments or might even commission a new set. It was only natural that such boxes were decorated with themes from literary traditions (see no. 138) or inspired by nature, such as this example.

The *makie* used on this box, called *togidashi-makie* (polished-out *makie*), is in fact embedded in the lacquer surface. (For the standard *makie* techniques, see no. 136.) In *togidashi-makie*, the pattern is first applied, as in basic *makie*, and the background then filled with lacquer to the level of the pattern, covering it over. After the entire surface is polished to a smooth finish, the pattern is once more revealed.

This inkstone box is also decorated with inlaid mother-of-pearl depicting autumn grasses. This theme is greatly favored in Japanese art and has been used throughout many centuries in different media. In this combination, bush clovers (*hagi*), star-shaped bell flowers (*kikyō*), pampas grasses (*susuki*), *ominaeshi* (*Patrinia scabrasaefolia*), *rindō* (*Gentiana scabra*), and *fujibakama* (*Eupatorium fortunei*) are gracefully and naturalistically rendered with some indication of ground surface and small rocks.

138
SUZURIBAKO (Inkstone Box)

Gold, silver, and lacquer on wood; Edo period, 18th century;
L. 24.3 cm (9⅝ in.) W. 22.1 cm (8¾ in.) H. 5.1 cm (2 in.);
B60 M438, The Avery Brundage Collection

Cover, interior

AFTER THE SECOND shogun, Hidetada (1579–1633), brought the noted lacquerer Kōami Chōan (act. late 1580s to 1610s) to Edo, lacquer production in the city reached its highest technical and aesthetic level.[1] The standard set of lacquer furniture and small articles used by women of high social rank came to contain a large number of pieces.[2] For everyday use, such as makeup and dressing, or reading and writing, the usual set consisted of three central cabinets furnished with many smaller boxes and articles made for specific purposes.

For instance, the lacquerwork produced for Chiyohime, daughter of the third Tokugawa shogun Iemitsu (reigned 1623–1651), who married in 1637, was well recorded. There were three special cabinets, a toilet set with accessories, gaming tables and game sets, utensils for the incense ceremony, musical instruments, a writing set, and more, all finely decorated with a theme taken from the *Tale of Genji*. It took the celebrated lacquerer Kōami Nagashige (1599–1651) and his studio three years to complete these items.[3] Ordinarily such objects would be decorated with a combination of the most elaborate types of *makie*.

Among all those personal articles made for women, by far the most important were the *suzuribako* (see no. 137), the reading table, and an accompanying writing-paper box with a matching pattern.

Inside the cover of this *suzuribako*, various lacquer techniques are liberally used to depict a scene from chapter 24, "Kochō" (Butterfly), of the *Tale of Genji* (see no. 64). The setting is a palatial garden with a large pond and a building (upper left). Two Chinese boats, one with a dragon-headed prow and the other (behind it) with a phoenix-headed prow, float in a pond that is half-hidden behind an island. (These boats were made specially for Genji and his ladies so they could view the mosses on the island.) The almond-shaped upper parts of large upright drums on the phoenix-prowed boat suggest that a musical accompaniment was also presented. An old pine tree with intertwined blossoming wisteria vines (above the boats) grows on the rocky island. This might seem an ordinary decorative theme, simply a combination of plants taken from any Japanese hillside in late spring. In the literary setting, however, the combination alludes to female dependency (wisteria) on a strong masculine figure (pine) and is used repeatedly in romantic tales, especially in the *Tale of Genji*; it appears in a wide range of decorative arts from the Heian period on.

The richness of decoration suggests that this box might once have graced the writing table of a woman of high social background. In fact, in Chiyohime's trousseau there is a writing-paper box with the "Kochō" theme, suggesting that it might have been a popular choice of rich parents for their daughters.

The decoration is a combination of various *makie* such as *hira-*, *taka-*, and *togidashi-makie* (see no. 136). *Taka-makie* is skillfully used to depict the three-dimensional quality of rocks, tree trunks, and some architectural features. A metal inlay of boat ornaments as well as *kirikane* (small, precisely cut gold squares) applied on the rocks add extra richness to the design.

The cover exterior is similarly decorated, predominantly with a design of rocks, pine, and wisteria. Plums and bamboo, combined with the pine, create the Three Friends, *shō chiku bai*, one of the most popular auspicious symbols of the Edo period. Two pairs of cranes and a pair of turtles, both symbols of longevity, give added favorable meaning to this *suzuribako*.

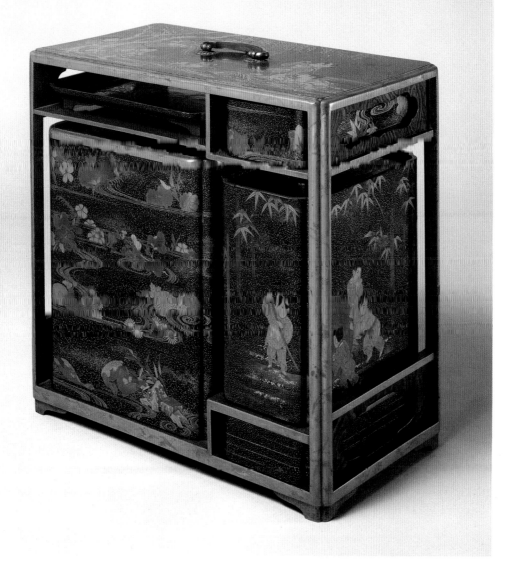

LACQUER PICNIC SETS were popular among Edo period townspeople, who used them in seasonal outings, during Kabuki performances, which lasted the good part of a day, and on other festive occasions. A standard lacquer picnic case had a metal carrying handle on top, was fitted with a set of small tiered boxes (*jūbako*), a tray, four or five small serving dishes, and a sake container. Quite often the sake containers were of a different material, such as porcelain or pewter, but in this set, a rectangular lacquered wooden container for sake is specially fitted to the case.

Many Edo genre paintings depict such sets. In the first panel on the right screen of no. 59, for example, they are being unloaded from a large, plain, wooden carrying box. The second panel on the left screen also shows a *jūbako* with a pair of sake bottles, probably made of porcelain.

This picnic set has extremely fine *makie* decoration. The main theme, *karako* (Chinese children) at play, is accompanied by scenes illustrating the four seasons. The cockfight on the top of the carrying case represents spring; irises on the *jūbako* cover stand for summer; pampas grass and *ominaeshi* (*Patrinia scabiosaefolia*) signify autumn; and the snowball scene on the sake container indicates winter.

Further allusions to the four seasons decorate the sides of the *jūbako*. From the top down, they include cherry blossoms, pinks and hibiscus, chrysanthemums, and reeds with a flock of geese. On the corners, a delicate series of phoenixes in gold *makie* are subtle and elegant against a gold background.

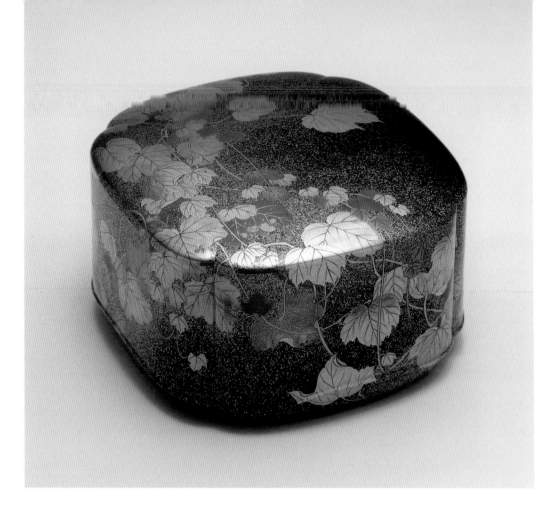

140
COVERED BOX
Signed Yūtokusai Hōgyoku

Lacquer, gold, and silver on wood; late Edo period, 19th century; L. 15.4 cm (6¹/₁₆ in.)
W. 14.8 cm (5¹³/₁₆ in.) H. 8.6 cm (3³/₈ in.); B60 M7+, The Avery Brundage Collection

THE TECHNICAL and compositional virtuosity of the late Edo period lacquer craftsman is best exemplified in this exquisitely crafted lacquer box with lobed corners. Its shape no longer follows traditional functional form, like those boxes made to contain writing implements or incense-burning utensils. Here the delicate form is an inseparable part of a whole design concept in which the *makie* artist displayed his highly developed skills (see no. 136 for *makie* techniques).

A naturalistic ivy design covers the top and deep sides of the box cover, which encloses virtually the entire container. Beneath the cover, the ivy vine theme sprawls up the box itself and down into its interior, fluidly merging into one continuous organic pattern.

Ivy, a popular motif of many famous Edo period painters of the Rimpa school, such as Sōtatsu (?–1643?) and Hōitsu (1761–1828), was used widely by later craftsmen. In fact, ivy has much older literary associations. In the famous ninth-century *Tales of Ise*, for example, the Mount Utsu chapter ("Utsu no yama") includes a scene on a dark and narrow mountain path which is covered with ivy. There the hero Ariwara no Narihira meets a priest, an old acquaintance, who carries Narihira's love letter back to the lady he left behind in the capital.[1]

Many famous artists as well as anonymous craftsmen of this period exploited the vast decorative possibilities offered by the stem and leaves of this rather commonplace plant which is so filled with romantic allusion. The little-known craftsman Yūtokusai (act. mid-nineteenth century) used two types of *makie* technique with utmost skill to create in the design on this box the illusion of depth and layers of leaves. The gold and silver pattern, with the addition of red for autumn leaves, floats against the black lacquer background, which is sprinkled with slightly coarser gold flakes. The piece may be considered one of the finest works of the Edo period lacquerer.

The skill of the core maker contributed to the creation of this masterpiece. The work of an anonymous craftsman, whose talent is quite literally hidden under the layers of lacquer, gold, and silver, this wooden core is so thin that the finished thickness of the box is not more than one-eighth of an inch.

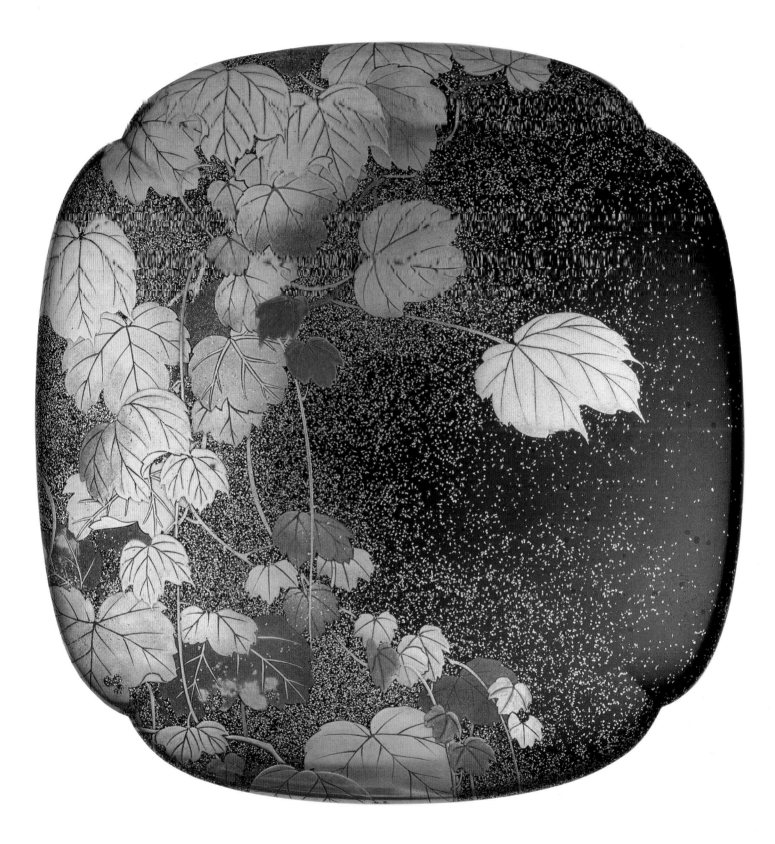

141

SUZURIBUTA (inkstone cover)
Shibata Zeshin, 1807–1891

Lacquer on wood; late Edo to Meiji period, 19th century; L. 23.6 cm (9³/₈ in.)
W. 21.7 cm (8¹/₂ in.) H. 3.1 cm (1¹/₄ in.); B60 M294, The Avery Brundage Collection

SHIBATA ZESHIN (see also nos. 80–82, 147) began his formal training in lacquerwork when he was only eleven years old, under the noted craftsman Koma Kansai (1766–1835). Before age twenty, he was working independently at home and able to support his parents. These early accomplishments stimulated his desire to learn more. He studied painting with Suzuki Nanrei (1775–1844) and for a time used the studio name Reisai, derived from the second half of the teacher's name.[1]

At age twenty-four, Zeshin moved to Kyoto, where he pursued painting studies with Okamoto Toyohiko (1773–1845), a Shijō school artist. His imagination was fired by his interests in *waka* poetry, haiku, and the tea ceremony, inspiring him in a much more diversified manner than possible by adherence to a single school or to design manuals. When he was twenty-seven, on his way to Nagasaki where he hoped to continue to expand his artistic horizons, illness forced him to return to Edo; there he took the name Zeshin.

This *suzuributa* is representative of Zeshin's refined taste. When in use, it was placed face-down, showing a plain surface with a special matte finish developed by Zeshin called *seidō-nuri* (bronze finish). This finish is quite different from the highly polished black lacquer used on more formal pieces, such as cases for formal swords. Achieved by repeated coating, texturing, and patient polishing, it presents a warm surface very soft to the touch.[2]

The inside of the cover is decorated with a mallet, the symbol of Daikokuten, one of the seven household gods. When shaken by the god, this mallet is supposed to grant all wishes. It is decorated with clouds, waves, and jewels. The waves exemplify another of Zeshin's favorite techniques, *seikai-nuri*. The method is said to have once been used by the artist Kanshichi of the seventeenth century, who came to be known as Seikai (blue sea) Kanshichi because of his skill in this technique. Instead of the gold lacquer that Kanshichi used in his wave patterns, Zeshin used dark lacquer against an even darker background for subtle contrast. The pattern was created by raking a fresh, still-wet lacquer coating with an extremely fine-tooth comb.

The idea of concealing decoration inside a box, anticipating that it will only be seen when the cover is removed from the inkstone, is reminiscent of the same subtle approach that places a decorative and often expensive lining in a *haori* (a garment worn over a kimono), which may be seen only fleetingly.[3]

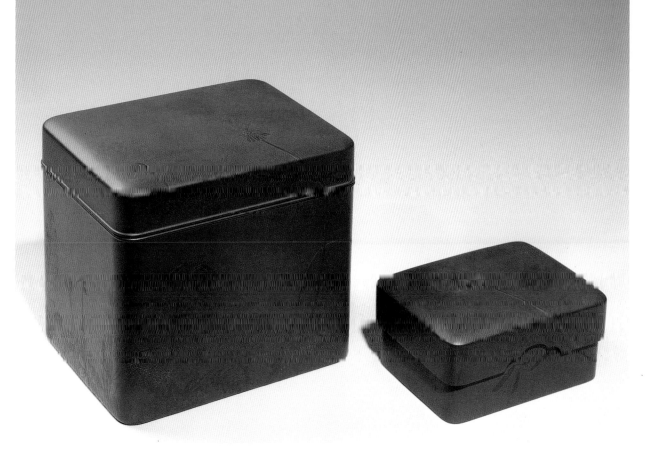

142
SET OF BOXES
Shibata Zeshin, 1807–1891

Lacquer on wood; late Edo to Meiji period, 19th century; H. 11.6 cm (4⁵/₈ in.)
W. 12.8 cm (5¹/₁₆ in.) Depth 10.2 cm (4 in.), H. 4.7 cm (1⁷/₈ in.) W. 9.6 cm (3³/₄ in.)
Depth 7.2 cm (2⁷/₈ in.); B60 M3+ (large box), B60 M4+ (small box), The
Avery Brundage Collection

AT A CASUAL GLANCE, this set of boxes appears to be without
decoration. Closer examination, however, reveals one of the most subtle
renderings of spring plants that Zeshin ever created. Completely monochromatic,
their matte finish and color quality are similar to the exterior of a *suzuributa* he
designed (no. 141).

In one of his most delicate and naturalistic depictions, Zeshin turned com-
monplace spring plants such as violets, dandelions, horsetails, and beach peas into
exquisite decorations. The stems and leaves of the plants are in slightly raised lac-
quer, while such delicate details as a flying butterfly and feathery dandelion seeds
are incised in hair-thin lines. On both boxes, ornamental schemes are continuous
from bottom to lid. Their inner trays are also decorated, the large box tray with a
beach pea sprig with seed pods, and the small one with fully open violet pods filled
with minute seeds.

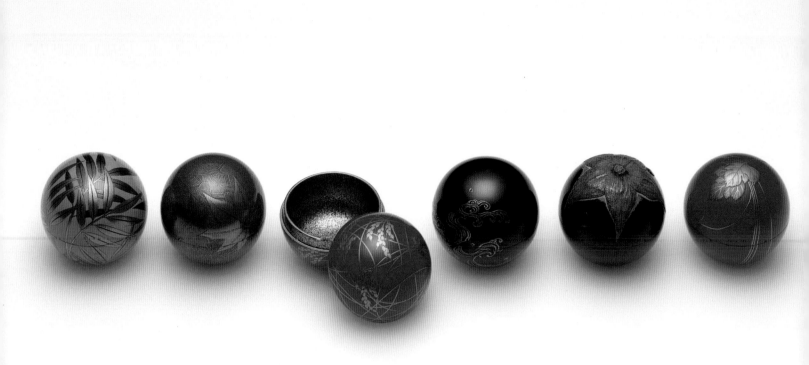

Kōgō months, artists, and themes, reading in Japanese order from right to left: *January*, Shūetsu Kōda (1881–1933), *temari* silk toy ball for girls' play around the New Year holidays. *February*, Shunkō Uehara (1877–1948), sacred jewel of the fox, messenger of the Shinto god Inari, whose main festival is in February. *March*, Kagyō Yuasa I (1875–1952), cascading willow branch. *April*, Gosaburō Dōmoto (1889–1964), cherry blossoms. *May*, Jisei Uono (1883–?), *yukinoshita*, a plant of early summer often painted by Rimpa school artists such as Ogata Kōrin and Watanabe Shikō. *June*, Gyokuhō Inai I (1876–1930), thunder god, representing early summer storms. *July*, Katei Kōda (1886–1961), silk-wrapped mulberry leaves. *August*, Rakuzen Yamada (1874–1939), a plump eggplant, a popular summer vegetable. *September*, Gyokushin Miki (1881–1944), waves. *October*, Shōho Okamoto (act. c. 1910), rice plants with grains representing the harvest. *November*, Yūkichi Kamisaka (1886–1938), maple leaves. *December*, Kōfu Tojima (1882–1956), bamboo plants.

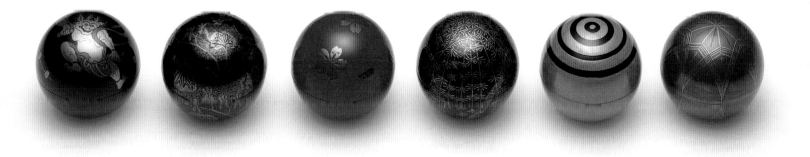

143

SET OF TWELVE *KŌGŌ* (incense container)

Lacquered by Hyōsaku Suzuki I, decorated and signed by twelve *makie* craftsmen;
lacquer, gold, and silver on wood; Taishō period, 20th century; Diam. 5 cm (2 in.) each;
B60 M295a–l, The Avery Brundage Collection

AMONG THE MANY AREAS of Japan known for lacquer production, Kyoto has been by far the most prestigious. By the Heian period (794–1185), lacquerers already formed an established elite among the skilled work force within the government system. According to Heian period records, lacquer ware production recognized the specialized skills of the maker of the wooden core and of the lacquerer.[1] By the Kamakura period (1185–1334), a third specialist, the decorator, appeared on the scene. These craftsmen were called *makie-shi* (after *makie*-type decoration; see no. 136). Close collaboration among these three specialists has always been a prerequisite for fine lacquer ware.

The set of twelve *kōgō* represents the highest achievement of Kyoto lacquerers, both in technique and aesthetics. In a unique project, Hyōsaku Suzuki I (1874–1943), a distinguished lacquerer, managed to engage twelve *makie-shi* from the Kyoto area to decorate his *kōgō*, each with a motif for one month of the year.

The Twelve Months theme originated in the Heian period capital of Kyoto among courtiers and court ladies. Living in a city nestled among nurturing hills and rivers in a relatively mild climate, Kyoto residents developed a deep appreciation of nature. The people's love of nature and their keen observation manifested itself early, both in literary and visual arts.

In the *kōgō*, each month is represented by a simple motif. Falling cherry blossoms for April not only symbolize spring but are a pictorial reminder of complex meanings derived from literature and poetry. Thousands of poems and paintings on this theme convey the deep joy and sorrow at the advent and passing of spring. An additional thematic touch on this *kōgō* is a delicately applied gold *makie* of *shinobu-gusa* plants. *Shinobu* is a pun on the verb meaning "to endure," which may be interpreted as a symbol of the sorrow of a love that has to be hidden as discreetly as this *kōgō*'s decorative band, invisible until its cover is lifted. The *makie-shi* for this month was Gosaburō Dōmoto (1889–1964).

For July, the *makie-shi* Katei Kōda (1886–1961) placed a couple of leaves on the soft, glowing surface of the *kōgō* and gently wrapped it with a strand of silk, a symbol of the Star Festival, which is celebrated on the seventh day of the month. According to Chinese legend, a weaver-maiden meets her love, a cowherd, only once a year on this day as their paths cross on the Milky Way. The leaves are the *kaji*, the mulberry tree on which silkworms feed, and the thread is the silk she spins.

In September, the full moon begins to have a special glow in the clear autumn sky. For Gyokushin Miki (1881–1944), this sphere was a perfect format on which to recreate a scene from a famous Nō play, *Chikubushima*. A passage — "the waves above which hares fly" — is here simply suggested by beautifully applied wave patterns. The hares, symbols of moonlight, are hidden inside, painted in gold and silver.

To reveal the complex beauty and meaning of such works requires that a hostess remove the cover of a *kōgō* in her palm and prepare the incense so her guest fully appreciates both incense and container. As the delicate scent of incense fills the room, perhaps she and her guest would recall their favorite poems on the theme of the *kōgō*.

As part of a treasured collection, each *kōgō* is kept in its own paulownia-wood box within a large storage box. Inside the lid of the outer box are the names of the twelve *makie-shi*, each under the month and title of his motif, with Suzuki's signature as lacquerer.

COSTUME, INRŌ, AND NETSUKE

144
KOSODE

Ink and silver on silk; early Edo period, 17th century; L. 137.5 cm (54 ⅛ in.)
W. 129.3 cm (50⅞ in.); B62 M74, The Avery Brundage Collection

T HE *KOSODE*, everyday garb for commoners and worn as undergarments by courtiers, was already in customary use during the Heian period.[1] During the Kamakura period, the gradual shift from an elaborate and slow lifestyle to a simple and more active one was reflected in the clothing of the upper class. Once hidden under flowing layers of outer garments, *kosode* came to be accepted as something to be seen and were sometimes worn with other outer garments. Their appearance changed accordingly.

A unique group of Nō costumes, the *Nō-kosode*, developed from the basic *kosode* during the Muromachi period as Nō performances gained popularity. From their beginning as rather rustic folk entertainers, generations of Nō players introduced stylized and refined theater costumes, which were normally made of various richly decorated textiles. These elaborate costumes reflected the gradual sophistication of the life of Nō performers as they enjoyed the approval of society and the personal patronage of its highest-ranking members. Costumes were named after their material—*karaori* (Chinese-style brocade) and *nuihaku* (embroidered on gold- or silver-foiled cloth). Otherwise they were collectively called *Nō-shōzoku* or *Nō-ishō*, terms that simply meant Nō costumes in the most generic sense.

Apparently very few *kosode* or *Nō-ishō* with painted decoration were made before the Edo period, since only a few examples survive, including a famous *kosode* that once belonged to Uesugi Kenshin (1530–1578).[2] Such rare pieces seem to have been specially commissioned and were therefore reserved for the upper class.

The decoration on this *kosode* is in black ink, on what was once a silver-foiled silk surface. The mynah-like black birds with large beaks may have been blockprinted. Additional details such as eyes, beaks, and claws appear to have been hand-painted. Some birds are shown in flight while others stand with wings folded, providing variation and movement.

This *kosode* falls somewhere between an ordinary garment and the *Nō-shōzoku* or *Nō-ishō*. It may have been made for someone who practiced Nō dancing as a hobby rather than for a professional Nō actor.

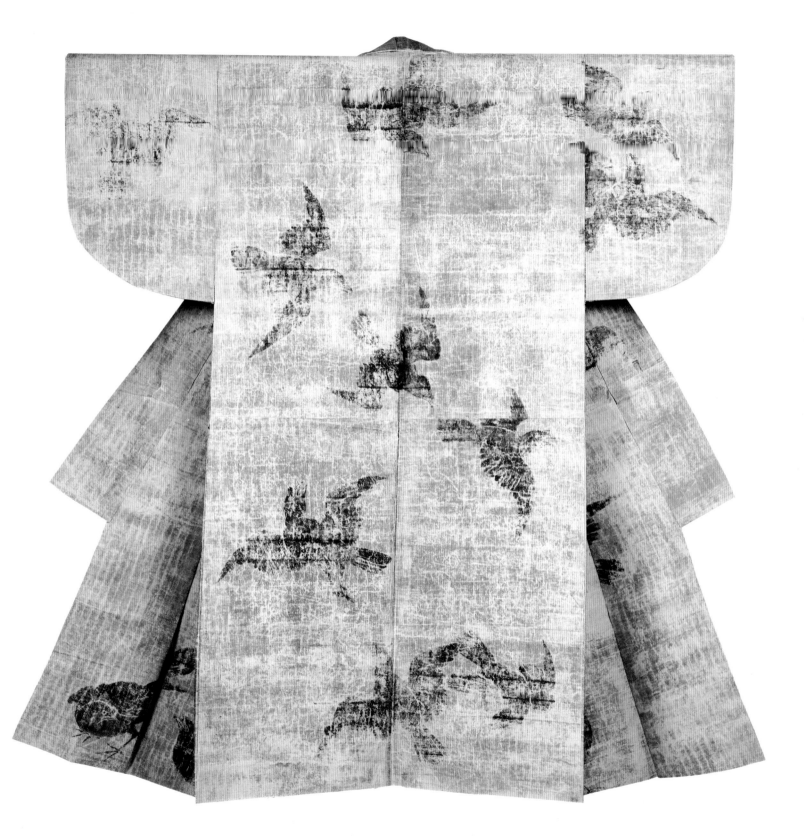

145
INRŌ AND NETSUKE WITH
INUBAKO AND PEACH BLOSSOMS

Lacquer, gold, and silver on wood with ivory netsuke; Edo period, late 18th–19th
century, signed Kajikawa saku; *Inrō*: H. 8 cm (3 1/8 in.) W. 6.9 cm (2 3/4 in.), Netsuke: H.
2.5 cm (1 in.) W. 3.8 cm (1 1/2 in.); B70 Y1379 (*inrō*), B70 Y1380 (netsuke), The Avery
Brundage Collection

THE TERM *INRŌ* (seal container) originally
referred to boxes used to hold personal seals,
usually a covered, tiered box about 4 or 5 inches square,
or, if circular, about the same in diameter. The inclusion
of such containers among personal writing articles
dates back to the fourteenth century; by the fifteenth,
they had become important implements for literary
men and were prominently displayed in studios. Quite
often they were imported artworks of carved or inlaid
decorated lacquer ware.[1]

These lacquer boxes, especially circular ones,
came to be called *yakurō* (medicine container). Even-
tually smaller, portable versions of tiered boxes were
produced. These small containers later were collec-
tively and erroneously called *inrō*, although they were
too small to contain seals.[2]

An *inrō* and netsuke were connected by a double
cord with a sliding bead (*ojime*) which tightened the
cord and held the tiered sections of the *inrō* together.
The netsuke, fastened on one end of the cord, was then
slipped under a man's narrow *obi*, allowing the *inrō* or
other small articles (a tobacco pouch, for instance) to
hang freely at his side. Travelers used these small cases
to carry pills, medicinal powders, and other personal
items. They also became a part of samurai attire of

the Edo period and were worn on formal occasions.
Although these personal accessories appear in earlier
genre paintings,[3] most of the surviving examples are
from the eighteenth and nineteenth centuries.

This three-compartment *inrō* is decorated with
the Hinamatsuri (Girls' Day Festival) theme, which is
celebrated on the third day of the third lunar month.
Here, a couple of *inubako* (a dog-shaped covered box)
appear with a blossoming peach branch, both impor-
tant parts of the day's decoration.

Inubako, derived from an *inuhariko* (papier-mâché
dog), were placed near an infant's bed to ward off evil
spirits. Traditional *inubako*, like those on this *inrō*, were
made with children's faces and dogs' bodies. The dog's
brocade-like covering is minutely decorated in gold
makie with the Three Friends, *shō chiku bai* (pine, bam-
boo, and plum), along with a crane and turtle, all aus-
picious symbols of longevity.

The accompanying netsuke is an ivory carving
representing an *inuhariko* box, made in two halves, the
box and its cover. In this style, the cords go through a
hole in the box bottom and are tied to a loop device
within the cover; when pulled tight, it secures the
cover.

146

INRŌ AND NETSUKE WITH
MELON AND PRAYING MANTIS DESIGN

Lacquer, gold, and mother-of-pearl on wood; late Edo period, 19th
century, signed Ishimaru; *Inrō*: H. 6.5 cm (2⁹/₁₆ in.) W. 7.7 cm (3 in.),
Netsuke: H. 3.7 cm (1⁷/₁₆ in.) W. 3.6 cm (1⁷/₁₆ in.); B70 Y1417 (*inrō*),
B70 Y1418 (netsuke), The Avery Brundage Collection

THE *INRŌ* AND netsuke of a set frequently share a decorative theme, as exemplified here. The main part of this *inrō* is a large melon on a vine surrounded by big and small leaves, some inlaid with mother-of-pearl. The vine wraps to the reverse side, where a praying mantis holds up its large front legs. The ivory netsuke is a comical small figure struggling to carry an enormous melon on his back.

The melon (*uri*) was introduced into Japan from Central Asia through China sometime during the early historical period and became popular as an exotic fruit. As a design it is seen in the background decoration on a famous Heian period calligraphy paper.[1] Some centuries later, melons appear in the traditional Japanese comic Kyōgen play, the *Melon Thief*, which might have inspired the Edo period netsuke carver who created this image.

This ivory netsuke is a *katabori* type, the most popular and therefore most plentiful among the large production of the late Edo period. *Katabori* (small carvings in the round) may also be of hard and soft woods, and may be plain, colored, or lacquered. The most fascinating and imaginative examples of carving can be found among *katabori*, which allowed artists an unlimited range of real and imaginary subjects.

Netsuke might have developed from suitable found objects, such as a gourd, twig, or nut. To be a good netsuke, an object had to be compact in shape and size, durable, with a smooth surface, and of course, preferably visually pleasing and decorative. Early carvers very likely also carved Buddhist images and Nō masks, but as netsuke gained popularity, professional netsuke carvers emerged, eventually to become teachers forming different schools with distinctive styles.

TONKOTSU (tobacco case) AND NETSUKE
WITH PRIEST SAIGYŌ
Shibata Zeshin, 1807–1891

Lacquer, gold, and silver on wood, Edo to Meiji period, 19th century; signed Zeshin on
tonkotsu; manubrium H. 6.6 cm (2⅝ in.) W. 5.0 (2¼ in.), Netsuke H. 3.2 cm (1¼ in.)
W. 3.2 cm (1¼ in.) Depth 1.5 cm (⁹/₁₆ in.); B70 Y1606 (*tonkotsu*), B70 Y1607 (netsuke),
The Avery Brundage Collection

To THE FUN-LOVING and adventurous Edo populace, netsuke and *inrō* as well as other small objects, such as tobacco cases, were means to exhibit personal taste through adornment, just as modern fashion-conscious people purchase designer jewelry. A new design or an interesting idea by a craftsman would attract many eager customers as well as prompt imitators who produced less attractive merchandise for less discriminating tastes.

Zeshin was an especially talented artist of seemingly limitless invention. He developed new techniques, which he mastered and polished to the point that they could not be successfully copied by others. His long and concentrated basic artistic training set him apart from the dozens of craftsmen who sought to please the Edo populace's appetite for novelty.

Although he produced the standard compartmented *inrō*, Zeshin seems to have preferred the *tonkotsu* shape, which has no compartments. The form of this small sack-shaped container with smooth contours gave him considerably more freedom in creating a composition, for he did not need to match designs as on the tiered, fragmented surface of *inrō*.

Here Zeshin portrayed the priest Saigyō (1118–1190), a famous poet also known for his extensive traveling and his love of nature. Saigyō, in dark clothes, carries a large bamboo traveling hat and a simple walking-stick. A bundle is tied across his back and shoulders. In his left palm he holds the silver cat ornament given to him by Minamoto no Yoritomo (1147–1199) after a political discussion to which Saigyō had been summoned. It is said that Saigyō, who was devoted to the Taira clan (the opponent of Yoritomo), after safely leaving Yoritomo's mansion, gave the precious present to some children playing around the residence and went on to continue his carefree, traveling life.[1]

Zeshin often used natural bamboo for the lid, a refreshing contrast to sophisticated lacquerwork. Above the small metal *ojime* in the shape of a Buddhist wooden gong is a square *manjū*-type wooden netsuke with a design of Buddhist prayer beads in lacquer.

LITERATURE AND NOTES

···

Literature and notes are listed in subject areas by catalogue entry; notes follow literature. For each entry, references are cited fully the first time and thereafter by short titles. The following short references are used in both literature and notes:

D'Argencé 1966

D'Argencé, René-Yvon. "The Avery Brundage Collection of Asian Art." *Asia Foundation Program Bulletin*, no. 40 (Aug. 1966), pp. 3–11.

D'Argencé 1968

D'Argencé, René-Yvon. *Selected Works of World Art: Avery Brundage Collection.* Exh. cat. Mexico City: National Museum of Anthropology, 1968.

D'Argencé 1976

D'Argencé, René-Yvon. *A Decade of Collecting.* San Francisco: Asian Art Museum, 1967.

D'Argencé 1978

D'Argencé, René-Yvon, ed. *Asian Art: Museum and University Collections in the San Francisco Bay Area.* Montclair, N.J.: Allenheld and Schram, 1978.

D'Argencé and Turner 1974

D'Argencé, René-Yvon, and Diana Turner, eds. *Chinese, Korean, and Japanese Sculpture in the Avery Brundage Collection.* San Francisco: Asian Art Museum, 1974.

Elisseeff 1985

Elisseeff, E. and V. *Art of Japan.* New York: Abrams, 1985.

Kakudo 1980a

Kakudo, Yoshiko. "Early Japanese Art." *Apollo* 112, no. 222 (Aug. 1980), pp. 101–7.

Kakudo 1980b

Kakudo, Yoshiko. "Later Japanese Art." *Apollo* 112, no. 222 (Aug. 1980), 108–16.

Kakudo 1981

Kakudo, Yoshiko. "The Dazzling Virtuosity of Arita Porcelain." *Antique World* 3, no. 9 (Sept. 1981), pp. 62–66.

Kakudo and Ng 1985

Kakudo, Yoshiko, and So Kam Ng. *Art with the Written Word from China and Japan.* Exh. brochure. San Francisco: Asian Art Museum, 1985.

Mayuyama 1966

Mayuyama, Junkichi. *Japanese Art in the West.* Kyoto and Tokyo: Mayuyama Ryūsendō, 1966.

Patronage 1989

Looking at Patronage: Recent Acquisitions of Asian Art. Exh. cat. San Francisco: Asian Art Museum, 1989.

Schobel and d'Argencé 1968

Schobel, Heinz, and René-Yvon d'Argencé. *The Four Dimensions of Avery Brundage.* Leipzig: Editions Leipzig, 1968.

Shimizu 1979

Shimizu, Zenzō. "Amerika Kanada ni aru Nihon chōkoku." *Bukkyō Geijutsu*, no. 126 (Sept. 1979), pp. 67–88.

PREHISTORIC ART

No. 1 Jōmon jar, B60 P932
No. 2 Jōmon jar, B62 P55
LITERATURE: (B60 P932) Schobel and d'Argencé 1968, pl. 98; d'Argencé 1978, fig. 91; Kakudo 1980a, p. 102, fig. 1; John La Plante, *Asian Art* (Dubuque, Iowa: William C. Brown Co., 1980), p. 33, fig. 34; Robert T. Singer, "Japanese Ceramics: The Fusion of Function and Aesthetics," *Antiques and Fine Art* 6, no. 2 (Feb. 1989), p. 96.

1. J. Edward Kidder, with contribution by Teruya Esaka, *Prehistoric Japanese Arts: Jōmon Pottery* (Tokyo and Palo Alto, Calif.: Kōdansha International, 1968), p. 285.

No. 3 Spouted Jōmon vessel, B67 P5
No. 4 Censer-shaped Jōmon vessel, B67 P4
LITERATURE: D'Argencé 1976, pls. 116–117.

1. Hiroyuki Kaneko, ed., *Kōki banki*, vol. 3 of *Jōmonjidai*, Nihon no bijutsu, no. 191 (Tokyo: Shibundō, 1982), p. 32.
2. Takashi Doi, ed., *Chūki*, vol. 2 of *Jōmonjidai*, Nihon no bijutsu, no. 190 (Tokyo: Shibundō, 1982), p. 37.
3. Sugao Yamanouchi et al., eds., *Jōmonjidai doki*, vol. 1 of Nihon genshi bijutsu (Tokyo: Kōdansha, 1964), ref. fig. 161.
4. Kaneko, *Kōki banki*, pl. 62.

No. 5 *Dogū* figurine, B69 S31
No. 6 *Dogū* head, B62 P69
LITERATURE: (B69 S31) D'Argencé 1976, pl. 115.

1. Kiyotari Tsuboi, ed., *Nihon genshi*, vol. 1 of Sekai tōji zenshū (Tokyo: Shōgakkan, 1979), pls. 57–58.
2. Hiroyuki Kaneko, ed., *Kōki banki*, vol. 3 of *Jōmonjidai*, Nihon no bijutsu, no. 191 (Tokyo: Shibundō, 1982), p. 31.
3. Ibid., p. 31. The recent discovery at the Shakadō site in Yamanashi Prefecture of more than one thousand figurines that appear to have been intentionally broken may offer more support to such a theory.
4. Isamu Kōno et al., eds., *Dogū sōshingu*, vol. 2 of Nihon genshi bijutsu (Tokyo: Kōdansha, 1964), pl. 3, figs. 29a–b.

No. 7 Yayoi jar, B60 P2286
No. 8 Yayoi jar, B60 P134+
LITERATURE: (B60 P2286) Mayuyama 1966, p. 325, pl. 409; John La Plante, *Asian Art* (Dubuque, Iowa: William C. Brown Co., 1980), p. 33, fig. 36; (B60 P134+) Kakudo 1980a, p. 102, fig. 2.

1. Masashi Kinoshita, *Yayoijidai*, Nihon no bijutsu, no. 192 (Tokyo: Shibundō, 1982), pp. 23–24.
2. Kiyotari Tsuboi, *Yayoi*, vol. 2 of Tōji taikei (Tokyo: Heibonsha, 1973), pl. 8.

No. 9 *Dōtaku*, B60 B14+
LITERATURE: Sueji Umehara, *Dōtaku no kenkyū* (Tokyo: Ōokayama shoten, 1927), *Zuroku* (pl. vol.), pl. 137-1; d'Argencé 1966, fig. 2; Mayuyama 1966, p. 327, pl. 412; Elisseeff 1985, pl. 20; *Ōiwayama shutsudo dōtaku zuroku*, exh. cat. (Yasu: Yasu chōritsu rekishi minzoku shiryōkan, 1988), p. 26.

1. Shōsuke Sugihara, *Seidōki*, vol. 4 of Nihon genshi bijutsu (Tokyo: Kōdansha, 1964), pp. 176–77, pls. 14, 71.

2. One famous example unearthed in Ōmi Province in A.D. 668 is recorded in the founding legend of Ishiyama temple and even illustrated, though incorrectly, in the handscroll version of the legend. See *Ishiyamadera engi*, vol. 22 of Nihon emakimono zenshū (Tokyo: Kadokawa Shoten, 1966), pl. 2. The finding of the Ōiwayama examples in 1881 was recorded at the time by the owner of the site and submitted to the local magistrate.

3. Recently the importance of these discoveries prompted the Yasu community to develop and open (in 1988) a special museum devoted to *dōtaku* and related local history. Twelve of the original fourteen *dōtaku* from the Koshinohara site, now belonging to various collections in both Japan and the West, were shown in the *dōtaku* museum [Dōtaku Hakubutsukan] in an exhibition commemorating its opening.

4. Shosuke Sugihara, ed., *Yayoi Period*, pt. 2 of Nihon, vol. 2 of Sekai kōkogaku taikei (Tokyo: Heibonsha, 1964), fig. 239.

No. 10 Haji jar and stand, B62 P3+, B62 P4+
1. Shōzō Tanabe and Migaku Tanaka, *Yayoi hajiki*, vol. 2 of Nihon tōji zenshū (Tokyo: Chūōkōronsha, 1978), p. 59.

No. 11 Haniwa warrior, B60 S201
LITERATURE: Seiroku Noma, *Haniwa-bi* (Tokyo: Jurakusha, 1942), pl. 42; *Nihon kodai hen*, vol. 1 of Sekai tōji zenshū (Tokyo: Kawadeshobō, 1958), pl. 116; Yukio Kobayashi, *Haniwa*, vol. 1 of Tōki zenshū (Tokyo: Heibonsha, 1960), pl. 13; d'Argencé 1966, pl. 1; Mayuyama 1966, p. 331, pl. 423; Schobel and d'Argencé 1968, pl. 99; d'Argencé and Turner 1974, pl. 193, p. 364; d'Argencé 1978, fig. 102; Kakudo 1980a, p. 103, fig. 4; John La Plante, *Asian Art* (Debuque, Iowa: William C. Brown Co., 1980), p. 35, fig. 38; Elisseeff 1985, pl. 22.

1. Recent study and the exhibition *Japanese Archaeology: History and Achievements* (Tokyo National Museum, 1988) suggest a new theory for the origin and emergence of such plain *haniwa*, pointing out the strong link between the cylindrical stands of Yayoi ware, such as those found in the Okayama area, and the plain cylindrical *haniwa*. This theory is supported by comparison of their common physical characteristics: reddish buff clay, coiled construction method, and a low firing temperature. They also show similar holes on the sides. On Yayoi ware the cut-outs must have been made to prevent warping during firing and also to reduce weight. The holes in the *haniwa* were supposedly used to link and secure the cylinders by inserting rods or rope through them. See *Nihon no kōkogaku*, exh. cat. (Tokyo: Tokyo National Museum, 1988), pp. xviii, 116–17.

No. 12 *Haniwa* female shamans, B60 S164+, B60 S165+
LITERATURE: D'Argencé and Turner 1974, p. 366, pl. 194; Elisseeff 1985, pl. 25 (detail).

1. *Senshi*, pt. 1 of Nihon, vol. 1 of Sekai bijutsu zenshū (Tokyo: Kadokawa Shoten, 1960), p. 215.

No. 13 *Haniwa* female head, B62 P6+
No. 14 *Haniwa* warrior head, B80 S1
LITERATURE: (B62 P6+) Seiroku Noma, *Haniwa-bi* (Tokyo: Jurakusha, 1942), pl. 18; d'Argencé and Turner 1974, p. 368, pl. 195.

1. See, for instance, *Nihon kodai hen*, vol. 1 of Sekai tōji zenshū (Tokyo: Kawadeshobō, 1958), figs. 214–16.
2. To this day in Japan the Shinto ritual for the dead is a celebration.
3. The largest *haniwa* kiln complex to date was excavated in Ibaragi Prefecture in July 1988, along with a work area and a large number of shards.

No. 15 *Haniwa* farmer, B80 S2
1. For an excellent treatment of cultural and agricultural

changes, see Richard Pearson's essay in *A Thousand Cranes: Treasures of Japanese Art* (Seattle and San Francisco: Chronicle Books, 1987), p. 18.
2. Fumio Miki, *Haniwa*, Nihon no bijutsu, no. 19 (Tokyo: Shibundō, 1967), pls. 75–76.
3. J. Edward Kidder, Jr., *The Birth of Japanese Art* (New York and Washington, D.C.: Praeger, 1965), p. 190, cat. no. 68.

No. 16 Haniwa helmet, B80 P1
1. Fumio Miki, *Haniwa*, Nihon no bijutsu, no. 19 (Tokyo: Shibundō, 1967), pl. 80.

No. 17 Bracelet, B62 S56
No. 18 Bracelet, B62 S57
LITERATURE: (B62 S56) Mayuyama 1966, p. 335, pl. 435.

1. Seattle Art Museum, *A Thousand Cranes: Treasures of Japanese Art* (Seattle and San Francisco: Chronicle Books, 1987), p. 94, fig. 5.
2. Yukio Kobayashi et al., eds., *Kofunjidai*, pt. 3 of Nihon, vol. 3 of Sekai kōkogaku taikei (Tokyo: Heibonsha, 1964), p. 37, fig. 73; and Iwao Murai, *Kofun*, Nihon no bijutsu, no. 57 (Tokyo: Shibundō, 1971), p. 103.

No. 19 *Sueki* jar, B60 P537
LITERATURE: Mayuyama 1966, p. 337, pl. 438; Kakudo 1980a, p. 103, fig. 3.

1. The early wheels, however, appear to have been less efficient than later models, and therefore very few whole vessels were actually thrown from one mass; rather, they were made by combining parts thrown separately. Fabrication of large vessels still depended more on traditional coiling and beating methods.

No. 20 Ring-shaped *sueki* bottle, B64 P33
LITERATURE: Fujio Koyama, ed., *Japanese Ceramics from Ancient to Modern Times*, exh. cat. (Oakland, Calif.: Oakland Museum, 1961), pl. 13a; Mayuyama 1966, p. 338, pl. 440; Robin Hopper, *Functional Pottery Form and Aesthetics in Pots of Purpose* (Randor, Penn.: Chilton, 1986), p. 15.

No. 21 Bird-shaped *sueki* bottle, B69 P35
LITERATURE: Fujio Koyama, ed., *Japanese Ceramics from Ancient to Modern Times*, exh. cat. (Oakland, Calif.: Oakland Museum, 1961), fig. 13b; Shōzō Tanabe, *Sueki*, vol. 4 of Tōji taikei (Tokyo: Heibonsha, 1975), p. 117, fig. 56; d'Argencé 1978, fig. 92.

1. Tanabe, *Sueki*, p. 94.

No. 22 Bottle in the shape of a leather bag, B60 P1189
LITERATURE: Mayuyama 1966, p. 338, pl. 439.

1. Shōzō Tanabe, *Sueki*, vol. 4 of Nihon tōji zenshū (Tokyo: Chūōkōronsha, 1977), p. 60.

No. 23 Mirror, B64 B9
No. 24 Mirror, B64 B10
1. In this type of burial, large jars are set mouth to mouth to form a container large enough for a corpse.
2. The term *kagami* also means "model."
3. Takayasu Higuchi, *Kokyō* (Tokyo: Shinchōsha, 1979), *Zuroku* (pl. vol.), no. 256 in pl. 128.

No. 25 Mirror, B65 B1
1. In Chinese prototypes, the creatures represented are the four directional animals: Blue Dragon of the East, White Tiger of the West, Vermilion Sparrow of the South, and Snake and Turtle of the North.

No. 26 Sword, B64 W1
No. 27 Sword hilt, B64 W2
1. Yukio Kobayashi et al., eds., *Kofunjidai*, pt. 3 of Nihon, vol. 3 of Sekai kōkogaku taikei (Tokyo: Heibonsha, 1964), p. 67.

2. This blade (no. 26), which is slightly wider than the scabbard, is obviously not an original part of this sword set, although it was acquired as such. The tubular part of the handle is also a later reconstruction.
3. Han Byong-sam, ed., *Han'guk misul chonjip*, vol. 2 of Kobun misul (Seoul: Han'guk Tonghwa ch'ulpangongsa, 1977), pl. 108.
4. See the *haniwa* warrior (no. 11) for a similar sword pommel.
5. This guard (no. 27), though in the correct shape, is smaller than it should be for this sword, and is probably a later addition from another set.

SCULPTURE

No. 28 Bonten, B65 S13
No. 29 Taishakuten, B65 S12
LITERATURE: D'Argencé 1966, fig. 9 (B65 S13 only) Joan M. Hartman, "The Brundage Collection in San Francisco," *Oriental Art* 13, no. 2 (Summer 1967), p. 123, figs. 31–32; d'Argencé and Turner 1974, pl. 197, p. 372; d'Argencé 1978, figs. 103–4; Shimizu 1979, no. 45; Bunsaku Kurata, ed., *Chōkoku*, vol. 8 of Zaigai Nihon no shihō (Tokyo: Mainichi shimbunsha, 1980), pls. 51–52; *Kōfukuji meihō*, vol. 5 of Nihon no bijutsu (Tokyo: Shōgakkan, 1981), p. 39, figs. 8–9; Kan Hirata, ed., *Nara bukkyō*, vol. 1 of Zusetsu Nihon no bukkyō (Tokyo: Shinchōsha, 1989), pp. 156–57.

1. See Harold Ingholt, *Gandharan Art in Pakistan* (New York: Pantheon, 1957), fig. 243.
2. See, for instance, Takaaki Sawa, *Art in Japanese Esoteric Buddhism*, vol. 8 of Heibonsha Survey of Japanese Art, trans. Richard L. Gage (New York and Tokyo: Weatherhill and Heibonsha, 1972), fig. 19.
3. The Tōdaiji sculptures are identified opposite to our identification of the pair, with Bonten wearing a cuirass, not Taishakuten.

No. 30 Nyoirin Kannon, B71 S3
LITERATURE: John M. Rosenfield, *Japanese Arts of the Heian Period: 794–1185* (New York: Asia Society, 1967), pl. B; d'Argencé and Turner 1974, pl. 199, p. 376; d'Argencé 1976, pl. 13; d'Argencé 1978, fig. 108; "Rarities of the Asian Art Museum of San Francisco," *Asia Foundation Program Bulletin*, 1978, cover; Shimizu 1979, p. 78, no. 42; Kakudo 1980a, p. 140, fig. 6; Bunsaku Kurata, ed., *Chōkoku*, vol. 8 of Zaigai Nihon no shihō (Tokyo: Mainichi shimbunsha, 1980), pl. 16; *Asian Masterpieces in Wood*, exh. brochure (San Francisco: Asian Art Museum, 1984), fig. 8; Elisseeff 1985, pl. 58; Sherry Fowler, "Nyoirin Kannon: Stylistic Evolution of Sculptural Images," *Orientations* 20, no. 12 (Dec. 1989), p. 60, figs. 3–3a.

1. This group includes the celebrated Kanshinji Nyoirin Kannon attributed to the mid ninth century and the contemporaneous Five Great Kokuzō Bodhisattvas of the Jingoji in Kyoto.
2. The prayer beads and lotus are standard attributes for Kannon. The Wheel of the Doctrine (which can be replaced by swastika or expressed by the mudra of the Turning of the Wheel) is traditionally a symbol of Buddhahood, in this case the Buddha Vairocana (Dainichi Nyorai). By turning the Wheel, Nyoirin Kannon relieves his believers from all suffering.

No. 31 Guardian king, B67 S1
LITERATURE: D'Argencé 1968, [p. 27]; Schobel and d'Argencé 1968, pl. 90; d'Argencé and Turner 1974, p. 374, pl. 198; d'Argencé 1976, pl. 121; Donald Jenkins, *Masterworks in Wood: China and Japan*, exh. cat. (Portland, Oreg.: Portland Art Museum, 1976), no. 26; d'Argencé 1977, fig. 105; Shimizu 1979, p. 79, no. 46; Bunsaku Kurata, ed., *Chōkoku*, vol. 8 of Zaigai Nihon no shihō (Tokyo: Mainichi shimbunsha, 1980), reference

pl. 7–11, *Asian Masterpieces in Wood*, exh. brochure (San Francisco: Asian Art Museum, 1984), fig. 7; Elisseeff 1985, pl. 75 (detail).

1. The pair of Jikokuten and Zōjōten in the Asian Art Museum collection is published in d'Argencé and Turner 1974, pl. 206. A similar guardian figure, most probably from an original group of four figures or a pair, is now in the Nelson-Atkins Museum of Art, Kansas City, and is published in Kurata, *Chōkoku*, no. 59.
2. The wood was identified by Zenzō Shimizu as *kaya* (*Torreya micifera*).

No. 32 Amida Nyorai, B60 S10+
LITERATURE: D'Argencé 1966, fig. 10; d'Argencé and Turner 1974, pl. 200; Donald Jenkins, *Masterworks in Wood: China and Japan*, exh. cat. (Portland, Oreg.: Portland Art Museum, 1976), no. 28; d'Argencé 1978, fig. 110; Shimizu 1979, p. 75, no. 29; Bunsaku Kurata, ed., *Chōkoku*, vol. 8 of Zaigai Nihon no shihō (Tokyo: Mainichi shimbunsha, 1980), pl. 11; Elisseeff 1985, pl. 53 (detail).

1. Yukio Yashiro, ed., *Art Treasures of Japan*, vol. 1 (Tokyo: Kokusai bunka shinkōkai, 1960), pl. 156.
2. This paradise is often represented in Buddhist paintings (see for instance no. 43).

No. 33 Shō Kannon, B60 S420
LITERATURE: Mayuyama 1966, p. 32, pl. 39; d'Argencé and Turner 1974, p. 384, pl. 202; d'Argencé 1978, fig. 111; Shimizu 1979, p. 76, no. 35; Kakudo 1980a, p. 104, fig. 7; Bunsaku Kurata, ed., *Chōkoku*, vol. 8 of Zaigai Nihon no shihō (Tokyo: Mainichi shimbunsha, 1980), pl. 24; *Asian Masterpieces in Wood*, exh. brochure (San Francisco: Asian Art Museum, 1984), fig. 9; Elisseeff 1985, pl. 59.

1. In the typical Amida triad, Kannon is on Amida's left and Seishi Bosatsu (Mahasthamaprapta) on his right (see no. 45).
2. The three generations—Kiyohira, Motohira, and Hidehira—spanned from 1056 to 1187.

No. 34 Daiitoku Myōō, B69 B1
LITERATURE: Saburō Matsubara, "Kondō Daiitoku Myōō zō kakebotoke," *Kobijutsu*, no. 22 (June 1968), pp. 113–16; d'Argencé and Turner 1974, p. 394, pl. 208; d'Argencé 1976, pl. 123; Shimizu 1979, p. 81, no. 53.

No. 35 Seated Kannon, B65 B50
LITERATURE: D'Argencé and Turner 1974, p. 397, pl. 211; Shimizu 1979, p. 77, no. 37.

No. 36 Standing Kannon, B60 B355
LITERATURE: D'Argencé and Turner 1974, p. 408, pl. 217; Shimizu 1979, p. 78, fig. 41.

1. Takeshi Kuno, *A Guide to Japanese Sculpture* (Tokyo: Mayuyama and Co., 1963), p. 67.
2. Bunsaku Kurata, *Butsuzō no mikata* (Tokyo: Daiichihōki shuppansha, 1965), p. 272.
3. Yasumitsu Washizuka, *Kondōbutsu*, Nihon no bijutsu, no. 251 (Tokyo: Shibundō, 1987), p. 76.
4. Kuno, *A Guide to Japanese Sculpture*, pl. 95.

No. 37 Shinto goddess, B69 S36
LITERATURE: *Asian Masterpieces in Wood*, exh. brochure (San Francisco: Asian Art Museum, 1984), fig. 10.

1. Mayuyama 1966, pl. 25.

No. 38 Wind god, B60 S2+
No. 39 Thunder god, B60 S3+
LITERATURE: D'Argencé and Turner 1974, p. 418, pl. 222; Donald Jenkins, *Masterworks in Wood: China and Japan*, exh. cat.

(Portland, Oreg.: Portland Art Museum, 1976), no. 63; d'Argencé 1978, figs. 112–13.

1. Hisashi Mori, *Sculpture of the Kamakura Period*, vol. 11 of Heibonsha Survey of Japanese Art, trans. Katherine Eickman (New York and Tokyo: Weatherhill and Heibonsha, 1974), pls. 65, 67.

2. Ibid., pls. 67, 80, 163.

BUDDHIST PAINTING

No. 40 *Utokunyo shomon daijōkyo*, B60 D116
LITERATURE: Kakudo and Ng 1985, no. 10.

1. Hirotoshi Suda, "Heian jidai no raihai kyōkan mokuroku ni tsuite," *Bukkyō geijutsu*, no. 136 (May 1981), p. 111.
2. This is the opening sutra in the Chinese *Tripitaka*, a compendium of Buddhist scriptures. Miyeko Murase, *Japanese Art: Selections from the Mary and Jackson Burke Collection*, exh. cat. (New York: Metropolitan Museum of Art 1975) no. 111 and John M. Rosenfield and Shūjirō Shimada, *Traditions of Japanese Art: Selections from the Kimiko and John Powers Collection*, exh. cat. (Cambridge, Mass.: Fogg Art Museum, Harvard University Press, 1970), pp. 78–81.

No. 41 Fugen Bosatsu, B66 D2
LITERATURE: Mayuyama 1966, p. 70, pl. 82; Schobel and d'Argencé 1968, pl. 92; Shūjirō Shimada, ed., *Bukkyō kaiga yamato-e suibokuga*, vol. 1 of Zaigai hihō (Tokyo: Gakken, 1969), p. 24; d'Argencé 1976, pl. 124; d'Argencé 1978, fig. 115; John M. Rosenfield and Elizabeth ten Grotenhuis, *Journey of the Three Jewels: Japanese Buddhist Art in Western Collections*, exh. cat. (New York: Asia Society, 1979), pp. 57–58, no. 7; Kakudo 1980a, p. 105, fig. 10.

1. Osamu Takata and Taka Yanagisawa, *Butsuga*, vol. 7 of Genshoku Nihon no bijutsu (Tokyo: Shōgakkan, 1969), p. 50.
2. Yoshitaka Ariga, *Hokekyō-e*, Nihon no bijutsu, no. 269 (Tokyo: Shibundō, 1988), p. 46.

No. 42 Fudō Myōō, B70 D2
LITERATURE: D'Argencé 1976, pl. 9; d'Argencé 1978, fig. 118; "Rarities of the Asian Art Museum of San Francisco," *Asia Foundation Program Bulletin*, 1978, p. 17, pl. 17; Kakudo 1980a, p. 105, fig. 11.

1. Mosaku Ishida, *Bukkyō bijutsu no kihon* (Tokyo: Tokyo bijutsu, 1967), pp. 188–89.
2. Fujihiko Takasaki, *Nihon bukkyō kaigashi* (Tokyo: Kyūryūdō, 1966), p. 40.

No. 43 Taima mandala, B61 D11+
LITERATURE: Mayuyama 1966, pl. 88; d'Argencé 1978, fig. 116; Elisseeff 1985, pl. 68; Junkichi Mayuyama, *Bijutsushō no yorokobi* (Tokyo: Mayuyama Ryūsendō, 1988), pl. 32.

1. Takaaki Sawa, *Art in Japanese Esoteric Buddhism*, vol. 8 of Heibonsha Survey of Japanese Art, trans. Richard L. Gage (New York and Tokyo: Weatherhill and Heibonsha, 1972), p. 14.
2. The two other types are the Chikō and Seikō mandalas. Chikō, a Tempyō period priest (dates unknown), witnessed the Pure Land in a dream and had a small, rather simple mandala painted on a board. In 996, a Heian period priest, Seikai (?–1017), had his version of the Pure Land mandala painted in a slightly more complex composition. Both originals were lost, and they are known only through later copies.
3. The original mandala, dating from 763, has deteriorated to the point where only 40 percent of the silk tapestry remains of the original 12-by-12 foot weaving.
4. As many as twenty surviving copies are of such high quality that they are designated as Important Cultural Properties.

No. 44 Butsugen mandala, B62 D20
1. Takaaki Sawa, *Art in Japanese Esoteric Buddhism*, vol. 8 of Heibonsha Survey of Japanese Art, trans. Richard L. Gage (New York and Tokyo: Weatherhill and Heibonsha, 1972), p. 14.
2. Takaaki Sawa, "Butsugen mandara ni tsuite," *Kokka*, no. 681 (Dec. 1948), p. 313.
3. Ibid., p. 317.
4. Ibid.

No. 45 Raigō Amida, B61 D7
1. Takashi Hamada, *Raigozu*, Nihon no bijutsu, no. 273 (Tokyo: Shibundō, 1969), pp. 61–65.
2. Ibid., pl. 11.

No. 46 Amida *shōjū raigōzu*, B60 D34+
1. Jūji Ōkanuki, *Pure Land Buddhist Painting*, vol. 4 of Japanese Arts Library (Tokyo, New York, and San Francisco: Kōdansha International and Shibundō, 1977), p. 95.
2. Takashi Hamada, *Raigozu*, Nihon no bijutsu, no. 273 (Tokyo: Shibundō, 1969), p. 11.
3. Jōji Okazaki, *Jōdokyōga*, Nihon no bijutsu, no. 43 (Tokyo: Shibundō, 1969), p. 79.
4. Ibid., p. 56.

No. 47 Zuzōshō, B64 D5
LITERATURE: Kakudo and Ng 1985, no. 12.

1. Fujio Takasaki, *Nihon bukkyō kaigashi* (Tokyo: Kyūryūdō, 1966), p. 46.
2. Other similar iconographical studies are *Besson zakki* by Shinkaku (1182–?), *Kakuzenshō* by Kakuzen (1143–?), and *Asabashō*, compiled from the 1240s to 1275 mainly by Shōchō(?). They consist of 57, 128, and 228 volumes respectively, and date from the twelfth to thirteenth century; the *Kakuzenshō* took some forty years to complete.
3. Taka Yanagisawa, "Shinshutsu zankan Zuzōshō daisankan," *Kobijutsu*, no. 23 (Sept. 1968), p. 75.

No. 48 Memyō Bosatsu, B64 D1
LITERATURE: Shūjirō Shimada, ed., *Bukkyokaiga yamato-e suibokuga*, vol. 1 of Zaigai hihō (Tokyo: Gakken, 1969), p. 49.

1. Takashi Hamada, *Zuzō*, Nihon no bijutsu, no. 55 (Tokyo: Shibundō, 1970), pp. 72, 78, pl. 107.

SECULAR PAINTING AND CALLIGRAPHY

No. 49 Jinnōji *Engi*, B66 D3
LITERATURE: Mayuyama 1966, p. 116, pl. 135; Shūjirō Shimada, ed., *Bukkyokaiga yamato-e suibokuga*, vol. 1 of Zaigai hihō (Tokyo: Gakken, 1969), p. 88; d'Argencé 1976, pl. 126; John M. Rosenfield and Elizabeth ten Grotenhuis, *Journey of the Three Jewels: Japanese Buddhist Art in Western Collections*, exh. cat. (New York: Asia Society, 1979), pp. 147–48, no. 43; Terukazu Akiyama, ed., *Emakimono*, vol. 2 of Zaigai Nihon no shihō (Tokyo: Mainichi shimbunsha, 1980), pl. 93, pp. 98–113; Kakudo 1980a, p. 107, fig. 15; Elisseeff 1985, pl. 103 (detail).

1. John M. Rosenfield, *The Courtly Tradition in Japanese Art and Literature, Selections from the Hofer and Hyde Collections* (New York: Japan House Gallery, 1979), p. 273. Rather than "mutilation," as erroneously described by Rosenfield, the scrolls were separated mostly along the original paper seams; very few continuous sheets of paper were cut.
2. Akiyama, *Emakimono*, pp. 98–113.
3. Many fragments had been identified simply as *Kōnin shōnin eden* (Pictorial Scroll of the Priest Kōnin) because the paintings bore this priest's name and lacked any other identification.
4. Akiyama, *Emakimono*, p. 103.

No. 50 *The Poets Ise and Fujiwara Kiyosuke no Ason*, B62 D1
LITERATURE: Tōru Mori, "Jidai fudō utaawase e ni tsuite," *Kobijutsu*, no. 8 (March 1965), p. 98, fig. 10; Jirō Umezu, *Emakimono zanketsu no fu* (Tokyo: Kadokawa Shoten, 1970), p. 167; Terukazu Akiyama, ed., *Emakimono*, vol. 2 of Zaigai Nihon no shihō (Tokyo: Mainichi shimbunsha, 1980), p. 145; Kakudo 1980a, p. 107, fig. 14; exh. cat. Yoshiaki Shimizu and John M. Rosenfield, eds., *Masters of Japanese Calligraphy: 8th–19th Century*, exh. cat. (New York: Japan House Gallery and Asia Society, 1984), no. 38, pp. 108–9; Kakudo and Ng 1985, no. 16.

1. Yoshi Shirahata, *Kasen-e*, Nihon no bijutsu, no. 96 (Tokyo: Shibundō, 1974), p. 21.
2. Mori, "Jidai fudō utaawase-e ni tsuite," p. 27.
3. The combination of contestants differs from one version to another; in other versions, the poet Ise is combined with Gokyōgoku sesshō dajō daijin.
4. Mori, "Jidai fudō utaawase-e ni tsuite," p. 27. This section has been grouped with other related sections, all of which have been identified as coming from a particular handscroll dated to the Nambokuchō period.
5. Ibid., p. 36.

No. 51 *Taming the Ox*, Sekkyakushi, B69 D46
LITERATURE: Yoshiho Yonezawa, "Sekkyakushi hitsu Bokudozu," *Kokka*, no. 802 (Jan. 1959), pp. 17–18; Shūjirō Shimada, ed., *Bukkyokaiga yamato-e suibokuga*, vol. 1 of Zaigai hihō (Tokyo: Gakken, 1969), p. 103; Ichimatsu Tanaka, *Shūbun kara Sesshū e*, vol. 12 of Nihon no bijutsu (Tokyo: Heibonsha, 1969), fig. 37; Yasuichi Awakawa, *Zen Painting*, trans. John Bester (Tokyo and Palo Alto, Calif.: Kōdansha International, 1970), pl. 29; Ichimatsu Tanaka and Yoshiho Yonezawa, *Suibokuga*, vol. 11 of Genshoku Nihon no bijutsu (Tokyo: Shōgakkan, 1970), fig. 23; Ichimatsu Tanaka, *Japanese Ink Painting, Shūbun to Sesshū*, trans. Bruce Darling (Tokyo: Heibonsha, 1972), fig. 62; d'Argencé 1976, pl. 129; Shūjirō Shimada, ed., *Suibokuga*, vol. 3 of Zaigai Nihon no shihō (Tokyo: Mainichi shimbunsha, 1979), no. 19; Kakudo 1980a, p. 106, fig. 12; Elisseeff 1985, pl. 420.

1. Awakawa, *Zen Painting*, p. 77.
2. Jan Fontein and Money L. Hickman, *Zen Painting and Calligraphy*, exh. cat. (Boston: Museum of Fine Arts, 1970), pp. 116–17.
3. Tanio Nakamura, "Bokudōzu," *Nihon bijutsu kōgei*, no. 378 (April 1979), p. 99.
4. Ibid.

No. 52 *Li Dabai Viewing the Waterfall*, Sōami, B62 D11
LITERATURE: Takaaki Matsushita, *Muromachi suibokuga* (Tokyo: Muromachi suibokuga kankōkai, 1969), pl. 79; d'Argencé 1978, fig. 120; Elisseeff 1985, pl. 400; *Byōbu-e meihin ten*, exh. cat. (Fukui: Fukui Fine Arts Museum, 1987), no. 1.

1. Yasuichi Awakawa, *Zen Painting*, trans. John Bester (Tokyo and Palo Alto, Calif.: Kōdansha International, 1970), p. 82.
2. Ma Yuan and Xia Guei dominated the Southern Song academy during the late twelfth and early thirteenth centuries.

No. 53 *Landscape of the Four Seasons*, Shikibu Terutada, B60 D49+, B60 D48+
LITERATURE: Muneshige Narasaki, "Ryūkyō hitsu shiki sansuizu," *Kokka*, no. 701 (Aug. 1950), pp. 264–68; Mayuyama 1966, p. 147, pls. 167A, B; George Kuwayama, *The Golden Age of Japanese Screen Painting*, exh. cat. (Los Angeles: Los Angeles County Museum of Art, 1972), no. 2; Yoshiaki Shimizu and Carolyn Wheelwright, eds., *Japanese Ink Paintings* (Princeton, N.J.: Princeton University Press, 1976), pp. 194–99, no. 25; d'Argencé 1978, figs. 121–22; Chū Yoshizawa, ed., *Sansuiga suiboku sansui*, vol. 2 of Nihon byōbu-e shūsei (Tokyo: Kōdansha, 1978), pp. 86–87; Shun Etō, *Sōami Shōkei*, vol. 6 of Nihon bijutsu

kaiga zenshū (Tokyo: Shūeisha, 1979), no. 74; Shūjirō Shimada, ed., *Suibokuga*, vol. 3 of Zaigai Nihon no shihō (Tokyo: Mainichi shimbunsha, 1979), nos. 80–81; Eiji Akazawa, ed., *Muromachi no suibokuga*, vol. 16 of Nihon bijutsu zenshū (Tokyo: Gakken, 1980), pls. 76–77; Kakudo 1980a, pp. 106–7, figs. 13, 16; Hiroshi Kanazawa, *Muromachi kaiga*, Nihon no bijutsu, no. 207 (Tokyo: Shibundō, 1983), no. 12; *Byōbu-e meihin ten*, exh. cat. (Fukui: Fukui Fine Arts Museum, 1987), nos. 7–8; *Muromachijidai no byōbu-e*, exh. cat. (Tokyo: Tokyo National Museum, 1989), no. 60.

1. The second seal had been traditionally misread *Ryūkyō*, and the identity of the artist was confused with fifteenth-century artists Chūan Shinkō and Kenkō Shōkei.
2. Muneshige Narazaki, "Ryūkyō hitsu shiki sansuizu," *Kokka*, no. 701 (Aug. 1950), p. 264.
3. Yuji Yamashita, "Shikibu Terutada no kenkyū," *Kokka*, no. 1084 (June 1985), p. 23.
4. Shimizu and Wheelwright, *Japanese Ink Paintings*, p. 194.
5. When Prof. Shūjirō Shimada viewed the screens in Japan in the late 1940s or early 1950s, they were not as heavily decorated with gold dust.

No. 54 *Bird with Long Tail Feathers*, Kano Yōsetsu, B76 D6
LITERATURE: D'Argencé 1976, pl. 155; Kakudo 1980a, p. 101, pl. 1.

1. Kōtei Asaoka, *Kogabikō*, vol. 3 (Tokyo: Yoshikawa kōbunsha, 1912), p. 1740.
2. René-Yvon d'Argencé, ed., *Treasures from the Shanghai Museum, 6000 Years of Chinese Art* (San Francisco: Asian Art Museum, 1983), p. 180.

No. 55 *Landscape with Figures*, Unkoku Tōgan, B60 D74+, B60 D73+
LITERATURE: Shizuya Suzukake, "Unkoku Tōgan hitsu. Tōenmei Rinnasei-zu," *Kokka*, no. 750 (Sept. 1954), pp. 265–67; Schobel and d'Argencé 1968, no. 96 (B60 D74 only); George Kuwayama, *The Golden Age of Japanese Screen Painting*, exh. cat. (Los Angeles: Los Angeles County Museum of Art, 1972), no. 6; *Byōbu-e meihin ten*, exh. cat. (Fukui: Fukui Fine Arts Museum, 1987), nos. 11–12.

1. Sukeichi Tanaka, "Unkoku-ha no hito to sakuhin," *Kokka*, no. 820 (July 1960), p. 251.
2. Miyeko Murase, *Byōbu, Japanese Screens from New York Collections*, exh. cat. (New York: Asia Society, 1971), p. 56.
3. Tanaka, "Unkoku-ha no hito to sakuhin," p. 252.
4. Suzukake, "Unkoku Tōgan hitsu Tōenmei Rinnasei-zu," p. 267.

No. 56 *Tartars Playing Polo and Hunting*, Kano Sōshū, B69 D18b, B69 D18a
LITERATURE: *Momoyama*, vol. 8 of Sekai bijutsu zenshū (Tokyo: Kōdansha, 1965), pl. 16; Yūzō Yamane, *Momoyama no fūzokuga*, vol. 17 of Nihon no bijutsu (Tokyo: Heibonsha, 1967), p. 80; Shūjirō Shimada, ed., *Shōhekiga rimpa*, vol. 2 of Zaigai hihō (Tokyo: Gakken, 1969), pl. 19; Yoshiko Kakudo, "Tartars Screen and Kano Sōshū," *Archives of Asian Art* 25 (1971–72), pp. 88–90; d'Argencé 1976, pls. 11, 154; d'Argencé 1978, figs. 123–24; Kakudo 1980b, pp. 112–13, figs. 8, 10; Tsuneo Takeda, ed., *Shōheiga*, vol. 4 of Zaigai Nihon no shihō (Tokyo: Mainichi shimbunsha, 1980), nos. 17–20; Hiroyuki Suzuki, "Dattanjin Shuryōzu byōbu," *Kokka*, no. 1077 (Oct. 1984), pls. 9, 11; *Byōbu-e meihin ten*, exh. cat. (Fukui: Fukui Fine Arts Museum, 1987), pp. 49–50, nos. 32–33; Toshie Kihara, "Den Kano Sōshū hitsu Dattanjin shuryō dakyūzu byōbu ni tsuite," *Museum* 450 (Sept. 1988), pp. 19–34.

1. Kōtei Asaoka, *Zōtei Kogabikō*, vol. 3 (Tokyo: Yoshikawa kōbundō, 1912), pl. 1607.
2. Shinichirō Tani, "Kano Sōshū ni kansuru ichishōjireki," *Bijutsu kenkyū* 2, no. 147 (May 1948), p. 47.

No. 57 *Namban byōbu*, B60 D78+, B60 D77+
LITERATURE: Tokutarō Nagami, *Namban byōbu taisei* (Tokyo: Kōgeisha, 1930); d'Argencé 1966, pl. 8; Schobel and d'Argencé 1968, no. 97; Shūjirō Shimada, ed., *Shōhekiga rimpa*, vol. 2 of Zaigai hihō (Tokyo: Gakken, 1969), pl. 24; Yoshitomo Okamoto and Tadao Takamizawa, *Namban byōbu* (Tokyo: Kajima shuppan kai, 1970), pl. vol. 3, pp. 26–27; George Kuwayama, *The Golden Age of Japanese Screens*, exh. cat. (Los Angeles: Los Angeles County Museum of Art, 1972), no. 5; Mitsuru Sakamoto, *Namban byōbu*, Nihon no bijutsu no. 135 (Tokyo: Shibundō 1977) fig. 87; d'Argencé 1978, figs. 125–26; Mitsuru Sakamoto, ed., *Fūzokuga namban fūzoku*, vol. 15 of Nihon byōbu e shūsei (Tokyo: Kōdansha, 1979) pp. 55–56, pls. 45–46; Kakudo 1980b, p. 112, pl. 9; *Byōbu-e meihin ten*, exh. cat. (Fukuoka Fukuoka Arts Museum 1987) nos. 28–29

1. A recent publication documents the existence of at least sixty pairs of these screens. See Shinichi Tani and Tadashi Sugase, *Namban Art*, exh. cat. (Washington, D.C.: International Exhibition Foundation, 1973), p. 23.
2. The Asian Art Museum screens closely resemble those in the imperial household and the Bunkachō collections. See Mitsuru Sakamoto, ed., *Fūzokuga namban fūzoku*, vol. 15 of Nihon byōbu-e shūsei (Tokyo: Kōdansha, 1979), pls. 39–40, 43–44.
3. Ibid., p. 172.
4. Ibid., pp. 98, 101.

No. 58 *Hawk on Oak*, Soga Nichokuan, B60 D18
LITERATURE: Harold P. Stern, *Birds, Beasts, Blossoms and Bugs*, exh. cat. (New York: Abrams, 1976), no. 31; Nobuo Tsuji, ed., *Bunjinga shoha*, vol. 6, Zaigai Nihon no shihō (Tokyo: Mainichi shimbunsha, 1980), pl. 110; *Soga Chokuan Nichokuan no kaiga*, exh. cat. (Nara: Nara Prefectural Museum, 1989), fig. 6.

1. Keisuke Kobayashi, *Genshoku Nihon chōrui zukan* (Osaka: Hoikusha, 1969), p. 115.
2. Sherman E. Lee et al., *Reflections of Reality in Japanese Art*, exh. cat. (Cleveland: Cleveland Museum of Art, 1983), p. 125.
3. E. W. Jameson, Jr., *The Hawking of Japan: The History and Development of Japanese Falconry* (Davis, Calif.: [E.W. Jameson], 1962), p. 1.
4. For fine examples see *Japanese Screen Paintings: Birds, Flowers and Animals* (Boston: Museum of Fine Arts, 1935), pls. 17a–b, 18a–b, and 19.
5. Shinsei Mochizuki, "Soga Nichokuan hitsu rōshō gunōzu," *Kobijutsu*, no. 41 (June 1973), p. 115.
6. Ibid.
7. The third seal, *In*, means lineage.

No. 59 *Inuoumono*, B60 D2, B60 D1
LITERATURE: Kakudo 1980b, p. 109, fig. 3 (B60 D1 only).

1. The other two drills are *kasagake* and *yabusame*. The first is an archery contest using hats (*kasa*) as targets. The second, also an archery contest, uses square boards as targets. In both, the archers are mounted.
2. Kazuo Mochimaru, "Inuoumono zukō," *Kokka*, no. 693 (Dec. 1949), p. 330.
3. Ibid., p. 335.
4. Ibid., p. 336. A pair of screens by Kano Sanraku in the Tokiwayamabunko collection in Japan is believed to be the oldest of this type. See Nobuo Tsuji, ed., *Fūzokuga kōbu fūzoku*, vol. 12 of Nihon byōbu-e shūsei (Tokyo: Kōdansha, 1980), nos. 60–62.
5. Shūjirō Shimada, ed., *Shōhekiga rimpa*, vol. 2 of Zaigai hihō (Tokyo: Gakken, 1969), pl. 21.
6. Tsuji, *Fūzokuga kōbu fūzoku*, nos. 67–68.

No. 60 *Gion Festival*, B60 D45+, B60 D9
LITERATURE: Shūjirō Shimada, ed., *Shōhekiga rimpa*, vol. 2 of Zaigai hihō (Tokyo: Gakken, 1969), pp. 38–39; Kakudo 1980b, pp. 108–9, figs. 1–2.

1. Masayoshi Nishitsunoi, *Nenjū gyōji jiten* (Tokyo: Tōkyōdō shuppan, 1958), p. 244.
2. Yuzō Yamane, *Momoyama no fūzokuga*, vol. 17 of Nihon no bijutsu (Tokyo: Heibonsha, 1967), p. 157.
3. Ibid.
4. *Muromachijidai no byōbu-e*, exh. cat. (Tokyo: Tokyo National Museum, 1989), nos. 33 34.

No. 61 *Mount Fuji and Seashore at Miho no matsubara*, Kano Tanyū, B60 D76, B60 D74
1. Tsuneo Takeda, *Kano Tanyū*, vol. 15 of Nihon bijutsu kaiga zenshū (Tokyo: Shūeisha, 1978), p. 99.
2. Ibid., p. 101.
3. Ibid., p. 110.
4. Shinichi Miyajima, "Fuji Miho no matsubarazu byōbu, *Kokka*, no. 1134 (May 1990), p. 23. For another Fuji scene showing this lone pine tree, painted when he was sixty-six, see Takeda, *Kano Tanyū*, pl. 23.

No. 62 *Tale of the Heike*, B80 D12
1. Yasuaki Akami et al., *Heike monogatari*, vol. 3 of Zusetsu Nihon no koten (Tokyo: Shūeisha, 1979), p. 31.
2. Keiko Kawamoto, "Heike monogatari ni shuzaishita kassen byōbu no shosō to sono seiritsu ni tsuite," in *Jimbutsuga yamato-e kei jimbutsu*, vol. 5 of Nihon byōbu-e shūsei (Tokyo: Kōdansha, 1979), p. 138.
3. Ibid., p. 139.
4. See *The Tale of the Heike*, trans. H. Kitagawa and B. T. Tsuchida (Tokyo: University of Tokyo Press, 1975), chap. 14, book 9.

No. 63 *Flowers and Birds of the Twelve Months*, Yamamoto Soken, B60 D82+b, B60 D82+a
LITERATURE: Tadao Tonomura, "Soken no Teika ei kachō waka-e (1)," *Kokka*, no. 802 (Jan. 1959), pp. 6, 8, 11–12; Nobuo Tsuji, ed., *Bunjinga shoha*, vol. 6 of Zaigai Nihon no shihō (Tokyo: Mainichi shimbunsha, 1980), nos. 101–4; Kakudo and Ng 1985, no. 18; Carolyn Wheelwright, ed., *Word in Flower: The Visualization of Classical Literature in Seventeenth-Century Japan*, exh. cat. (New Haven, Conn.: Yale University Press, 1989), p. 39, fig. 14; Miyeko Murase, *Masterpieces of Japanese Screen Painting: The American Collection* (New York: George Braziller, 1990), no. 7.

1. Shūko Nishimoto, "Ogata Kōrin hitsu junikagetsu uta-i-e byōbu ni tsuite (1)," *Kokka*, no. 1006 (Jan. 1977), p. 21.
2. Wheelwright, *Word in Flower*, pp. 40–41, fig. 15.
3. Tadao Tonomura, "Soken no Teika ei kachō waka-e (2)," *Kokka*, no. 803 (Feb. 1959), p. 46.

No. 64 *Tale of Genji*, B60 D47+, B60 D46+
LITERATURE: Tsuneo Takeda, ed., *Shōheiga*, vol. 4 of Zaigai Nihon no shihō (Tokyo: Mainichi shimbunsha, 1980), pls. 92–93.

1. A handscroll in the Asian Art Museum Collection contains twelve *shikishi*-type Genji paintings, see *Patronage* 1989, pp. 90–91.
2. Miyeko Murase, *Japanese Art: Selections from the Mary and Jackson Burke Collection*, exh. cat. (New York: Metropolitan Museum of Art, 1975), no. 58.
3. Tsuneo Takeda, *Kompeki shōheiga*, Nihon no bijutsu, no. 131 (Tokyo: Shibundō, 1977), p. 58.
4. Miyeko Murase, *Iconography of the Tale of Genji: Genji Monogatari Ekotoba* (New York and Tokyo: Weatherhill, 1983), pp. 289–90.

No. 65 *Consort Ming on Her Way to Mongolia*, Iwasa Katsumochi, B64 D3
LITERATURE: Shūjirō Shimada, ed., *Nikuhitsu ukiyo-e*, vol. 3 of Zaigai hihō (Tokyo: Gakken, 1969), pl. 14; Nobuo Tsuji, *Iwasa Matabei*, vol. 13 of Nihon bijutsu kaiga zenshū (Tokyo: Shūeisha, 1980), pl. 34; Nobuo Tsuji, ed., *Bunjinga shoha*, vol. 6 of Zaigai Nihon no shihō (Tokyo: Mainichi shimbunsha, 1980), no. 96; Masayuki Fujiura, "Matabei hitsu kasenga o megutte," *Kobijutsu*, no. 73 (Jan. 1985), p. 75; *Byōbu-e*

meihin ten, exh. cat. (Fukui: Fukui Fine Arts Museum, 1987), p. 53, no. 34; Nobuo Tsuji, *Iwasa Matabei, Nihon no bijutsu*, no. 259 (Tokyo: Shibundō, 1987), pl. 42.

1. Tsuji, *Iwasa Matabei*, p. 10.
2. Ibid., p. 131. In 1898, a set of thirty-six *kasen* paintings painted and signed by Matabei was examined; it was discovered that the painter Tosa Mitsunobu was closely associated with Matabei.
3. Ibid. p. 133. These screens were also called the Ikeda screens since they were in the Count Ikeda collection in Okayama.
4. Ibid., pp. 132–33.

No. 66 Calligraphy model book, Prince Sonchō, B64 M3
LITERATURE: Yoshiaki Shimizu and John M. Rosenfield, eds., *Masters of Japanese Calligraphy: 8th–19th Century*, exh. cat. (New York: Japan House Gallery and Asia Society, 1984), pp. 88–89, no. 30; Kakudo and Ng 1985, no. 13.

1. Yūjirō Nakata, *Sho*, suppl. vol. of Nihon no bijutsu (Tokyo: Heibonsha, 1967), p. 70. Shōrenin teachers believed that once students mastered the *gyōsho* style, even quite young pupils could advance into more exacting *kaisho* (a writing style equivalent to the modern printed type) and *sōsho*, a very cursive, much freer style, with opportunity for individual expression in advanced stages.

No. 67 *Shū Moshuku Admiring Lotus*, Ogata Kōrin, B76 D1
LITERATURE: D'Argencé 1976, pl. 162; Motoaki Kōno, *Ogata Kōrin*, vol. 17 of Nihon bijutsu kaiga zenshū (Tokyo: Shūeisha, 1976), pl. 32; "Rarities of the Asian Art Museum," *Asia Foundation Program Bulletin*, 1978, pl. 11; Holly Holts, "The Permanent Collection," *Triptych* (Summer 1980), p. 9, fig. 2; Kakudo 1980b, p. 115, fig. 13.

1. In a painting technique called *tarashikomi* (dripped-onto), which Kōrin and other Rimpa artists used frequently, liquid pigments were literally dripped onto a still-wet painting surface, creating an interesting fluid quality. This technique was also used by artists with much wider technical backgrounds and stylistic affiliations.
2. A book of more than three hundred pages was published by Yūzō Yamane on the documents and sketches that Kōrin left in the Konishi family. See *Kōrin kankei shiryō to sono kenkyū* (Tokyo: Chūōkōronsha, 1962). For an abridged chronology of Kōrin's life, see Howard Link, *Exquisite Visions: Rimpa Paintings from Japan* (Honolulu: Honolulu Academy of Arts, 1989), pp. 138–40.
3. Payments made by the shogun's household for kimono materials purchased at Kariganeya in the year 1618 amounted to over 30 *kan* of silver. By comparison, in the year 1677, the sizable house that Kōrin inherited was worth 28 *kan* of silver.
4. Yūzō Yamane, *Sōtatsu to Kōrin*, vol. 14 of Genshoku Nihon no bijutsu (Tokyo: Shōgakkan, 1969), p. 232.
5. Link, *Exquisite Visions*, p. 139.
6. Ichimatsu Tanaka, ed., *Kōrin* (Tokyo: Nihonkeizai shimbun, 1959), p. 26.
7. Ibid., fig. 52.

No. 68 Letter to Isshi Monju, Karasumaru Mitsuhiro, 1988.28
LITERATURE: *Patronage* 1989, no. 46.

1. The reading and deciphering of old letters is especially difficult because of the basic nature of letter writing, which omits facts mutually understood. At the same time the content can provide historical information through an understanding of the writer's allusions.
2. For instance, some imperial letters of premodern times were by *nyōbō* (court ladies in charge of personal tasks for emperors) and thus were in the feminine style of writing.
3. Nagatsugu Zaitsu, *Tegami*, Nihon no bijutsu, no. 82 (Tokyo: Shibundō, 1973), pp. 33, 38.

4. Ibid., p. 47.

No. 69 *Flowering Plants*, Watanabe Shikō, B72 D10
1. Ex–Harry G.C. Packard Collection Charitable Trust, R1988.34.1a,1b. In this extremely bold composition, Shikō employed large, flat, colored areas using two completely different stylized depictions of water in a seemingly continuous composition. Details such as tree trunks and rocks are in bold Kano-style strokes executed in a rather unskilled manner.
2. The companion scroll was published in the exhibition catalogue *Rimpa* (Tokyo: Tokyo National Museum, 1972) and is now in a private collection in Seattle.
3. Hiroshi Mizuo, "Watanabe Shikō hitsu shūtō sansuizu byōbu," *Kokka*, no. 899 (Feb. 1967), p. 12.
4. Oliver Impey, "Watanabe Shikō: A Reassessment," *Oriental Art* 17 (Winter 1971), pp. 329–32.

No. 70 *Elephant and Chinese Children*, Nagasawa Rosetsu, B80 D1
1. John M. Rosenfield and Shūjirō Shimada, in *Traditions of Japanese Art: Selections from the Kimiko and John Powers Collection*, exh. cat. (Cambridge, Mass.: Fogg Art Museum, Harvard University Press, 1970), p. 219, report one account that states Rosetsu was poisoned by a jealous craftsman, and another that states Rosetsu took his own life.
2. The screens, in the Burke collection, may best represent Rosetsu's wit and skill. See Miyeko Murase, *Japanese Art: Selections from the Mary and Jackson Burke Collection*, exh. cat. (New York: Metropolitan Museum of Art, 1975), no. 62.
3. Tanio Nakamura, ed., *Sōjūga ryūko enkō*, vol. 16 of Nihon byōbu-e shūsei (Tokyo: Kōdansha, 1978), p. 165.
4. Ibid., p. 138, pls. 78–79. Rosetsu's large seal *Gyo* that appears on both screens suffered a chip (the upper right section of the outline is missing) sometime before 1794, information which is now used as one reliable means of dating.
5. Shinichi Miyajima, *Nagasawa Rosetsu*, Nihon no bijutsu, no. 219 (Tokyo: Shibundō, 1984), p. 100.

No. 71 *Ferry at Imai on the Tone River*, Shiba Kōkan, B66 D18
LITERATURE: Mayuyama 1966, p. 247, pl. 298; d'Argencé 1976, pl. 167.

1. For this style of painting Kōkan used the name Harushige, with which he sometimes used a seal reading *Harunobu*. In his diary (*Shumparō Hikki*, published in 1811), he recorded having forged Harunobu paintings "intentionally, but people did not notice; thus I lost interest [in forging] and the challenge [of deceiving people]."
2. Yoshinobu Tokugawa, "Shiba Kōkan saku tōsei furisode seiyō ningyō," *Kobijutsu*, no. 35 (Dec. 1971), pp. 70–74.
3. Shiba Kōkan, *Seiyōgadan* (1799) as published in Fujio Naruse, *Shiba Kōkan*, vol. 25 of Nihon bijutsu kaiga zenshū (Tokyo: Shūeisha, 1977), p. 124.
4. Fujio Naruse, "Shiba Kōkan to Fujisan," *Nihon bijutsu kōgei*, no. 499 (April 1980), p. 47.
5. Fujio Naruse, *Shiba Kōkan*, vol. 25 of Nihon bijutsu kaiga zenshū (Tokyo: Shūeisha, 1977), pl. 29.
6. Calvin L. French, *Shiba Kōkan: Artist, Innovator, and Pioneer in the Westernization of Japan* (New York and Tokyo: Weatherhill, 1974), p. 15.

No. 72 *Pine, Bamboo, and Plum*, Maruyama Ōkyo, B60 D56+, B60 D55+
LITERATURE: *Sanōsō zōhin tenran zuroku* (Tokyo: Bijutsu Kurabu, 1935), pl. 191; Hiroshi Mizuo, "Maruyama Ōkyo hitsu ume shōchiku-zu byōbu," *Kokka*, no. 815 (Feb. 1960), pp. 57, 61; Mayuyama 1966, pp. 226–27, pls. 272A, B; d'Argencé 1977, figs. 130–31; *Kachōga kachō sansui*, vol. 8 of Nihon byōbu-e shūsei (Tokyo: Kōdansha, 1978), pp. 22–23, nos. 9, 10; Nobuo Tsuji,

ed., *Bunjinga shoha*, vol. 6 of Zaigai Nihon no shihō (Tokyo: Mainichi shimbunsha, 1980), nos. 47, 50.

1. Johei Sasaki and Motoaki Kōno, *Taiga Gyokuran Ōkyo, bunjinga to shaseiga*, vol. 24 of Nihon bijutsu zenshū (Tokyo: Gakken, 1979), p. 165; Elisseeff 1985, pl. 112 (detail).

2. A stereopticon, an early form of projector or "magic lantern," used a powerful projection light and paired pictures, each projected with a separate lens, to produce dissolving views.

3. T. Yamakawa, *Okyo Goshun*, vol. 22 of Nihon bijutsu kaiga zenshū (Tokyo: Shueisha, 1977), p. 103.

4. Sherman E. Lee et al., *Reflections of Reality in Japanese Art*, exh. cat. (Cleveland: Cleveland Museum of Art, 1983), p. 150.

5. For *shō chiku bai* see also nos. 102, 118.

6. A pair of hanging scrolls of trouts, see Yamakawa, *Ōkyo Goshun*, no. 21.

7. Ibid., nos. 37, 49.

8. Ibid., no. 29.

No. 73 *Landscape*, Ike Gyokuran, B76 D3
LITERATURE: D'Argencé 1976, pl. 163; Kakudo 1980b, p. 114, fig. 12; Pat Fister, *Japanese Women Artists: 1600–1900*, exh. cat. (Lawrence, Kans.: Spencer Museum of Art, University of Kansas, 1988), no. 30.

1. Rei Hoshino, "Ike Gyokuran hitsu bokubai-zu," *Kokka*, no. 998 (March 1977), p. 36.

2. Hiroshi Mizuo, "Ike Gyokuran hitsu kakeisansui-zu," *Kokka*, no. 779 (Feb. 1957), p. 70.

3. Fister, *Japanese Women Artists*, p. 88.

4. Hoshino, "Ike Gyokuran," p. 37.

No. 74 *Standing Woman*, Baiyūken Katsunobu, B60 D119
1. Harold P. Stern, *Ukiyo-e Paintings*, exh. cat. (Washington, D.C.: Freer Gallery of Art, Smithsonian Institution, 1973), p. 65.

No. 75 *Ōtsu-e*, B65 D18
1. Tadashige Ono, "Ōtsu-e kō," *Kobijutsu*, no. 33 (March 1971), p. 47.

2. Jinichi Suzuki, *Ōtsu-e no bi* (Tokyo: Hōgashoten, 1975), p. 142.

3. *Komusō* were lay Buddhist priests of the Fuke sect who went begging door to door playing a flute. They wore a secular garb of silk *kosode* with tubular *obi* and a sword, a simple *kesa* around the neck, and a deep straw hat.

4. Male *komusō* impersonators frequently traveled on personal secular pursuits. Most often they were seeking enemies in revenge.

5. Suzuki, *Ōtsu-e no bi*, p. 177.

No. 76 *Playing Kin under a Pine Tree*, Uragami Gyokudō, B69 D49
LITERATURE: D'Argencé 1976, pl. 165; d'Argencé 1978, fig. 128; Kōzō Yabumoto, "Wantei Enkajō," *Kokka*, no. 1010 (April 1978), p. 20, fig. 33; Kakudo 1980b, p. 113, fig. 11.

1. James Cahill, *Scholar Painters of Japan: The Nanga School* (New York: Asia Society, 1972), p. 71.

2. Jōhei Sasaki and Motoaki Kōno, *Taiga Gyokudō Ōkyo*, vol. 24 of Nihon bijutsu zenshū (Tokyo: Gakken, 1979), p. 153.

3. Hidetaro Wakita, *Uragami Gyokudō*, vol. 20 of Nihon bijutsu kaiga zenshū (Tokyo: Shūeisha, 1978), pl. 57.

No. 77 *Herons and Reeds*, Yamamoto Baiitsu, B65 D14
LITERATURE: Nobuo Tsuji, ed., *Bunjinga shoha*, vol. 6 of Zaigai Nihon no shihō (Tokyo: Mainichi shimbunsha, 1980), no. 29.

1. Miyeko Murase, *Japanese Art: Selections from the Mary and Jackson Burke Collection*, exh. cat. (New York: Metropolitan Museum of Art, 1975), p. 286, no. 86.

2. James Cahill, *Scholar Painters of Japan: The Nanga School* (New York: Asia Society, 1972), pp. 116, 120.

No. 78 *Landscape*, Nakabayashi Chikutō, B67 D16
LITERATURE: D'Argencé 1968, pp. 34–35; d'Argencé 1976, pl. 166; d'Argencé 1978, fig. 129.

1. Dong Beiyuan (1555–1636) is the Chinese artist more popularly known as Dong Qichang.

2. Published by Hiroshi Kamiya in "Nakabayashi Chikutō hitsu chōroku sansui-zu," *Kokka*, no. 1133 (Oct. 1990), p. 34.

3. In the letter that accompanied the polychrome silk version, Chikutō mentioned that he would not be painting any more color landscapes because of his strained eyesight. Therefore, the monochrome version following the polychrome was a natural development.

No. 79 *Pure View of Stream and Hills*, Takahashi Sōhei, B76 D2
LITERATURE: D'Argencé 1977, pl. 164; Chū Yoshizawa, "Takahashi Sōhei hitsu keizan shinshū-zu," *Kobijutsu*, no. 52 (May 1977), pp. 150, 154–55.

1. Chū Kobayashi, "Takahashi Sōhei hitsu bozan enu-zu," *Kokka*, no. 900 (Nov. 1967), p. 33.

No. 80 *Oni*, Shibata Zeshin, B65 D5l
No. 81 *Tea Utensils*, Shibata Zeshin, B65 D5m
LITERATURE: Bernard Hurtig, "Shibata Zeshin," pts. 2 and 3, *Journal of the International Netsuke Collectors Society* 5, no. 3 (Dec. 1977), pp. 33–34, nos. 35–36, 38–39; 5, no. 4 (March 1978), pp. 23, 25; Tadaomi Gōke, *Shibata Zeshin meihin shū* (Tokyo: Gakken, 1981), pls. 27–34.

1. Tadaomi Gōke, *Shibata Zeshin meihin shū* (Tokyo: Gakken, 1981), no. 146.

2. Howard A. Link, *The Art of Shibata Zeshin: The Mr. and Mrs. James O'Brien Collection* (Honolulu: Honolulu Academy of Arts, 1979), p. 21.

3. Gōke, *Shibata Zeshin*, p. 165.

No. 82 *Deer and Bat*, Shibata Zeshin, B60 D59+
LITERATURE: Mayuyama 1966, p. 245, pl. 296; Harold P. Stern, *Birds, Beasts, Blossoms and Bugs*, exh. cat. (New York: Abrams, 1976), pp. 158–59, pl. 82; Bernard Hurtig, "Shibata Zeshin," pt. 2, *Journal of the International Netsuke Collectors Society* 5, no. 3 (Dec. 1977), p. 33, no. 37; Tadaomi Gōke, *Shibata Zeshin meihin shū* (Tokyo: Gakken, 1981), no. 146.

CERAMICS

No. 83 Long-necked *sueki* bottle, B60 P526
1. Shōzō Tanabe, *Sueki*, vol. 4 of Tōji taikei (Tokyo: Heibonsha, 1975), p. 126, and pl. 22.

2. They are now in the collection of the Tokyo National Museum and the Board of Education of the Miyagi Prefectural Government. Migaku Tanaka and Shōzō Tanabe, *Sueki*, vol. 4 of Nihon tōji zenshū (Tokyo: Chūōkōronsha, 1977), p. 60; Tanabe, *Sueki*, pl. 22.

3. Shigeo Kuwabara, "Tōhoku no sueki," in *Nihon kodai*, vol. 2 of Sekai tōji zenshū (Tokyo: Shōgakkan, 1979), p. 170.

No. 84 Flat *sueki* bottle, B67 P9
LITERATURE: D'Argencé 1976, pl. 119; Stephen Little, "Cross Cultural Influence in Asian Ceramics," *Apollo* 112, no. 222 (Aug. 1980), p. 124, fig. 1.

1. Shōzō Tanabe, *Sueki*, vol. 4 of Tōji taikei (Tokyo: Heibonsha, 1975), pl. 78; Takayasu Higuchi, "Sueki," in *Nihon kodai hen*, vol. 1 of Sekai tōji zenshū (Tokyo: Kawadeshobō, 1958), p. 198, figs. 127–30.

No. 85 Long-necked Sanage bottle, B65 P39

LITERATURE: Sekai Tōkōkan odi, Nara Heian Momoyama Muromachi hen, vol. 2 of Sekai tōji zenshū (Tokyo: Kawadeshobō, 1958), pl. 47; Mayuyama 1966, p. 338, pl. 441; Kakudo 1980a, p. 103, fig. 5; Seizō Hayashiya, ed., Tōji, vol. 9 of Zaigai Nihon no shihō (Tokyo: Mainichi shimbunsha, 1981), pl. 2.

1. Shōichi Narasaki, Shirashi, vol. 6 of Nihon tōji zenshū (Tokyo: Chūōkōronsha, 1976), p. 54.
2. Ibid., p. 46. In the early days of studying this new ware, it was called shirashi, the term entered in the Heian-period dictionary, which lists it as a desirable glazed ware. Shirashi literally means white-glazed ware, and the dictionary listed it along with aoshi (green-glazed ware), another type made about the same time but in smaller quantities.
3. Heijōkyōten, exh. cat. (Kyoto: Kyoto National Museum, 1989), pl. 90.

No. 86 Flat Sanage pitcher, B87 P2
LITERATURE: Patronage 1989, no. 41.

1. Shōichi Narasaki, Shirashi, vol. 6 of Nihon tōji zenshū (Tokyo: Chūōkōronsha, 1976), pl. 30.

No. 87 Large Shigaraki jar, B66 P38
LITERATURE: Koyama Fujio and Ken Domon, Shigaraki ōtsubo (Tokyo: Tokyo Chūnichi Press, 1964), monochrome, pl. 3; Mayuyama 1966, p. 281, pl. 328; d'Argencé 1976, pl. 130; Louise Allison Cort, Shigaraki: Potter's Valley (Tokyo and Palo Alto, Calif.: Kōdansha International, 1979), fig. 71; Seizō Hayashiya, ed., Tōji, vol. 9 of Zaigai Nihon no shihō (Tokyo: Mainichi shimbunsha, 1981), pl. 7.

1. Shōichi Narasaki, Chūsei no tōki, exh. cat. (Yokohama: Kanagawa kenritsu hakubutsukan, 1972), p. 5.
2. Masahiko Kawahara, Shigaraki, vol. 12 of Nihon tōji zenshū (Tokyo: Chūōkōronsha, 1977), p. 50.
3. Ibid., p. 53.
4. Cort, Shigaraki, p. 84.

No. 88 Spouted Bizen jar, B76 P3
1. Shōichi Narasaki, Chūsei no tōki, exh. cat. (Yokohama: Kanagawa kenritsu hakubutsukan, 1972), p. 9.
2. Akira Itō and Setsuo Uenishi, Bizen, vol. 10 of Nihon tōji zenshū (Tokyo: Chūōkōronsha, 1977), p. 45.
3. Chūsei no tōki, exh. cat. (Seto: Aichi tōji shiryōkan, 1989), p. 66.
4. Tadahiko Makabe, "Bizen no koyō to shutsudohin," in pt. 1 of Momoyama, vol. 4 of Sekai tōji zenshū (Tokyo: Shōgakkan, 1977), p. 170.

No. 89 Mino tea container, B85 P11
1. Seizō Hayashiya, ed., Hanaire chaire chatsubo, pt. 1 of Cha no dōgu, vol. 10 of Sadō shūkin (Tokyo: Shōgakkan, 1986), p. 105.
2. One exceptionally important chaire in the Gotō Museum collection in Tokyo comes with seven decorative sacks made of a variety of fine imported textiles; ibid., pls. 65–66.
3. Sōshitsu Sen, ed., Chaire, vol. 5 of Sadō bijutsu zenshū (Kyoto: Tankōsha, 1970), pl. 36.
4. Shōichi Narasaki, ed., Mino no kotō (Kyoto: Kōrinsha, 1976), pp. 34–35, pl. 199.
5. Ibid., p. 45.

No. 90 Bizen tea jar, B67 P10
LITERATURE: D'Argencé 1976, pl. 132.

1. Tadahiko Makabe, "Bizen no koyō to shutsudohin," in pt. 1 of Momoyama, vol. 4 of Sekai tōji zenshū (Tokyo: Shōgakkan, 1977), p. 172.
2. Ibid., p. 178.

J. Seizō Hayashiya, Bizen, vol. 6 of Nihon no tōji (Tokyo: Chūōkōronsha, 1974), p. 117.

No. 91 Tamba jar, B62 P30
LITERATURE: Hitoshi Sasaki, "Japanese Ash Glaze," Ceramic Monthly 25, no. 2 (Feb. 1977), p. 54.

1. Tamba is one of the so-called Six Ancient Kilns made famous by noted historian Fujio Koyama and others in the early period of Japanese ceramic study.
2. Narasaki bases his discussion of Tamba ware on his experience with other medieval kilns, works of the earlier researcher Masao Sugimoto, and ceramic collections assembled by local collectors who had been inspired by such philosophers as Sōetsu Yanagi, who advocated the beauty of utilitarian ware (see no. 121). Shōichi Narasaki, Tamba, vol. 11 of Nihon tōji zenshū (Tokyo: Chūōkōronsha, 1977), p. 43.
3. Masahiko Kawahara, Tamba, vol. 9 of Tōji taikei (Tokyo: Heibonsha, 1975), pp. 86–87.
4. Heian period sueki production is mentioned sporadically in historical documents. The Sue potters, who worked under the shōen (privately owned land) system, mainly served the local Shinto shrines, and their output gradually declined.
5. Shōichi Narasaki, Shigaraki Bizen Tamba (Kodai chūsei hen), vol. 6 of Nihon no tōji (Tokyo: Chūōkōronsha, 1976), p. 156. Narasaki strongly believes that there must have been many more kilns actively working to have been able to produce the great number of examples surviving to date.
6. From its partially collapsed remains, Sugimoto estimated this hillside anagama type to have been a little over 8 feet long, about 5 feet wide, and 3 feet high. Narasaki, using the same visible evidence, judges it to have been the center part of a kiln with a firing chamber considerably below the hillside, originally more than 40 feet long. Noting cautiously that there has been no excavation attempt, Narasaki sees this elongated form to be close to that of the later jagama (literally, snake kiln) or the better known dragon kiln more typical of this region. Ibid., p. 50.
7. Narasaki, Tamba, pp. 48–49.

No. 92 Iga water jar, B68 P4
LITERATURE: René-Yvon d'Argencé, "New Acquisitions in the Avery Brundage Collection," Museum News 47, no. 9 (May 1969), p. 18, fig. 9; d'Argencé 1976, pl. 133; Hitoshi Sasaki, "Japanese Ash Glaze," Ceramic Monthly 25, no. 2 (Feb. 1977), p. 58; "Rarities of the Asian Art Museum," Asia Foundation Program Bulletin, 1978, p. 20, fig. 13.

1. These characteristics of Iga ware were observed by Shōichi Narasaki; see Seizō Hayashiya, Iga, vol. 13 of Nihon tōji zenshū (Tokyo: Chūōkōronsha, 1977), p. 49.
2. Tadanari Mitsuoka, "Iga Shigaraki," in pt. 1 of Momoyama, vol. 4 of Sekai tōji zenshū (Tokyo: Shōgakkan, 1977), p. 217.
3. Ibid., p. 219.

No. 93 Large E-Shino dish, B66 P37
LITERATURE: Ken Domon, "E-Shino kusabana-mon Shinobachi," Kobijutsu, no. 12 (Feb. 1966), pp. 97–99; Mayuyama 1966, p. 289, pl. 340; Yukio Yashiro, "Avery Brundage and the Art of the Orient," Asia Foundation Program Bulletin, no. 40 (Aug. 1966), fig. 18; d'Argencé 1968, [p. 29]; d'Argencé 1976, pl. 134; d'Argencé 1978, fig. 95; Kakudo 1980b, p. 110, fig. 4; Seizō Hayashiya, ed., Tōji, vol. 9 of Zaigai Nihon no shihō (Tokyo: Mainichi shimbunsha, 1981), pl. 27.

1. Seizō Hayashiya, "Mino no tōgei," in pt. 2 of Nihon, vol. 2 of Sekai tōki kōza (Tokyo: Yūzankaku, 1972), p. 333.
2. Ibid.

3. For a summary study of *ōgama* type kiln, see *Shino and Oribe Kiln Sites*, exh. cat. (Oxford: Ashmolean Museum, 1981), pp. 23–33.

No. 94 Shino *mukōzuke*, B69 P1
No. 95 Shino *mukōzuke*, B69 P2
No. 96 Shino *mukōzuke*, B76 P2
LITERATURE: (B69 P1) Takumi K□□, "Shino Kaseto Umbo," in *Momoyama*, vol. 3 of *Sekai tōji zenshū* (Tokyo: Kawadeshobo, 1930), fig. 71, d'Argencé 1976, pl. 135; (B76 P2) □□ g□□□ 1976, pl. 136; Hitoshi Sasaki, "Japanese Ash Glaze," *Ceramic Monthly* 25, no. 2 (Feb. 1977), p. 56.

1. Takumi Mitsuoka, "Momoyamajidai no tōgei," in pt. 2 of *Nihon*, vol. 7 of *Sekai tōki kōza* (Tokyo: Yūzankaku, 1972), p. 102.

No. 97 Oribe dish with handle, B64 P34
LITERATURE: Hitoshi Sasaki, "Japanese Ash Glaze," *Ceramic Monthly* 25, no. 2 (Feb. 1977), p. 58; d'Argencé 1978, fig. 94; Kakudo 1980b, p. 110, fig. 5; Seizō Hayashiya, ed., *Tōji*, vol. 9 of *Zaigai Nihon no shihō* (Tokyo: Mainichi shimbunsha, 1981), p. 143; Robert T. Singer, "Japanese Ceramics: The Fusion of Function and Aesthetics," *Antiques and Fine Art* 6, no. 2 (Feb. 1989), p. 99.

1. Records reveal this preference. For instance, on the twenty-eighth day of the second month in 1599, Kamiya Sōtan (1551–1635), a wealthy Hakata merchant, entered in his diary *Sōtannikki* a tea gathering he attended and recorded an "irregularly shaped Seto tea bowl."
2. Shōichi Narasaki, ed., *Mino no kotō* (Kyoto: Kōrinsha, 1976), p. 57.

No. 98 Oribe square dish, B67 P8
LITERATURE: Hajime Katō, *Oribe*, vol. 5 of *Tōki Zenshū* (Tokyo: Heibonsha, 1959), fig. 63; Yoshiko Kakudo, "An Unusual Square Ao-Oribe Dish in the Avery Brundage Collection," *Archives of Asian Art* 22 (1968–69), pp. 104–5; d'Argencé 1976, pl. 138.

1. The bridge and heron, together or alone, are both popular subjects among the decorators who worked in Mino and Karatsu. The bridge often appears on Shino tea bowls, while the heron is omnipresent on various forms of Karatsu and Shino *kaiseki* dishes.

No. 99 E-Oribe incense container, B74 P4
LITERATURE: D'Argencé 1976, pl. 137.

1. Seizō Hayashiya, ed., *Kama kōgō mizusashi*, pt. 3 of *Cha no dōgu*, vol. 12 of *Sadō kinshū* (Tokyo: Shōgakkan, 1985), p. 77.
2. Ibid., p. 140.

No. 100 Large E-Karatsu bowl, B84 P1
LITERATURE: *Patronage* 1989, no. 44.

1. Masahiko Satō, *Karatsu*, vol. 17 of Nihon tōji zenshū (Tokyo: Chūōkōronsha, 1976), pp. 44–45.
2. Ibid., p. 53.
3. Vessels of similar shape and size were often fired without saggers to maximize usable kiln space. Various refractory materials were used to separate vessels to prevent their glazes fusing together; in seacoast communities like Karatsu, shell-calcium was the most abundant and therefore most inexpensive, although it was not the most effective material.
4. The bowl clearly has marks from a very early and rather crude attempt at repair.
5. For further discussion see *Patronage* 1989, pp. 84–87.

No. 101 E-Karatsu *mukōzuke*, B74 P7
LITERATURE: Seizō Hayashiya, *Karatsu*, vol. 5 of Nihon no tōji (Tokyo: Chūōkōronsha, 1974), pl. 174; d'Argencé 1976, pl. 141.

1. *Ceramic Art of Japan* (Seattle: Seattle Art Museum, 1972), pp. 119–20, nos. 49–50.
2. Seizō Hayashiya, *Karatsu*, p. 143.

No. 102 Arita jar, B64 P28
LITERATURE: Richard Cleveland, *200 Years of Japanese Porcelain*, exh. cat. (St. Louis, Mo.: Saint Louis Art Museum, 1970), p. 142, no. 4; Kakudo 1981, p. 66.

1. The excavation project was headed by the late Prof. Tsugio Mikami and supported by local government offices.
2. Hiroko Nishida, *Ko-Imari*, vol. 23 of Nihon tōji zenshū (Tokyo: Chūōkōronsha, 1976), p. 50.

No. 103 Imari jar, B62 P1146
LITERATURE: Kakudo 1981, p. 65.

1. Takeshi Nagatake, *Imari*, vol. 19 of Tōji taikei (Tokyo: Heibonsha, 1973), pp. 93–94.
2. Richard Cleveland, *200 Years of Japanese Porcelain*, exh. cat. (St. Louis, Mo.: Saint Louis Art Museum, 1970), no. 75.
3. Ibid., p. 149.

No. 104 Imari plate with VOC mark, B60 P974
LITERATURE: Kakudo 1981, p. 65.

1. Hiroko Nishida, *Ko-Imari*, vol. 23 of Nihon tōji zenshū (Tokyo: Chūōkōronsha, 1976), p. 55.
2. Ibid.
3. Richard Cleveland, *200 Years of Japanese Porcelain*, exh. cat. (St. Louis, Mo.: Saint Louis Art Museum, 1970), p. 153, no. 34.
4. Hiroko Nishida, *Ko-Imari*, vol. 23 of Nihon tōji zenshū (Tokyo: Chūōkōronsha, 1976), p. 57, and Yoshiko Kakudo, *The Effie B. Allison Collection: Kosometsuke and Other Chinese Blue-and-White Porcelains* (San Francisco: Asian Art Museum, 1982).

No. 105 Kakiemon jar, B60 P1206
LITERATURE: Yukio Yashiro, "Avery Brundage and the Art of the Orient," *Asia Foundation Program Bulletin*, no. 40 (Aug. 1966), pl. 23; d'Argencé 1978, fig. 96; Kakudo 1981, p. 63.

1. Hiroko Nishida, *Kakiemon*, vol. 24 of Nihon tōji zenshū (Tokyo: Chūōkōronsha, 1977), p. 48.

No. 106 Kakiemon ewer, B65 P59
1. Kankichi Ryū and Takeshi Nagatake, *Arita*, vol. 2 of Nihon no yakimono (Kyoto: Tankōsha, 1966), p. 141.
2. Hiroko Nishida, *Kakiemon*, vol. 24 of Nihon tōji zenshū (Tokyo: Chūōkōronsha, 1977), p. 51.
3. In Japan the first mention of Kakiemon was in a governmental guidebook published in 1878. The distinctive characteristics of Kakiemon were finally recognized in 1916 in a historical publication on art, in which the author described the soft sheen of its surface, its sophisticated patterns, and the subdued decoration that enhance the white clay bodies of Kakiemon pieces; ibid., pp. 47–48.

No. 107 Pair of Imari jars, B62 P60, B62 P61
LITERATURE: Kakudo 1981, p. 64.

1. Hiroko Nishida, *Ko-Imari*, vol. 23 of Nihon tōji zenshū (Tokyo: Chūōkōronsha, 1976), p. 59. Unofficial exports of inferior quality porcelain lasted through another couple of decades.
2. Ibid., p. 67.
3. Ibid., p. 64.
4. Ibid., pl. 53, and *The Kyushu Ceramic Museum Collection* (Saga: Kyushu Ceramic Museum, 1987), pl. 163.
5. Nishida, *Ko-Imari*, p. 65.

No. 108 Kakiemon lobed plate, B62 P47

1. Kakiemon Chōsadan, ed., *Kakiemon* (Saga: Kankudō, 1957), pp. 73–82.

2. Richard Cleveland, *200 Years of Japanese Porcelain*, exh. cat. (St. Louis, Mo.: Saint Louis Art Museum, 1970), p. 178, no. 102; Hiroko Nishida, *Kakiemon*, vol. 24 of Nihon tōji zenshū (Tokyo: Chūōkōronsha, 1977), pl. 51.

No. 109 Kakiemon woman, B62 P5+
LITERATURE: Kakudo 1980b, p. 111, fig. 7.

1. Hiroko Nishida, *Kakiemon*, vol. 24 of Nihon tōji zenshū (Tokyo: Chūōkōronsha, 1977), pls. 35–41.
2. Ibid., p. 48.

No. 110 Kakiemon water dropper, B69 P30
LITERATURE: D'Argencé 1976, no. 149.

No. 111 Kakiemon jar, B64 P37
LITERATURE: Richard Cleveland, *200 Years of Japanese Porcelain*, exh. cat. (St. Louis, Mo.: Saint Louis Art Museum, 1970), p. 148, pl. 21.

1. A published example of a similar jar in the Saint Louis Art Museum has a bird decoration in cobalt blue, a similar set of decorative bands around the neck and shoulder, and a somewhat unsuccessfully finished foot. Cleveland, *200 Years of Japanese Porcelain*, p. 35, pl. 21.

No. 112 Imari celadon bottle, B62 P65

1. Hiroko Nishida, *Kakiemon*, vol. 24 of Nihon tōji zenshū (Tokyo: Chūōkōronsha, 1977), p. 51.

2. *Kokunai shutsudo no Hizen tōji*, exh. cat. (Saga: Kyushu tōji bunkakan, 1984).

3. Tsugio Mikami et al., *Arita Tengudani koyō* (Tokyo: Chūōkōronsha, 1972), p. 152, fig. 54, pls. 49, 54.

No. 113 Nabeshima dish with camellia, B60 P46+
LITERATURE: D'Argencé 1978, fig. 97.

1. Yoshiaki Yabe, *Nabeshima*, vol. 25 of Nihon tōji zenshū (Tokyo: Chūōkōronsha, 1976), p. 51.

2. Genryū Imaizumi, *Nabeshima*, vol. 21 of Tōki taikei (Tokyo: Heibonsha, 1972), p. 104.

3. Yabe, *Nabeshima*, p. 63.

No. 114 Nabeshima dish with flower basket design, B62 P23
LITERATURE: D'Argencé 1978, fig. 97; Kakudo 1981, p. 62.

1. Toyoji Takasu, *Kakiemon Nabeshima*, vol. 23 of Tōki zenshū (Tokyo: Heibonsha, 1964), p. 15.

2. Yoshiaki Yabe, *Nabeshima*, vol. 25 of Nihon tōji zenshū (Tokyo: Chūōkōronsha, 1976), pp. 60–61.

No. 115 Kutani plate, B64 P31
LITERATURE: D'Argencé 1968, [p. 31]; Kakudo 1980b, p. 116, fig. 15.

1. Daisuke Kitahara raised this question in Japan in 1938. In 1956 Soame Jenyns raised a similar question regarding a piece in a European collection, datable to before 1671 (Oriental Ceramic Society, *Catalogue of Exhibition of Japanese Porcelain* [London, 1956]). See Hiroko Nishida, *Kutani*, vol. 22 of Tōji taikei (Tokyo: Heibonsha, 1978), p. 86.

2. *Kutani koyō daiichiji chōsa gaihō dainiji chōsa gaihō* (Ishikawa: Ishikawa-ken Kyōikuiinkai, 1971–72).

3. Shards of a plate with so-called Kutani-style underglaze blue decoration were collected during excavations in Arita in Kyushu. This suggests that some of these wares were fired in Arita, then shipped to another still-undetermined location to be enameled.

4. Sensaku Nakagawa, *Ko-Kutani*, vol. 8 of Tōki zenshū (Tokyo: Heibonsha, 1963), p. 5.

5. Susumu Shimazaki, *Ko-Kutani*, vol. 26 of Nihon tōji zenshū (Tokyo: Chūōkōronsha, 1978), p. 50. Among the four individuals listed as "Saijirō" in provincial records, the Saijirō who signed and dated a temple bell he cast appears to have been the founder of the kiln.

6. Ibid., p. 55. Maeda Toshimitsu sent his own agent to Nagasaki to purchase fine polychrome Chinese porcelain. He was the first Japanese to place special orders with Dutch traders for Delft merchandise.

7. Ibid., p. 56. Many Kutani pieces, like Kōchi ware, do not include red enamel.

8. Ibid., p. 57.

9. Ibid., p. 51.

No. 116 Black Raku tea bowl, B76 P5
LITERATURE: D'Argencé 1976, pl. 142; Kakudo 1980b, p. 111, fig. 6.

1. Taka Akanuma, *Raku daidai*, vol. 21 of Nihon no tōji (Tokyo: Chūōkōronsha, 1976), p. 54.

2. Seizō Hayashiya, "Edojidai no Raku yaki," in pt. 1 of *Edo*, vol. 6 of Sekai tōji zenshū (Tokyo: Shōgakkan, 1975), p. 287.

3. The inner box has an inscription by Nintokusai, the tenth-generation Urasenke grand master (act. 1801–26), stating the name "Natsu kagura" and authenticating the bowl.

No. 117 Incense container, B74 P5
LITERATURE: D'Argencé 1976, pl. 143; "Rarities of the Asian Art Museum," *Asia Foundation Program Bulletin*, 1978, p. 20, fig. 14; Seizō Hayashiya, ed., *Tōji*, vol. 9 of Zaigai Nihon no shihō (Tokyo: Mainichi shimbunsha, 1981), pl. 77.

1. For a nearly identical incense container, see Carolyn Wheelwright, ed., *Word in Flower: The Visualization of Classical Literature in Seventeenth-Century Japan*, exh. cat. (New Haven, Conn.: Yale University Press, 1989), p. 53, fig. 26.

2. Masahiko Kawahara, *Ninsei*, vol. 27 of Nihon tōji zenshū (Tokyo: Chūōkōronsha, 1976), p. 47.

3. Ibid., p. 48. The records concerning Ninsei are often quite specific. For instance, in 1648, Matsuya Hisashige, a tea connoisseur in Nara, noted that after being invited by Kanamori Sōwa for a tea gathering, he saw a square tea caddy by Ninsei made according to the design provided by Sōwa (p. 47).

No. 118 Fan-shaped plate, B62 P17

1. Masahiko Kawahara, *Kyōyaki*, vol. 26 of Tōji taikei (Tokyo: Heibonsha, 1976), p. 90.

2. Ibid.

3. Ibid., p. 96.

No. 119 Bowl, Kenzan, B69 P32
LITERATURE: D'Argencé 1976, p. 145; d'Argencé 1978, fig. 100; Kakudo 1980b, p. 116, fig. 14.

1. Kōetsu founded the artist colony at Takagamine, where Kenzan's father, also an accomplished calligrapher in his own right, had a residence.

2. We know little about Ninsei II except that he was a generous potter who gave Kenzan his father's famous *densho*, the professional handbook containing formulas for clay and glaze preparations.

3. Seizō Hayashiya, *Kenzan*, vol. 12 of Nihon no tōji (Tokyo: Chūōkōronsha, 1975), pls. 118–20.

4. Ibid., p. 139. Kenzan often incorporated his own signature in a design. A systematic study of the wide range of his style and stroke variations was only recently begun by calligraphy specialist Akira Nagoya for the exhibition *Kenzan no tōgei* (Tokyo: Gotō Museum, 1987). According to this study, the signature on this bowl falls into the C type, often seen on a set of dishes, and most probably attributable to his studio.

No. 120 Stem bowl, Okuda Eisen, B60 P1234
LITERATURE: Yoshiko Kakudo, "A Stem Bowl by Okuda Eisen,"
Archives of Asian Art 26 (1972–73), pp. 74–75; d'Argencé 1978,
fig. 101; Seizō Hayashiya, ed., *Tōji*, vol. 9 of Zaigai Nihon no
shihō (Tokyo: Mainichi shimbunsha, 1981), pl. 87.

1, Tadanari Mitsuoka, "Okuda Eisen Aoki Mokubei," in pt. 1 of
[illegible]
2. Ibid., pls. 74–75.
3. Both the inscription *Rikuhōzan*, on this stem bowl, and *Tenmei
nensei*, on the brush tray, are covered with a green enamel. This
similarity may indicate that they were made within a short time
of each other.

No. 121 Seto dish, B61 P88
1. Built and fired in private gardens, such exclusive kilns were
called *oniwayaki*, or "garden firing."
2. In western Japan, *karatsumono* (wares from Karatsu, see nos.
100, 101) was used as a generic term for pottery.
3. See *Patronage* 1989, pp. 101–3.
4. Kiyotoshi Kikuta, *Seto no kotōji* (Kyoto: Kōrinsha, 1973), p.
154.

No. 122 Pair of guardian lions, B64 P43, B64 P44
1. *Hōryūji Ōkagami*, pt. 2, vol. 2 of Nanto jūdaiji ōkagami (Tokyo:
Ōtsukakōgeisha, 1934), pl. 49.
2. *Tōdaiji Ōkagami*, pt. 1, vol. 16 of Nanto jūdaiji ōkagami (Tokyo:
Ōtsukakōgeisha, 1932), pls. 7–13.
3. Tokyo National Museum, ed., *Sculpture*, vol. 3 of *Pageant of
Japanese Art* (Tokyo: Tōto Bunka, 1953), pl. 49.
4. Shizuo Honda, *Tōji no komainu* (Tokyo: Kyūryūdō, 1976).
5. Shōichi Narasaki, *Seto Mino*, vol. 9 of Nihon tōji zenshū
(Tokyo: Chūōkōronsha, 1976), p. 70, nos. 48–51.
6. Ibid., p. 242.

No. 123 Square plate, Kitaōji Rosanjin, B80 P8
1. Having been disappointed in calligraphers, Rosanjin never had
a teacher but turned instead to the study of Chinese and
Japanese classics.
2. Kōji Yoshida, ed., *Kitaōji Rosanjin*, vol. 2 of Nihon tōgei zenshū
(Tokyo: Shūeisha, 1980), p. 88.
3. Ibid., p. 104.

No. 124 Bottle, Kanjirō Kawai, 1988.58.2
LITERATURE: *Patronage* 1989, no. 53.

1. Yoshiaki Inui, ed., *Kawai Kanjirō*, vol. 4 of Gendai Nihon tōgei
zenshū (Tokyo: Shūeisha, 1978), p. 75.
2. Volumes of his minutely detailed class notes on glaze chem-
istry and the basics of ceramics are kept in the Kawai Kanjirō
Memorial Museum in Kyoto; ibid., p. 79. Kanjirō's thousands of
glaze tests, made when he was at the Technical Research
Institute in Kyoto, were not only famous but also laid the
foundation for his later work.
3. The term *mingei* was created by Yanagi, Kawai, and Hamada
during a trip in 1925 to Ki Province, where they were searching
for material that they could use to promote "crafts for people,"
or *minshū teki kōgei*, from which came the shortened form *mingei*.
4. Especially remarkable was Kenichi Kawakatsu, who collabo-
rated with Kawai for his first one-man show and became a
patron-friend. In 1968, at the time of a retrospective exhibition,
he donated over four hundred Kawai pieces to the Kyoto
National Museum of Modern Art.
5. Kanjirō Kawai, *We Do Not Work Alone* (Inochi no mado) (Kyoto:
Folk Art Society, 1953; reprint, Kawai Kanjirō Kinenkan, 1973).

No. 125 Sake cup, Kitaōji Rosanjin, B81 P79
1. Rosanjin owned an antiques shop and began his restaurant
business there, serving patrons on genuine antique ware. As
business expanded, he began copying antique food-serving

pieces in order to keep up appearances with the growing number
of restaurant patrons. Kōji Yoshida, ed., *Kitaōji Rosanjin*, vol. 2 of
Gendai Nihon tōgei zenshū (Tokyo: Shūeisha, 1980), p. 89.
2. Ibid., pl. 77.
3. Sidney B. Cardozo and Masaaki Hirano, *The Art of Rosanjin*
(Tokyo, New York, and San Francisco: Kōdansha International,
1987), p. 161.

METALWARE

No. 126 Eight-lobed mirror, B65 B56
LITERATURE: John M. Rosenfield, *Japanese Arts of the Heian Period:
794–1185* (New York: Asia Society, 1967), p. 123, pl. 43.

1. Masaki Nakano, *Wakyō*, Nihon no bijutsu, no. 42 (Tokyo:
Shibundō, 1969), p. 30.

No. 127 Mirror with *matsuhui zuru*, B60 B339
LITERATURE: John M. Rosenfield, *Japanese Arts of the Heian Period:
794–1185* (New York: Asia Society, 1967), p. 124, pl. 46.

1. It is speculated that this mirror was found in a sutra burial
site. Rosenfield, *Japanese Arts of the Heian Period*, p. 124.
2. Masaki Nakano, *Wakyō*, Nihon no bijutsu, no. 42 (Tokyo:
Shibundō, 1969), p. 40.
3. Ibid.

No. 128 Sutra case, B60 B310
1. This date marked 1,500 years after Sakyamuni's passing.
Mosaku Ishida, *Bukkyō bijutsu no kihon* (Tokyo: Tokyo bijutsu,
1967), p. 452.
2. Osamu Kurata, "Kyōzuka ron," *Museum*, no. 181 (April 1966),
p. 26, fig. 46.
3. *Kyōzuka ihō ten*, exh. cat. (Nara: Nara National Museum, 1973),
pls. 65–81.

No. 129 Mirror with chrysanthemum design, B60 B24+
1. One Haguro-type Fujiwara period mirror (see no. 127)
weighed about 68 grams; a Kamakura period mirror of similar
diameter weighed 367 grams. Masaki Nakano, *Wakyō*, Nihon no
bijutsu, no. 42 (Tokyo: Shibundō, 1969), p. 44.

No. 131 *Gokosho* and *gokorei*, B60 B357a, B60 B357b
1. Masayuki Sekiguchi, ed., *Mikkyō*, vol. 2 of Zusetsu Nihon no
bukkyō (Tokyo: Shinchōsha, 1989), p. 93.
2. Mosaku Ishida and Jōji Okazaki, Nara National Museum, eds.,
Mikkyō hōgu (Tokyo: Kōdansha, 1965), pls. 2–3.
3. Ibid., p. 8.
4. Ibid., pl. 85.

No. 132 Eight-lobed mirror, B60 B21+
No. 133 Mirror with landscape, B65 B55
1. Masaki Nakano, *Wakyō*, Nihon no bijutsu, no. 42 (Tokyo:
Shibundō, 1969), p. 52.
2. Ibid., p. 60.

No. 134 Censer, B65 B49
1. Osamu Kurata, *Butsugu*, Nihon no bijutsu, no. 16 (Tokyo:
Shibundō, 1967), pls. 14, 58.

LACQUERWARE

No. 135 Negoro ewer, B60 M1+
LITERATURE: D'Argencé 1966, pl. 9.

1. Raw lacquer is obtained by scarring the tree trunk in a
manner similar to that used for collecting rubber sap. Stickier
than rubber and extremely toxic, lacquer sap is collected by
carefully scraping the open grooves with a metal tool. After
refining, the still-sticky substance is applied to a basic form
with wooden spatulas or special flat brushes made of human

hair. Curing applied lacquer requires a rather high humidity and temperature; in Japan the climate of Kyoto and Nara is nearly ideal for its production. But even in good atmospheric conditions, craftsmen augment the curing process by enclosing lacquer objects in special curing chambers.

2. Ivan Morris, *The Tale of Genji Scroll* (Tokyo and Palo Alto, Calif.: Kōdansha International, 1971), p. 55, pl. 3 of "Kashiwagi," chap. 3.

3. Mixed with lacquer juice, expensive natural cinnabar results in a bright red; the less expensive iron oxide gives a much darker and more subtle range of reds; see Tei Kawada, *Negoronuri*, Nihon no bijutsu, no. 120 (Tokyo: Shibundō, 1976), p. 33.

4. Ibid., p. 28.

5. They are in the Mary and Jackson Burke collection, Freer Gallery collection, and the Kimiko and John Powers collection. The first two have been published: Miyeko Murase, *Japanese Art: Selections from the Mary and Jackson Burke Collection*, exh. cat. (New York: Metropolitan Museum of Art, 1975), p. 328, and Ann Yonemura, *Japanese Lacquer*, exh. cat. (Washington, D.C.: Freer Gallery of Art, 1979), p. 15, pl. 6.

No. 136 Box for writing paper, B60 M162
LITERATURE: Yoshiko Kakudo, *Later Japanese Lacquers*, exh. brochure (San Francisco: Asian Art Museum, 1987), no. 13.

1. The left-hand screen of a pair of Genji screens in the Asian Art Museum depicts such an aviary (R1988.34.12b); the design is unique among numerous Genji screens and may reflect the taste of the Edo period elite.

No. 137 *Suzuribako*, B60 M440
LITERATURE: Yoshiko Kakudo, *Later Japanese Lacquers*, exh. brochure (San Francisco: Asian Art Museum, 1987), no. 5 (cover); Yoshiko Kakudo, "Looking beyond Surface Embellishment: Themes in Later Japanese Lacquer from the Asian Art Museum of San Francisco," *Orientations* 18, no. 2 (Feb. 1987), p. 46.

1. Ivan Morris, *The Tale of Genji Scroll* (Tokyo and Palo Alto, Calif.: Kōdansha International, 1971), p. 77.

2. *Tōyō no shiggei*, exh. cat. (Tokyo: Tokyo National Museum, 1977), no. 95.

No. 138 *Suzuribako*, B60 M438
LITERATURE: Yoshiko Kakudo, *Later Japanese Lacquers*, exh. brochure (San Francisco: Asian Art Museum, 1987), no. 2; Yoshiko Kakudo, "Looking beyond Surface Embellishment: Themes in Later Japanese Lacquer from the Asian Art Museum of San Francisco," *Orientations* 18, no. 2 (Feb. 1987).

1. Hirokazu Arakawa, ed., *Makie*, vol. 4 of Nihon no shiggei (Tokyo: Chūōkōronsha, 1979), p. 178.

2. National Gallery of Art, *Japan: The Shaping of Daimyo Culture, 1185–1868* (Washington, D.C., 1988), pls. 227–28.

3. Arakawa, *Makie*, p. 104, pls. 18–19.

No. 139 *Sagejūbako*, B60 M156
LITERATURE: D'Argencé 1968, [p. 33]; Yoshiko Kakudo, *Later Japanese Lacquers*, exh. brochure (San Francisco: Asian Art Museum, 1987), no. 39.

No. 140 Covered box, Yūtokusai Hōgyoku, B60 M7+
LITERATURE: Yoshiko Kakudo, "Looking beyond Surface Embellishment: Themes in Later Japanese Lacquer from the Asian Art Museum of San Francisco," *Orientations* 18, no. 2 (Feb. 1987), p. 40.

1. For a pair of screens depicting this theme in the Asian Art Museum collection, see *Patronage* 1989, no. 48.

No. 141 *Suzuributa*, B60 M294
LITERATURE: Tadaomi Gōke, *Shibata Zeshin meihin shū* (Tokyo:

Gakken, 1981), pl. 6; Yoshiko Kakudo, *Later Japanese Lacquers*, exh. brochure (San Francisco: Asian Art Museum, 1987), no. 11.

1. Gōke, *Shibata Zeshin meihin shū*, p. 160.

2. Ibid., p. 186.

3. This was a custom devised by Edo period merchants after the *bakufu*'s issuance of an ordinance regulating the use of sumptuous garments by different classes. Style-conscious rich merchants thus hid their extravagant linings under somber textiles.

No. 142 Set of boxes, Shibata Zeshin, B60 M3+, B60 M4+
LITERATURE: Tadaomi Gōke, *Shibata Zeshin meihin shū* (Tokyo: Gakken, 1981), pl. 32.

No. 143 Set of twelve *kōgō*, B60 M295a–l
LITERATURE: Yoshiko Kakudo, *Later Japanese Lacquers*, exh. brochure (San Francisco: Asian Art Museum, 1987), no. 25 (*kōgō* for seventh month only); Yoshiko Kakudo, "Later Japanese Lacquers," *Triptych*, Aug.–Sept. 1987, pp. 5–7; Yoshiko Kakudo, "Looking beyond Surface Embellishment: Themes in Later Japanese Lacquer from the Asian Art Museum of San Francisco," *Orientations* 18, no. 2 (Feb. 1987), p. 48.

1. The *Engishiki* (Procedures of the Engi Era, 901–922; fifty volumes of supplementary government regulations) records that many, many more hours were spent in lacquering than in making wooden cores.

COSTUME, INRŌ, AND NETSUKE

No. 144 *Kosode*, B62 M74

1. Eiko Kamiya, *Kosode*, Nihon no bijutsu, no. 67 (Tokyo: Shibundō, 1971), p. 18. The term "kosode" (literally, small sleeves), in contrast to the traditional large-sleeved *ōsode*, was already in use as well.

2. Ibid., pl. 4. Kamiya believes the painted pattern on this *kosode* is part of a *tsujigahana*-type textile in which painted and dyed patterns were combined. These textiles were popular during the Muromachi and Momoyama periods. Only during the Edo period were truly hand-painted *kosode* made. *Kosode* with floral patterns painted by such artists as Ogata Kōrin (see Chigyō Yamanobe, *Senshoku*, vol. 8 of Nihon bijutsu taikei [Tokyo: Kōdansha, 1961], pl. 132) and Sakai Hōitsu (see Shōhei Kumita and Tanio Nakamura, *Sakai Hōitsu gashū*, vol. 1 [Tokyo: Kokusho kankōsha, 1976], pl. 157) are good examples of this type.

No. 145 *Inrō* and netsuke, B70 Y1379, B70 Y1380

1. Hirokazu Arakawa, *Inrō to netsuke*, no. 195 of Nihon no bijutsu (Tokyo: Shibundō, 1982), pp. 64–66.

2. Ibid., p. 70.

3. For one of the most often-cited paintings, see Ichirō Kondō, *Japanese Genre Painting: The Lively Art of Renaissance Japan*, trans. Roy Andrew Miller (Rutland, Vt., and Tokyo: Charles E. Tuttle, 1961), pls. 5, 89.

No. 146 *Inrō* and netsuke, B70 Y1417, B70 Y1418

1. Saburō Mizoguchi, *Design Motifs*, trans. Louise Allison Cort, vol. 1 of *Arts of Japan* (New York and Tokyo: Weatherhill and Shibundō, 1973), pl. 64.

No. 147 *Tonkotsu* and netsuke, Shibata Zeshin, B70 Y1606, B70 Y1607

1. William H. Edmunds, *Pointers and Clues to the Subjects of Chinese and Japanese Art* (London: Sampson, Low, Marston and Co., 1934), pp. 553–54.

SELECTED BIBLIOGRAPHY

Arakawa, Hirokazu, *The Gō Collection of Netsuke*. Tokyo, New York, and San Francisco: Kōdansha International, 1983.

Awakawa, Yasuichi. *Zen Painting*. Trans. John Bester. Tokyo and Palo Alto, Calif.: Kōdansha International, 1970.

Cahill, James. *Scholar Painters of Japan: The Nanga School*. New York: Asia Society, 1972.

Cort, Louise Allison. *Shigaraki: Potters Valley*. Tokyo and Palo Alto, Calif.: Kōdansha International, 1979.

Coullery, Marie Therese, and Martin S. Newstead. *The Baur Collection: Netsuke*. Geneva: Collection Baur-Genève, 1977.

Famous Ceramics of Japan. 12 vols. Tokyo and New York: Kōdansha International, 1981–82.

Fontein, Jan, and Money L. Hickman. *Zen Painting and Calligraphy*. Exh. cat. Boston: Museum of Fine Arts, 1970.

French, Calvin L. *Shiba Kōkan: Artist, Innovator, and Pioneer in the Westernization of Japan*. New York and Tokyo: Weatherhill, 1974.

Genshoku Nihon no bijutsu. 30 vols. Tokyo: Shōgakkan, 1967–72.

Heibonsha Survey of Japanese Art. 31 vols. New York and Tokyo: Weatherhill and Heibonsha, 1972–80.

Honda, Shizuo. *Tōji no komainu*. Tokyo: Kyūryūdō, 1976.

Ienaga, Saburō, Toshihide Akamatsu, and Taijō Tamamuro, eds. *Nihon Bukkyōshi*. 3 vols. Kyoto: Hōzōkan, 1967.

Japanese Arts Library. 11 vols. Tokyo, New York, and San Francisco: Kōdansha International and Shibundō, 1979.

Kageyama, Haruki, and Christine Guth Kanda. *Shinto Arts: Nature, Gods, and Man in Japan*. Exh. cat. New York: Japan Society, 1976.

Kidder, J. Edward, Jr. *The Birth of Japanese Art*. New York and Washington, D.C.: Praeger, 1965.

Kitagawa, Joseph M. *Religion in Japanese History*. New York: Columbia University Press, 1966.

Kōdansha Encyclopedia of Japan. 9 vols. Tokyo and New York: Kōdansha International, 1983.

Kuno, Takeshi. *A Guide to Japanese Sculpture*. Tokyo: Mayuyama and Co., 1963.

Kurata, Bunsaku. *Butsuzō no mikata*. Tokyo: Daiichihōki shuppansha, 1965.

Kurata, Bunsaku, ed. *Hōryū-ji: Temple of the Exalted Law: Early Buddhist Art from Japan*. Exh. cat. New York: Japan House Gallery, 1981.

Lee, Sherman E., et al. *Reflections of Reality in Japanese Art*. Exh. cat. Cleveland: Cleveland Museum of Art, 1983.

Matsunaga, Daigan, and Alicia Matsunaga. *Foundation of Japanese Buddhism*. 2 vols. Los Angeles and Tokyo: Buddhist Books International, 1974–76.

Mayuyama, Junkichi. *Japanese Art in the West*. Kyoto and Tokyo: Mayuyama Ryūsendō, 1966.

Murase, Miyeko. *Byōbu, Japanese Screens from New York Collections*. Exh. cat. New York: Asia Society, 1971.

————. *Japanese Art: Selections from the Mary and Jackson Burke Collection*. Exh. cat. New York: Metropolitan Museum of Art, 1975.

————. *Iconography of the Tale of Genji: Genji Monogatari Ekotaba*. New York and Tokyo: Weatherhill, 1983.

Nihon bijutsu kaiga zenshū. 25 vols. Tokyo: Shūeisha, 1976–80.

Nihon bijutsu zenshū. 25 vols. Tokyo: Gakken, 1977–80.

Nihon byōbu-e shūsei. 17 vols. plus suppl. Tokyo: Kōdansha, 1977–81.

Nihon emakimono zenshū. 24 vols. Tokyo: Kadokawa Shoten, 1958–69.

Nihon genshi bijutsu. 6 vols. Tokyo: Kōdansha, 1964–66.

Nihon no bijutsu. Tokyo: Shibundō, 1966–.

Nihon no shiggei. 6 vols. Tokyo: Chuokoronsha, 1978–79.

Nihon tōji zenshū (A Pageant of Japanese Ceramics). Brief summaries of text in English. 30 vols. Tokyo: Chuokoronsha, 1975–78.

Pearson, Richard. *Image and Life: 50,000 Years of Japanese Prehistory*. Vancouver: University of British Columbia Museum of Anthropology, 1979.

Pearson, R., G. Barnes, and K. Hutterer, eds. *Windows on the Japanese Past: Studies in Japanese Archaeology and Prehistory*. Ann Arbor: Center for Japanese Studies, University of Michigan, 1986.

Pekarik, Andrew J. *Japanese Lacquer, 1600–1900: Selections from the Charles A. Greenfield Collection*. Exh. cat. New York: Metropolitan Museum of Art, 1980.

Rague, Beatrix von. *A History of Japanese Lacquerwork*. Trans. Annie R. de Wassermann. Toronto and Buffalo: University of Toronto Press, 1976.

Rimpa kaiga zenshū. 5 vols. Tokyo: Nihonkeizai shimbunsha, 1977–80.

Rosenfield, John M. *Japanese Arts of the Heian Period: 794–1185*. New York: Asia Society, 1967.

Rosenfield, John M., and Elizabeth ten Grotenhuis. *Journey of the Three Jewels: Japanese Buddhist Art in Western Collections*. Exh. cat. New York: Asia Society, 1979.

Rosenfield, John M., and Shūjirō Shimada. *Traditions of Japanese Art: Selections from the Kimiko and John Powers Collection*. Exh. cat. Cambridge, Mass.: Fogg Art Museum, Harvard University Press, 1970.

Sadō shūkin. 10 vols. Tokyo: Shōgakkan, 1983–87.

Sekai tōji zenshū. 22 vols. Tokyo: Shōgakkan, 1976–86.

Shimizu, Yoshiaki, and John M. Rosenfield, eds. *Masters of Japanese Calligraphy: 8th–19th Century*. Exh. cat. New York: Japan House Gallery and Asia Society, 1984.

Shimizu, Yoshiaki, and Carolyn Wheelwright, eds. *Japanese Ink Paintings*. Princeton, N.J.: Princeton University Press, 1976.

Stern, Harold P. *Ukiyo-e Paintings*. Exh. cat. Washington, D.C.: Freer Gallery of Art, Smithsonian Institution, 1973.

Suiboku bijutsu taikei. 15 vols. Tokyo: Kōdansha International, 1973–75.

Tōji taikei. 48 vols. Tokyo: Heibonsha, 1972–79.

Tokyo National Museum, ed. *Pageant of Japanese Art*. 6 vols. Tokyo: Tōto Bunka, 1957–58.

Ueda, Reikichi. *The Netsuke Handbook of Ueda Reikichi*. Rutland, Vt., and Tokyo: Charles E. Tuttle Co., 1964.

Yamane, Yūzō. *Momoyama Genre Painting*. New York and Tokyo: Weatherhill and Heibonsha, 1973.

Yonemura, Ann. *Japanese Lacquer*. Exh. cat. Washington, D.C.: Freer Gallery of Art, Smithsonian Institution, 1979.

Zaigai hihō. 3 vols. Tokyo: Gakken, 1969.

Zaigai Nihon no shihō. 12 vols. Tokyo: Mainichi shimbunsha, 1979–81.

INDEX